PHOTOSHOP®
ELEMENTS
2018

PHOTOSHOP®
ELEMENTS
2018
From Novice to Expert

Vickie Ellen Wolper

MERCURY LEARNING AND INFORMATION
Dulles, Virginia
Boston, Massachusetts
New Delhi

Publisher: David Pallai
MERCURY LEARNING AND INFORMATION
22841 Quicksilver Drive
Dulles, VA 20166
info@merclearning.com
www.merclearning.com
1-(800)-232-0223

V. E. Wolper. *Photoshop® Elements 2018: From Novice to Expert.*
ISBN: 978-1-683922-33-9

The publisher recognizes and respects all marks used by companies, manufacturers, and developers as a means to distinguish their products. All brand names and product names mentioned in this book are trademarks or service marks of their respective companies. Any omission or misuse (of any kind) of service marks or trademarks, etc. is not an attempt to infringe on the property of others.

Library of Congress Control Number: 2018950341

181920321 This book is printed on acid-free paper in the United States of America.

Our titles are available for adoption, license, or bulk purchase by institutions, corporations, etc. For additional information, please contact the Customer Service Dept. at 800-232-0223(toll free).

All of our titles are available in digital format at *authorcloudware.com* and other digital venders. The sole obligation of MERCURY LEARNING AND INFORMATION to the purchaser is to replace the book, based on defective materials or faulty workmanship, but not based on the operation or functionality of the product. *Companion files are available by writing to the publisher at info@merclearning.com.*

*This book is dedicated to all of my friends
and family who continue to support
my passion for writing,
with special thanks to
Barry, Shaunna, and Noah.*

CONTENTS

Part Two: *Working in the* Elements Photo Editor.............. 71

Chapter 3 Basics for All Editing Modes ... 73

Chapter 4 Basics of the Expert Mode ... 95

Chapter 7 Making Good Photographs Great by Removing Unwanted Content ... 215

CREDITS

The following list of friends have generously given their permission to have their photographs included in this book.

Conway, George
Chapter 8: Title page, Figure 8.19, Figure 8.20, Figure 8.21, Figure 8.22, Figure 8.23, Figure 8.24, Figure 8.25, Figure 8.27, Figure 8.28

Demers, Sarah
Chapter 7: Title page, Figure 7.16, Figure 7.17, Figure 7.18, Figure 7.19, Figure 7.20, Figure 7.25, Figure 7.27, Figure 7.28, Figure 7.29, Figure 7.31, Figure 7.32
Chapter 9: Figure 9.36
Chapter 10: Title page, Figure 10.13, Figure 10.34
Chapter 11: Figure 11.8
Part Two section cover

Krupa, Micki
Chapter 8: Title page, Figure 8.2, Figure 8.3, Figure 8.4, Figure 8.6, Figure 8.7, Figure 8.8, Figure 8.9, Figure 8.10, Figure 8.11, Figure 8.13, Figure 8.14, Figure 8.15, Figure 8.16, Figure 8.17

Meyers, Joannie
Chapter 10: Figure 10.16, Figure 10.17

Meyers, Robert
Chapter 8: Figure 8.31, Figure 8.32, Figure 8.33

Wolper, Barry
Photographs from Canada, Colonial Williamsburg, Galapagos Islands, Holland, and Machu Picchu

PREFACE

Everybody loves to take pictures. Although some of us may have a DSLR or another type of digital camera, we all take pictures with our phones... and *lots* of them. However they are taken, some of the pictures we take come out great... some not so great. Working through the projects in this book, you can learn how to search and *find* them on your hard drive, and how to make them *all* great, and have *fun* doing it. This book is designed to teach you step-by-step from downloading your photographs, to creating a slideshow of your finest makeover masterpieces.

Photoshop Elements 2018 is comprised of two workspaces: the Elements Organizer, and the Elements Photo Editor. Perhaps you want to "learn it all," or perhaps your primary interest is in learning to use Photoshop Elements as an organizational tool, or to use it as an editing tool. Because this book is divided into two parts, you can focus your learning on your specific personal photography needs and goals.

If photograph enhancement is one of your goals, the Elements Photo Editor provides three modes to work in: Quick, Guided, and Expert. Although some features require a specific mode, others can be achieved using multiple modes. When multiple modes can produce similar results, this book presents solutions within each mode, allowing you to choose the mode that best suits your personal and professional needs in your future work.

A chapter is also included which focuses on the challenges unique to photograph restoration: scanning and creating a composite canvas, surface damage repair, and restoring faded colors and tones.

To further guide you through your training, additional learning tools are included in this book:

- **Tips:** Keyboard and execution short cuts designed to streamline your skills and proficiency.

- **Notes:** Clarification and additional relevant information regarding the content under discussion.

- **Companion Files:** Project files, figure examples, and additional practice projects designed to further advance your expertise. These files are available both on the companion disc included with this text, as well as available from the publisher by writing to: info@merclearning.com.

It is time now to release your creativity and learn to become a Photoshop Elements 2018 expert. Let's get started.

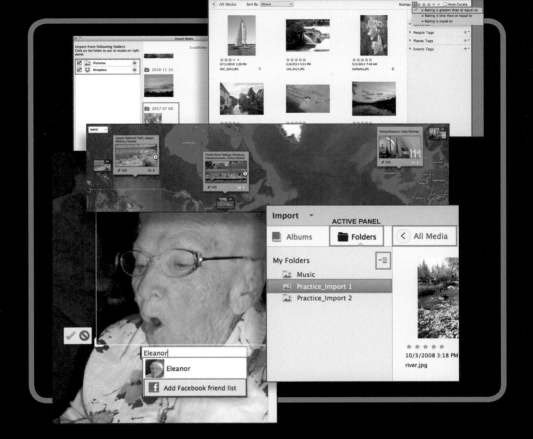

Part One

Working in the Elements Organizer

1

Bringing in Your Photographs

This first chapter will focus on mastering fundamental commands, panels, and operational features required to maximize your future efficiency and expertise in the Elements Organizer.

NOTE ▶ This book is divided into two sections. In Part One, we will learn to work in the Elements Organizer, with Part Two focusing on the features of the Photo Editor. If you prefer to jump right into the Photo Editor, you can begin your learning with Part Two, starting with Chapter Three; you can always return to Part One at any time.

1.1　　Before Launching the Organizer

1.1.1　　Organizing for the Organizer

Once we are working within the Elements Organizer module of Photoshop Elements 2018 (referred to hereafter as simply the Organizer), we will learn multiple ways to import our pictures from within our Photos (or My Pictures) folder, as well as from any additional folders located on our computer and on external media sources, and how to easily sort and manage them. However, if you currently also have some photographs on your computer that are not already organized into folders (randomly located on your desktop, for example), it will be very helpful to move them into

Figure 1.1 Organizing miscellaneous photographs prior to working in Photoshop Elements 2018.

folders prior to initially launching Photoshop Elements 2018 by creating an umbrella folder, with general category subfolders inside, and moving all of your stray images into them. Although this does not *have* to be done prior to launching the Organizer the first time, best practice is to create a folder on your computer for all of these photos, which will "pre-organize" them and expedite their import and management once you are working within the Organizer. Figure 1.1 exemplifies a suggested folder hierarchy to do that based on the tagging scheme built into the Organizer: however, choose the number of subfolders and subfolder names that work most logically for you.

A copy of each figure shown in this chapter can be viewed in the companion files included with this book.

1.1.2　　Accessing the Companion Practice Files

A folder named Practice Files containing several subfolders of working files to accompany our learning in Photoshop Elements 2018 has been provided for you in the companion files included at the back of this book as well as available from the publisher by writing to info@merclearning.com. This folder should be copied to your hard drive prior to launching the program (please review the "ReadOnlyMessage. pdf" document *first*).

1.2　　Launching the Organizer

OK, we are ready. Let's click to launch Photoshop Elements 2018. Once we have done that, a Welcome Screen opens asking us whether we want to launch the Photo

Editor or the Organizer. However, there is also a small gear icon at the top right of this dialog box. When clicked, a drop down menu appears, offering us the option to select a specific module to always open by default as shown in Figure 1.2 (you can always switch back and forth between the two modules once you are working within one of them). Instead of selecting it from the On Start Always Launch menu, let's click

Figure 1.2 Choosing to launch the Organizer module.

the icon for the Organizer at the bottom center of this Welcome Screen to launch it.

When the Organizer opens for the first time, a screen titled "Organize your media with the Elements Organizer" displays with a Start Importing button located at its lower left and another smaller Skip button located at the lower right. If you already have some photographs on your computer in your Photos (My Pictures) folder, the Organizer detects them and is ready to import them automatically for you. Great.

Let's click Start Importing as shown in Figure 1.3.

Once we have done that, an Import Media dialog box opens as shown in Figure 1.4. By default, Pictures is listed on the left representing your Photos (My Pictures) folder, and will be pre-checked, along with any storage options such as Dropbox, OneDrive, etc., that the Organizer has detected that you may also use. To the right of their names, each of these folders will have a small round yellow circle icon with a pair of binoculars inside. This indicates that the folder is a "watched folder" by default, which we will learn about later in this chapter. Notice that there is both a plus

Figure 1.3 Choosing to select or skip the automatic import feature of the Organizer.

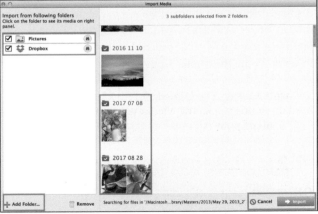

Figure 1.4 Customizing an import.

sign with the words "Add Folder" and a Remove button located at the bottom left of this dialog box. Folders can be added and removed from the list with the head "Import from following folders" prior to clicking the Import button. If you chose earlier to create an umbrella folder to collect all of your random images scattered throughout your computer, you could click the plus sign here, navigate to that folder, and select to import them as well at this time. However, rather than adding them now, let's import these images later using a different method once we are working within the Organizer workspace.

If you have a significant number of photographs in your Photos (My Pictures) folder, you do not have to import all of them in your first import. In the dialog box shown in Figure 1.4, you can uncheck the Pictures checkbox in the left pane first, which will uncheck all of your subfolders and turn the color of their checkboxes displayed in the right pane to gray. You can then selectively click the subfolder checkboxes of the images you *do* want to import (once checked, the small folder icon changes from gray to blue indicating it will be included in the import).

1.3 An Introduction to the Organizer Workspace

Once we click the Import button in the Import Media dialog box, the photographs we have chosen to add to the Organizer will display in the Organizer workspace. Above them, the words "Last Import" appear with a Back arrow on the left that we will need to click so that our newly imported images will display within the main Media view window as shown in Figure 1.5.

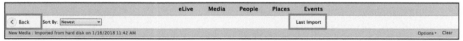

Figure 1.5 Last Import view with Back button to return to the Media view.

Now with the word "Media" highlighted in black and the words "All Media" displayed above our images, we are in the main "central processing" Media view of the Organizer workspace, which we can see has many components. For now let's learn just a few of them, as identified in Figure 1.6, to allow us to comfortably begin to work within the Media view.

> MEDIA VIEW: The Organizer provides four views to help sort and organize your photographs. The Media view opens by default and displays thumbnails of all of your imported images. As we learned earlier, the title is highlighted in black; let's keep this view chosen for now.

> MENU OPTIONS: As we build our expertise in the Organizer, we will employ many of the commands located under these menus. To start, let's select View>Media Types. All of the media types listed here—Photos, Videos, Audio, and Projects—are checked to display by default. Let's choose

to *uncheck* all of them *except* Photos for now. You may have noticed gray boxes with audio icons on them that appeared along with your photograph thumbnails when the Organizer Media view opened. These are complimentary .mp3 music files that were added automatically. They are great free files for adding a professional touch to your projects, which we will learn to incorporate in later chapters.

SORT BY DISPLAY OPTIONS: From the Sort By drop down menu located just below the Media view tab, we can choose to display our photograph thumbnails by Newest, by Oldest, by Name, or by Import Batch, which divides them into sections based on when they were taken. To also have the file information display below the thumbnails as shown in Figure 1.6, let's choose View>Details. Once we have chosen to view the details of our images, their file names can be displayed as well by selecting View>File Names.

GRID VIEW: When working in the Media view, thumbnails are displayed in rows referred to as the Grid view. If desired, you can choose View>Grid Lines to display the grid.

SHOW/HIDE PANEL: Toggle this button on/off to view the Albums and Folders panels of the workspace.

TASKBAR: Buttons provide one click access to many of the features of the Organizer.

EVENT DATE: As we move through the thumbnails of our photographs using the scroll bar provided, their date range displays to the left of it.

Figure 1.6 A few key features of the Organizer workspace.

THUMBNAIL SIZE: This zoom slider allows us to select a viewing size for our thumbnails, from a small group view to a large single image view. Select a zoom view you are comfortable working in that displays a few rows of your thumbnails based on your monitor size and resolution.

ACTIVE CATALOG IDENTIFICATION: In small print at the lower right-hand corner of the Organizer workspace, the name of the active catalog–My Catalog–is displayed. As you generate new catalogs, this listing updates to display whichever catalog is currently in use.

TiP The date options which display when Details has been selected can be further customized if desired by choosing Edit>Preferences>General in Windows or Elements Organizer>Preferences>General in Mac OS.

1.4 Understanding Catalogs

The first time you launch the Organizer, a master "central linking station" named My Catalog is created by default. Every time a photograph is added to the Organizer, this catalog enters a link between the original storage location of the image and the Organizer: the Organizer does *not* actually import your photographs. As tags and other search options are added to that image through the Organizer, the linked file updates to reflect the assigned search attributes.

1.4.1 Creating Additional Catalogs

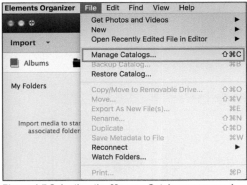

Figure 1.7 Selecting the Manage Catalogs command.

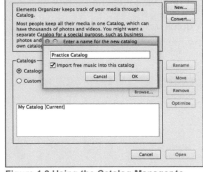

Figure 1.8 Using the Catalog Manager to create a new catalog.

Although the default My Catalog can single-handedly manage all of the photographs you will probably ever want to import into the Organizer, you can create one or more additional catalogs at any time for purposes such as for keeping work-related photography separate from your personal photography. Let's create one now that we will use exclusively for working with the companion files provided with this book. From the File menu, let's choose Manage Catalogs as shown in Figure 1.7.

Once we have done that, the Catalog Manager dialog box opens, and we can see that our default My Catalog is shown as the current active catalog in this dialog box. Let's click the New button at the top right to create a second catalog, then in the field

"Enter a name for the new catalog" that appears, type
"Practice Catalog" as shown in Figure 1.8. We will
leave its option "Import free music into this catalog"
checked and then click OK to make our new catalog the
active one in the Organizer workspace.

Figure 1.9 Verifying the
current active catalog.

When we click OK, we are brought back to the dialog box titled "Organize your
media with the Elements Organizer" (Figure 1.3) with the Start Importing button.
This dialog box appears not only when the Organizer is launched for the first time
but also whenever a new catalog is created. Although we could click the Start
Importing button and search for the folder of practice images we want to import, let's
choose to click the small Skip button instead and learn to add these images using
another import method. The Media view no longer displays any image thumbnails,
and when we look at the lower right corner of the Organizer workspace, our new
Practice Catalog now displays as the active catalog instead of our default My
Catalog, as shown in Figure 1.9.

1.4.2 Managing Catalogs

Just as we used the Catalog Manager dialog box to create our new active catalog, this
same dialog box can also be used to rename or delete existing ones. However, when
in the Catalog Manager dialog box, you cannot delete the active catalog labeled as
Current. To delete it, you must create at least one additional catalog that you can
select to make it the new "Current" one, which will then allow you to reopen the
Catalog Manager dialog box and delete the previously active catalog.

A quick way to open the Catalog Manager dialog box at any time is to single click on
the name of the active catalog in the lower right corner of the Organizer workspace.

1.5 Importing Photographs Into the Organizer

We have already learned that the first time the Organizer is launched, it will search
default locations for files and folders to import automatically. However, when we
created our new Practice Catalog, we chose at that time to skip this step. Let's
explore additional methods of importing photographs from folders on our computer,
from a camera, from a cellphone, and from a scanner, beginning with the From Files
and Folders command.

1.5.1 Importing Photographs Located in Folders on Your Computer

1.5.1.1 Importing Using the From Files and Folders Command

Let's add some images by selecting either File>Get Photos and Videos>From Files
and Folders (Figure 1.7) or, directly below the menu bar, press on the word "Import"

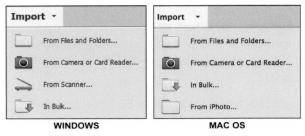

WINDOWS **MAC OS**

Figure 1.10 Using the Import down arrow menu to add files to the Organizer.

(Figure 1.6) to access its down arrow menu and select From Files and Folders as shown in Figure 1.10.

Once the command has been selected, locate the Practice Files folder that you copied to your computer from the companion files provided. Inside that folder select *only* the Practice_Import 1 folder as shown in Figure 1.11. In this import dialog box, we will select Enable: Media Files, keep Get Photos From Subfolders checked by default, choose to *not* check both Automatically Fix Red Eyes and Automatically Suggest Photo Stacks, then click the Get Media button to complete the import. (If you are working in Windows, be sure to select Get Media, *not* Open. If you are working in Mac OS, you may need to first click the Options button for the Get Media and other checkbox features to become available.)

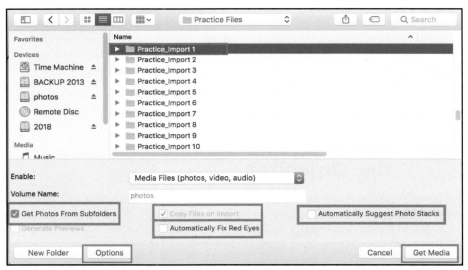

Figure 1.11 Importing files into the Organizer using the Import Files and Folders command.

NOTE▸ As shown in Figure 1.10, the Organizer Import down arrow menus vary slightly between computer operating systems. In Windows (and only available there), we can scan directly through the Organizer (which we will learn to do later in this chapter); when working in Mac OS, a fourth option of "From iPhoto" will display in addition to the choices of From Files and Folders, From Camera or Card Reader, and In Bulk *if* the computer's operational software has been upgraded from a earlier version of Mac OS which used iPhoto.

The new images display in the Last Import view just as the images did in our initial import into your My Catalog. We will once again need to click the Back button as shown in Figure 1.5 to have them display in the Media view. (If a window opens regarding Stacks, click Cancel: we will learn about stacks later in this chapter.)

1.5.1.2 Importing Photographs Into the Organizer Using the Drag and Drop Method

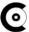

Let's add some more images using a quick and easy alternative to selecting a command. This time, with the Media view active, locate the Practice Files folder again on your computer, open it to display all the Practice_Import folders, then select *only* the Practice_Import 2 folder. Without opening it, simply drag it onto the Media pane of the Organizer workspace, then release the mouse. The folder will automatically open and display the image thumbnails in the Last Import view, allowing us to once again click the Back arrow and see them added to the Practice_ Import 1 photographs we previously imported.

1.5.1.3 Importing Photographs From a Watched Folder

By default, you already have some watched folders the Organizer created for you in My Catalog. When we chose the Start Importing option when we launched the Organizer the first time, Pictures, and any other folders such as Dropbox were automatically checked along with the small yellow circle icon with the binoculars inside. When this icon is yellow, the Organizer will "watch" the designated folder and will notify you, or automatically import (depending on the preference you assign) any new images as they are added to that watched folder.

We can create additional watched folders at any time to have the Organizer monitor them for importation. A typical application might be a folder you create on your desktop to add any images sent to you through email, for example. If that folder is assigned as a watched folder, any time an image is then added to it, the Organizer will either ask if you would like to add it to your catalog or add it automatically, depending on the management option you select. Let's learn how to create one.

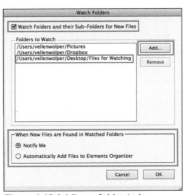

Figure 1.12 Adding a folder to be watched by the Organizer.

First of all, outside of the Organizer, create a folder of images you want to have watched on your computer. Once you have done that, make your My Catalog the current catalog *first*, then choose File>Watch Folders. In the dialog box, shown in Figure 1.12, that opens, the folders already assigned to be watched by your current catalog will be listed in the Folders to Watch section, with an Add button to the right of this pane. Select the Watch folders and their Sub-Folders for New Files checkbox at the top left *first*, then click the Add

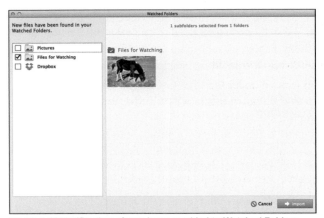

Figure 1.13 Notification of new images added to Watched Folders.

button to browse your computer and locate the folder you want added to the list of watched folders. If a folder is selected in this dialog box, the Remove button will become active, allowing you to delete it from the Folders to Watch list. Below the Folders to Watch section in the area titled "When New Files are Found in Watched Folders," you can manage the watched folders by designating what you want done when the Organizer sees that images have been added to any of your watched folders. When images are added to one of your watched folders, if you have chosen the default Notify Me radio button here, a dialog box will open displaying the location(s) where the new photographs have been discovered, with the option to choose to add them, to add only ones you check, or to cancel the importation, as shown in Figure 1.13. If you select the Automatically Add Files to Elements Organizer option, they will always be added without notification.

Figure 1.14 Features available in the Import Media dialog box when Import>In Bulk is chosen.

NOTE If you add an image into one of your watched folders while the Organizer is open, the Organizer may not "discover" the photograph until the next time it is launched.

1.5.1.4 *Importing Photographs in Bulk*

The In Bulk import command located under the File>Get Photos and Videos menu, or as an option under the Import drop down menu, will allow us to add multiple folders of images with one import.

With your My Catalog still the current catalog, let's choose to select this option now. When its dialog box opens, we can see that it is identical to the initial Import Media dialog box that opened when we chose the Start Importing option from the Organize your media with the Elements Organizer dialog box, except it now also contains any additional folders we have assigned to be watched. As in our initial import more files and folders can be added using the green plus sign, including external sources such as CD or USB drives. Let's examine a few more of its options as shown in Figure 1.14.

- Uncheck the box to the left of a folder name to choose to exclude it from an import entirely, or then click to select only some of its subfolders for importation.

- When the name of a folder is highlighted, its contents are revealed in the pane on the right.

- When the watched folder icon is clicked and changed from yellow to white, the folder will be deactivated from watched status.

If you chose to not import all of the images from your Photos (My Pictures) folder when we first launched the Organizer, feel free to add them now. Also, if you created a Pictures for Elements folder of random images on your desktop, click the green plus sign to locate it and add it to the list titled "Import from following folders." If you add any more pictures into that folder in the future, because it will become a watched folder, the Organizer will monitor it for importation.

1.5.1.5 *Importing Images From an External Source*

When adding an image from an external source such as a CD or USB drive, the Organizer detects that the file is on a device *connected* to your computer but not actually *physically located* on your computer. To solve this, it adds a copy of the image *automatically* onto your computer, then creates a link from the active catalog to that *copy* of the original file: the option Copy Files on Import is preselected by default. If you prefer to *not* have a copy added to your computer from the external drive, this option can be turned off when

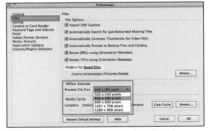

Figure 1.15 Assigning a preview file size preference for offline media.

selecting the file to import as shown in Figure 1.11. If you choose to not have the file copied, you can assign a low resolution Preview File Size in the Offline Volumes section of the Organizer preferences for how the image will display in

the Organizer when the disc or drive is not connected to your computer by selecting Edit>Preferences>Files in Windows or Elements Organizer>Preferences>Files in Mac OS, as shown in Figure 1.15.

If you choose to not copy the files, when the device where the image is located is disconnected from your computer, a small red warning icon will display and when you attempt to view the image in Full Screen mode in the Organizer or work on it in the

Figure 1.16 Find Offline Drives dialog box.

Photo Editor, the Find Offline Drives dialog box will open, prompting you to skip or reconnect to the external source where the original image is stored, as shown in Figure 1.16.

1.5.2 Importing Photographs From Your Digital Camera

While your My Catalog is still your current catalog, let's learn to import photographs from a digital camera or card reader using the Elements Organizer Photo

Downloader. Starting with the Organizer open in its default Media view, the first thing you will need to do is attach your camera or card reader to your computer and turn it on. If you are working in Mac OS and have already established your camera as an import device for your photos, as soon as you have done this, Photos will open and your images will begin to download. You will want to take advantage of the Organizer's download capability instead, so in the Photos application, click to stop the download or quit the application. If downloading

Figure 1.17 Choosing the Organizer for downloading in Windows.

in Windows for the first time, once you connect and turn on your camera, Windows will recognize that you have connected a camera and open a dialog box allowing you to select the Organizer to download the images as shown in Figure 1.17.

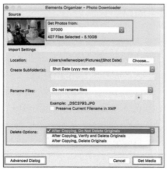

In the Organizer, choose File>Get Photos and Videos>From Camera or Card Reader, or select this option from the Import drop down menu shown in Figure 1.10. The Elements Organizer Photo Downloader opens ready to import your images, as shown in Figure 1.18.

Figure 1.18 Elements Organizer Photo Downloader.

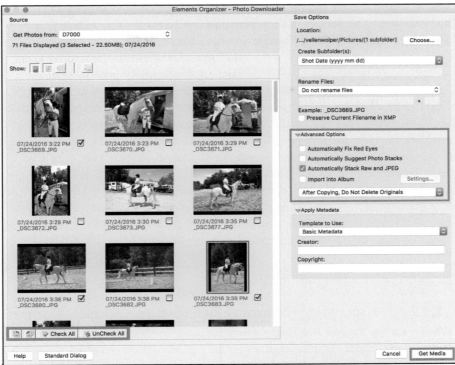

Figure 1.19 Selecting download options in the Advanced Dialog window of the Elements Organizer Photo Downloader.

Under the Get Photos from: section at the top of this dialog box, you may need to select your camera from the drop down list. You can then select options to customize the download under the Import Settings section: however, of these four setting categories, the critical one is to assign what will happen to the images after they are copied into the Organizer. If you do nothing, the default option of retaining the originals on your camera will be applied. If you want to download all of the images on your camera, the final step is to click the Get Media button at the lower right of this dialog box. However, if you want to selectively download only some of your photographs from your camera, click the Advanced Dialog button instead.

If you choose to open the Advanced Dialog box shown in Figure 1.19, you can select the UnCheck All option at the lower left, which will allow you to then check to import only the images you want instead of all of them. From the Advanced Options down arrow menu, you can select to automatically fix red eye issues and suggest stacks, both of which are features we will explore later. However, if your camera is set to generate both Raw and JPEG files, you may want to check the Automatically Stack Raw and JPEG option to place the two formats of the same image one on top of the other for convenience and to maximize Media view space.

Once you now click the Get Media button, your photographs will be added to the Organizer in the Last Import view. When you click the Back arrow, they will be added in the Media view to the images you have already imported.

1.5.3 Importing Photographs From Your Cellphone

Just as you needed to select the Organizer as your download method for your digital camera, (instead of Photos in Mac OS for example), you will need to choose to have the Organizer download the images on your cellphone as well. Working within the Organizer, the steps we have just learned for downloading from your digital camera are the same for downloading photographs from your phone. However, once your phone has been connected to your computer and selected from the Get Photos drop down menu, the message "This device does not contain any supported media" or "No Valid Files Found" may appear. If it does, simply select the Refresh List command from the Get Photos menu. Your phone will be recognized by the Photo Downloader, and it will begin searching for the images on your phone.

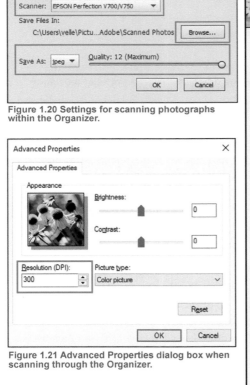

Figure 1.20 Settings for scanning photographs within the Organizer.

Figure 1.21 Advanced Properties dialog box when scanning through the Organizer.

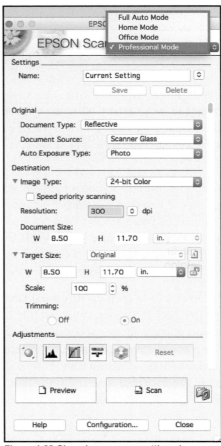

Figure 1.22 Choosing scanner settings in Professional Mode.

1.5.4 Scanning Through the Organizer (Windows Only)

While Mac OS users need to scan images outside of the Organizer using the software supplied with their scanner, Windows users can scan within the Organizer directly if one is attached. If File>Get Photos and Videos>From Scanner is chosen, or the option is selected from the Import drop down menu we saw in Figure 1.10, the dialog box shown in Figure 1.20 opens.

After selecting your scanner, choosing the location the scanned images will be stored, and file format (the default of JPEG is fine), it is critical to assign Maximum for the quality of the scan. (If you would like, you can choose to make these selections the default settings for the Organizer by choosing Edit>Preferences>Scanner.) Once you click OK, you will be able to assign basic color and prescan settings. To further improve the resulting scan, select the option titled "Adjust the quality of the scanned picture" below the radio buttons. When the Advanced Properties dialog box shown in Figure 1.21 opens, it will not be necessary to adjust its Appearance sliders, as we will learn to adjust tonal quality more professionally within the Organizer and the Photo Editor. What will be important is the resolution to scan at, which can be selected from the Resolution (DPI) menu or typed in the field provided (we will learn about resolution in Chapter Three).

1.5.4.1 Scanner Settings

Although it is convenient to be able to access your scanner directly through the Organizer, as an expert, whether you work in Windows or Mac OS, you will most likely want even more control over the quality of your scans. By using the dedicated software that came with your scanner, you will be able to select its professional mode to assign image type, sizing, and more, in addition to resolution. Although the labeling of the scanning options may vary slightly depending on the make and model of your scanner, the settings typically available in its professional mode are shown in Figure 1.22.

By creating a folder on your computer for your scans, and then making it a watched folder, every time you scan a photograph, the Organizer will add it automatically to your My Catalog.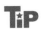

NOTE If you have chosen to add more images to your My Catalog from your Photos (My Pictures) folder or from your Pictures for Elements folder, or you have imported some from your camera, your cellphone, or your scanner, be sure to make your Practice Catalog the *active catalog now* prior to continuing on to our next learning topic.

1.6 Ways to View and Select Multiple Photographs in the Organizer

In order to use the Organizer as an expert, let's learn a variety of ways to view and select our imported images.

1.6.1 Viewing Folders

When the left panel area is visible (if hidden, single click the Hide panel button below the grid view), two panels appear: Albums and Folders. Icons for all folders that have been imported into the active catalog are located under My Folders when the Folders panel is selected. When we single click on one of these icons, only the contents of the selected folder become visible within the Media pane, hiding the rest of our images. We can return to the view of all of our imported photos by single clicking either on the All Media arrow that appears above the media pane shown in Figure 1.23, or again on the same folder.

Figure 1.23 Choosing to display the contents of a folder in the active panel.

Figure 1.24 View as Tree with watched and managed folder icons identified.

There is also a small menu icon with an arrow located to the right of the words "My Folders" outlined in Figure 1.23. When we click on this menu, we can select the View as Tree option, which details the paths to the locations of the original images as shown in Figure 1.24. This view identifies managed folders with "mountain" icons and watched folders with "binoculars" icons. To close this view and return to the default select View as List from the same menu.

 If the Folders panel is not wide enough to display the full path to your managed folders, place the pointer over the border between this panel and the media pane. A double arrow will appear allowing you to drag it to widen the panel as needed.

1.6.2 **Thumbnail Viewing Options**

1.6.2.1 *Single Image View*

We have already learned how to display both the details and file names of our thumbnails in the Media view of the Organizer and also how to display our images by newest, oldest, etc. We have also learned that by dragging the Zoom slider left or

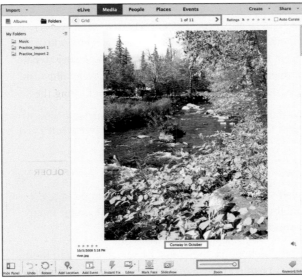

right, we can adjust the size of our thumbnails within the Media view pane. With our Practice Catalog active, let's select Oldest from the Sort By drop down menu and then drag the zoom slider all the way to the right.

The river.jpg image (because we chose Sort by Oldest) is now displayed in single image view as shown in Figure 1.25, with arrows and "1 of 11" shown above it, allowing

Figure 1.25 Viewing a thumbnail in single image view.

Figure 1.26 Features of a selected thumbnail in Full Screen view.

us to stay in this single image large view and cycle through all of our photographs, one at a time. The word "Grid" with an arrow at the top left of this pane allows us to return to all of our thumbnails, displayed at the view we were using prior to moving the zoom slider to the far right. Below the image, the words "Click here to add caption" are displayed. Although this is an optional feature of the Organizer, adding a caption here can help us sort and search for this photograph later on. Let's single click anywhere on the words and in the entry field that appears, type "Conway in October," then press Enter/Return to apply it. Alternatively, we could select a thumbnail in the Media view, then choose Edit>Add Caption (or Right/Control click and select Add Caption from the context-sensitive menu that appears) to enter a caption in the entry field that opens. Once we have done that, let's click the Grid option to return to viewing all of our images in our chosen thumbnail size.

 You can also double click on the thumbnail you want to view in single image view. Once enlarged, double click on it again to return to your smaller chosen thumbnail view, or press the ESC key.

1.6.2.2 Full Screen View

We have just learned how we can view any thumbnail in a larger, single image view. The Organizer also provides another view that allows us to view the image even larger and with more viewing options: Full Screen view.

To enter Full Screen view for any thumbnails, they must be selected first. In Media view, let's single click on the photo named House of Dragons_Spain.jpg. With this image selected, we will choose View>Full Screen. The image now fills our entire monitor area, with black around it as room allows. If we single click on the photograph, our view will toggle between a larger and smaller screen view. Editing and sorting options are available on the left edge of our screen, and when we move our mouse across the image, a control bar appears with options for viewing our images as a slideshow within this mode. Let's examine a few of them as shown in Figure 1.26:

- **ARROW:** An arrow on the left will begin a slide show to cycle us through all the images in the Media view, beginning with the image we selected.

- **THEME:** Allows us to customize the transition for the slides.

- **FILM STRIP:** When Film Strip is clicked, all of the rest of the images display below the full view, allowing us to choose another image to view full screen.

- **ZOOM:** We can zoom in to our selected image by pressing the Control/Command key combined with the plus sign key, or the Control/Command key combined with the minus sign key to zoom out. When zoomed in, we can press and drag on the image to view areas currently hidden by our selected magnification.

- **VIEW OPTIONS:** Allows us to examine two images simultaneously, either vertically or horizontally. When this icon is clicked, the screen splits in half based on the orientation we choose. The selected image will have a thin blue border indicating that it is active. When we click any image in the film strip, our active image changes to the new one we have selected, so that we can compare it to the other image we have chosen. We can even click the lock icon to zoom in and have our views of both our selected images enlarge simultaneously and also move together if we press and drag on one of them to scroll around our magnified view.

- **SETTINGS:** Allows us to customize the audio, choosing from the default tracks that come with the program or our own.

- **FIX:** Choose to rotate, delete, or print a slide.

- **X:** An "X" will let us revert back to our thumbnail view, which can also be achieved by pressing the ESC key on our keyboard.

Let's choose now to either click the "X" in the control bar or press the ESC key to return to view all of our images in thumbnail view.

NOTE If you have an exceptionally wide monitor and have the Organizer workspace utilizing its full width, when an image is opened in the Full Screen view, a question mark may display instead of the image. The missing icon is displayed for large files when the thumbnail cannot be created. If you decrease the width of your workspace window a little, the question mark will be replaced by the full screen view of the selected photograph.

1.6.3 Selecting Multiple Thumbnails in the Organizer

One way to select all of our thumbnails in the Media view is to choose Edit>Select All or press the Control/Command key combined with the letter "A" key. However, sometimes we may want to multiselect thumbnails that are next to each other without selecting *all* of our thumbnails, or want to select only some of our thumbnails scattered *throughout* the Media view. Let's learn how to do both.

1.6.3.1 Selecting Sequential Thumbnails

With Sort By still set to Oldest, let's select the photograph of some daffodils. Now let's hold the Shift key down and click on the horse photograph named "Favory" the images located between them become selected as well.

1.6.3.2 Selecting Nonsequential Thumbnails

This time let's choose to select three images, but ones that are not sequential. We will select the river photograph, then hold the Control/Command key down and, with it held down, click to add the Butterfly photograph, and then add the House of Dragons_Spain photograph. While these are all still selected and the Control/Command key is still held down, we can remove one or more nonsequential images from a selection, such as the Butterfly image, or add one or more images such as the

daffodils, by clicking on it: the selected image toggles to be added or subtracted from our selection each time it is clicked if the Control/Command key is also engaged.

We can also multiselect thumbnails by dragging the pointer to create a "box" to include them. When thumbnails are next to each other, we can press and drag across any images the pointer touches to include them in our selection. To deselect one within the selected group, with the Control/Command key held down, click on the one(s) you want to deselect.

1.7 Stacking, Hiding, and Deleting Photographs in the Organizer

When you import a folder of images, you may realize after you chose to add them all that there may be multiples of the same subject that basically all look the same, that some of them are "iffy" (you sort of like them and sort of don't) and so want to hide them for now, and that some you realize you just *don't* want in the Organizer. Let's learn how to stack, hide, and delete images in the Organizer beginning with creating a stack.

1.7.1 Stacking Photographs in the Organizer

Stacks allow us to have multiple images "stacked" on top of each other, with only one visible, but with the ability to display the rest at any time. Let's add another folder of images from our Practice Files folder, the one named Practice_Import 3 and learn to stack some of these images. Feel free to add them by choosing File>Get Photos and Videos>From Files and Folders, or by selecting From Files and Folders from the Import menu, or by using the drag and drop method.

1.7.1.1 *Creating Stacks in the Media View of the Organizer*

Once these images have been imported, we will click the Back arrow to show them along with the rest of our images in the Media view. Once we have done that, let's select only the thumbnails named—100_1551.jpg, 100_1552.jpg, 100_1553.jpg, 100_1554.jpg, and 100_1555.jpg—using any one of the multiselection methods we have learned. With these five images selected let's choose Edit>Stack>Stack Selected Photos or, with the images selected, Right/Control click and choose this command from the context-sensitive menu that appears. The images become stacked one on top of the other, with only one image visible, and an icon at the top right corner of it representing the stack. It also contains a small arrow on its right side which, when clicked, expands to show the entire stack. If the stack is expanded, a reverse arrow appears that can be clicked to again collapse the stack as shown in Figure 1.27.

We can choose to change which image is chosen to display when the stack is collapsed. With the stack expanded, let's select the photo in the stack named 100_1552.jpg; then, from the Edit menu, choose Stack>Set as Top Photo, or Right/Control click and choose Stack>Set as Top Photo from the context-sensitive menu that appears.

When you selected the new top image, you may have noticed the additional commands available for stacks: to unstack the photos or, if the stack is expanded, to select an image within it and choose to remove it from the stack, or you can also choose Flatten. The Flatten command will delete all images under the top photo of the stack. Fortunately, in case you choose this command by accident, prior to their deletion, a dialog box will open first warning you that all photographs beneath the top image will be deleted, allowing you to cancel the command. If you have been following along and selected the Flatten command, choose Cancel, as we will keep this collapsed stack in our Practice Catalog.

Figure 1.27 Collapsed and expanded stack.

1.7.1.2 *Having the Organizer Automatically Suggest Photo Stacks for You on Import*

If we import photographs using the File>Get Photos and Videos>From Files and Folders, or select the From Files and Folders option from the Import down arrow menu, we can also check the Automatically Suggest Photo Stacks option shown in Figure 1.28.

Figure 1.28 Choosing to Automatically Suggest Photo Stacks when importing images.

Figure 1.29 Visual Similarity Photo Search dialog box.

If this option is selected, when the images are being imported, the Organizer will analyze them, and if it recognizes similar images, it will suggest stacks for you, with the option to elect to Stack or Unstack the suggested photo collections it has created in the Visual Similarity Photo Search dialog box shown in Figure 1.29. If we click the Stack button provided next to each suggested stack, the images will become pre-stacked when they are added to the Media view of the Organizer. Alternatively, we can choose Unstack or Remove from Catalog. The Unique Photos arrow will display all other photographs that are part of the current import that have not been detected as stacks.

Once stacks have been chosen, the Done button will add them to the Media view of the Organizer. A special folder has been included in the Practice Files folder named Practice_Import Stacks if you would like to try this now.

NOTE▶ The Automatically Suggest Photo Stacks option is also available any time in the Media view by choosing multiple images first, then choosing to apply the command from the Edit>Stacks menu or, if downloading from your camera or cellphone as shown in Figure 1.19 under Advanced Options, when the Advanced Dialog box is selected.

1.7.2 Hiding Photographs in the Organizer

Figure 1.30 Marking a thumbnail as hidden.

We can choose to hide images in the Organizer that we may be unsure about deleting, but *are* sure we don't want to view them all the time, until we decide for sure what we want to do with them. Let's select the photograph 100_1550.jpg. With the image selected, choose Edit>Visibility>Mark as Hidden, or Right/Control click and select Visibility>Mark as Hidden from the context-sensitive menu that appears. The image still displays in the Media view, now with an "eye" icon in its lower left corner with a slash through it, as shown in Figure 1.30.

Figure 1.31 Selecting a Hidden Files option.

From the View menu shown in Figure 1.31, now let's press and hold on the Hidden Files command, where we can choose to Hide Hidden Files, to Show All Files, or to Show Only Hidden Files. When we select Hide Hidden Files, our hidden thumbnail is no longer visible in the Media view.

These same three hidden files commands listed under the View>Hidden Files are also available from the context-sensitive menu that appears when we Right/Control click on any thumbnail.

Let's choose View>Hidden Files>Show All Files, then select the file that we marked as hidden. Now let's select Visibility>Mark as Visible either from the Edit menu, or when we Right/Control click on it from the context-sensitive menu that appears. We will choose to delete it from the Organizer instead.

1.7.3 Deleting Photographs From the Organizer

If the photograph 100_1550.jpg is not still selected, select it now. With the thumbnail selected, let's choose Edit>Delete from Catalog, or Right/Control click and select Delete from Catalog from the context-sensitive menu that appears. When we choose to do that, the dialog box shown in Figure 1.32 opens, providing the opportunity, if desired, to not only delete the image from the catalog but to delete it also from our computer. Let's *not* check the option to delete from the hard disk: just click OK to delete it from our Practice Catalog.

Figure 1.32 Confirm Deletion from Catalog dialog box.

If we wanted to delete an entire folder of images from the Media view, we could select the folder we wanted to delete from My Folders in the Folders panel, then Right/Control click and select Delete Folder from the context-sensitive menu that appears. The same warning dialog box shown in Figure 1.32 would open, and if we selected OK, the folder and all of its contents would be removed from the Organizer.

1.8 Finding Missing Files

We have learned that the Organizer does not actually import our photographs but instead, creates links *to* our photographs. Because of that, we have also learned that when media is imported from an external source and we elect to not have it copied to our hard drive for the Organizer to link to, the link will need to be made active (device attached) for the file to be viewed in Full Screen mode or edited. But what happens when a photograph has been copied to our hard drive and our current catalog has created a link to it, but then the original file is moved? Let's learn how the Organizer handles a missing file.

Outside of the Organizer, locate the Practice_Import 1 folder inside your Practice Files folder. Choose to open it, select only the _DSC4623.jpg file and then move it out of the folder to another location on your computer.

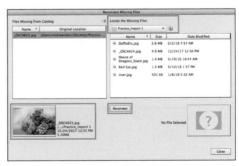

Figure 1.33 Reconnecting Missing Files.

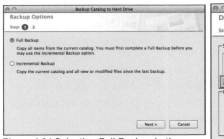

Figure 1.34 Selecting Full Backup in the Backup Catalog to Hard Drive dialog box.

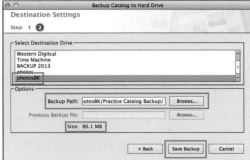

Figure 1.35 Assigning the path for a catalog backup.

Back in the Organizer, a small question mark icon now appears at the top left of the thumbnail. The Organizer attempts to locate the original file to reconnect to it, and when we double click on its thumbnail, the dialog box shown in Figure 1.33 opens, asking us to locate the file, so that the current catalog can link to its new location. Although we could now enter the path to where we moved the file, let's not, and just choose Close instead. Outside of the Organizer, let's move the file back into its original location: the Practice_Import 1 folder inside our Practice Files folder. Once we return to the Organizer, it recognizes that the file is in the Practice_Import 1 folder and removes the question mark icon from the thumbnail. If it doesn't find it, select File>Reconnect>Missing Files, then use the dialog box shown in Figure 1.33 to reconnect it.

NOTE▶ If you need to rename or move a file that you have imported into the Organizer, because the Organizer links to your files but does not actually copy them into it, changes should be made within the Organizer. To rename a file, select it in the Media view, then choose File>Rename. To move a file's location, select it, choose File>Move, and then Browse to locate where you want to move the file to.

1.9 Backing Up and Restoring Catalogs

Computer crashes are a harsh reality and can be devastating if you are not prepared. To assure that if (or more realistically *when*) your computer crashes, you have all of your catalog files saved, best practice is to create and *maintain* a backup plan. The Organizer makes it easy. Let's learn how to do that now, using our Practice Catalog.

1.9.1 Creating an Initial Backup

The first step is to define where the backup will be stored. An external drive, with 2TB to 4TB of space, should be ample for all your backups. Although we will not need anywhere near that amount of space for our Practice Catalog backup, as you build your personal My Catalog library of images, you will want ample space for backup storage.

Once the drive has been attached, with our Practice Catalog open, let's choose File>Backup Catalog. Because this is our first backup, we will select Full Backup

from Step 1 of the Backup Catalog to Hard Drive dialog box that opens as shown in Figure 1.34.

Once we click the Next button, we are brought to the Step 2 window of the Backup Catalog to Hard Drive dialog box shown in Figure 1.35, where we choose where the backup will be created and stored. Under the Select Destination Drive, if your source drive has been attached prior to entering this dialog box, it will display under the drives to select from. Once the drive is selected, we will need to assign the path. When we click the Browse button to open our chosen destination drive, we need to create a destination folder on that drive. Let's create one named "Practice Catalog Backup." Once the backup path is assigned, we can click the Save Backup button. The backup is created, followed by a confirmation dialog box to click OK in and return to the Media view of the Organizer. That's it!

1.9.2 Creating an Incremental Backup

It is great to create a backup the first time, but so important afterward to periodically do incremental backups as well to keep your backup current: once a month, for example. In order to have new data to practice an incremental backup, let's add more photographs to our Practice Catalog first.

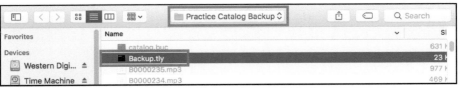

Figure 1.36 Selecting the special Backup.tly file for an incremental backup.

Locate your Practice Files folder then add the Practice_Import 4 folder of images to the Organizer using the method of your choice. Once they have been added, let's select the File>Backup Catalog command again. This time in Step 1 of the Backup Catalog to Hard Drive dialog box, we will select *Incremental Backup* instead of

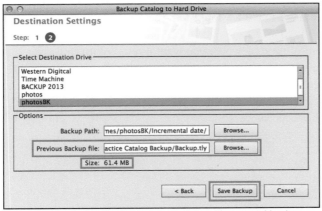

Full Backup. When we click the Next button, once again we will need to select the same Destination Drive we used for our initial full backup. When we browse our backup path to the destination drive, once there, we will need to create a *new* folder instead of the one

Figure 1.37 Assigning the Backup.tly file for an incremental backup.

we created for our full backup. Let's call this one Incremental date (putting today's date here, for example). This time we also need to complete the Previous Backup file field. For this, we will need to browse to locate a special file which is created when a backup is made, named Backup.tly (perhaps choose to remember it as "Backup Totally") which will be located inside our original backup folder shown in Figure 1.36.

Once we click Open we are returned to the Backup Catalog to Hard Drive dialog box shown in Figure 1.37. Here we should now see the path to our special Backup. tly file listed in the Previous Backup file field. Notice that its size is smaller, as it represents only the new images added since our first back up—the ones located in our Practice_Import 4 folder. Now when we click Save Backup, we will again receive the confirmation dialog box that the backup has been completed successfully.

1.9.2.1 Creating Future Incremental Backups

Each time an incremental backup is created in the future, you will need to browse to locate the Backup.tly file inside the previous *most recent* incremental backup folder to enter it in the Previous Backup file field of the Backup Catalog to Hard Drive dialog box.

NOTE▶ We have just learned how to backup our Practice Catalog. Remember that the process of backing up is *catalog specific*. You may want to stop and back up your My Catalog before continuing. You can use the same external drive as the one we used for our Practice Catalog backup (we required only a small amount of space for our full and incremental backups), by simply creating a new backup folder on it with the name My Catalog Backup. You can also elect to have the Organizer remind you to back up by choosing Edit>Preferences>Files in Windows or Element Organizer>Preferences>Files in Mac OS. In this dialog box, select Automatically Prompt to Backup Files and Catalog, as shown in Figure 1.15.

1.9.3 Restoring a Catalog

Although we currently do not need to restore our Practice Catalog, let's learn how you will restore your My Catalog if you should need to in the future. To restore it, first choose File>Restore Catalog. In the Restore From section of the dialog box that opens, you will need to browse to locate the most *recent* incremental Backup.tly file on your external hard drive, followed by where you want it restored to. Once you click Restore, the Organizer will recognize the number of backups you have created and prompt that you will need to back up each of them in reverse order of creation as shown in Figure 1.38. Once you have done that, you will receive a confirmation dialog box that the restore has been successful.

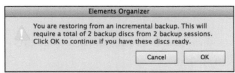

Figure 1.38 Notification that the restoration backup will require multiple incremental backup sessions.

If you have a crash and have to reinstall Photoshop Elements 2018, when you first launch the Organizer prior to adding your My Catalog back, a default empty My Catalog will have been created. If you would like to restore your My Catalog back to its original location, if you first choose Help>System Info while this empty catalog is open, it will show you the path to its default location on your computer (which can be hard to find without this path location information). Once you have restored your My Catalog to an easy to find location such as your Desktop, you can then move it to override the empty default My Catalog in the location shown in the System Info dialog box.

PRACTICE MAKES *PERFECT*√

At the end of each chapter of this book, two practice exercises will be provided to further reinforce key features of the program learned within it, with some of the chapters providing a third project in PDF format on the companion DVD. Feel free to enhance your knowledge with the exercises provided, or jump forward to sorting and searching photographs in Chapter Two.

PRACTICE PROJECT 1

1. In the Media view of your Practice Catalog, select the river.jpg thumbnail.

2. Choose Edit>Visibility>Mark as Hidden, or Right/Control click and select Visibility>Mark as Hidden from the context-sensitive menu that appears.

3. Choose View>Hidden Files>Show Only Hidden Files.

4. Select the river.jpg thumbnail and now choose Edit>Visibility>Mark as Visible, or Right/Control click and select the command from the context-sensitive menu that appears.

5. Choose View>Hidden Files>Show All Files.

6. Select the Butterfly.jpg image and choose to delete it from the catalog only.

7. Choose to add it back using the drag and drop method (it is located in the Practice_Import 2 folder).

8. Once added back, select it and add the caption "The Butterfly Place."

PRACTICE PROJECT 2

1. Choose File>Manage Catalogs.

2. In the Catalog Manager create a new catalog named Test Catalog.

3. When it opens, add the files from the Practice_Import 2 folder only to this new catalog from your Practice Files folder.

4. Return to the Catalog Manager dialog box and select your Practice Catalog.

5. Once your Practice Catalog is the current catalog, use the Catalog Manager dialog box to delete your Test Catalog.

6. Your Practice Catalog should now be the current catalog, with only one additional catalog (My Catalog) available for selection when the Catalog Manager dialog box is opened.

2

Easy Ways to Sort, Search, and Find Your Photographs

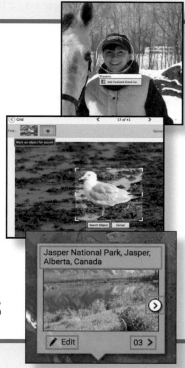

In This Chapter

- Create keyword tags for search purposes
- Learn to create photo albums
- Explore the facial recognition technology available in the Organizer
- Apply cropping, tonal, clarity, color, and special effects to images using the Instant Fix editor

Finding the photograph or photographs you are looking for can be challenging if you take a lot of pictures. We will master a variety of sort and search methods applicable to people, places, events, and more, as well as how to create and save advanced searches. When working with the Instant Fix editor, we will explore Version Sets.

2.1 Using the Timeline

In this chapter we will learn a variety of ways to sort, tag, search, and find photographs. Later, in your own work, you may find yourself using all of these techniques to varying degrees, or, alternatively, perhaps only a few sort and search methods will be needed to complement your working style. Which methods will maximize your efficiency and become best practices for you as an expert? Let's explore them all so that you can decide that for yourself, beginning with searching using the Timeline command.

We imported the Practice_Import 4 folder in Chapter One so that we could learn to perform an incremental backup. Before exploring the Timeline, let's delete *only* this most recent folder of images for now; we will import its images again later in this chapter. We could click on the Practice_Import 4 folder under My Folders when the Folders panel is active, and then select all of the images and press the Delete key. However, let's simply single click on it under My Folders, then Right/Control click and select Delete Folder from the context-sensitive menu that appears. In the dialog box that opens, we will *not* choose to delete the images from our hard disk, only our Practice Catalog.

OK, we are ready. In the Media view with All Media displayed at the top of the pane, let's choose View>Timeline (the Timeline is only available in the Media view). With the Sort By menu set to Oldest, the Timeline now appears above the grid as shown in Figure 2.1, with dates at each end of it corresponding to the earliest and latest photo shoot dates from left to right, of the images we have imported into our Practice Catalog.

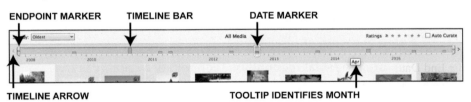

Figure 2.1 Timeline chosen from the View menu.

A copy of each figure shown in this chapter can be viewed in the companion files included with this book.

Let's take a closer look at its features:

TIMELINE: Displays thumbnails when in the Media view by the date the photograph was taken divided into years. When the pointer hovers over one of 12 dividing lines between the years, a tooltip displays its month.

HEIGHT OF A TIMELINE BAR: Corresponds to the number of photographs in the catalog taken in that date range. When there are no photographs taken in a particular month or year, no timeline bar displays.

DATE MARKER: When a vertical bar is clicked, the date marker appears around it, the month the image was taken will appear as a tooltip, the image will become selected in the grid with a check mark and green rectangle around it, and the shoot date will even flash temporarily below the image to help you identify the selection. If there were multiple images taken at that date, the first image will be selected.

ARROWS: Pressing on one of the arrows at each end of the Timeline allows us to see the rest of the Timeline if its dates extend beyond those visible within the span provided in the workspace.

ENDPOINT MARKERS: Dragging inward reduces the active timeframe area, narrowing the search. When the pointer hovers over one of the markers, a tooltip appears displaying the exact date that has been selected by its placement.

Let's drag the right endpoint marker to the left to shorten our active timeline until its tooltip reads July 31, 2011. We can see when we do that that only three images are still visible in the Media view—those between the starting date corresponding to the oldest image and the ending point we have defined. When we now click on the first visible bar in the timeline, the river.jpg image becomes selected and outlined as shown in Figure 2.2.

Alternatively, rather than dragging one or both endpoints inward to reduce the search area, if we know the general date range we are searching for, we can choose View>Set Date Range and, within the dialog box that opens, define the date range of images we want to view as shown in Figure 2.3. When the End Date year in the Set Date Range dialog box is changed from 2017 to 2011, only the thumbnails within the defined range are visible in the Media view. Once a view has been assigned either by dragging the endpoint markers or by using the Set Date Range dialog box, we can choose View>Clear Date Range to again show all of our images.

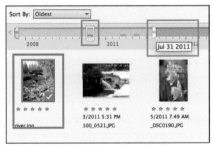

Figure 2.2 Refining a search using the Timeline.

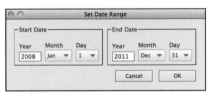

Figure 2.3 Assigning a date range for thumbnail images in the Media view.

Because we currently have only a few images in our Practice Catalog, it may be difficult to visualize the power of this quick and easy search method. However, if you have hundreds of photographs in your My Catalog and, continue to add more, being able to narrow down which images are displayed by choosing a date range can be very helpful.

NOTE▶ If you have selected View>Timeline to have the timeline displayed and adjusted its endpoint markers to reduce the number of visibile images in Media view, choosing View>Timeline to uncheck the command will only hide the Timeline; it will not return your view of all the images. To do that, drag the endpoints back to their original positions when the Timeline is visible, or choose View>Clear Date Range whether Timeline visibility is on or off. Be sure to do that now, prior to our working with Smart Tags.

2.2 Smart Tags

Before we learn how to manually add tags to our images, let's explore the Smart Tags feature, in which the Organizer will analyze the content within our images and assign tags for us based on what it recognizes. For this to happen automatically, the

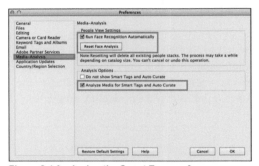

Figure 2.4 Assigning the Smart Tags preference.

preference for it must be chosen first. It is assigned by default, which is what we want. However if you wanted to deactivate it in the future, choose Edit>Preferences>Media-Analysis in Windows or Elements Organizer>Preferences>Media-Analysis in Mac OS, as shown in Figure 2.4. (We will examine the Face Recognition and Auto Curate preferences also shown here later in this chapter.)

2.2.1 Using Smart Tags

With our Practice Catalog active and all of our images displayed in the Media view, let's open the Search view and explore the Smart Tags feature within it by single clicking on the magnifying glass icon or the word "Search" at the top right corner of the workspace. Once we do that and then select the Smart Tags icon at the top left, all of our images display with "smart" tags pre-applied to them, in which the Organizer has analyzed our images and "presorted" them for us based on content it has discovered within the images. When we click on the daffodil image with the word "garden(4)" on it, the name of the selected tag appears in the text field at the top, and when we click on the results pane to the right of the Smart Tags pane to display it, four images are found, including images from within the stack we made. Ones within the stack that the Organizer did *not* recognize as "garden" have the "none" symbol displayed in the top left corner.

NOTE▶ When completing these exercises working with Smart Tags, depending on how the Organizer analyzes the images in your Practice Catalog, the number of images it may detect for the smart tags "garden," "waterfall," and "water" may differ slightly from the totals shown here: the process of applying Smart Tags searches and combining them will be the same.

An image is added to a Smart Tags search by single clicking it when the Smart Tags window is active. Conversely, the same image can be removed from a Smart Tags search by clicking the "X" next to the filter name in the text field, or by simply single clicking on the same image again in the Smart Tags view to toggle it off from the search.

Now let's click on the Smart Tags icon again; then, with the word "garden" still

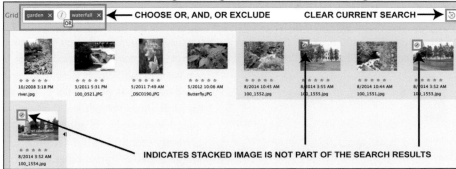

Figure 2.5 Assigning a search using Smart Tags.

visible in the search field, click on the image it has identified as "waterfall(3)." We can see in Figure 2.5 that the slash which displays between the two search tags represents "or." Because of that, the Organizer has now displayed six images. Rather than selecting to have the Smart Tags feature show us garden images *or* waterfall images, if we press and hold on the slash and select the plus sign instead, we are requiring images to have the criteria of both garden *and* waterfall, and, our search reduces to one image. To clear our current search to begin another one, let's single click on the Clear Search icon at the top right of the text field. Once we do that, we can see that we can type in a custom search in this field instead. Let's type "water." Pretty slick—five images are found, all of which contain water. When the cursor is clicked in this text field, our last ten recent searches will also display as a menu to select from if desired. To complete the search, we will click the Grid arrow; our search results now display below the words "Items matching 'smarttags: water.'" Options are available from a down arrow menu that we will examine later in this chapter. Next to this menu is a Clear button that we can click, or we can simply click the Back arrow to clear the search and return to All Media.

However, the Smart Tags feature is not perfect. Let's click the Search button to apply another Smart Tags search, by typing in "food" in the text field. As we can see in Figure 2.6, when we do that, two images of snow and ice on Christmas decorations have been identified as food. And if we now type in the search word "snow" instead, the message "No media available. Please clear applied filter and try again" appears.

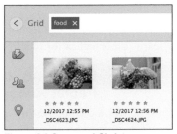

Figure 2.6 Snow and Christmas decoration images identified with Smart Tags as food.

When a Smart Tags search filters images correctly for us, we can use them as desired in the Items matching pane. If not, we can press the "X" next to the search word to clear it, or click the Clear Search icon at the top right, or press the ESC key to cancel all searches and return to the Media view.

2.2.2 Removing Smart Tags

When in the Media view, because we have the preference selected for the Organizer to assign Smart Tags for us, all of our images have them assigned, whether we view them in the Smart Tags area of the Search view or not. You may have noticed when

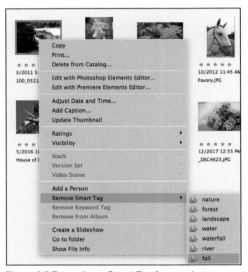

we were in the Search view that the same image was oftentimes displayed multiple times with different search tags; for example, in addition to correctly identifying the daffodil image it also assigned other tags to the same image, such as "spring," "bloom," etc. We can remove any Smart Tag that has been applied to a particular photograph by Right/Control clicking on it in the Media view, and from the context-sensitive menu that appears, choosing Remove Smart Tag first, then highlighting the tag we want to remove from the submenu that appears. Let's select image 100_0521.jpg, Right/Control click on it and choose Remove Smart

Figure 2.7 Removing a Smart Tag from an image.

Tag, then select "fall" from the list of Smart Tags as shown in Figure 2.7. This image is of snow in the Basin, a popular tourist attraction located in Franconia Notch, New Hampshire, which is not an image we would be looking for if we were searching for photographs with fall foliage.

2.3 Tagging Photographs Through Facial Recognition

The Organizer contains technology that can recognize people in a photograph and "learn" their names for identification in future photographs.

2.3.1 Preparing to Use the Facial Recognition Technology

In order for the Organizer to tag and help you sort images by their faces, the preference must be assigned. If we look again at Figure 2.4, we can see that by default the Run Face Recognition Automatically option is already turned on for us.

Great. Once we have confirmed that the preference is active, we will need to be sure that the menu option View>People Recognition is also checked in the Media view. Once facial recognition has been turned on in both of these locations, we can begin to apply it to our images.

2.3.2 Identifying Faces for the Organizer

Let's add the Practice_Import 4 files again from our Practice Files folder by using either the File>Get Photos and Videos>From Files and Folders or by selecting the From Files and Folders option from the Import drop down menu. When selecting the Practice_Import 4 folder, we will keep both the Automatically Suggest Photo Stacks and Automatically Fix Red Eyes shown in Figure 1.11 *unchecked*; we will work with red eyes in later chapters.

Once the images are imported and we have returned to the All Media view, we can see that there are several people photographs we can apply facial recognition to. To begin the facial recognition process, each person must initially be identified to the Organizer. Depending on the number of different people you want identified, this first step can take a while. However, once established, the more photographs of the same person you identify, the more accurate the Organizer will become at helping you identify additional photographs of the same person going forward. There are two ways to complete the initial tagging process: assigning them in single image view or in the People view. Let's explore both, beginning with the single image view.

NOTE As you work through the various stages of these facial recognition exercises, your results provided by the Organizer may vary slightly from the samples shown, based on the operating system of your computer.

2.3.2.1 *Assigning People in the Single Image View*

Let's single click on the Practice_Import 4 folder in the Folders panel in the Media view to work with only our most recently imported images and Sort By>Oldest still assigned, and then double click the first one, _DSC0085.jpg, to view it in single image view. We then see that when the pointer is moved over the face of the person in the photograph, the opportunity to name it appears: Add Name. Let's click on it and type "Shaunna," then press Enter/Return to apply it as shown in Figure 2.8. A small people icon now appears below this photograph in single image view with her name. The same icon appears in the Media view below her thumbnail to identify that this person has been named, and when the pointer is moved over the people icon below the thumbnail in the Media view pane, her name displays.

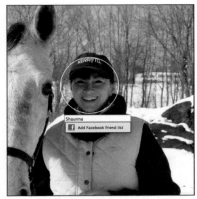

Figure 2.8 Tagging in single image view.

NOTE▶ In the Media view, your thumbnails must be displayed large enough for the tag icons to appear below them. If you have Details and File Names chosen from the View menu and the people icon does not display below your Shaunna thumbnail, drag the Zoom slider to the right until it does.

TiP If the circle and Add Name option does not immediately appear when the pointer is moved over Shaunna's face, the Organizer has not finished analyzing the imported images; it may take a little time to finish completing this task. You can monitor this progress by looking in the lower right corner of the workspace to the left of the active catalog name as shown in Figure 2.9.

Zoom	Keyword/Info
Analyzing faces in your catalog: 51 % complete	Practice Catalog

Figure 2.9 Monitor as the Organizer analyzes faces in your catalog.

Let's click the arrow at the top of the single image view to display the next image in the folder (2 of 10). When the pointer is moved over the face of this person, we will identify her as "Eleanor" and then press Enter/Return to assign her name. Once we

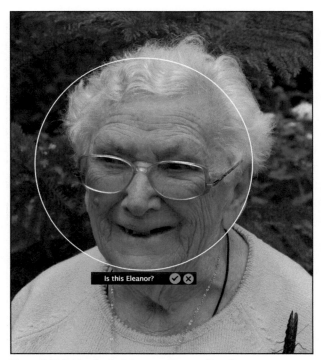

Figure 2.10 Asking for facial recognition confirmation.

have done that, when we click to view the third image in this folder (3 of 10) and we move the pointer over the face of the person—voilà! It has already recognized Eleanor and asks us if in fact the photograph is of her as shown in Figure 2.10. We click the check mark to confirm that the Organizer has correctly identified her.

We could continue to identify each person in the rest of these folder images using this method, but let's return to the All Media view and learn another method instead.

2.3.2.2 *Using the People View to Assign Facial Recognition*

When we click on the People view to the right of the Media view at the top of the workspace to make it active, two tabs display: Named and UnNamed. When the Named tab is clicked, we can see that it lists two people: Eleanor and Shaunna. When a blue exclamation point appears next to a stack, it notifies us that one or more photos have been added to the stack. When the stack is clicked to examine the photos in it, the addition is confirmed, and the exclamation point disappears.

Let's click the UnNamed tab. Because all of our stacks each consists of only a few photographs, we will need to uncheck the Hide Small Stacks option at the top left of this view for them to display. Once we do this, we can see in Figure 2.11 that it has detected several faces with Add Name shown below each of them.

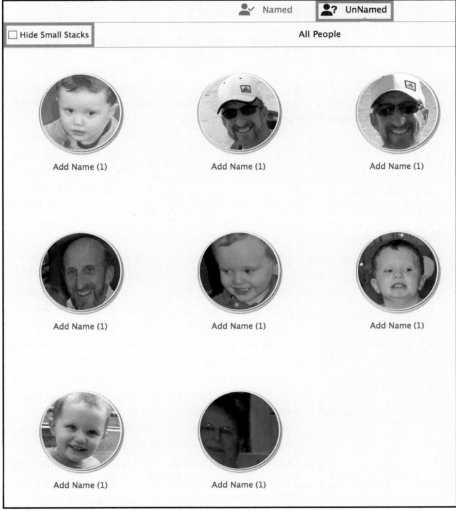

Figure 2.11 Viewing faces in the UnNamed People view.

NOTE If we had started our facial recognition by clicking the People view instead of assigning some of them first in the single image view, all of the images with faces in them would have opened automatically under the UnNamed tab, stacked in groups that the Organizer was able to detect when Hide Small Stacks is unchecked.

Using the names and faces identified in Figure 2.12, click below each face and add the person's name, then click the check mark to confirm the assignment. When we begin to type a name, if the person has already been identified in a previous stack, we will click to select the name that the Organizer recognizes rather than have to type the person's name again. This should leave one person to identify. Sometimes the Organizer needs a little help detecting faces. Let's learn how to help it out by manually assigning a name to a photograph.

Figure 2.12 Identifying people for the Organizer.

 In your own work, when working in the UnNamed category of the People view, if the Organizer has created multiple stacks of the same person, you can merge them into one stack by Control/Command clicking to select the stacks, then single clicking the Merge People button at the bottom of the workspace or Right/Control clicking and choosing Merge People from the context-sensitive menu that appears.

2.3.2.3 Manually Assigning Facial Recognition

In the UnNamed category of the People view, when we click on the word "Photos" below the single remaining unnamed stack, it displays the full photograph below it. We can see that it is actually another picture of Eleanor, with two other people

Figure 2.13 Using the Mark Face feature for facial recognition.

behind her. We will first need to display it in single image view. Once we have done that, the Organizer wants us to identify the person on the left. We will not name that person right now, nor will we click the "X" shown next to her. What we will do instead is select the Mark Face button available below the image. A small box will appear on top of the image that we can press inside and drag over Eleanor's face. Once we have adjusted it by dragging its corner handles as needed to fully enclose her face, we will add her name when prompted, then click the check mark to apply it as shown in Figure 2.13.

NOTE If any of the photographs of the people identified in Figure 2.12 were not detected when the Organizer first analyzed your files, you can add them now using the Mark Face option. Once added, if they appear as separate stacks instead of being added to your original stack for that person, apply the Merge People feature. When done, the total number of photographs tagged for each person should be Barry (3), Eleanor (3), Noah (4), and Shaunna (2).

2.3.3 Renaming, Changing, and Removing Facial Recognition

People stacks or images within the stacks can have their names changed, images within a stack can be reassigned, or facial recognition can be turned off for a person altogether. Let's learn each of these facial recognition options beginning with renaming a person.

2.3.3.1 *Renaming a Person Already Assigned With Facial Recognition*

If a stack or image within a stack has been named incorrectly, it can be changed. Once it has been selected in the Named category of the People view, you can Right/Control click and choose Rename from the context-sensitive menu that appears or click the Rename button at the bottom of the workspace. If the stack has been selected, the entire stack will change to reflect the new name. If Faces is clicked first and a misnamed person within a stack is someone you have already identified, when you change the name, the face will automatically be deleted from the wrong stack and added to the correct one. If the misnamed person has not been previously identified, the image will be removed from the stack and appear as a separate new named stack.

2.3.3.2 *Changing the Identification of a Person Already Assigned With Facial Recognition*

When we click the Named tab of the People view, our identified faces display in stacks, with the number of photographs of them listed next to their names. We can move the pointer over each stack to see the faces in the pictures included in the stack or click Photos below the stack to view the full image. If we have identified a person incorrectly, when we click Faces, we can move the pointer over it and click the "none" symbol that appears representing Not This Person as shown in Figure 2.14 to cancel the recognition and remove the photograph from the stack. Alternatively, we can select the photo then click the Not This Person button located below the Named pane. The image will *not* be deleted from the facial recognition feature; it will be *moved* to the UnNamed category as a new stack to be identified.

For example, in Named view, let's select Faces under Barry, then move the pointer over one of them to view the Not This Person icon. However, we don't want to actually remove him from our Barry stack, so let's *not* click the Not This Person symbol; we will just move the pointer off of the image instead.

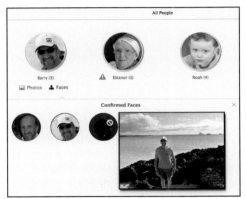

Figure 2.14 Choosing the Not This Person option.

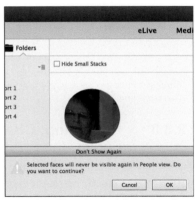

Figure 2.15 Choosing to delete a face from the People view.

2.3.3.3 *Removing a Photograph From Facial Recognition*

We can train the Organizer not to include a person in future facial recognition. Let's return to the UnNamed People category, where we still have one stack showing: the person the Organizer wanted us to identify when we were in the single image view of Eleanor blowing out the candles on her birthday cake. We will click on this stack now and select the Don't Show Again button at the bottom of the People view or Right/Control click and select Don't Show Again from the context-sensitive menu that appears. As soon as we do that, the confirmation dialog box shown in Figure 2.15 warns us that the selected face will never be visible again in People view (although it is not deleted from the active catalog); we will click OK to confirm this is what we want.

2.3.3.4 *Adding Facebook Friends to Your Named People*

Any time you are assigning a name for a person in the Organizer, the opportunity to also add your Facebook Friends list becomes available to click on below the name field. If you choose to click on the option, you will be prompted to log into Facebook within the Organizer (we will learn more about logging into Facebook in Chapter Eleven). Once you do that, your Friends list will be downloaded into it.

2.4 Using the Places View

Photographs can be pinned to the location on a map where they were taken. When the pinned location is later double clicked on the map, all photographs that have been assigned to that location will display. Let's learn a few different ways to do this, so that going forward you can incorporate the method that works best for you with your own images.

NOTE In order for the Places feature of the Organizer to function, its map requires an internet connection.

2.4.1 Assigning Locations in the Media View

Working in the Media view, let's add the Practice_Import 5 folder of images from our Practice Files folder by using the File>Get Photos and Videos>From Files and

Folders command, by selecting From Files and Folders from the Import down arrow menu, or by simply dragging and dropping the folder onto the Media view grid. Let's multiselect three of the images in it—100_1839.jpg, 100_1841.jpg, and IMG_1844. jpg—and then single click on the Add Location button provided below the Media view grid in the Taskbar as shown in Figure 2.16.

Figure 2.16
Selecting the Add Location button in the Media view.

The Add a Location dialog box opens and provides a field to enter where on the map we want to place the photographs we have selected. Let's type Jasper National Park, Alberta, Canada, in the field provided, then press Enter/Return. The Organizer displays a suggested full address for us: Jasper National Park, Jasper, AB TOE 1EO, Canada, which we must click on to select, then press Apply. A second dialog box appears, asking us if we want to add a sub-location. Our images will be added to the map even if we click No; however, let's add Jasper National Park in the field provided, then click Yes to add the images to the map, as shown in Figure 2.17.

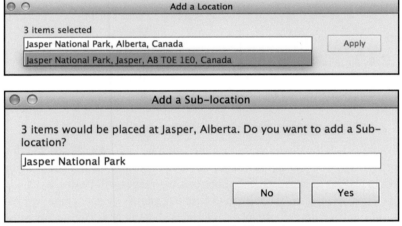

Figure 2.17 Adding a location and sub-location for the Places view.

Before we view them on the map, let's take a look, while we are still in the Media view, at the thumbnails of the images we have chosen for the map. A small Places icon has now been added below each of the three images we chose. When the pointer is moved over the icon, the location displays. When we now click the Places view to the right of the People view, because we assigned a location, we will click the Pinned tab. A map appears in Hybrid view, with a small pin displaying one of our Jasper National Park images. (If the location does not appear when the map is opened, type "Jasper National Park, Alberta, Canada" in the Search for a location field to have the map move to display the area we have added images to.) A pin has been placed at the

location we requested, and when we move the pointer over the pin, it expands to a larger view, displaying some additional features. Let's explore them, as identified in Figure 2.18:

LOCATION: Identifies the assigned location at the top of the expanded pin.

EDIT: Changes the location for the selected images.

ARROW RIGHT CENTER: Allows us to preview the images we have assigned to the location.

SMALL ARROW LOWER RIGHT: Notes the number of images placed at the pinned location, and, if clicked, will display their thumbnails.

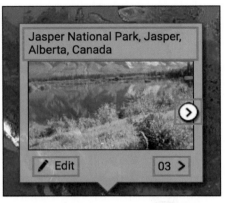

Figure 2.18 Jasper National Park, Jasper, Alberta, Canada, pin applied to the map.

NOTE The Hybrid map drop down menu located at the top left of the map provides three additional viewing alternatives to the default satellite view: Map, Light, and Dark.

2.4.2 Assigning Locations in the Places View

Let's learn more ways to add pinned locations, this time working within the UnPinned pane of the Places view.

2.4.2.1 Adding Locations by Search and Select

We will click the Places view, then the UnPinned tab. We can see that this will now provide access to all of the images we have in our Practice Catalog. By default when UnPinned is chosen, all of our catalog images will be displayed with Group By Time selected so that we can choose our images by date range. We will keep it selected and drag the Number of Groups slider to Max (located directly below UnPinned). Now from the groups displayed by date, we will click the check mark to select only the September 11, 2010, group. Now in the Search for a location field provided on the map, we will type in "Newbury, MA." Once we click Enter/Return, the exact location of Newbury, MA, USA, appears; we will confirm the suggested location by selecting it. Newbury, MA, USA, becomes identified on the map and the program asks if we want to "Place 4 Media Here?" at that location. We will click the confirmation check mark shown in Figure 2.19.

Alternatively we can select Add Location above the selected group, then type in the location in the dialog box that opens. We can also add a pin by unchecking Group By Time, multiselecting only the images we want to pin, then clicking the Add Location

button in the Taskbar below the UnPinned pane. Then in the dialog box that opens, type in the specific location, just as we did in the Media view for Jasper National Park. The location will be pinned on the map with our four images assigned to Newbury, MA, USA. Let's click the Undo button in the Taskbar to learn another way to add a pin.

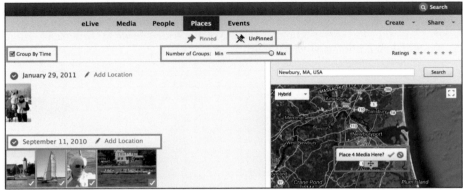

Figure 2.19 Adding a group of images to a Location Pin.

When working in the UnPinned pane, when the pointer is placed between the border of the images and the map, a double arrow appears that can be dragged to the left to display more of the map.

With the UnPinned pane active, and Group By Time either checked or unchecked with no images selected, we will click in the Search for a location field above the map and type in "Newbury, MA." We will once again need to select the exact address that the Organizer finds for us of Newbury, MA, USA, then press the Enter/Return key to confirm it. Because we have not selected any specific images yet this way, the map prompts us with the question "Place All Media Here?" Because we do not want to pin all of our images to that location, we will multiselect the same four images: DSC_0015.jpg, DSC_0060.jpg, DSC_0062.jpg, and DSC_0115.jpg. The Place All Media Here? updates to reflect that we have selected only four images to pin. We will click the check mark to pin them to Newbury, MA, USA.

2.4.2.2 Adding Location Pins by the Drag and Drop Method

Let's click the Undo button in the Taskbar to learn one more way to pin a location. This time we will first need to type in "Newbury, MA, USA" into the Search for a location field of the map in UnPinned view to update the map to display the general location of our search request. Once the general location of Newbury is visible, we will need to click the none symbol when Place All Media Here? displays to dismiss that option. We will use the plus sign in the lower right corner of the map to zoom in closer until the words "Parker River National Wildlife Refuge" display. Now let's multiselect the same four images in the UnPinned pane—DSC_0015.jpg, DSC_0060.jpg, DSC_0062. jpg, and DSC_0115. jpg—and then press and drag them onto the

map and release them on top of the words "Parker River National Wildlife Refuge." Once we do that, the Sub-location dialog opens; let's type "Parker River Refuge," then click Yes to assign it. The images are pinned to the map on the Parker River Wildlife Refuge in Newbury, MA, USA; these steps are shown in Figure 2.20.

 When the map is selected, you can press and drag on it, or alternatively press the up, down, left, and right arrow keys on your keyboard to easily move around it. Additionally, you can press the plus key on your keyboard to enlarge or minus key to decrease your view of the map; you can also hold either one of those keys down to dynamically zoom in or out of your current view of the map.

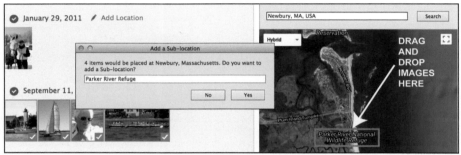

Figure 2.20 Dragging images onto a location to add a pin and adding a sub-location.

2.4.3 Adding an Image with GPS Information

 If a photograph has GPS information attached to it, the Organizer will recognize it when the image is imported and automatically add it to the map for you. Let's do that now. We do not have to leave the Places view to return to the Media view (although we could); we can see that the menu options to import show up in all of the three views we have been working in thus far. Using any of the methods we have learned, let's choose to import the Practice_Import 6 folder, which has only one image in it. As soon as it has been added to our Practice Catalog, let's click the Places tab, then Pinned. If the map is not zoomed out enough, we may need to do that; however, when we are zoomed out enough for Norway to display—there it is, our imported photograph of the Viking Museum in Oslo, Norway, added automatically to the map for us.

When we move the pointer over the pin to expand it, we can see that although the pin was added to the map for us, we can assign its specific location by single clicking on the words "Get Location Here." Let's type "Viking Museum" in the Add a Sub-location dialog box that appears. Once we have done that, the pin updates to reflect our specific assignment for it, shown in Figure 2.21.

To now view all three of our pinned locations, we will need to zoom out of the map a few times. Figure 2.22 shows all three pins in both their collapsed and expanded views.

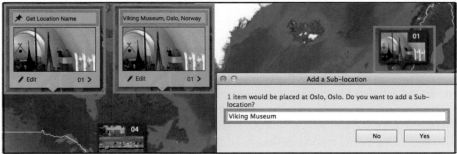

Figure 2.21 Adding a Sub-location to a GPS added pin.

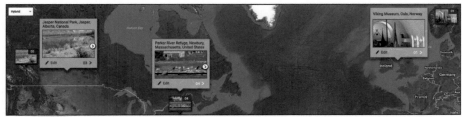

Figure 2.22 Map with Jasper, Alberta Canada; Parker River Refuge, Newbury, MA, USA; and the Viking Museum, Oslo, Norway, pins shown in collapsed and expanded views.

2.4.4 Adding and Removing Photographs From Pinned Locations

At any time after a location has been pinned, images can be added to it and removed from it or, if desired, the pin can be removed entirely from the map.

2.4.4.1 Adding a Photograph to an Assigned Pin Location

Additional photographs can be added to a pinned location at any time by dragging the image on top of the map and releasing it over the pinned location. Let's practice that now. We will select the UnPinned tab and type "Newbury, MA, USA" in the Search field of the map, so that we can easily find the pinned location we want to add our image to if it is not visible. Once we can see our Newbury, MA, pin, we can drag and release the daffodil image on top of it; we will see the number of images listed on the pin change from four to five. We will not want to keep that image with the Newbury files, so let's learn how to remove it.

2.4.4.2 Removing a Photograph From a Pinned Location

Let's learn how to remove a photograph from a pinned location, without having to eliminate the pinned location altogether. If it is not currently visible, we will first need to double click on the Newbury, MA, USA, pin to view the images included in it. Once we have done that, when we select the daffodil photograph, we can single click on the Remove button which becomes active below the Places pane. A warning dialog box asks us if in fact we want to remove this particular image from the pin,

and once we click OK, it is removed. When viewed on the map, the pin will now show that it contains only four images.

2.4.4.3 Removing a Pinned Location From the Map

If we wanted to completely remove one of our pinned locations and not just remove an image from it, we could remove it at any time by simply Right/Control clicking on the pin on the map, and from the context-sensitive menu that appears, select Remove Pin, or click to activate the pin and then click the Remove button which becomes active below the Places pane.

2.5 Adding Events

Photographs taken at a special occasion can be saved as an event. Events can be added in the Organizer two ways: using the Media view or the Events view.

2.5.1 Adding an Event in the Media View

To work with this feature, we will add another folder of images. In the Media view, let's add the Practice_Import 7 folder of images to the Organizer using any method of importation we have learned. Once they have been added we will multiselect them, then single click on the Add Event button located in the Taskbar shown in Figure 2.23. As soon as we do that, the Add New Event panel appears to the right of the All Media pane, where we can assign information about the event. Notice that the date is already plugged in for us, as the Organizer assigned the date provided by the metadata of the images.

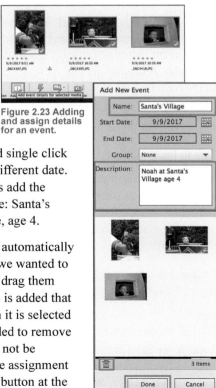

Figure 2.23 Adding and assign details for an event.

However if we wanted to change it, we could single click on the calendar next to the dates to select a different date. We can assign information for the event; let's add the information also shown in Figure 2.23: Name: Santa's Village; Description: Noah at Santa's Village, age 4.

We can see that the images we selected have automatically been added to the collection bin below it. If we wanted to add additional images to it, we could simply drag them into this area to add them to the event. If one is added that we decide we do not want in the event, when it is selected in this bin, we can click the trash icon provided to remove it; it will be removed from the event but will not be removed from the Organizer. To complete the assignment of this event, we will need to click the Done button at the bottom of the Add New Event panel.

Once we have clicked the Done button, an event icon is added below the thumbnail of each image in the event. When we move the pointer over the icon, the name of the event displays. We can view our new event by selecting the Events view, then the Named tab within it: our event displays with the images stacked, the date assigned, and an information icon at the lower right that when clicked reveals the description we assigned to the event. When the pointer is moved over the thumbnail image, the rest of the photographs in the event are displayed. We can Right/Control click on any one of them and then choose Set as Cover to assign a different image to display when the images are stacked, choose to edit the event, or choose to remove the event.

We can see when we are in the Named Event tab that the Add Event button can be selected in the Taskbar here as well. If we click on it, we are brought back to the Media view to select images to create a new event.

2.5.2 Adding an Event Using the Suggested Tab

Let's learn another way that an event can be added to the Organizer. To begin, we will delete our current event. In addition to the ability to Right/Control click on an event and select Remove This Event, we can also select the event in the Named pane, then single click the Remove button provided in the Taskbar. Let's select our Santa's Village event now and choose to delete it. In the deletion confirmation dialog box that opens, we will click OK.

Once we have done that, we will click on the Suggested tab of the Events view to add an event. All of our Practice Catalog images display, divided into groups by

their dates. A calendar is provided on the right that we could use to select a date range for events; however, a Number of Groups slider is also available above the pane to limit the size of the groups of our images, based on date. With the slider set to Max, our Santa's Village photographs are shown as their own event, and we are able to click on the words "Add Event" above the group to assign the details of the event as shown in Figure 2.24, or select the date and then click the Add Event button in the Taskbar.

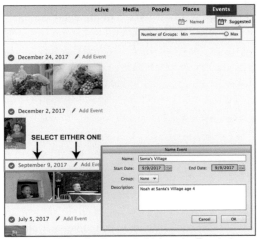

Figure 2.24 Using the Suggested tab under Events to add a named event to the Organizer.

Because we deleted the Santa's Village event we created in the Media view, select the Add Event option and then complete the Name Event dialog box that appears and save the event again. Sometimes the Organizer remembers our previous event, even

though we have deleted it. A dialog box may open asking us if we want to use that name anyway; if it does, we will click OK to do that.

2.6 Examining and Editing a Photograph's Information

We have worked with a variety of photographs from our Practice Files folder, most of which had only their camera file names applied to them. Let's learn how to customize their names and dates, add star ratings and notes, and view their location, history, and metadata.

In the Media view, let's select the daffodils photograph, which currently does not have a custom name, only its original assigned file name of _DSC0190.jpg. When we now look down at the lower right-hand corner of the Media view, we can see a small Keyword/Info icon, which when clicked, toggles the visibility of the Tags and Information panel group to the right of our images.

Let's click to make the Tags and Information panel group visible, then click the Information panel to make it active. Here we can see three information categories: General, Metadata, and History. Let's add some information to the General category.

2.6.1 Adding Information to a Photograph

When the down arrow to the left of the General category is clicked, we can customize the information attached to a photograph. Let's type in "First sign of spring" in the Caption field. This is another method of adding a caption in addition to the ways we have already learned. To customize its

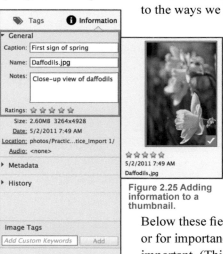

Figure 2.25 Adding information to a thumbnail.

filename, we will first need to highlight and delete its existing one. Once we do that we will type in "Daffodils." We will not need to add its file format extension of .jpg back to the image; the Organizer will add that automatically. In the Notes field, anything that you would like to assign for reference purposes to an image can be added here; we will type "Close-up view of daffodils."

Below these fields we can assign a star rating for quality, or for importance, or for whatever criteria you consider important. (This can be used for search purposes, which we will learn to do later in this chapter.) Let's give this one a five-star rating for its composition and depth of field by simply single clicking the fifth star to the right of the Ratings section. What you may have already discovered

is that star ratings can also be applied to any image in the Media view if the Details command has been selected from the View menu first, using this same method of application. If we wanted to change the rating, we can simply click on the rating we want to change it to. If we decide we want to remove a star rating completely, we can just click again on the assigned star to toggle it off.

These settings are shown in Figure 2.25, along with the date the photograph was taken and its location. When we single click on the word "Date," we could change how it is listed, and when we click on the word "Location," the location we have stored the file will be displayed.

2.6.2 Examining Photograph Metadata and History

When the down arrow is clicked next to Metadata, in addition to file name and date, the camera information will display with more in-depth metadata information available by clicking the small menu icon provided to the right of this category. Below this section is one named "History," which will list when the file was imported and where it was imported from. A section named "Image Tags" is located below History with an Add Custom Keywords text field allowing us to assign a keyword tag to a selected image. This can be assigned when either the Information or the Tags panel is active. We will learn about this field when working with the Tags panel in the next section.

2.7 Working With the Tags Panel

Tags allow us to sort and locate photographs we have imported into the Organizer. We have already explored Smart Tags, the tags the Organizer creates automatically for us. The Tags panel allows us to add custom tags that we can apply to our images for sorting. However, because we have some people named in the People view, have pinned some locations in the Places view, and have a named event in the Events view, we already have some tags assigned. In the Media view, let's click to make the Tags panel active in the Tags and Information panel group and explore these now.

2.7.1 Working With Assigned People Tags

When the Tags panel is active, four categories display in the top section of the pane: Keywords, People Tags, Places Tags, and Events Tags. If we click the down arrow to the left of each one, we can see that the people, places, and events we have already created are listed here. Let's click the arrows to close the Keywords, Places Tags and Events Tags categories for now, and keep just the down arrow next to the People Tags engaged. When we single click inside the box to the left of Eleanor, an icon of a pair of binoculars appears as shown in Figure 2.26, and our pictures of Eleanor are displayed.

People Tags can be organized into groups. Notice that in addition to the four People Tags that we have created, three people groups are available by default: Colleagues,

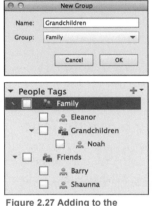

Figure 2.26 Selecting the Eleanor People Tag.

Figure 2.27 Adding to the Family group tag and creating a Grandchildren subgroup.

Family, and Friends. Let's delete the Colleagues group. To do this, we can Right/Control click on it and choose Delete from the context-sensitive menu that appears or, when it is selected, click the down arrow menu next to the green plus sign to the right of the People Tags also shown in Figure 2.26, select Delete, then click OK in the confirmation dialog box that appears. Notice that this menu also provides the opportunity for us to edit the name of the group, create more groups, or add a person to an existing group. Let's press and drag on the Eleanor tag and drop it on top of the Family group tag: a green plus sign appears, and when we release the mouse, her tag becomes indented, indicating it has been added to the Family group tag. Let's do the same for Noah. Once we do that, we can still click the box provided next to Eleanor to show only her images or click the Noah box to show only his images; however, we can also now click on the Family group tag box to display the images of both Eleanor and Noah simultaneously.

We can create subgroups as well. Let's choose to create one. We first need click the down arrow menu to the right of the People Tags category to select New Group, then in the dialog box that opens, we will type "Grandchildren" in the Name field and select Family from the Group drop down menu. Once we do that, the Grandchildren subgroup becomes part of the Family group, and we can drag the Noah tag onto it to become included in it, as shown in Figure 2.27.

Barry and Shaunna are friends; let's drag them now onto the Friends group tag to become included in it. Once we do that, we can click the Friends box to show both of them (be sure Family is *unchecked* prior to clicking the Friends box for *only* the content of the Friends group to display).

 The Barry and Shaunna tags can be moved to the Friends tag simultaneously by selecting one, then holding down the Control/Command key and selecting the second one; they can then be dragged and dropped together.

When working in the People view with either the Named or UnNamed tab active, the Groups icon located in the lower right corner of the Taskbar can be clicked to open the All People panel. Here new people groups can be added, group tags can be applied to images, and existing groups can be selected, renamed, or deleted.

NOTE If you have people that you want to keep in a group, but do not want to include them in a particular search, you can select the group first, then Right/Control click on the names you do not want included in the current search, and select Exclude from Search. Their names will be listed with a slash through them, and their thumbnails will be eliminated from the current search but not eliminated from the group.

2.7.1.1 Assigning an Existing Tag to an Untagged Image in the Media View

When new photographs are imported into the Organizer, existing tags can be added to them at any time. In Media view, let's drag the Eleanor tag onto photograph DSC_0060.jpg. This image becomes added to the Eleanor tag; moreover, when we click the Named tab of the People view, the image has also been added under her name automatically. Let's do the same for the images of Noah in the Media view that are not currently identified with the People icon: _DSC4395.jpg, _DSC4367.jpg, and _DSC4418.jpg.

We can drag the Noah tag individually onto each photograph or Shift-click the images and then drag them simultaneously onto the Noah tag. Conversely, we can Shift-click the images, then drag the Noah tag onto one of them; the tag will be applied to all of the images we selected.

2.7.2 Working With Assigned Places and Events Tags

When we click the down arrow for the Places Tags and study it more closely, we can see it has automatically generated the same kind of hierarchy for our pinned locations that we have just created for the Family People Tag. When we take a closer look at the example shown in Figure 2.28, the green plus sign will add a new place, or when the down arrow menu is clicked next to Places Tags, we can add another Places tag, rename an existing one, or delete one.

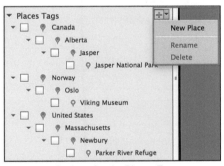

Figure 2.28 Options for the Places Tags.

If we click the green plus sign, or click the down arrow menu located to the right of the Events Tags, similar options relative to it are available: New Event, New Group, Edit, and Delete.

2.7.3 Working With Keyword Tags

Above the People Tags section is one named "Keywords." Keyword tags can be thought of as subject-specific labels we can use to sort our images. When we click the down arrow to the left of its name, we can see that the Organizer has already provided us with four general default keyword tags—Nature, Color, Photography, and Other—that can be converted into categories which can be customized, renamed,

or deleted. Additional categories and subcategories can also be created. Let's explore all of these options, beginning with converting a default keyword tag to a category and customizing it.

2.7.3.1 Converting a Default Keyword Tag Into a Category and Customizing It

Let's select the Nature keyword tag, then customize it by choosing Edit from the Keywords down arrow menu to the right of the green plus sign, or from the context-

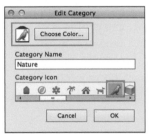

sensitive menu that appears when we Right/Control click on the Nature keyword tag. In the Edit Category dialog box that opens, we can assign a tag outlining color and a category icon from one of the choices provided for us. These features are optional; however, let's click Choose Color and then select any shade of green (pick any shade of green you like from the picker that appears), then choose the bird from the Category Icon section as shown in Figure 2.29.

Figure 2.29 Converting a default keyword tag into a category.

2.7.3.2 Changing Names and Adding or Deleting Categories

Let's convert the default Color keyword tag into a category named "Animals." To do that, we will select it, then choose Edit from the Keywords down arrow menu to the right of the green plus sign or Right/Control click its name and select Edit from

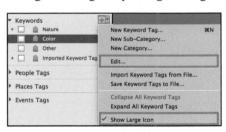

the context-sensitive menu that appears. In the dialog box that opens, we will rename it "Animals," choose orange for its color, and select the dog for its category icon as shown in Figure 2.30.

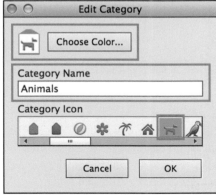

Now let's add a new keyword tag category named "Architecture." To do that, we will choose New Category from the same menu where we chose Edit, which will open the same dialog box shown in Figure 2.29 except that it will display Create Category at the top rather than Edit Category. The assignment of the new category name, with the ability to select a color tag and category icon, are the same: choose any color you would like for the tag color, type "Architecture" for the category name, and select the house for the category icon.

Figure 2.30 Editing an existing default keyword tag to create a new category.

We can change the stacking order of our categories by selecting one then dragging and releasing it when a line appears when we have reached the location we want to move it to. Let's move our new Architecture category to just above our Animals category.

We will not use the default Photography keyword tag, so let's delete it. To do that, we will select it, then Right/Control click and choose Delete from the context-sensitive menu that appears. A dialog box warns us that deletion will also delete any subcategories that may be part of the category; we will click OK to proceed.

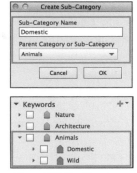

Figure 2.31 Creating a subcategory.

2.7.3.3 Creating a Subcategory

Categories can be divided into subcategories for further organization, following the basic format of an outline. Let's select the Animals category we have created. Once we do that, we can select New Sub-Category from the down arrow menu next to the green plus sign, or Right/Control click on the category and select Create new sub-category from the context-sensitive menu that appears. A dialog box opens for us to name our new subcategory; we will name it "Domestic" and assign Animals for the Parent Category. We will repeat the process to add a second subcategory named "Wild" and assign Animals again for the Parent Category. We now have two subcategories of the Animals keyword category as shown in Figure 2.31.

2.7.3.4 Adding and Assigning Keyword Tags

Now that we have created custom keyword categories and subcategories, let's create keyword tags within those categories and apply them to our images. Just as we learned how to assign a people tag to a photograph, we could drag each of these general category tags onto images to assign it to them. However the power of these tags lies in the ability to create custom keywords within these general categories for more refined sorting and searching. Let's select the Nature category, then choose Create Keyword Tag by clicking the green plus sign, or by selecting New Keyword Tag from the down arrow menu to the right of the green plus sign, or by Right/Control clicking the word "Nature" and selecting Create new keyword tag from the context-sensitive menu that appears. When we do that, in the dialog box that opens, with Nature shown in the Category section, we will type "Flowers" in the Name field. Anytime a keyword is created, reference information can also be added to it in the Note field. We will not add any additional note information but will simply

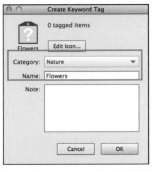

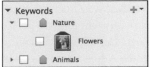

Figure 2.32 Creating and applying a keyword tag.

click OK. The name becomes indented, indicating that this keyword tag is part of the Nature category. Once created, we will drag it on top of the Daffodils.jpg image, then onto the Butterfly.jpg image. Because we applied it to the Daffodils photograph first, the tag becomes identified in the Tags pane with the image of the daffodils shown in Figure 2.32.

NOTE► In order for the keyword to display the image of the daffodils, Show Large Icon must be selected as identified in Figure 2.30. This can be selected from the down arrow menu or assigned in the Preferences. When Edit>Preferences>Keyword Tags and Albums in Windows or Elements Organizer>Preferences>Keyword Tags and Albums in Mac OS is selected, the Keyword Tag Display can be changed, as well as the sorting method for the tags.

TiP If desired, the image icon which identifies a custom keyword tag can be changed. With the keyword tag selected, choose Edit from the down arrow menu to the right of the green plus sign or Right/Control click it and choose Edit, then in the dialog box that opens, choose Edit Icon. You can select a different icon image from any of the photographs the tag has been applied to by scrolling through the images, selecting one, then adjusting the viewing area provided (the resulting look of the icon will appear above the customizing window prior to clicking OK to apply it).

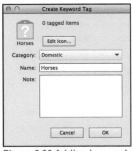

Let's create keyword tags within the subcategories we created under our Animals category, following the same format we learned for creating the Flowers keyword tag under the Nature category. We will create a keyword tag named "Horses" and select the category

Figure 2.33 Adding keyword tags to subcategories.

Domestic to add it to our Domestic subcategory and then create one named "Seals" and select the category Wild to add it to our Wild subcategory. The keyword tags become indented to indicate they are part of their respective subcategories. We can now apply the Horses keyword tag to the Favory.jpg image and the Seals keyword tag to IMG_3056.jpg as shown in Figure 2.33.

2.7.4 Using the Image Tags Text Field to Create a Keyword Tag

Another way to create a keyword tag is to select an image, then type a name for the tag you want to apply to it in the Image Tags text field located below the Events Tags. Let's select the House of Dragons_Spain.jpg image first, then type "Gargoyles" in the Add Custom Keywords field below the words "Image Tags." Once we have done that, we will click the Add button to create the keyword tag. It will be added to

the Other category under the Keywords; however, we will drag it and release it on top of the Architecture category to move it there, as shown in Figure 2.34.

Figure 2.34 Creating a keyword tag using the Image Tags Add Custom Keywords text field and adding it to an existing category.

2.7.5 Importing Images With Keyword Tags Already Assigned

If keyword tags have already been applied to images outside of the Organizer, when you choose to import them, a dialog box will open, listing the keywords the Organizer has detected, that will allow you to import the images with or without their pre-assigned keywords or to modify the keywords.

Let's import some images that have keyword tags already applied to them. Choose to import the Practice_Import 8 folder of images using any one of the methods of importation we have learned. Once we have done that, the Import Attached Keyword

Tags dialog box opens. To have the attached keywords applied when the images are imported, we must select them. We will click the checkbox next to each keyword tag or choose the Select All button below the keyword

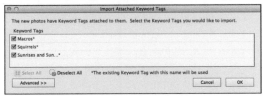

Figure 2.35 Choosing to import attached keyword tags when importing images.

tags as shown in Figure 2.35. An Advanced option would allow us to change the name of any keyword tag we selected; however, we will simply check each keyword tag in the Basic dialog box and then click OK to import the images with their keyword tags attached.

Once we have imported the images and returned to the Media view of the Organizer, the Keywords section of the Tags panel has a new category added: Imported Keyword Tags. When its down arrow is clicked, the three keyword tags are listed, and when an imported keyword tag is clicked, the images with the tag applied to it display.

These images can be left under the Imported Keyword Tags category or moved to any other category or subcategory, or made into their own category. Let's examine

them first, then reassign them. When we click the box to view the Macros images, and then do the same for the Squirrels, we can see that they each display only one photograph. However, when we click the Sunrises and Sunsets keyword tag, we

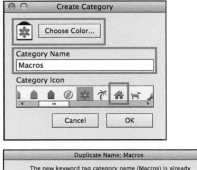

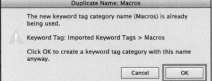

Figure 2.36 Creating a new category using an existing keyword name.

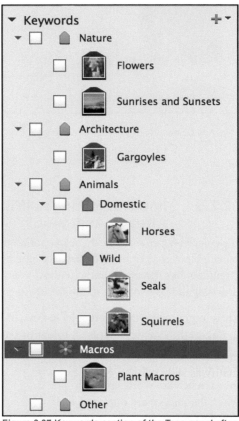

can see it has been applied to three images. Let's drag the Squirrels keyword tag to be added to the Wild subcategory of the Animals category. Now let's drag the Sunrises and Sunsets keyword tag and add it to the Nature category. For the Macros, let's choose to create a new category named "Macros." In the dialog box that opens, we will name

Figure 2.37 Keywords section of the Tags panel after categories, subcategories, and imported keywords have been created and assigned.

the category Macros, assign a purple color for the icon, and select the flower for the category icon. Once we click OK, we are warned that Macros has already been used for an imported keyword tag. We will click OK again to create the category anyway, as shown in Figure 2.36.

Once the new Macros category has been added, we will drag the Macros keyword tag into it. However rather than keeping a category and a keyword tag with the same name, with the Macros keyword tag selected, let's choose Edit to enter the Edit Keyword Tag dialog box to rename it "Plant Macros." To finish cleaning up our Tags pane, we will delete the Imported Tags category and drag the Macros category above the Other category. Once we have done that, our Keywords section of the Tags panel should match the sample shown in Figure 2.37.

Some of the images in our Practice Catalog have more than one type of tag applied to them. In addition to being able to apply different types of tags to the same image, multiple keyword tags can be applied as well. In your own catalog, if you have multiple keyword tags applicable to a particular image, Control/Command click to select them in the Tags panel, then drag them as a group onto the image you want to apply them to.

2.8 Sorting By Star Rating

We applied a five-star rating to the Daffodils.jpg photograph. Let's star a few more images so that we can explore how star ratings can be another way to filter and sort photographs. We learned that when an image is selected, the star rating can be applied under the Information panel of the Tags and Information panel group, or without pre-selecting any images, we can click the desired star rating below an image to apply it in the Media view pane. We will assign five stars to 100_0521.jpg (basin), IMG_3056.jpg (seals), Macro closeup.jpg, House of Dragons_Spain.jpg, and Sunset over the lake.jpg; four stars to _DSC4418.jpg (Noah), IMG_3677.jpg (purple sunset), IMG_3676.jpg (sunset), and 100_1709.jpg (river); three stars to DSC_0062.jpg (sailboat); two stars to Butterfly.jpg, and DSC_0115.jpg (lighthouse); and one star to _DSC0449.jpg (Eleanor-Christmas).

To sort by their rating, above the Tags and Information panel group the word "Ratings" is shown, with five empty stars, and a greater than or equal to icon between the word "Ratings" and the empty stars. When this icon is clicked, two alternative rating filters appear that can be selected instead of the default: Rating is less than or equal to and Rating is equal to. When the default rating filter is selected and a star rating is clicked here such as three stars, only images will be displayed that qualify as shown in Figure 2.38.

Figure 2.38 Assigning a star rating and using it to sort and filter photographs.

Star ratings can also be applied when in the single image view, by assigning the star in the lower left corner of the view area, and in Full Screen mode in the dialog box that appears when the Info icon is clicked.

2.9 Using Albums

An album provides another way to store and access images. The same image can be in multiple albums depending on the theme of the albums—i.e., a special photograph of a person might be in a birthday album, a family album, and a trips album. Albums can be created as well as categories for types of albums, if desired. Let's learn to create albums, as well as add and delete images and generate categories and subcategories for them.

2.9.1 Creating an Album

With the All Media view active, to the left of the Folders panel that we have been using with our Practice Catalog, a panel named "Albums" is available. Let's single click it: My Albums appears below it, with a green plus sign and down arrow menu to the right of it. With no images selected, let's click the green plus sign. When we do, on the opposite side of the Media pane, a New Album panel appears with an

Figure 2.39 Creating an album.

Album Name field, a menu to select a category for the album, and a drag and drop area below for moving items to a media bin. Let's assign an album name of "Top Ten" and leave the Category menu set to None (Top Level). So what will our Top Ten images be? Let's use a star rating to determine which images we will use. Next to Rating, let's click the three-star rating, with the default option (Rating is greater than or equal to) assigned. Ten images appear. We could drag them one by one into the bin; however, let's drag a marquee to select them or press Control/Command plus the letter "A" key to select all of these images. Now when we press and drag one into the media bin area, small thumbnail images of all ten photographs appear there, indicating they will become part of the new album. Below this bin, let's click OK to create the album as shown in Figure 2.39. Alternatively, we can select images, then click the green plus sign to the right of My Albums; they will be added to the new album media bin automatically, ready for us to name the album and click OK.

Once our album has been created, a green album icon and its name display when the down arrow is clicked to the left of My Albums. When either the name of the album or its icon is clicked, only the images contained within the selected album display, each image shown with a small green album icon below it. This feature toggles on and off; click the album name or its icon again, and the view returns to All Media.

When working in the People, Places, or Events view, you can select images within the view and then click the green plus sign to the right of My Albums to create an album from the images selected. You can also Right/Control click any folder when the Folders panel is active and select Create an Instant Album from the context-sensitive menu that appears. After it has been created, you can Right/Control click on the new album and choose Rename from the context-sensitive menu that appears. A Rename dialog box opens, with a New Name field to change the name of the album.

NOTE▶ If the Advanced Dialog box is chosen when downloading images from your camera, when the down arrow next to Advanced Options is clicked, the option Import Into Album is available to add the downloaded images to an existing album or create a new one into which they can be downloaded, as shown in Figure 1.19.

2.9.2 Adding and Removing Photographs From an Album

We can edit the contents of an album—add or delete images from it or change its name. If the Top Ten album is selected under My Albums, we can Right/Control click and select Edit from the context-sensitive menu that appears. The same panel shown in Figure 2.39 appears, except that instead of the words "New Album" at the top, it will display "Edit Album" instead.

We can also add images to an album by dragging the selected album icon in the My Albums panel onto any image to add it to the album. Let's drag our Top Ten album icon onto the Squirrel.jpg image to add it to the album. Now when we view the album, he has been added to it. Conversely, we could drag images onto an album icon to add them. A green plus sign will appear to confirm that they have been added to the album.

When the pointer is moved over the album icon of an image that it has been applied to in Media view, a tooltip appears that will list which album or albums the image is included in.

We will change our mind and delete the squirrel image from the Top Ten album. To do that, we could choose to edit the album as we have learned, or when we Right/Control click on the album icon located below his image in Media view, the option Remove from Top Ten Album appears. When we select that option, then view the contents of the Top Ten album, he is no longer included in it.

2.9.3 Deleting an Album

At any time if we decide we no longer want an album we have created, we can Right/Control click on it under the My Albums list and select Delete from the context-sensitive menu that appears. The album will be deleted, although the images will not be deleted from the catalog.

2.9.4 Assigning Photograph Order Within an Album

One of the advantages of creating an album is the ability to change the order of how images within the album display. When an album is selected, not only can we select images by Newest, Oldest, Name, or Import Batch from the Sort By drop down menu, we can also select Album Order. This sort view will add a sequential number to the top left of each thumbnail. However, we can press and drag on a thumbnail to move it to a different position in the album. When we do, its numerical identification will update to reflect its new sequence in the album as shown in Figure 2.40.

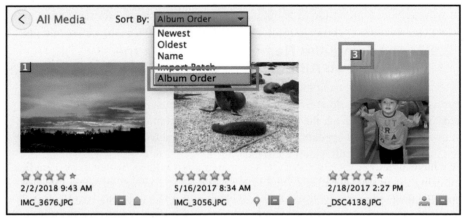

Figure 2.40 Assigning Album Order.

2.9.5 Creating Categories for Albums

If you create a lot of albums, you can organize them into categories. When the down arrow menu to the right of the green plus sign is clicked under My Albums, New Album Category can be selected. A "Parent" category and, if desired, subcategories under the Parent category can be created first into which to add albums. When the same command is chosen once a category has already been created, a new parent category or subcategory can be selected from the drop down menu or selected by Right/Control clicking on the Parent category and choosing the option from the context-sensitive menu that appears.

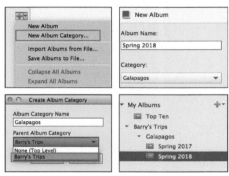

Figure 2.41 Creating an album category, a subcategory, and adding albums to a subcategory.

Once a category or subcategory has been created, New Album can be selected when either the green plus sign or the down arrow menu next to it is clicked. In the New Album panel, the category for the album can be selected from the Category drop down menu. These options, along with a typical application of an album Parent category and subcategory, are shown in Figure 2.41.

2.10 Auto Curate

The Auto Curate feature gets its name from its ability to "rank" your photographs based on its analysis technology combined with your tagging activity in the Organizer. This feature is enabled by default, but can be turned off if desired by choosing Edit>Preferences>Media-Analysis in Windows or Elements Organizer>Preferences>Media-Analysis in Mac OS, as shown in Figure 2.4. When the option is checked in the Media view, a slider appears above the Tags and Information panel group, allowing you to drag it to the left to narrow the results it will provide. A minimum of ten images must be in the catalog for the feature to become available. Feel free to try it now or make your My Catalog active and give it a try. However, if you do make your My Catalog active, be sure to make your Practice Catalog the active catalog again before continuing with the search and find features we will cover next.

2.11 Searching and Finding the Photographs You Want

We have already learned a variety of ways to find our images by using the Timeline or using the sorting systems we have established—i.e., Keywords, People, Places, and Events tags or star ratings, albums, and the Auto Curate feature. We have also learned how we can choose the Search option and have the Smart Tags option "auto-search" for us and, when using it, how we can type in refinements to our search.

2.11.1 Using the Search View

Let's explore the rest of the search options that appear when the Search feature located at the top right corner of the Organizer workspace is clicked when any view—Media, People, Places or Events—is active using the search icons that appear at the left of the Search view shown in Figure 2.42.

PEOPLE: Select the person or people to find.

PLACES: Select the place or places to find.

DATE: Select a date range to find.

FOLDERS: Select a folder from all of your imported folders of images; when a folder is clicked, its contents display.

KEYWORDS: Find by any attached keywords.

ALBUMS: Select the album or albums to find.

Figure 2.42 Search view categories.

EVENTS: Select an event to find.

RATINGS: Find images by their star ratings; select the number of stars you want results for from the pop out menu that opens when the star icon is clicked.

MEDIA TYPES: Select the type of media you want to find; in addition to Photos, select Audio, Videos, or Projects from the pop out menu that opens when the Media Types icon is clicked.

NOTE▶

When the search icon is clicked under any category of the Search view, the same filtering options shown in Figure 2.5 that we learned when working with Smart Tags apply to each of the rest of the search categories as well: combine categories by selecting one and then clicking to add another, and apply the "Or," "And," and "Exclude" filters to refine your search. When the Grid arrow is clicked, the results of the search display in the Items matching pane.

2.11.2 Searching Using the Find Menu

When we examine the Find menu, we can see a variety of ways that the Organizer can search and locate images for us. Most of the options listed here are self-explanatory; however, let's explore the Find>By Visual Searches>Objects appearing in photos command shown in Figure 2.43.

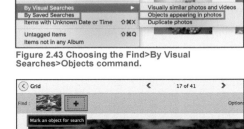

Figure 2.43 Choosing the Find>By Visual Searches>Objects command.

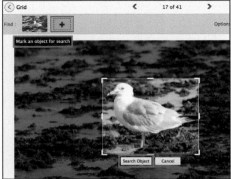

Figure 2.44 Marking an object for a search.

This Find option allows us to select an object within an image to apply a search by Color and Shape for similar content within the rest of our images. Let's learn how this works by adding the Practice_Import 9 folder of images from our Practice Files folder using any of the methods we have learned.

Once we have done that and returned to the All Media view, let's choose Find>By Visual Searches>Objects appearing in photos. A Find filter appears at the top of the media pane, with a plus sign and a slider to search by similar colors or similar shapes. We will select image _DSC2939. jpg (alternatively, we could select the image, then select the command). A box appears over the image, which resembles the Mark Face box we have used for People. We will drag the box to enclose the seagull as shown in Figure 2.44, then click the Search Object button below the box we have drawn. A dialog box will ask if we want to index the images

first; we will click OK Start Indexing to have the Organizer analyze our images to provide a more accurate search.

Our images are filtered by their percentage of similarity to our request, as shown in the lower left corner of each thumbnail. Although we can see as we scroll down through our images that some of the percentage similarities do not accurately resemble our request, the search has discovered the two additional seagull images and placed them at the top of the list for visually matching our search criteria, as shown in Figure 2.45. Once the results appear, the color/shape slider can be adjusted to refine the search.

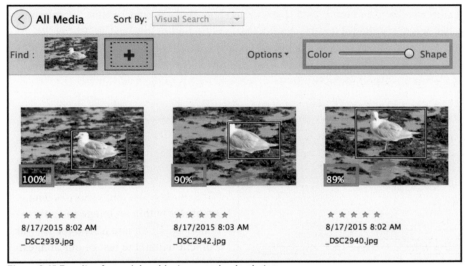

Figure 2.45 Results of search by objects appearing in photos.

2.12 Saving Searches

Searches can be saved for future applications by choosing to save the results of a search and by creating search criteria to filter by.

2.12.1 Saving the Results of a Search for Future Use

When a search has been applied and results display in the Items matching pane, a down arrow menu named "Options" appears in the gray bar at the top right of the pane. When this arrow is clicked, choices are available for the search that was made, one of which is Save Search Criteria as Saved Search. When this option is selected, a dialog box Create Saved Search opens, allowing us to assign a name to the search as shown in Figure 2.46.

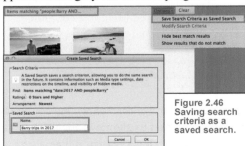

Figure 2.46 Saving search criteria as a saved search.

To later implement this saved search, we can select Find>By Saved Searches (outlined in Figure 2.43), select our search from the list, then click the Open button to view the images in the saved search.

2.12.2 Creating a Saved Search by Assigning Criteria

We can also create a saved search by first selecting the Find>By Saved Searches command, then clicking the New Search Query button in the lower left corner of the dialog box that opens. Once we do that, the New Search Query dialog box opens. Here we can name a search and assign criteria we want to use to search by. A plus sign allows us to add another level of criteria to the search if desired, with these features outlined in Figure 2.47. Let's create one. We will name it Best Photographs, select the All of the following search criteria radio button, then assign Rating, Is, and 5 for the search criteria, then click OK to create the saved search. The search results appear, and if we select the Find>By Saved Searches command again, our new search is listed for selection. If we choose to assign the five-star rating to

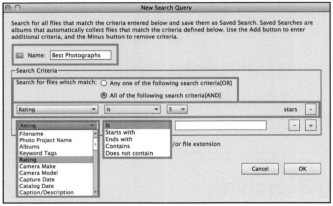

Figure 2.47 Assigning criteria for a new search query.

another image in the future, it will automatically be added to this search. When in the Saved Searches dialog box, here is where any previously saved searches can be deleted if desired by selecting the search first and then clicking the trash icon located at the top right corner of the dialog box.

2.13 Using the Instant Fix Editor

In-depth corrections to images require the Photo Editor which we will soon be working in. However, oftentimes our images may only require minor adjustments that can be performed right within the Organizer.

In the Media view, we can select one or multiple images, then click the Instant Fix button in the Taskbar. If we choose multiple images, once in the Instant Fix pane, we can assign adjustments which will apply to all of the images globally, or select View>Show One Photo to apply custom corrections to each of them individually (the Crop and Red Eye options are only available when working with one image). Let's select the _DSC4624.jpg image, then click the Instant Fix button located in the

Taskbar. Our image displays in a large single image view, with a variety of editing tools provided on the right, as shown in Figure 2.4. Let's take a closer look at what they do:

CROP: Provides preset crop dimensions or allows us to create a custom crop. Once a crop preset has been selected, the content can be adjusted within it using the preview area that appears.

RED EYE: Removes red eye. We will explore red eye in depth in the Photo Editor; however, if desired, it can be removed here.

EFFECTS: Features such as converting an image to black and white or sepia can be selected.

SMART FIX: Analyzes your photograph and applies corrections based on what it determines the image needs.

LIGHT: Presets for the lightening and darkening of an image are provided; single click a preset to apply it.

COLOR: Presets for adjusting the saturation of an image are provided; single click a preset to apply it.

CLARITY: Presets for sharpening or blurring an image are provided; single click a preset to apply it.

Figure 2.48
Correction
options of
Instant Fix.

Below the workspace buttons are provided to Undo/Redo, Flip the image, Reset to start over, view a Before/After sample of the adjustment, launch the Editor, or Save the changes, as well as a Done check mark to return to the Media view when all corrections have been completed.

Starting with the Smart Fix option can be great if you have no idea what is wrong with the lighting or color but you just know it could be better. Even if you click the Undo or Reset buttons after applying the Smart Fix option to then employ your own custom adjustments instead, it can help you visualize what you will need to adjust.

TIP

We will apply lighting, color, and clarity adjustments to this image, beginning by lightening it. When we click the Light icon, a blue slider appears that can be dragged up to lighten or down to darken. When dragged, a red line identifies our origin. We will drag the slider up a little to lighten the photograph (there is no right or wrong, just what looks great to you). Now let's adjust its color, dragging the blue slider up a little until we are satisfied with the adjustment. Finally, let's adjust the clarity by dragging it up a little as well. We are now done with our adjustments. We will click the Save button, then the Done check mark to return to the Media view.

2.14 Version Sets

When we return to the Media view after applying our Instant Fix, we can see that the image now has a gray box surrounding it like our stack has. However unlike our stack which has a "layered" icon in its top right corner, our ice photograph has a small brush icon indicating that this is a version set—the image has been edited. Although a version set can be assigned when working in the Photo Editor, the Organizer's Instant Fix editor creates one for us automatically. When we click the arrow located on the right side of the gray box, our original displays next to our corrected version, as shown in Figure 2.49.

Figure 2.49 Version set expanded and menu options for a version set.

When the version set is selected in either collapsed or expanded view, we can choose Edit>Version Set, or when we Right/Control click on the image either collapsed or expanded, we can select Version Set from the context-sensitive menu that appears, to access the menu options also shown in Figure 2.49. When a version set is created, a copy of the corrected image is also saved into the same folder as the original image.

We are ready to move forward to working with the Photo Editor in Chapter Three. Before we "switch gears," feel free to further reinforce your Chapter Two learning by completing one or more of the Practice Makes Perfect exercises provided.

PRACTICE MAKES *PERFECT* ✔

PRACTICE PROJECT 1

1. Select the People view, then UnNamed. When Hide Small Stacks is unchecked, a picture of Eleanor will appear, as the Parker River Refuge images were added to our Practice Catalog after we named her (remember that Hide Small Stacks must be unchecked for her to appear in the UnNamed pane).

2. Add her name.

3. View all the images of her now under the Named tab of the People view or when in Media view, by selecting her keyword tag under the Family group in the People Tags section of the Tags panel.

PRACTICE PROJECT 2

1. Select the three seagull images either individually, by using the Sort By>Import Batch option, or by using the Find>By Visual Searches>Objects appearing in photos.

2. With the images selected in Media view, click to view the Tags panel.

3. In the Add Custom Keywords field of the Image Tags section, type "Seagulls" and then press the Add button.

4. Drag the new Seagulls keyword tag from the Other category to add to the Wild subcategory of the Animals category.

5. The Tags panel should now match the sample shown in Figure 2.50.

Figure 2.50 Tags panel with Seagulls keyword added to the Wild subcategory of the Animals category.

PRACTICE PROJECT 3

A third exercise named "Chapter Two Practice Project 3.pdf" is available in the Additional Practice Projects folder on the companion DVD.

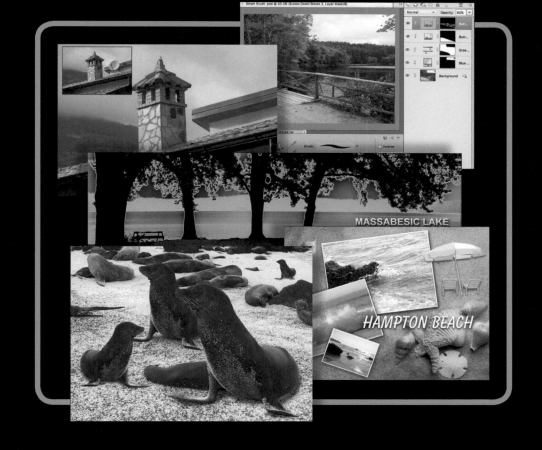

Part Two

Working in the
Elements Photo Editor

3

Basics for All Editing Modes

In This Chapter

- Explore fundamentals of the Photo Editor workspace
- Master resolution
- Apply basic color and clarity adjustments
- Clarify color modes versus color profiles

Working within the Quick edit mode, we will learn to open files, apply tools and commands to them, adjust their resolution, and assign the proper file format when saving. We will also color manage our work by learning to assign the best color profile to files and printers for expert results.

 NOTE ▸ Part Two focuses on the features of the Photo Editor. If you chose to exclude Part One from your learning, you will need to access the practice files provided with this book for completing the exercises in the remaining chapters. A folder named Practice Files containing several subfolders of working files to accompany our learning in Photoshop Elements 2018 has been provided for you in the companion files included at the back of this book as well as available from the publisher by writing to info@merclearning.com. This folder should be copied to your hard drive prior to launching the program.

3.1 Accessing the Photoshop Elements Photo Editor

When Photoshop Elements 2018 is launched, we can access the Photo Editor from within the Organizer or from the default Welcome Screen that appears. Let's explore the ways we can choose to begin working in the Photoshop Elements Photo Editor (hereafter referred to as the Editor).

3.1.1 From the Elements Organizer

When an image is selected in the Media view of the Organizer, we can single click the Editor button in the Taskbar below the All Media pane to open the image within the Editor; the module will be launched if needed, and the image will appear in the center Edit pane of the Editor. Alternatively, when working in the Instant Fix editor, below the view pane, the same Editor button is available to launch and open the selected image within the Editor.

3.1.2 From the Photoshop Elements Welcome Screen

By default, when Photoshop Elements 2018 is launched, the Welcome Screen will display the Editor and the Organizer modules as buttons which can be clicked to launch the desired workspace. A small gear icon at the top right of the Welcome Screen allows us to choose to have one of the modules always open by default when the program is launched. When selecting the Editor, in addition to simply single clicking on its name to launch the program, we can alternatively press the down arrow provided to the right of its name to access a

Figure 3.1 Welcome Screen features identified and selecting to open the Editor workspace module highlighted.

menu of recently opened files, as well as having the option to choose Open and New File. When the pointer is moved over one of the recently opened files listed in this menu, its location on your computer appears as a tooltip, with all of these options identified in Figure 3.1. (Tooltips can be disabled in the Preferences dialog box by choosing Edit>Preferences>General> in Windows or Adobe Photoshop Elements Editor>Preferences>General in Mac OS and then unchecking Show Tool Tips.) We will be working in the Editor for the first time, so let's single click the Editor button at the lower left of the Welcome Screen to launch it.

A copy of each figure shown in this chapter can be viewed in the companion files included with this book.

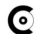

3.2 Opening an Image in the Editor

When the Editor launches, it opens with three available editing mode options: Quick, Guided, and Expert. The number and types of features available vary depending on the edit mode selected; however, all of the edit modes contain three basic sections: a Tools panel area on the left, the edit area in the middle, and a panel area with adjustment and effects options on the right. Some of the commands, tools, and menu options that appear in the Quick edit mode (hereafter referred to as the Quick mode) are identical to those available when working in either of the other two editing modes. Let's open a few images to explore features that are available in all three editing modes by examining them within the Quick mode.

With the Quick mode tab active, let's choose File>Open, then locate the Practice_ Import 10 files folder within the Practice Files folder you copied to your hard drive. Within this folder, let's open the files contained within it: 100_1653.jpg, 100_1907. jpg, and _DSC2670.jpg.

Each file can be opened individually, or, when in the Open dialog box, we can click to select the first image, then hold the Shift key down and select the third one; with all three selected when we click Open, they will all be added to the Editor. Alternatively, you could add the folder into your Practice Catalog in the Organizer, then Control/ Command click the three images in the Organizer, then single click the Editor button in the Taskbar below the All Media view.

NOTE Once you have worked in the Editor, the File>Open Recently Edited File will list your 20 most recently opened files to select from to reopen. The number of files that will be listed here can be changed in the Preferences dialog box by choosing Edit>Preferences>Saving Files> in Windows or Adobe Photoshop Elements Editor>Preferences>Saving Files in Mac OS, then assigning a higher or lower number in the Recent List Contains field.

3.3 Basics of the Editor Workspace

With the Quick mode selected, let's take a look at some features available in all three editing modes of the Editor as shown in Figure 3.2 (the Create and Share down arrow menus will be covered in Chapter Eleven):

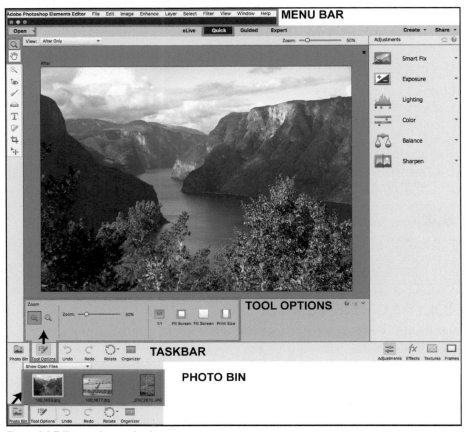

Figure 3.2 Editor workspace basics.

MENU BAR: Provides drop down menus for commands and panels.

OPEN BUTTON AND DOWN ARROW MENU: Opens a dialog box to locate a file to work on. When the down arrow is pressed next to the word "Open" instead, recently opened files will be listed to allow easy reopening of one you have worked on, as well as the ability to create a new image based on content which has been copied onto the clipboard or create a new file from scratch. We will explore the File>New Blank File feature later in our learning.

TOOLS PANEL: Displays tools applicable to the edit mode selected. To show or hide the Tools panel, choose Window>Tools from the Menu Bar. The Zoom and Hand tools are available in all three modes; we will learn to use both of them later in this chapter.

TASKBAR: Displays below the work pane with buttons for the Photo Bin, Tool Options, Undo, Redo, and Rotate, while also providing the ability to jump to the Organizer.

PHOTO BIN BUTTON: When clicked, the bin appears above the Taskbar, with all open images shown as thumbnails within it. A drop down menu defaults to Show Open Files, as well as providing the ability to select to display images from the Organizer instead. In the Photo Bin, the active image in the Edit pane will be outlined in blue, with the ability to single click on any other image stored in it to make it the active image instead. When multiple images are open, they can be dragged to change their sequence in the bin.

TOOL OPTIONS BUTTON: When clicked, the Photo Bin area becomes replaced by options specific to the tool that has been selected in the Tools panel.

You can Right/Control click on any thumbnail in the Photo Bin, then choose Show Filenames to have all of the images in the bin display their file names as well as their thumbnails or, alternatively, choose to duplicate the selected image, edit the file information for it, rotate it left or right, or close it.

3.4 View Features

View features that are available in all three editing modes include displaying a Grid, using the Zoom and Hand tools, and being able to monitor image edits by displaying before and after views of the active image. Let's take a look at each of these.

3.4.1 Displaying a Grid

A grid can be displayed over an image for alignment purposes by choosing View>Grid. The subdivisions and color of the grid lines can be changed in the Preferences dialog box by choosing Edit>Preferences>Guides & Grid in Windows or Adobe Photoshop Elements Editor>Preferences>Guides & Grid in Mac OS. To hide the grid once it has been displayed, choose View>Grid again; the command toggles on and off when selected.

3.4.2 Using the Zoom Tool

When an image is open in the Editor, we can select View>Fit on Screen, which means no matter how large or small the image, it will be scaled proportionately up or down as needed to fill the available edit area. At the top of the Tools panel is a magnifying glass icon which represents the Zoom tool. This tool can be applied in a variety of ways. In its most basic application, the tool can be selected and single clicked on the active image to enlarge the view. Each time it is clicked, the image will be enlarged by a preset increment. Holding down the Alt/Option key while using the tool changes it from its default plus mode to a minus mode to decrease your magnification using the same preset increments. These same increment adjustments can also be applied by selecting View>Zoom In or View>Zoom Out, or by holding the Control/Command key down while pressing the plus key to zoom in or, while

pressing the minus key, to zoom out. When using this keyboard shortcut, the Zoom tool does not need to be selected.

When the tool is selected and the Tool Options button is clicked in the Taskbar, we can choose the Zoom In tool, the Zoom Out tool, drag the Zoom slider provided to the right to zoom in or to the left to zoom out, or we can highlight the percentage shown to the right of the slider and type in a specific desired magnification, then press the Enter/Return key to apply it. As an expert you will oftentimes need to zoom in to examine an area at a high magnification and then examine the same area zoomed out.

3.4.2.1 Applying a Dynamic Zoom

We can zoom in to an exact area of an image quickly and easily by selecting the Zoom tool, then pressing and dragging across the image to draw a marquee of the area we want to examine in an enlarged view. Once the mouse is released—voilà! We are there; the view we created with the marquee now fills our workspace. When we want to again see our image in its entirety, we can select View>Fit on Screen or Right/Control click on the image and select Fit on Screen from the context-sensitive menu that appears.

 Without selecting the Zoom tool, you can engage it to dynamically zoom by holding down the Control key and the Spacebar simultaneously in Windows or the Command key and the Spacebar simultaneously in Mac OS. Whatever tool in the Tools panel is currently selected will be temporarily converted to the Zoom tool while those two keys are pressed at the same time. Additionally when zoomed in, you can press the Spacebar by itself to engage the Hand tool without selecting it in the Tools panel. You can also return to the Fit on Screen view when you are currently zoomed in by double clicking on the Hand tool.

3.4.3 Using the Hand Tool

The Hand tool allows us to move around an image when we have magnified in. When we have zoomed in larger than the Fit on Screen view, the Hand tool can be used to press and drag to move around the magnified view we have defined.

3.4.4 Viewing Before and After Versions of an Image

To the right of the Tools panel in the Quick and Guided modes is a View drop down menu with four view options: Before Only, After Only, Before & After—Horizontal, and Before & After—Vertical, with After Only chosen by default. As we make edits to our work, being able to easily compare our changes with the original image at any time will be very helpful. (When working in the Expert mode, before and after views can be visible using the Layout options which will be covered in Chapter Four.)

3.5 **Understanding Resolution**

The visual clarity of an image is determined by its resolution. Digital images are composed of small boxes of color named "pixels." When we zoom in on an image, we can see its individual pixels. Let's select the image (100_1653.jpg) in the Photo Bin, then dynamically zoom in as shown to the mountain area in the enlargement in Figure 3.3. At this magnification, its pixels can clearly be seen as individual boxes of color.

Figure 3.3 Magnified area to examine pixels.

Resolution is determined by the number of pixels an image contains within a 1" × 1" square, referred to as ppi ("pixels per inch"). When a 1" × 1" square contains only 72 ppi, the image is defined as a low resolution image. In contrast, when a 1" × 1" square contains 300 ppi, it is defined as a high resolution image.

However, the pixel dimensions of an image are not the same as its physical dimensions. With the fjord image (100_1653.jpg) still active in the edit pane, let's choose Image>Resize>Image Size. When the dialog box opens, Resample Image will be checked by default as shown in Figure 3.4. We can see that the Document Size (physical size) is very large (Width: 50.667" × Height: 38") but has a resolution of 72 ppi. If we change the physical dimensions here with Resample Image checked, we are letting the Editor decide which pixels to throw away if we want to make the image smaller or allowing the Editor to fabricate pixels by replicating existing ones if we choose to increase the physical dimensions. In both of these choices, the

Editor applies an interpolation method to perform the resampling, chosen from one of the following interpolation methods selected from the drop down menu below the Resample Image checkbox: Nearest Neighbor, Bilinear, Bicubic, Bicubic Smoother (best for enlargement), and Bicubic Sharper (best for reduction), with Bicubic the default general use choice.

When changed in this manner, the Pixel Dimensions change as well. Because the Editor must add or delete pixels when Resample Image is checked, the quality of the resulting image will oftentimes be compromised.

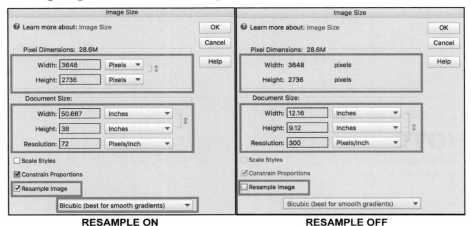

RESAMPLE ON **RESAMPLE OFF**

Figure 3.4 Resample Image checked in the Image Size dialog box.

Figure 3.5 Assigning a resolution of 300 ppi with Resample Image unchecked.

NOTE▶ If you enter information into the Image Size dialog box and want to start over without having to click the Cancel button and then reopen the dialog box, you can press the Alt/Option key while still in the dialog box, which temporarily converts the Cancel button into a Reset button you can click to clear your entries and start over. If you have typed any values into the Image Size dialog box with the Resample Image check mark engaged, hold the Alt/Option key down and select Reset now to start over.

Let's uncheck the Resample Image checkbox. Notice that the Width and Height fields in the Pixel Dimensions section can no longer be altered; only its Resolution and Document Size Width and Height fields (physical dimensions) can be changed. These two attributes are interdependent: when the resolution is changed, the Document Size (physical dimensions) changes correspondingly; however, the *pixel dimensions remain constant*, which is what we want. Now let's type in 300 ppi for a resolution. Notice that when the Resample Image checkbox is *not* checked, changing the resolution to 300 ppi *reduces* the physical dimensions (Width: 12.16" × Height: 9.12"), as shown in Figure 3.5.

By assigning a higher resolution without resampling, what we are doing is pushing the *existing* pixels closer together, packing 228 more of them (300 vs. the original 72) into a square, which increases the total number of pixels per inch. Once they

have been pushed together, because the pixels closer together require less area to display, the physical dimensions of the document get reduced.

3.6 Scanning

If you are scanning a small photograph that you will want to print larger, this same concept applies but in reverse. For example if you want a 4" × 5" photograph to become an 8" × 10" high resolution image, it should be is scanned at 600 ppi, which is double the final resolution size you want (300 ppi × 2). Once it has been opened in the Editor and the Image Size dialog box is opened, when Resample Image is unchecked, if the Document Size is changed—e.g., Width: 8" × Height: 10" (4" × 2 = 8", 5" × 2 = 10"), the resolution drops automatically to 300 ppi. Or if the resolution is changed from 600 ppi to 300 ppi, the Document Size increases automatically to 8" × 10". By scanning the image at a resolution of 600 ppi (300 ppi × 2), when the document size is doubled to 8" × 10" the resolution drops to 300 ppi: which is just what we want.

NOTE➤ This formula works for all types of scans. If you wanted a 1" x 1.5" area of a pre-digital film negative to be printed as a 4" x 6" image, it should be scanned at 1200 ppi (1" x 4 = 4", 1.5" x 4 = 6": 300 ppi x 4 = 1200 ppi).

Under the Image>Resize menu, in addition to being able to select Image Size, we can also select Canvas Size. Although this dialog box may initially appear to resemble the Image Size dialog box, it is used to change the size of the surface the image resides on, defined as its "canvas." Later in our learning we will examine this dialog box to explore ways it can be very useful.

3.7 Saving an Image in the Editor

We have made changes to the fjord photograph (100_1653.jpg) that should be saved. In your own work, best practice is to open an image to work on and choose File>Save As before beginning to work on it. This practice will assure that you can always return to your original unedited photograph if needed. Let's learn about file formats and saving options that are available when working in the Editor.

3.7.1 Saving a File

To save our changes to the fjord image, let's choose File>Save As. When the dialog box opens, let's take a look at its options:

SAVE AS: Although any name can be assigned to a file when it is being saved, the Editor lists the file with its original name and file format extension by default. If the photograph has been imported into the Organizer prior to entering the Save As dialog box of the Editor, it will also have an underscore added, along with the word "edited" and a number referring to how many times you have

saved that file using the Save As command, which creates a new file each time. In the dialog box shown in Figure 3.6, the file is being saved for the first time; therefore, a hyphen and a number one (-1) have been added.

FORMAT: Displays the original file format. However, we will want to select Photoshop from the Format menu instead. The images we have imported are JPEG files. The JPEG file format creates smaller file sizes by applying a "lossy" compression method. What "lossy" means is that every time the file is saved, a small amount of data is permanently removed from the file. When reduced file size is critical, the more popular alternative to the JPEG file format is the TIFF file format, which uses a "lossless" compression method when LZW is assigned to it. What "lossless" means is that the file will be compressed; however, no data will be lost. Rather than use the TIFF file format, we will always want to assign the native Photoshop (PSD) file format, which preserves all data and layers created in the file (working with layers will be part of our learning in Chapter Four).

SAVE: AS A COPY: Useful when saving a flattened copy of a layered file.

ORGANIZE: INCLUDE IN THE ELEMENTS ORGANIZER: Adds a copy of the edited version to the Organizer, even if you choose to save the file in a different location from its origin.

ORGANIZE: SAVE IN VERSION SET WITH ORIGINAL: Provides the option to save a Version Set if the file has been imported into the Organizer before electing to save the file. If you choose to uncheck this option, the automatic addition of the text "_edited-1" will be removed from the name in the Save As text field.

COLOR: Provides the option to not embed the color profile. The color profile assigned to the image will be chosen by default. We will learn about color profiles later in this chapter.

Let's choose to save the file back into the same folder we opened it from, select Photoshop for the file format, keep the default naming format (original file name with "_edited-1" added), elect to add a copy to the Organizer, opt to embed the color profile, and then click the Save button. If you previously added the images to the Organizer, optionally choose to keep the "_edited-1" as part of the file name and the Save in Version Set with Original checked. If you are saving a file for the first time and do not want to assign a new name to the file, a great alternative in your own work is to simply add "_edited" to the original name to identify it as an altered version of the original file. Once we have saved and named the file, we do not need to select the Save As command again unless we want to change the file's name or its location. All future updates to the file can be executed by simply choosing File>Save or using the keyboard shortcut of holding down the Control/Command key while pressing the letter "S" key.

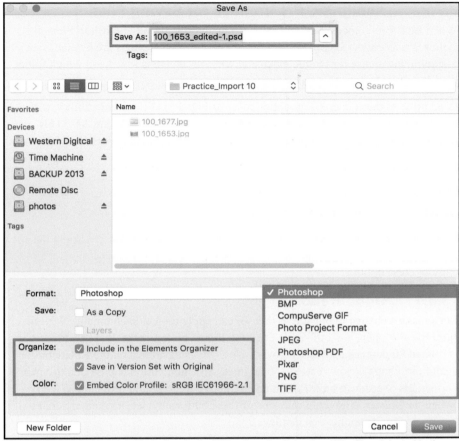

Figure 3.6 Choosing Format>Photoshop in the Editor Save As dialog box if the file originated in the Organizer.

Best practice is to save frequently. Unfortunately all software programs occasionally lock up. When that happens, all changes made to the file since the last Save or Save As command was applied are lost. By saving frequently, you will have minimal negative ramifications when a crash or lock up occurs.

Figure 3.7 Graphic and warning dialog box in the Organizer when an image is open in the Editor.

NOTE▶ While an image is open in the Editor, if you launch the Organizer, a band and lock icon will display across the image in the Organizer to indicate it is currently open in the Editor. If you attempt to delete it in the Organizer, the warning message shown in Figure 3.7 will appear.

3.7.2 Assigning Preferences for Saving Files

When Edit>Preferences>Saving Files in Windows or Adobe Photoshop Elements Editor>Preferences>Saving Files in Mac OS is selected, options are available such as assigning lowercase for the file extension when an image is saved and which folder the file will default to being saved into.

In addition to these, there is an option to Maximize PSD File Compatibility, with three choices available from a drop down menu: Always, Never, and Ask. This option refers to the compatibility of the saved file with previous versions of Elements and other applications. Although it will create a slightly larger file, choosing Always is a safe and important preference to assign.

3.8 Undo Options

The Editor allows us multiple Undos and Redos. Alternatively we can apply the Revert command, which is helpful when the file has been saved recently. Let's explore these options.

3.8.1 Undo/Redo

Let's make a change to our file so that we can apply the Undo command. With the fjord file still open, we will single click the Rotate button in the Taskbar: the image is rotated 90 degrees counterclockwise. Now let's single click on the Rotate button again: our image is now rotated 180 degrees. An Undo button is provided to reverse our actions one step at a time, with an alternative Redo button provided as well (when the pointer is hovered over one of these buttons the latest command that will be affected by its application displays).

These Undo/Redo commands can also be chosen from the Edit menu or applied as a keyboard shortcut. The keys on the keyboard that will be used for the Undo/Redo keyboard shortcuts can be selected from three options available under the Step Back/ Fwd drop down menu in the Preferences dialog box under Edit>Preferences>General in Windows or Adobe Photoshop Elements Editor>Preferences>General in Mac OS.

3.8.2 Revert Command

If you have experimented with the Undo/Redo options, apply the Redo command now until the image is again rotated to 180 degrees. We will use this state to learn the value of the Revert Command.

When we choose Edit>Revert, the file is returned to the state it was when the most recent save was applied. If you have saved frequently and want to undo multiple steps, you can choose Revert to skip all the Undo steps and return to the last saved version with one click. Let's choose Edit>Revert; our fjord file is returned to its original position. Let's choose File>Save to update our changes to this image.

3.9 Applying Basic Adjustments

Before we learn about color management and printing, let's explore a few of the color correction options that are unique to the Quick mode. The Enhance menu has a variety of correction options that are identical to those available in the Expert edit mode; however, we will explore the Enhance menu when working in the Expert edit mode in Chapter Five. Instead, let's explore a panel to the right of the Edit pane, named "Adjustments" that is used for basic color and detail enhancements.

The Adjustments panel opens by default when the Quick mode is active. In the Taskbar area below it, buttons to access three alternative panels—Effects, Textures, or Frames—can be single clicked to replace the Adjustments panel; we will keep the Adjustments panel active.

Let's choose File>Open, then locate the Practice_Import 2 files folder within the Practice Files folder you copied to your hard drive. Inside this folder we will open the file named Butterfly.jpg. (If you have been using the Organizer, you can single click the Organizer button in the Taskbar of the Editor to jump to the Organizer, select the Butterfly.jpg file within it, then click the Editor button on the Taskbar of the Organizer to jump back to the Editor.)

Let's begin by choosing File>Save As. In the Save As dialog box, if you have added the file to the Organizer, you can choose the default name addition that has been assigned of ("_edited-1"). If not, add "_edited" to the name "Butterfly" and choose to save it back into the original folder, select Photoshop for the format, elect to embed the color profile, and optionally choose to include a copy in the Organizer and as a Version Set.

From the View drop down menu, let's select Before & After—Horizontal. This will allow us to easily monitor our adjustments as we make them. We will also want to select the Fit on Screen view by selecting it from the View menu or by double clicking on the Hand tool.

Let's take a look at our available adjustment options:

SMART FIX: Provides auto corrections for lighting and color balance.

EXPOSURE: Adjusts the overall lightness and darkness of an image.

LIGHTING: Adjusts contrast and provides Auto options, with the ability to independently modify the Shadows, Midtones, and Highlights of the image.

COLOR: Provides an Auto option along with specific settings to individually modify Saturation, Hue, and Vibrance.

BALANCE: Adjusts color through Temperature (warm or cool) and Tint (green vs. magenta) sliders.

SHARPEN: Details can be enhanced by dragging the slider provided or by applying its Auto option. The Sharpen adjustment should always be used *only* after all other adjustments have been applied.

Smart Fix analyzes our photograph and applies general adjustments. To access its options, we can click on its icon, its name or its down arrow. When any one of them is clicked, a slider is provided along with a text field, nine preset adjustments, a reverse icon, and an Auto button. Our starting point is outlined with a blue border

Figure 3.8 Assigning the Lighting>Shadows Adjustment in the Quick edit mode.

and reverse icon. When we move the pointer over each of the nine presets, we can see how they will affect our photograph. Alternatively, we can drag the slider provided, type a value in the text field, or click the Auto button. Many times Smart Fix is a great correction by itself, and always worth trying. However we can see when applying it to this image, none of its settings appear to positively affect the color and tonal quality of our photograph. To exit one of the adjustment categories without changes, we can click the reverse icon within the adjustment option, choose Edit>Undo, press the Undo button in the Taskbar, or apply the Undo command as a keyboard shortcut. If the Reverse icon *above* the panel is clicked after one or more adjustments have been applied, *all* adjustments that have been applied will be removed.

Figure 3.9 Applying Sharpen after all other adjustments have been made.

Applying an Exposure adjustment would alter our overall lightness and darkness; since these are currently satisfactory, we will not want to add one. However the Lighting adjustment option can help us to lighten the darks separately from the

midtones and highlights. When Lighting is selected and the Shadows tab is active, we can select a preset, drag the slider, or type a value. Let's assign 50 as shown in Figure 3.8. With the menu still open, we will click the Midtones tab and also assign 50. Once we have done that, we will close the Lighting menu. All of the Adjustments menus follow the same method of application. Although personal preference should take priority, one additional suggested setting is Color>Saturation: –10.

To adjust sharpness, it is best to zoom in first. Let's zoom in to the area between the butterfly and the flower, so that we can see a little of each. Now when the Sharpen option is opened, the key to success is to sharpen enough to improve clarity without adding a fake "halo" effect around the edges. Let's apply 125 as shown in Figure 3.9. (Before assigning it, if you drag the slider to 500, you will be able to clearly identify the halo effect.) With the color adjusted, we will save and close this file.

3.10 Color Modes

The Editor supports four color modes: RGB, Index, Grayscale, and Bitmap. Our learning will include the RGB mode and the Grayscale mode (we will learn about grayscale in Chapter Five). Index color uses a maximum of 256 colors and is useful for reducing image file size when creating graphics for the web, with Bitmap mode using only black and white, typically applied to line art. The RGB color mode is assigned by default, with the alternative color mode choices available by selecting Image>Mode as shown in Figure 3.10. The CMYK color mode is typically used for commercial printing and is not available in the Editor.

Figure 3.10 Choosing a color mode.

3.11 Color Management

Color management is critical to assure consistent color between your camera, your monitor, your scanner (if you use one), and your printer. This is achieved by choosing the proper color management setting for printing and assigning the appropriate color profile to your images. The sRGB profile is typically used for on-screen applications, with the Adobe RGB (1998) profile used for printing. Let's learn to how to assign a color setting for the Editor and how to apply a color profile to an image.

3.11.1 Monitor Calibration

Applying color management will help us to enjoy prints that match our hard work in the Editor. We will apply color management settings to the Editor, learn to assign a color profile, and find out how to apply the appropriate printer profile for output,

so that what we view on our monitor screen will match our prints. It is typically recommended to calibrate your monitor first. A variety of third party calibration products are available, along with a few free downloadable calibration options. However, let's learn the color management steps within the Editor first. Afterward, if your print output still does not satisfactorily match your monitor screen, you should try using calibration to help.

3.11.2 Setting Up Color Management

To assign our color management, we will choose Edit>Color Settings to open the Color Settings dialog box. The color setting Always Optimize Colors for Computer Screens utilizes sRGB as the RGB working color space, preserves embedded profiles, and assigns sRGB when opening a file without an embedded profile. This RGB working color space is best for on-screen viewing—not what we want. We will choose Always Optimize for Printing, then click OK to apply it as shown in Figure 3.11. This color setting uses Adobe RGB (1998) as the RGB working color space, preserves embedded profiles, and assigns Adobe RGB (1998) when opening

Figure 3.11 Assigning the Always Optimize for Printing color setting

a file without an embedded profile. This setting combined with specific printer color management settings will achieve the best color matching output.

Once we have done that, let's reopen the fjord photograph that we saved as 100_1653_edited.psd (or 100_1653_edited-1.psd). We have assigned the color settings for the Editor; however, we will need to be sure that whenever we open a file we want to print that it also has the Adobe RGB (1998) color profile assigned to it. Let's choose Image>Convert Color Profile. Here we can see from the submenu that opens that this

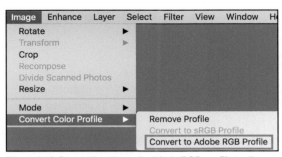

Figure 3.12 Converting the embedded sRGB profile to the Adobe RGB (1998) Profile.

image currently has the sRGB color profile embedded, so we will choose Convert to Adobe RGB Profile as shown in Figure 3.12 to assign it. If our image was already Adobe RGB, the option to Convert to sRGB Profile would be available instead; we will always want our files to have the Adobe RGB (1998) profile assigned for print color management. Once we have assigned this profile, before learning to print the file, let's choose File>Save.

3.12 Printing Basics

Creating and printing contact sheets and picture packages will be explored in Chapter Eleven. At this time, let's learn how to assign color management settings to our printer and then print a single image file with these settings applied.

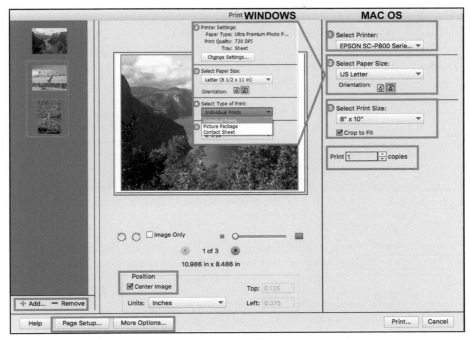

Figure 3.13 Initial print dialog box that opens when the File>Print command has been chosen.

With the Adobe RGB (1998) profile assigned, let's choose File>Print. The initial print dialog box opens, as shown in Figure 3.13, with several options we must choose before clicking the Print button. Let's apply them sequentially:

SELECT PRINTER: Assigns the printer to use. If you have multiple printers, you will want to select the one you will be using for color-managed printing.

PRINTER SETTINGS: Assigns the specific paper profile that was installed on your computer as part of the printer software installation. This feature is shown in the insert added to Figure 3.13 and is specific to Windows. (In Mac OS it is assigned under More Options detailed below.)

SELECT PAPER SIZE AND ORIENTATION: Provides a drop down menu that allows you to select a paper size from the options available for your printer. We will be printing our file at 10" × 8" therefore, we will select Letter (8½" × 11"), and Horizontal for the orientation.

SELECT TYPE OF PRINT: If working in Windows, select Individual Prints. (In Mac OS, the Picture Package and Contact Sheet features shown here for Windows are assigned from the File menu and will be explored in Chapter Eleven.)

SELECT PRINT SIZE: Provides a drop down menu for paper choices of standard sizes, actual size, or custom. We will select 8" × 10" and *uncheck* Crop to Fit. When you want an image to be cropped in order to proportionately *fill* a selected print size, check the Crop to Fit option.

PRINT: Assigns the number of copies to print; we will assign the default number of one copy.

POSITION: Positions the image in the center of the assigned paper size by default. If we were printing a small photograph (e.g., Width: 4" × Height: 6") on a sheet of paper 8.½" × 11", we could uncheck this option to reuse paper and minimize waste.

ADD/REMOVE: Buttons allowing us to choose what images we want to print that are currently open in the Editor. We will select _DSC2670.jpg and 100_1907.jpg and then click the Remove button.

PAGE SETUP: Here is where the settings specific to your selected printer will display. The important option to turn off Color Management will be found here. For our colors to print as we want them to, we must have the Editor manage color, not our printer. In Windows, the Mode category will provide the option to select Off (No Color Adjustment). In Mac OS, under Printer Settings, Color Mode will be available to select No Color Management. (The exact wording and location for turning off printer color management varies between printers and models. If you are unable to locate it for your printer, refer to your printer's instruction manual.)

MORE OPTIONS: Opens a dialog box with more advanced color options: Printing Choices, Custom Print Size, and Color Management with its features shown in Figure 3.14.

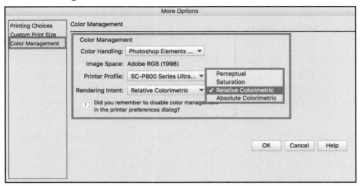

Figure 3.14 Color Management settings provided in the More Options print dialog box.

PRINTING CHOICES: Options such as printing in reverse for T-Shirts and adding Crop Marks are available; we will not make any assignments here.

CUSTOM PRINT SIZE: Displays our current print size and allows us to select Scale to Fit Media to scale down proportionately an image that is larger than our assigned paper size.

COLOR MANAGEMENT: Here we must make critical choices for our prints to match our monitors. We will examine and assign each one of its options individually (also shown in Figure 3.14):

COLOR HANDLING: This critical choice works along with our setting to turn off Color Management by our printer. Here we must select Photoshop Elements to color handle the file.

IMAGE SPACE: If you have forgotten to convert the color profile from sRGB to Adobe RGB (1998), you will see sRGB listed here. If that happens, close the print dialog box, choose Image>Convert Color Profile>Convert to Adobe RGB Profile as shown in Figure 3.12, then return to the print dialog box. Adobe RGB (1998) will now be listed under the Image Space section.

PRINTER PROFILE: This drop down menu will display every paper profile that your printer has; select the specific paper that you plan to print on from the list.

RENDERING INTENT: This term refers to the fact that different devices have different "color ranges" and to how we want the Editor to handle the conversions, with four methods to choose from: Perceptual, Saturation, Relative Colorimetric, and Absolute Colorimetric. The default choice of Relative Colorimetric is usually always good.

PRINTER PREFERENCES: This feature is available only in Windows, and opens the same dialog box that opens when Page Setup is selected from the initial print dialog box.

With these settings applied, we will click OK, return to the initial print dialog box, and click Print to produce our first color-managed print.

PRACTICE MAKES *PERFECT*✔

Before we continue to advance our learning by exploring the basics of the Expert mode, feel free to complete the following projects to further reinforce your new Chapter Three skills.

PRACTICE PROJECT 1

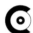

1. Open the cave photograph (100_1907.jpg) located in the Practice_Import 10 files folder within the Practice Files folder you copied to your hard drive and then choose File>Save As. In the dialog box that opens, give the image a new name ("Cave"), then choose Photoshop for the Format.

2. Select your options under the Organize category. Notice that the file currently has the sRGB color profile, then click the Save button.

3. From the Image menu, select Convert Color Profile then Convert to Adobe RGB Profile.

4. From the View drop down menu, select to display the Before & After—Horizontal view option, then choose Fit on Screen.

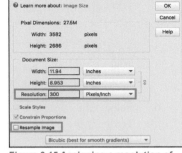

5. Choose Image>Resize>Image Size and with Resample Image unchecked, assign a resolution of 300 ppi as shown in Figure 3.15.

6. Select the Lighting option in the Adjustments panel. Click the Shadows tab and then assign 25 as shown in Figure 3.16.

Figure 3.15 Assigning a resolution of 300 ppi to the cave photograph.

7. Select the Color option in the Adjustments panel. Click the Saturation tab and then assign –25 as also shown in Figure 3.16.

8. Select the Sharpen option in the Adjustments panel and then assign 125 as also shown in Figure 3.16.

9. Save the changes to the photograph, then close the file for now. We will learn to crop and straighten this image in Chapter Six.

Figure 3.16 Assigning a Lighting, Color, and Sharpen adjustment to the Cave.psd file.

PRACTICE PROJECT 2

1. Open the _DSC2670.jpg file located in the Practice_Import 10 files folder within the Practice Files folder you copied to your hard drive, and then choose File>Save As. In the Save As dialog box, name the image "Blue Heron" and choose Photoshop for the Format.

2. Select your options under the Organize category. Notice that the file currently has the sRGB color profile, then click the Save button.

3. From the Image menu, select Convert Color Profile, then Convert to Adobe RGB Profile.

4. From the View drop down menu, select to display the Before & After— Horizontal view option.

5. Choose Image>Resize>Image Size and with Resample Image unchecked, assign a resolution of 300 ppi. This will convert the Document Size to Width: 10.88" × Height: 16.427".

6. Select the Balance option in the Adjustments panel then click the Temperature tab and assign 42.

7. Zoom in to the area of the heron's neck as shown in Figure 3.17.

8. Once magnified to clearly view his neck feathers, assign Sharpen 300.

9. Choose File>Save, then close the file. We will learn to apply the Rule of Thirds to create an artistic crop of this photograph in Chapter Six.

Figure 3.17 Applying the Sharpen option in the Adjustments panel.

4

Basics
of
the
Expert
Mode

In This Chapter

- Explore the Expert workspace and customize it for efficiency
- Learn to create precise selections
- Master working with multilayered files
- Combine selections and layers to create composite images

After a thorough exploration of the workspace available in the Expert mode, we will become proficient in a variety of methods of selection, using them in both singular and integrated ways for professional results. We will also work with layers, learning to create, organize, and manipulate them, and more.

4.1 Workspace Fundamentals

Let's begin our work in the Expert edit mode (hereafter referred to as the Expert mode) by mastering its fundamentals. If you are not currently in the Expert mode, click the tab to enter it. Feel free to open the photograph named Expert Workspace. jpg located in the Practice_Import 11 files folder within the Practice Files folder you copied to your hard drive, or any photograph of your own if you would like. Let's examine the workspace fundamentals outlined in Figure 4.1.

Figure 4.1 Basics of the Expert workspace.

A copy of each figure shown in this chapter can be viewed in the companion files included with this book.

> **TOOLS PANEL:** Provides tools divided into six sections: View, Select, Enhance, Draw, Modify, and Color. As we can see, its View tools are identical to those we have mastered within the Quick mode. In this chapter we will continue to use the View tools along with a comprehensive application of the Select tools.

> **FILE NAME:** Displays along with the current view size percentage, color mode, and bit depth (RGB/8) in the dock area above the Edit pane. When a file contains an asterisk *within* the RGB/8 parentheses, it warns that the color profile does not match the Editor Color Settings assigned. If an asterisk appears *outside* the parentheses, it indicates that the file has not yet been saved or an edit has been made since the last save was performed.

STATUS BAR: Displays the same view percentage shown above the Edit pane along with the document size. The size is identified with two file sizes listed with a slash between them (Doc: 42.2M/42.2M), which, for our current open file, are identical. We will learn when and how these numbers can change independently later in this chapter. If the arrow to the right of the document size is pressed, alternative information can be chosen to display as shown in Figure 4.1. Document Sizes is the default; we will choose to keep it selected.

TASKBAR: Provides buttons to access common panels used in the Expert mode: Layers, Effects, Filters, Styles, Graphics, and More. The ones we will work with in this chapter are Layers, More>History, More>Navigator, and More>Custom Workspace.

TOOL OPTIONS BAR: When active, a drop down menu appears at the right side of it with three choices: Reset Tool, Reset All Tools, and Auto Show Tool Options. As we can see in Figure 4.1, Auto Show Tool Options is selected by default. This assures that when a tool is selected in the Tools panel, its available options will automatically be displayed in the Tool Options bar. We will always want this option selected. When a tool setting is changed, the setting becomes the new default setting for the tool. The Reset Tool option will reset the settings of a specific tool. Choosing Reset All Tools will reset all tools back to the Editor default settings. If you select Reset All Tools, a dialog box will open to confirm the request.

NOTE In addition to resetting all tools, *all* of the Editor preferences including preferences for the number of Recently Edited Files, saving options, etc. can be reset by choosing Edit>Preferences>General in Windows or Adobe Photoshop Elements Editor>Preferences>General in Mac OS, then choosing Reset Preferences on next launch, or by holding down three keys simultaneously: Control, Alt, and Shift in Windows or Command, Option, and Shift in Mac OS when launching the program. A confirmation dialog box will open: if one does not, finish launching the program, quit the application, and try again. Sometimes if a tool or command does not seem to be performing as expected, resetting all preferences can help.

4.1.1 Rulers and Guides

Guides can help align content especially when combining images together. Let's learn how to show rulers, change the ruler origin, add guides, snap to them, lock them, and delete them.

4.1.1.1 Rulers and Assigning a Unit of Measurement

To use guides, the rulers must be made visible first by choosing View>Rulers. A horizontal ruler will be displayed above the Edit pane, with a vertical ruler displayed to the left of it. The unit of measurement will be in inches by default but can be changed to Pixels, Centimeters, Millimeters, Points, Picas, or Percent by choosing Edit>Preferences>Units & Rulers in Windows or Adobe Photoshop Elements Editor>Preferences>Units & Rulers in Mac OS.

The unit of measurement can also be changed by Right/Control clicking inside one of the rulers and selecting a different unit of measurement or by double clicking inside one of the rulers to open the Units & Rulers category of the Preferences dialog box.

The ruler increments extend down and to the right from the top left corner. The square between the two rulers is referred to as the ruler origin. When this square is pressed and dragged, the ruler origin can be moved. To return it to the top left corner, double click in the original ruler origin square area again.

4.1.1.2 Adding Guides, Moving Guides, Hiding Guides, Locking Guides, Deleting Guides, and Snap To Guides

Once the rulers have been made visible, guides can be added by pressing and dragging, starting from within one of the rulers and releasing when the desired location is shown in the opposite ruler. Once a guide has been added, it can be moved using the Move tool. The Move tool is identified by four arrows plus a larger arrow and is located in the Select section of the Tools panel. When the Move tool is over a guide, its icon changes to two arrows and two lines to drag the guide. (The Move tool is also used to move layer content, which we will learn to do later in this chapter.) The default guide color of Cyan can be changed by choosing Edit>Preferences>Guides & Grid in Windows or Adobe Photoshop Elements Editor>Preferences>Guides & Grid in Mac OS. Guides which have been added to an image, can be temporarily hidden by choosing View>Guides to uncheck them. This command toggles off and on; choose View>Guides again to make them visible. The additional options of Lock Guides, Clear Guides, and New Guide, which provides a text field to add a guide at a specific vertical or horizontal measurement location, are also available under the View menu.

The View>Snap To options, which are checked by default, are usually helpful. Occasionally you may need to align content when Snap To causes the content to "jump" over your desired destination. When that happens, temporarily disabling the Snap To feature for Guides, Layers, or Document Bounds will solve the problem; to disable it, uncheck the desired option from the View menu. However, overall, the Snap To feature is great; don't forget to enable it again once your content has been moved as desired.

4.1.2 Customizing Your Workspace

As shown in Figure 4.1, key panels display as buttons in the Taskbar by default in the

Figure 4.2 Selecting Custom Workspace from the More down arrow menu.

Expert mode. Three panels we will want to use typically in our expert work will be the Layers panel, the History panel, and the Navigator panel. Let's single click the Layers button to display the Layers panel in the Panel Bin that appears to the right of the Edit pane. Once we have done that, from the More down arrow menu in the Taskbar, we will select Custom Workspace as shown in Figure 4.2 which will allow us to modify which panels appear as tabs in the Panel Bin based on our workflow.

The rest of the panels which were accessible as buttons in the Taskbar have become tabbed together with the Layers panel; the Panel Bin can now be customized by adding new panels to it or removing existing ones from it.

4.1.2.1 Creating a Custom Panel Group

We have chosen Custom Workspace because we can make it our own. Using the pointer, press and drag on the Effects tab and drag it down and to the left; it becomes a floating panel by itself. Now select the Filters, Styles, and Graphics tabs one at a time and drag them down and to the left to also remove them from the Panel Bin. We will click the "X" provided to close/hide all of these floating panels, as we will not be using them at this time.

NOTE Any panel that is removed from the Panel Bin when Custom Workspace has been selected is always accessible from the Window menu.

Now we can create a custom panel group of the three panels we will use most commonly in the Expert mode. From the More down arrow menu, or from the Window menu, select Navigator. The Navigator panel becomes visible, tabbed together with additional panels. We will press and drag on the word "Navigator" to separate it from the panels it is grouped with. Now as a single floating panel, drag it up and release it to the right

of the word "Layers" in the Panel Bin. The border of the Layers panel will turn blue, and the Navigator panel will become grouped with it. Now let's select History from the More down arrow menu or from the Window menu, or from the group of panels that opened when we selected the Navigator panel, separate it from the additional panels it is grouped with, then drag it up and release it to the right of the

Figure 4.3 Creating a custom workspace panel group.

Navigator tab in the Panel Bin. The border around the grouped Layers and Navigator panels turns blue to indicate the additional inclusion of the History panel, and our custom workspace group has been created as shown in Figure 4.3. We can now close the group of panels that the Navigator and History panels were originally part of by clicking the "X" provided in the corner, then single click the name of one of the panels in our custom group to access it.

When more editing area (often described as "screen real estate") is needed, the panel bin can be temporarily hidden at any time by choosing Window>Panel Bin. Choose Window>Panel Bin again to return its visibility to the workspace.

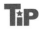

4.2 Using the Navigator and History Panels

Now that we have created a custom workspace, let's learn why we wanted to group the Navigator and History panels together (we will work with the Layers panel extensively later in this chapter).

4.2.1 The Navigator Panel

We have learned a variety of ways to magnify in to an area of a photograph—all valuable. However the Navigator offers another way to zoom in and move around an image at the same time. When you have zoomed in to a high magnification (you can zoom up to 3200%), it can sometimes be hard to tell what part of the image you are actually looking at. The Navigator provides a red square that identifies the area you are viewing in the Edit pane, along with the ability to press and drag within the square to move around at your chosen magnification. The Zoom slider provided can be dragged to the right to zoom in or left to zoom out, or the minus and plus signs provided can be single clicked to zoom out or in, respectively, by the same preset increments we learned in Chapter Three.

Figure 4.4 Using the Navigator panel.

4.2.2 The History Panel

The History panel records our work and allows us to reverse our edits to a previous "state" or stage of our work if desired. The number of states we can reverse back to is set to 50 by default; however, the number of history states can be changed in the preferences by choosing Edit>Preferences>Performance in Windows or Adobe Photoshop Elements Editor>Preferences>Performance in Mac OS. Once the

Performance category of the Preferences dialog box is opened, the History States text field number can be changed to up to 1000 states; however, because history states require RAM to hold the content for us, a good number of history states to assign is 200.

Figure 4.5 History panel with states.

So now that we know how to assign a number of history states, why use the History panel? Let's perform a few actions to our open image to understand how valuable the History panel will be for you as an expert.

Let's choose to show rulers (View>Rulers) then drag two vertical and two horizontal guides onto the image (add them anywhere). Now let's click the Rotate button in the Taskbar a couple of times. Once we have done that, our History panel should match the sample in Figure 4.5.

Let's click on the words New Guide *directly below* the word Open. What we have done is reverted back to the "state" where we added our first guide to the image. We can see that everything we did after that disappears in the Edit pane. However, the rest of the states remain visible in the History panel; they are just currently grayed out. By being grayed out, we can click on any state to return to it, such as the first Rotate. However, as soon as we do, if we decide to make a change such as to drag in another guide, all states added *after* the state we selected will be removed (in this example, the second rotation).

NOTE History states are available to revert to only while an image is open. If an image is closed and reopened, the History panel's opening state will reflect the last saved version of the file. Additionally, history states are memory intensive for the Editor. You can free up memory if needed by choosing Edit>Clear>Clear History; however, the opening state will become the last state you were at before choosing this command. An alternative if memory is an issue, is to change the number of history states in the preferences dialog box to a lower number.

4.3 Layout Options

The Layout button in the Taskbar allows us to choose how we want to view multiple open files when working in Expert mode. If we press on it, currently all of its options are grayed out, because we have only one image open. Let's close this photograph, choose to not save any changes when prompted, and open two new files to explore layout options and begin our learning of selection.

Let's open the file named House.jpg and the one named Lasso Practice.jpg both in the Practice_Import 11 files folder located within the Practice Files folder you copied to your hard drive.

With these two images open, now when we press the Layout button the options shown in Figure 4.6 become available.

Figure 4.6 Layout options in Expert mode.

The default view tabs the open images; with the two files open, when we click the house image's tab, it becomes visible, and when we click the name of the Lasso Practice file, it toggles to become the visible image instead. Alternatively, if the Photo Bin button is clicked in the Taskbar, we can use it to select viewing any open file. However both of these options allow us to view only one image at a time. By selecting a choice of All Row or All Column, for example, from the Layout options, we can view and work with multiple open images simultaneously.

4.3.1 Assigning the All Floating Layout Option

When we view the Layout options, we can see that even though we have multiple documents open, the All Floating option is still grayed out. This option allows files to be dragged away from the dock above the Edit pane and moved freely around the workspace, but it must be assigned in the preferences by choosing Edit>Preferences>General in Windows or Adobe Photoshop Elements Editor>Preferences>General in Mac OS, then selecting Allow Floating Documents in Expert Mode. To return a floating image back to the dock, press and drag on its name tab and drag it back up to the top edge of the Edit pane. When a blue line appears, release the pointer and the image will be added back to the dock. If you prefer this work environment, you can apply it now, or if you try it and prefer to not have the files float, simply return to the preference and uncheck it.

We will keep both images open but click the tab of the house photograph to make it the active image in the dock to begin our work with selection.

 When working on an editing project, you can keep the original file open as well as your renamed edited file, then choose Layout>All Column to view your before and after files simultaneously, providing the same effect as the View>Before & After—Horizontal option provided in the Quick and Guided modes.

4.4 Selection Methods of the Editor

To understand why there are so many selection tools and selection options and why it is critical to learn them all, we need to understand what selection is used for. Selection allows us to isolate an area to affect rather than affecting an entire image. When we were applying color corrections in Chapter Three, they applied globally to the images. But what if we only needed to adjust the shadows of a small area of a photograph instead of the entire image? Or what if we wanted to bring only a small area of content from one image into another? These are just two of the many reasons why accurate selection, and learning the most efficient way to achieve it, is paramount for an expert.

Let's explore the Rectangular and Elliptical Marquee tools, the Lasso tools, the Quick Selection tool, Magic Wand tool, Selection Brush tool, Refine Selection Brush tool, the Auto Selection tool, and the Refine Edge dialog box, beginning with the Rectangular and Elliptical Marquee tools. When creating selections, we will also learn to apply anti-alias and/or feathers to them, transform them, and save them for future use. While some of these selection tools are accessible within the Quick mode and used with some of the projects in Guided mode, they are all available in the Expert mode. By mastering them in the Expert mode, we will be able to make professional selections in all modes.

4.4.1 Rectangular and Elliptical Marquee Tools

Let's save the house photograph as House Selection.psd. Once we have done that, we will select the Rectangular Marquee tool. When we press and drag diagonally down across the image, a rectangle appears as a moving dotted outline originating from its upper left corner by default. The area within this rectangle becomes our "change" area; the area outside of our selection is unaffected. When we hold the Shift key down while dragging we can constrain the selection drawn to a perfect square, but note we must release the mouse *before* the Shift key. Instead of drawing upper left to lower right, we can draw from the center by holding down the Alt/Option key while dragging, but we must again release the mouse *before* the Alt/Option key to complete the selection from the center outward. We can also combine these two alternatives: by holding down both the Shift key and the Alt/Option key simultaneously while drawing, we will be creating a perfect square, drawn from the center outward, again releasing the mouse before the Shift and Alt/Option keys.

You may have noticed that each time you draw a new marquee selection, the previous one is deleted. To deselect a selection without drawing another one, choose Select>Deselect.

To deselect a selection without choosing Select>Deselect, with the Control/Command key held down, press the letter "D" key or Right/Control click inside the selected area and choose Deselect from the context-sensitive menu that appears.

When we look at the Tool Options bar when the Rectangular Marquee tool is active, selection alternatives unique to the Rectangular Marquee tool appear here, along with some options that are available with all of the selection tools. Let's examine them, as outlined in Figure 4.7:

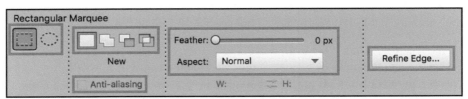

Figure 4.7 Options of the Marquee tools.

ELLIPTICAL MARQUEE TOOL: With a single click we can switch to the Elliptical Marquee tool which draws ovals, or with the Shift key held down draws circles, and also create ovals drawn from the center outward by holding down the Alt/Option key while drawing, or circles from the center by holding down both the Shift and Alt/Option keys when drawing.

SELECTION OPTIONS: Four box icons to the right of the Elliptical Marquee tool icon represent ways to affect the selection drawn: New Selection, Add to Selection, Subtract from Selection, and Intersect with Selection. The two most common alternatives to creating a new selection are adding to and subtracting from an existing selection. A more efficient expert way to add to an existing selection is to hold down the Shift key when drawing to add to it or hold down the Alt/Option key when drawing to subtract from it. If you have an active selection and press the Shift or Alt/Option key, you will see that the Editor automatically switches to the desired selection alternative in the Tool Options bar.

ANTI-ALIASING: Available for elliptical selections and will be discussed along with Feather in the next section.

FEATHER: Can be assigned here prior to drawing a selection and will be discussed along with Anti-Aliasing in the next section.

ASPECT: Provides crop options for a rectangular selection, which will be covered in Chapter Six.

REFINE EDGE: Allows us to tweak an existing selection made with any selection tool and is particularly beneficial for selecting fine details like hair and fur, which we will work with later in this chapter.

4.4.2 Anti-Alias Versus Feather

As we have learned, digital images are composed of pixels, "boxes" of color in a grid. If a square or rectangular selection is drawn, it will follow the grid. Perfect. However any other shape selection must include "stair step" transition from one box of the grid to the next. Applying anti-alias and optionally an additional small feather radius removes this stair step appearance when curved selections are required.

Assigning anti-alias creates transition pixels along the edge of a selection, eliminating the grid appearance without blurring the edges or compromising its accuracy. A feather softens the edge of a selection by transitioning the edge pixels to transparency by blurring them (like a mini gradient) based on the pixel radius setting assigned.

Figure 4.8 includes three selections of the background content of a tomato photograph: with anti-alias off, with anti-alias on, and with anti-alias plus a feather with Radius: 1 px assigned. In our work, we will always want anti-alias assigned (it will be checked by default), and we will apply a small feather to our selections to soften their transition when applying a change.

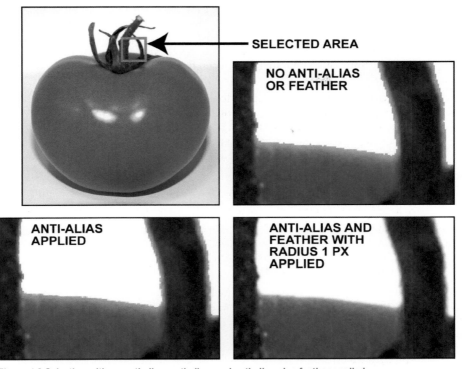

Figure 4.8 Selection with no anti-alias, anti-alias, and anti-alias plus feather applied.

4.4.3 Transforming a Selection

If we wanted to create a selection of content in an image using any selection tool, after the initial selection has been made and while it is still active, we can choose Select>Transform Selection. Bounding box handles will appear around the selection that can be dragged to reshape the selection, with a green check mark provided to complete the transformation and a cancel icon we can click to nullify it.

4.4.3.1 Transforming Individual Corner Handles of a Selection

In addition to changing the width and height of a selection by choosing Select>Transform Selection, any selection can be further customized when it has bounding box handles around it, by holding down the Control/Command key while dragging one of its corner handles. Let's learn how this can be helpful by drawing a rectangle to enclose the roof of the house as shown in Figure 4.9. Once we have done that, we will choose Select>Transform Selection, then hold down the Control/Command key and while it is held down, drag each corner selection handle, one at a time, to align with the respective corners of the roof as also shown in Figure 4.9, then click the green check mark to complete the transformation.

ORIGINAL RECTANGULAR SELECTION

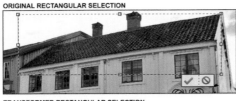

TRANSFORMED RECTANGULAR SELECTION

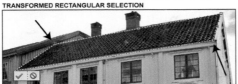

Figure 4.9 Drawing a rectangular marquee and then transforming it.

Our selection has been created, but what about assigning a feather radius? If a feather is assigned in the Tool Options bar prior to applying the tool, the setting amount will become the default setting every time the tool is used, until the tool settings are reset. Rather than change the default, we will always choose to apply one *after* a selection has been made. Let's choose Select>Feather, and then in the dialog box that opens assign 1 in the Feather Radius pixels text field.

 With any active selection you can Right/Control click inside of it and choose Feather from the context-sensitive menu that appears.

4.4.4 Saving a Selection

We will want to keep this selection, as we will learn to change the color of the roof of the house in Chapter Five. Even if we chose to stop and save the house file now, the selection would not be saved; we must save the *selection* as well as saving the file. Let's choose Select>Save Selection.

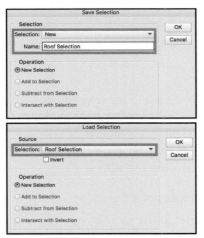

Figure 4.10 Saving and loading a selection.

Once we do that, the Save Selection dialog box shown in Figure 4.10 opens. Here we will assign a description for the selection as "Roof Selection" in the Name field, then click OK to save the selection.

We can now deselect the selection. Let's choose File>Save to have our saved selection also be saved with the file. If we later decide at any time to add or subtract from our saved selection, we can choose Select>Load Selection, select the named selection we want to edit (multiple selections can be saved with a single file), make the changes, and then when we choose Select>Save Selection, and then select Roof Selection from the Selection menu, Replace Selection will be available instead of New Selection, allowing us to update the changes as also shown in Figure 4.10.

To delete a selection, we can choose Select>Delete Selection, then select the specific selection we want to delete from the Selection menu. Because deleting selections reduces file size, best practice is to always delete a selection once it is no longer needed. However, we will keep the selection saved with this file, as we will use it in

Chapter Five. For now, we will choose to close the House Selection.psd file, and save the changes when prompted.

NOTE▶ When selections are saved with a file, or layers are added to it, the document size of an image is increased. When we compare the two document sizes now in the Status bar, one of the numbers has changed: Doc: 28.6M/32.1M. The larger number on the right reflects the file with the saved selection; the size on the left reflects the size of the file if the selection is deleted. Additionally, selections can only be saved in native .psd or .tiff files. If a file with a saved selection is later saved as a .jpg file, the saved selection will not be saved with it.

4.4.5 Creating Selections With the Lasso Tools

When the Lasso tool is selected in the Tools panel, the Tool Options bar provides three lasso tools to choose from: Lasso tool, Polygonal Lasso tool, and Magnetic Lasso tool. These tools all draw freeform selections. Let's explore them now.

The Lasso Practice.jpg file should still be open after saving and closing the house image. Let's save it now as Lasso Selection.psd.

4.4.5.1 Using the Lasso Tool

When we select the Lasso tool, it works like a pencil: we simply trace around the area we want selected. Let's trace around the arched doorway on the right. When drawing with this tool, if you release the mouse before completing the selection, it will automatically be completed with the moving dotted outline returning to the beginning using the shortest distance. As we can see, accuracy can be difficult. However, all of the Editor selection tools can be combined as needed; a selection can be started with one tool and refined with another. Let's make the best selection we can right now using the Lasso tool (without spending a lot of time), as shown in Figure 4.11. We will finish refining this selection later, so we will not add a feather radius to it now. Let's choose Select>Save Selection and name the selection "Doorway."

Figure 4.11 Selection of the doorway using the Lasso tool.

4.4.5.2 Using the Polygonal Lasso Tool

Let's select the Polygonal Lasso now from the Tool Options bar. This tool is very effective for selecting straight-sided freeform shapes. It works like a piece of string; instead of pressing and dragging to draw a selection as we did with the Lasso tool, the Polygonal tool works by assigning points of change. After an initial click on the edge of the area we want to select, without dragging the mouse, the next point of change desired is single clicked. At each point of desired change, a single click is made. When we return to the beginning, a small circle will appear, indicating that

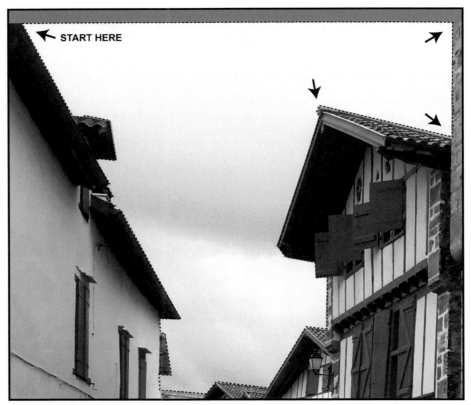

Figure 4.12 Selecting with the Polygonal Lasso tool.

when we again single click, the selection will be closed and completed. If we return to the beginning and a small circle does not appear, we can double click to close and complete the selection. Figure 4.12 details a suggested starting point (you can start anywhere) and a few initial arrows to indicate how each corner requires a click to assign a turning point. It will be helpful to magnify in as large as possible but still be able to see all of the sky prior to beginning to select it (using the Navigator can help).

NOTE▶ The amount of feather radius to apply to an image is based on three factors: resolution, size of the area, and future application of the resulting selection. A low resolution image will require a smaller feather radius compared to the same size selection in a high resolution image. Deciding on the amount of feather radius also is relative to the physical size of the selection. A very small area will have to have Radius: 1 px, even 2 can sometimes make the selection disappear. Future application of the resulting selection should also be considered. If you will be blending foliage such as grass into another photograph with similar content, a larger feather will work best, allowing the "gradient" effect of the feather to fade into the destination area around the imported selection. A good rule of thumb is to apply a feather with a radius between 1 and 5 pixels, based on the factors of resolution, size, and future application. Because detail is lost at the edge of a feather, always set the minimum needed. In your own work, study the results of applying different feather radius amounts; you'll be an expert at determining an appropriate feather radius amount in no time.

Once we have completed our selection, we will assign a feather with Radius: 1 px (Select>Feather), save the selection as "Sky" (Select>Save Selection) then choose File>Save, and close the file for now.

4.4.5.3 Combining the Lasso Tool With the Polygonal Lasso Tool

Within the same selection, you can toggle between the Lasso tool and the Polygonal Lasso tool when a selection requires both curves and straight segments.

Let's open the image named Vegetables for Lasso Practice.jpg located in the Practice_Import 11 files folder inside the Practice Files folder you copied to your hard drive.

The Lasso and Polygonal Lasso tools can be alternated while being applied by holding down the Alt/Option key; if we start with the Lasso tool, holding down the Alt/Option key will toggle the tool to the Polygonal Lasso tool and vice versa. Let's select the Polygonal Lasso tool and begin to trace the knife starting with its tip, moving down the back of the blade, then down the handle. When we reach the end of the handle, if we hold down the Alt/Option key we will be temporarily converted to the Lasso tool for as long as the Alt/Option key is held down to trace the curved edges and return to the tip of the knife to complete its selection.

Let's deselect the knife, and instead select one of the cut pieces of celery. We can begin to trace around it with the Lasso tool, and when we reach the straight side of the piece, hold the Alt/Option key to temporarily convert to the Polygonal Lasso, click to complete the straight side, then release the Alt/Option key to return to the Lasso tool to complete the selection. These selections are both shown in Figure 4.13.

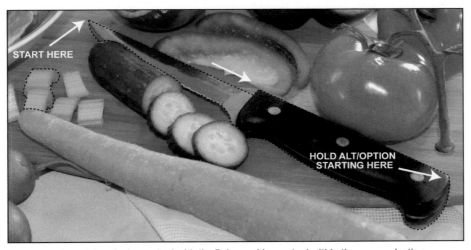

Figure 4.13 Combining the Lasso tool with the Polygonal Lasso tool within the same selection.

4.4.5.4 *Using the Magnetic Lasso Tool*

The Magnetic Lasso tool helps us select by "clinging" to the edge of a selection and trying to follow it. It is controlled by edge contrast, which, when enough is present, can be an easy and accurate method of selection. When the tool is selected, it provides three settings: Width, Contrast, and Frequency. The default settings of Width: 10, Contrast: 10, and Frequency: 57 are a great place to start. Width refers to the distance away from an edge we want the tool to search, Contrast defines how strong a contrast we want the tool to use for determining the selection (a low number is good), and Frequency determines how often we want it to define an edge with a selection point.

Let's first magnify in to a view of just the cut pepper. Always working in an enlarged view for all selection work will help to ensure accuracy. We will begin by single clicking the tool on the left side of the cut pepper where it intersects with the cutting board. Once we have done that, we must release the mouse, then slowly guide the Magnetic Lasso icon along the edge of the pepper, and watch it add selection points based on our default settings. It can be amazingly accurate; however, it is not perfect. The photograph must contain enough contrast for the tool to be able to identify the edges of the content we want to select. Even when there is enough,

Figure 4.14 Selecting the pepper using the Magnetic Lasso tool.

sometimes a point is added where it is not wanted. When that happens, immediately click the Backspace/Delete key and it will be removed (you must do this prior to continuing the selection). Alternatively, if a point is not added where one is needed, single click to add a point (again, you must do this prior to continuing the selection). When we return to the starting point, a small circle will appear allowing us to single click to complete the selection. Figure 4.14 illustrates applying points with the Magnetic Lasso tool to select the pepper. When you have completed the selection, feel free to practice selecting other content in this image, then close the file without saving any changes.

4.4.6 Using the Quick Selection Tool

To the right of the Lasso tool in the Tools panel is the Quick Selection tool. When we select it, we can see in the Tool Options bar that it is one of five selection tools. These tools are grouped together; however, each one creates selections differently and will be covered individually.

The Quick Selection tool creates a selection based on edge detection variances in color and texture. Let's open the file Sunflower for Quick Selection.jpg located in the Practice_Import 11 files folder inside the Practice Files folder you copied to your

hard drive, then choose File>Save As and rename it Flower Selection.psd. We will enhance this image by changing its background. It will be helpful in your own work to assign names to your files relative to their future application.

To change its background, we need to isolate the flower from it. Because of the colors of the flower versus the siding on the building behind it, the Quick Selection tool will work well for this. When the tool is chosen, its options become available in the Tool Options bar as shown in Figure 4.15:

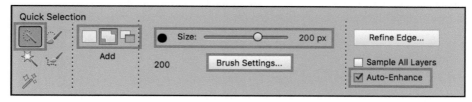

Figure 4.15 Options for the Quick Selection tool.

QUICK SELECTION TOOL: Grouped with the Magic Wand tool, the Selection Brush tool, the Auto Selection tool, and the Refine Selection Brush tool.

SELECTION OPTIONS: Icons are provided to create a new selection or add or delete from a selection. We will choose instead to use the Shift key to add and the Alt/Option key to delete from our selections.

SIZE: Provides a slider to assign a brush size or type a size in the size field; let's assign 200 px for a size. In your own work, a brush size large enough to affect areas quickly without going outside the bounds of the area you want to select will work well. The Brush Settings button can be clicked to open a dialog box to customize the hardness, spacing, and roundness, or assign pen pressure settings if using a tablet; we will keep the default settings.

AUTO-ENHANCE: Helps to improve the accuracy of the selection drawn. (Refine Edge will be covered later in this chapter, with Sample All Layers covered in Chapter Six).

Let's press inside the flower and drag diagonally, slowly zigzagging down from the top right corner of the flower to the lower left corner; the entire flower becomes selected except for the small green leaves.

NOTE▶ All of the selection tools available in the Editor, whether they are part of the Quick Selection tool group, the Marquee group, or the Lasso group, can be combined together or interchanged to improve a selection by selecting the alternate tool, then holding the Shift key to add or the Alt/Option key to delete from any selection created by any other selection tool.

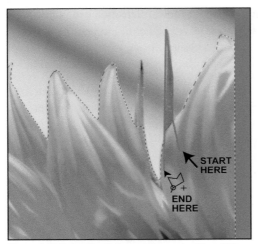

Figure 4.16 Using the Polygonal Lasso tool to add to a selection made with the Quick Selection tool.

To add the green leaves to our selection, let's switch to the Polygonal Lasso tool. To add each leaf with the Polygonal Lasso tool, press the Shift key when you single click *inside* the flower to start, then release the Shift key, trace around the leaf, then double click to end the use of the Polygonal Lasso tool once we have returned back *inside* the flower as shown in Figure 4.16.

4.4.7 Contracting or Expanding a Selection

Sometimes a slight "halo" will appear around the selection when part of one photograph is added to another photograph. We can eliminate this by contracting or expanding the selection by a few pixels (lower file resolution, lower modification number). If we were selecting the background instead of the flower, we would

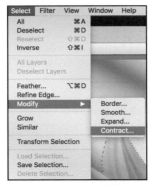

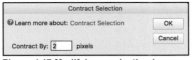

Figure 4.17 Modifying a selection by assigning Select>Modify>Contract.

expand our selection. Because we have chosen to select the flower instead of the background, we will want to contract our selection. Let's choose Select>Modify>Contract and then assign Contract By: 2 pixels as shown in Figure 4.17.

Now that we have isolated the flower with a professional selection and have contracted our selection, let's assign a small feather with Radius: 2 px (Select>Feather). One last important step is to save this selection for use later in this chapter. Let's save the selection as "Flower" (Select>Save Selection). Once we have done that, we can deselect our selection, then save and close this file for now.

4.4.8 Using the Magic Wand Selection Tool

When the Magic Wand is selected in the Tool Options bar, we will see that it contains familiar icons for adding and subtracting from a selection, but it also contains a slider used to assign the sensitivity of the selection. The Magic Wand tool selects by color range assigned as Tolerance. The default setting of 32 allows adjacent pixels

to be 32 pixels different in color from the one chosen and still be included within the selection. Many times this default setting works well. Just as with the Quick Selection tool, we will cover Sample All Layers later in Chapter Six. Note that contiguity is required; the colors being selected must be touching to be included in the selection. Also, remember that we always want anti-aliasing applied.

Let's open the file named Magic Wand Selection.jpg located in the Practice_Import 11 files folder inside the Practice Files folder you copied to your hard drive. Once we have done that, with the default setting of Tolerance: 32, let's single click with the Magic Wand tool inside the ground area; because of the similarity of the colors within it due to the time of day, the entire ground is selected with one click.

Let's deselect this selection and now single click in the sky, but not on the moon. Again with Tolerance: 32, most of the sky is selected but not all of it. Let's deselect this selection and then assign Tolerance: 50; we can drag the slider or highlight the 32 and change it to 50, then press the Enter/Return key to assign it. With the slightly higher Tolerance setting of 50, when we single click with the tool in the sky area, it is enough to include all the colors in the sky but different enough to not select the ground or the moon. Let's close this file now and not save the changes when prompted.

4.4.9 Using the Auto Selection Tool and the Selection Brush Tool

The Auto Selection tool looks for an edge to snap to. When one is clearly visible in an image, this can be a fast and easy way to create a selection. It is oftentimes not perfect but can be teamed up with one or more other selection methods to improve its precision. We will learn how to use it to make an initial selection, then refine the selection with the accuracy provided by the Selection Brush tool.

4.4.9.1 Creating a Selection With the Auto Selection Tool

When we choose the Auto Selection tool in the Tool Options bar, in addition to add and subtract options, we can see some additional familiar selection tools included here: the Marquee and the Lasso tools. The Auto Selection tool requires that an initial selection be created first to apply its magic to.

Let's open the file named Auto Selection.jpg located in the Practice_Import 11 files folder inside the Practice Files folder you copied to your hard drive, then save this file as Sculpture.psd. Let's choose to select the sculpture. To apply the Auto Selection tool, we must first trace around the area we want to select using one of the tools provided in the Tool

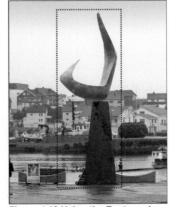

Figure 4.18 Using the Rectangular Marquee tool to draw the selection border for the Auto Selection tool.

Options bar when the Auto Selection tool is chosen. Let's choose the Rectangular Marquee tool option and draw a rectangle that fully encloses just the sculpture as shown in Figure 4.18. As soon as we complete the rectangle and release the mouse, the selection contracts to the edges of the sculpture.

4.4.9.2 Improving a Selection Using the Selection Brush Tool

We could use the Lasso tool to add to the selection of the sculpture, or in some areas improve it with the Polygonal Lasso tool or Quick Selection tool; however, let's learn how the Selection Brush tool can turn a general selection into an accurate one.

With our selection created for us using the Auto Selection tool still active, let's choose the Selection Brush tool in the Tool Options bar, with its unique options detailed in Figure 4.19.

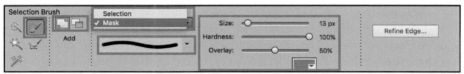

Figure 4.19 Options of the Selection Brush tool.

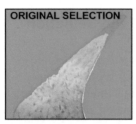

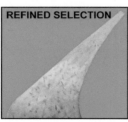

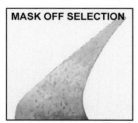

Figure 4.20 Selection refined using the Mask option of the Selection Brush tool.

In its basic Selection mode, the tool will "paint" a selection based on the style brush chosen from the drop down menu in conjunction with a size and hardness selected to paint with. However, what sets this tool apart from all of the tools we have learned thus far is its Mask alternative.

Let's press on the word "Selection" and choose Mask from the drop down menu. The area outside of our selection becomes filled with a red overlay. The opacity of this overlay can be changed; let's drag the Overlay slider to 50% or highlight the default overlay percentage and type in "50%," then press Enter/Return to apply it. This will allow us to see what is selected, but also more clearly see what is not selected. The color box below the Overlay slider allows us to click and choose a different color for the overlay. While red is great most of the time, tracing a red shirt, for example, and discerning its edges would be difficult with a red overlay; the option to select an alternative overlay color would help.

When the add icon is selected, we can paint to expand the selection. When the subtract icon is chosen instead, we can remove any part of our selection that goes beyond the area we want included in our final selection. When

needed, we can zoom in and literally paint adjustments to a selection pixel by pixel. Although this process can be time intensive, when accuracy is a must, this is one way to ensure it in your selection. Figure 4.20 illustrates part of the original selection created with the Auto Selection tool, the selection refined using the Mask option, and the result once the mask has been turned off.

Continue to refine this selection, save the selection as "Sculpture," and then save and close this file. We will work with it again in Chapter Nine.

4.4.10 Using the Select Inverse Command

Sometimes the fastest and easiest way to select content in a photograph is to select the opposite of what you want and then apply the Select>Inverse Command.

Let's open the file named Select Inverse.jpg located in the Practice_ Import 11 files folder inside the Practice Files folder you copied to your hard drive. Let's first save this file as Tonal Correction.psd; we will use the selection we make now to adjust its tonal quality in Chapter Five.

Using the Quick Selection tool, let's drag diagonally from the top right area between the rocks down to where the water is dark, as shown in Figure 4.21.

Once we have done that, let's choose Select>Inverse; everything except the area we selected becomes selected instead. Let's apply a small feather radius of 2 px, save this selection as "Rocks," then save and close the file for now.

Figure 4.21 Selection of the light area between the rock formations.

When a selection is active, you can Right/Control click inside the selection and choose Select Inverse from the context-sensitive menu that appears.

4.4.11 Using the Refine Selection Brush Tool

This tool is designed to do just what its name implies: refine an existing selection. It is particularly helpful with edges that would be hard to select using any other method we have learned.

Let's open the file named Refine Selection Fish.jpg located in the Practice_Import 11 files folder inside the Practice Files folder you copied to your hard drive. We will save this file as Fish for Transformation.psd, as we will use this selection in Chapter Six.

The Refine Selection Brush tool requires an initial selection. Feel free to select the fish using whichever selection method has already become your favorite. Once the selection has been made, we will click to select the Refine Selection Brush tool in the Tool Options bar. Once we have done that, let's take a look at its options, shown in Figure 4.22:

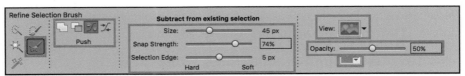

Figure 4.22 Tool Options bar when the Refine Selection Brush tool is selected.

ADD AND SUBTRACT ICONS: Allow us to refine an existing selection. In Add mode, place the tool with the white edge of the circle just enclosing the area to refine, then press and hold; the selection will expand while the mouse is held down out to the edge of the *outer* circle of the tool.

PUSH: Can also be used to add or delete from a selection, depending on which side of the selection you place the tool; however, it is very effective if you drag to paint with the tool along the *edge* of a selection to redefine the selection.

SMOOTH: Helps smooth a selection as its edge is dragged along. However, a small feather with Radius 1px is recommended to apply after using this tool.

SETTINGS: Assign brush Size, Snap Strength (to edge details), and Selection Edge (sensitivity—soft for finer details).

OVERLAY: Appears around our selection just as the Mask mode of the Selection Brush tool does; we will again lower the opacity of the overlay to 50%. It also contains a View drop down menu with two alternative views of our selection—against black or against white—and the ability to change the color of the overlay.

Let's assign the settings shown in Figure 4.22 and magnify in to a view comparable to the one shown in Figure 4.23. Using the Push mode, if we paint along the edge of the fish, the inner circle of the icon will turn black and a slightly darker color red brush stroke will follow as we trace an edge. When the mouse is released, the selection has been refined. If you have fins that were missed in the initial selection, try switching to the Add mode, then press and hold the tool inside the existing selection, to watch the selection "expand." Typically a *combination* of the Refine Selection Brush modes will yield the most effective results.

Once the selection of the fish has been refined, click any selection tool to exit the overlay mode, save the selection as "Fish Selection," then save and close the file for now.

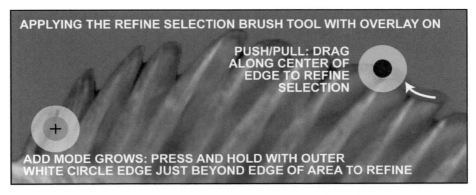

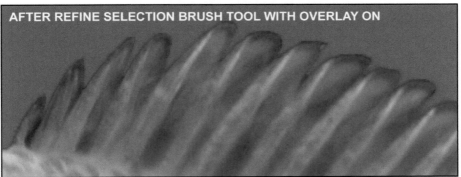

Figure 4.23 Demonstrating the application of the Refine Selection Brush tool.

4.4.12 Using the Refine Edge Dialog Box

We have seen the Refine Edge button available in the Tool Options bar with every selection tool except the Refine Selection Brush tool. This feature can improve any

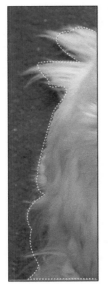

selection but is especially effective for fine selections such as hair and fur that would be difficult using any other method.

Let's open the file named Dog For Refine Edge.jpg located in the Practice_Import 11 files folder inside the Practice Files folder you copied to your hard drive. We will save this file as Dog Selection.psd. We will begin by using the Quick Selection tool to selection the dog, going out around the tufts of hair, as shown in Figure 4.24.

Once we have done that, we will single click the Refine Edge button to enter the Refine Edge dialog box. Here we can set a variety of options as shown in Figure 4.25:

Figure 4.24 Initial selection of the dog using the Quick Selection tool.

VIEW MODE: Assigns a background for the area outside of the selection; we will choose the Overlay mode.

REFINE RADIUS/ERASE REFINEMENTS TOOLS: Adjusts the edge of the refinement.

EDGE DETECTION: Smart Radius will adjust for soft and hard edge differences along the edge of the selection and is always a good choice.

RADIUS: Assigns how the tool will work depending on the edges detected; assign a higher number for soft edges. If Smart Radius is checked, the Editor will adjust this for you automatically; more can be added here if needed.

ADJUST EDGE: Options for smoothing, feathering, adjusting the contrast of the edges to be detected, and shifting the selection edge (eliminates the "halo" effect which we have learned to remove by applying the Expand/Contract commands).

DECONTAMINATE COLORS: Assigns neighboring pixel colors to eliminate slight background color differences along edges of the selection, with the default amount of 50% working well.

OUTPUT TO: A refined selection can be chosen to output as a Selection, Layer Mask, New Layer with Layer Mask, New Document, or New Document with Layer Mask. If Decontaminate Colors is assigned, Selection and Layer Mask are eliminated from the output choices.

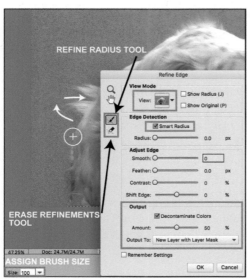

Figure 4.25 Assigning settings in the Refine Edge dialog box.

We will assign a brush size of 100 in the Tool Options bar, then select the Refine Radius tool and press and drag along the edge of the dog's fur as shown in Figure 4.25, with the crosshair centered over the edge of the fur. If we need to, we can select the Erase Refinements tool to undo. Around the nose and mouth area, we will switch to a smaller brush size such as 25. Once our selection has been made, we will assign Decontaminate Colors and Output To: New Layer with Layer Mask. It is OK if some of the mouth area does not select correctly; we will be able to adjust the layer mask created later in this chapter. For now, we will save and close the file.

4.4.13 Choosing the Best Selection Method for a Task

You may have noticed that sometimes more than one selection method can accurately select the content we need. By learning all of the selection options available to you, later, in your own work as an expert, you will be able to evaluate content that needs to be selected and assign the method or methods of selection that will most effectively and efficiently select the content for you.

4.5 Using Layers in the Editor

The use of layers in the Editor is invaluable to an expert. A few of the advantages of incorporating layers into your work are the ability to add content from another photograph; show, hide, lock, and change the opacity of the imported content; duplicate an image to work on with easy access to the original; and so much more. Let's get started.

4.5.1 Understanding Layers

Layers are "pixel containers" equal to the dimensions of the original image that can be stacked one above the other like sheets of paper. When a layer has an area with no pixels in it, the area is displayed as a checkered pattern.

We will begin by examining the features of the Layers panel by opening any photograph of your own or the file named Galapagos Birds.jpg located in the Practice_Import 11 files folder inside the Practice Files folder you copied to your hard drive. Once the file is opened, click to make the Layers panel the active panel in the custom group of the Layers, Navigator, and History panels we have created. We will work with all of its features shown in Figure 4.26 in this chapter, with the

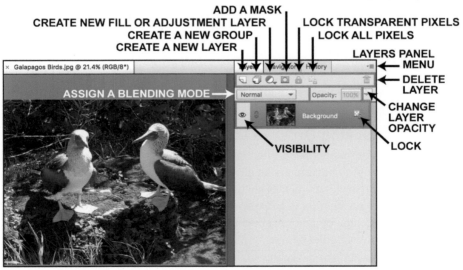

Figure 4.26 Background layer with parts of the Layers panel identified.

exception of Adjustment Layers and Blending Modes, which will be covered as they become applicable to our learning in future chapters.

4.5.2 The Background Layer

All images in the Editor open with a single layer named "Background" that will be pre-selected by default and identified by its blue color. The Background layer contains both an "eye" icon to indicate its visibility and a lock icon that indicates pixels on a Background layer can be edited but the layer cannot be moved or deleted. We can see that the Lock options, the Opacity slider, and the Delete Layer icon are all currently unavailable; these features are only accessible for regular layers.

4.5.3 Panel Options

All layers display at a default thumbnail size in the Layers panel. The thumbnails in the Layers panel can be made either larger or smaller by pressing on the Layers panel menu icon to open it, selecting Panel Options, then clicking the radio button next to the desired alternative icon size.

4.5.4 Layer Visibility

When a file has multiple layers, individual layers can be hidden. Let's close this file and examine layer visibility using a file with six layers already created for us.

Let's open the file named Layers Practice.psd located in the Practice_Import 11 files folder inside the Practice Files folder you copied to your hard drive. We can see in this multilayered file that it contains a Background layer along with five additional layers above it. Each layer contains an eye icon just as we saw in the Layers panel of the Galapagos Birds image. However, because this is a multilayered file, each layer's visibility can be individually turned off or on at any time, including the Background layer. Single click the eye icons of each of the layers to hide them (the eye icon will display a slash through it), then click each eye icon one at a time again to turn it on, then off to view the content of each layer individually. Once you have examined each layer's content, return visibility to all of the layers.

A quick way to turn the visibility of multiple contiguous layers off or on is to press and drag up or down through the eye column of the Layers panel.

4.5.5 Stacking Order of Layers

When a file contains more than just its Background layer, the sequence of how the additional layers are placed above the Background layer in the Layers panel is referred to as the "stacking order." The locked Background layer will always be at the bottom of the stacking order and cannot be moved; however, the rest of the layers can have their stacking order, or position in the stack of layers, changed. Let's learn to change the stacking order of layers by selecting the Left content layer. Once it has been selected as identified by its blue highlight color, we will press and drag it above the Right content layer. When a double line appears, we will release the mouse as shown in Figure 4.27.

Once we have done that, we can see that some of the image pixels on the Right content layer are now hidden, because the image pixels of the Left content layer have covered them. Let's use the History panel to undo our action.

Now let's drag the Gull1 layer below the Right content layer; all of the content on both of these layers is still visible, because there are no pixels on the Right content layer in the area of the Gull1 layer that contains image pixels. Let's use the History panel again to return this image back to its original stacking order, or choose Edit>Revert.

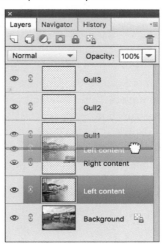

Figure 4.27 Changing the stacking order of layers in a multilayered file.

4.5.6 Changing the Opacity of a Layer

When we are working with a multilayered file, we can change the Opacity for any layer we select, except the Background layer. Let's select the Gull2 layer first, then drag the Opacity slider to 90%, or type "90" in the Opacity percentage text field, then press Enter/Return to apply it. Our gull becomes slightly paler, helping to make him appear further away. We will also reduce the opacity of the Gull3 layer by selecting the layer first, then changing the Opacity setting to 85%.

4.5.7 Moving Content on a Layer

The Move tool, identified by four arrows plus a larger arrow, is located in the Select section of the Tools panel and is used to move layer content. When the tool is selected, its options display in the Tool Options bar as shown in Figure 4.28:

AUTO SELECT LAYER: Allows us to click on the specific location of the content we want in order to select it, even if we have not selected its layer first; when we select it, its layer will become selected for us. When this option is unchecked, the layer with the content we want to move must be selected first.

SHOW BOUNDING BOX: Adds eight bounding box handles around a layer's content automatically for us when the layer is selected.

SHOW HIGHLIGHT ON ROLLOVER: Provides a blue bounding box that identifies the outer perimeter of the content of an unselected layer when the mouse is rolled over it if Auto Select Layer has been assigned.

ARRANGE: Provides a down arrow menu to adjust the stacking order of the selected layer by choosing Bring to Front, Bring Forward, Send Backward, or Send to Back.

ALIGN: Options allowing us to align multiple layers when two or more layers are selected.

Figure 4.28 Options in the Tool Options bar when the Move tool is chosen.

NOTE Although with this file Auto Select works great, when a file has several layers, especially with content on one layer in close proximity to content on another layer, Auto Select may make it difficult to select the specific layer content desired. When that happens, turning off the Auto Select Layer feature and instead selecting the desired layer to move in the Layers panel first may work more effectively.

Let's select the Move tool, then click on the Gull1 in the image. Because we have checked Auto Select Layer and Show Bounding Box in the Tool Options bar by default, the gull becomes selected with bounding box handles around him and the Gull1 layer becomes selected. We will press and drag on Gull1 and drag him in front of the sign, as shown in Figure 4.28. Because the Gull1 layer is above the Background layer in the stacking order, he appears in front of it.

4.5.8 Adding Layers to a File

Layers can be added to a file by creating a new blank layer, duplicating a layer, copying content from an existing layer, or importing content from another file.

4.5.8.1 Creating a New Blank Layer

A new blank layer can be added to a file by single clicking on the Create a new layer icon at the top left of the Layers panel, or by choosing Layer>New>Layer, or by choosing New Layer from the Layers panel menu. An empty layer, identified by its checkered pattern, will be added above the layer that was selected when the command was chosen. Creating an empty layer can be helpful when applying draw and tool effects whose application we will want to control and be able to easily delete when needed.

4.5.8.2 Duplicating a Layer

Any layer, including a Background layer, can be duplicated, even if the file contains only a Background layer. Once a layer has been selected, the Duplicate Layer command is accessible from the Layer menu, the Layers panel menu, or by Right/Control clicking on the layer and selecting Duplicate Layer from the context-sensitive menu that appears. When this command is selected using any one of these methods, a dialog box opens to name the new layer or accept the default same name as the layer selected, with the word "copy" added after it. The duplicated layer will always be added directly above the selected layer.

Let's learn another way. Let's select the Gull1 layer, then drag it up and release it on top of the Create a new layer icon. The layer is duplicated, appears directly above the layer it was created from, and has the original name plus the word "copy." Let's use the Move tool now to select and drag the Gull1 copy layer and place this gull at the front corner of the dock as shown in Figure 4.29.

4.5.8.3 Using the Layer Via Copy Command

The Layer Via Copy Command has many powerful applications. In this chapter, let's learn the basics of how to apply it by adding a second dock to the Layers Practice.

psd photograph. Using the Polygonal Lasso tool, select the Background layer *first*, then trace the dock, including a little of the water below it, and finally apply a feather with Radius: 1 px to the selection, as shown in Figure 4.29.

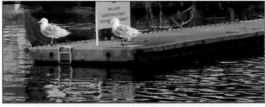

Once we have done that, the Layer via Copy command can be selected by choosing Layer>New>Layer Via Copy or by Right/Control clicking inside the active selection with the Polygonal tool still chosen and

Figure 4.29 Creating a selection, then applying the Layer via Copy command.

choosing Layer Via Copy from the context-sensitive menu that appears. The content is copied as a new layer named "Layer 1" above the selected layer (the Background layer) and can now be moved using the Move tool to place it to the right of the original dock, as also shown in Figure 4.29.

NOTE If the wrong layer is selected prior to moving the selection, the warning message shown in Figure 4.30 will appear. If this happens, check which layer you are selecting to be sure you are selecting the one with your active selection on it.

Figure 4.30 Warning that no pixels have been selected.

4.5.8.4 Add a Layer by Importing Content

A layer will be created automatically when content is added from another file. Let's open the file named Boat.psd located in the Practice_Import 11 files folder inside the Practice Files folder you copied to your hard drive. Once the file has been added to the Edit pane, let's click the Layout button in the Taskbar to select All Column to be able to access both open files.

When a layer is added to a file, it will be added above the currently selected layer. Let's select the Right content layer in the Layers Practice.psd file. Once we have done that, we will choose the Move tool. In addition to moving content on a layer, the Move tool is used to import content from another file. With the Move tool selected, we will press and drag on the boat in the Boat.psd file and drag it into the Layers Practice.psd file. As soon as it appears in the Layers Practice file, we can close the Boat.psd file and choose not to save the changes if prompted.

Because we selected the Right content layer first, the boat layer is added directly above it in the Layers panel and appears as Layer 2. We will use the Move tool to drag the boat to the center area of the water as shown in Figure 4.31.

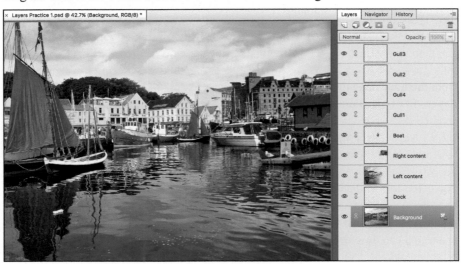

Figure 4.31 Importing content into a file and renaming layers.

4.5.9 Renaming a Layer

The name of any layer except the Background layer can be changed. Let's change the name of the Gull1 copy layer to "Gull4." To do that, we will double click directly on

the letters of the original name. The name becomes highlighted ready for us to type the new name.

Let's also double click on the layer we created using the Layer via Copy command and change it from Layer 1 to Dock and change Layer 2 to "Boat," with these new names also shown in Figure 4.31.

4.5.10 Multi-selecting Layers

You will oftentimes need to multiselect layers of a file to manipulate them in some manner such as color, placement, etc. If the layers are contiguous, select the first one, then hold the Shift key and select the last one you want selected; all layers in between them will become selected as well. If you need to select noncontiguous layers, select the first one, then hold the Control/Command key as you click to select each additional layer you want added to the selection of the original layer.

4.5.11 Linking and Unlinking Layers

Layers can be linked and unlinked. When linked, they can be moved together and transformed as a unit. Let's learn how to link layers to move them; we will learn transformation in Chapter Six.

4.5.11.1 Linking Layers

With the Gull4 layer selected, let's single click the chain link icon located between the visibility icon and the layer thumbnail of the original Gull1 layer; the chain link of both layers turns yellow, and the layers become linked together. Using the Move tool, press and drag to move one of them slightly to the right of its location—they move together. Then choose to undo the move. If we select multiple layers first, we can then single click the link icon of any one of the multiselected layers to link them all together. Selected layers can also be linked together by choosing Link Layers from the Layers panel menu or Right/Control clicking them and choosing Link Layers from the context-sensitive menu that appears.

4.5.11.2 Unlinking Layers

When linked layers are selected, Unlink Layers can be chosen from the Layers panel menu or by Right/Control clicking one of the linked layers and selecting Unlink from the context-sensitive menu that appears, or by clicking the chain icon of one of the linked layers. The linkage toggles off if only two layers are linked; if three or more are linked, the rest of the linked layers will remain linked. Only the one clicked will become disengaged from the rest.

4.5.12 Grouping Layers

Let's use the History panel to revert to the state in which we renamed our imported Layer 2 to "Boat." Layers can be grouped to move and scale together like linked layers, with some additional advantages as well.

4.5.12.1 Creating a Group

Let's select the Gull1 layer, then with the Shift key held down, select the Gull3 layer to multiselect all four of the gull layers, then single click on the group icon, the icon directly to the right of the Create a new layer icon. As soon as we have done that, a

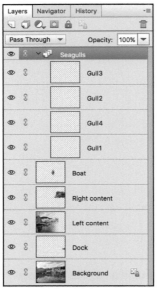

group named "Group 1" is created, the four layers become added to the group, and the group becomes collapsed, freeing up space in the Layers panel. When the down arrow provided next to the name "Group 1" is clicked, the layers within the group are displayed and identified as part of a group by being indented as shown in Figure 4.32. We can also rename the group just as we were able to rename the Gull1 copy layer; let's double click the name "Group1" and change it to "Seagulls."

A group can be also be created from selected layers by choosing Layer>Group Layers, by choosing New Group or Group from Layers from the Layers panel menu, or by Right/Control clicking the selected layers and choosing Group from Layers from the context-sensitive menu that appears.

Figure 4.32 Creating a layer group and changing its default name.

In addition to the advantage of being able to collapse the group to save space in the Layers panel, we can move and scale the group as a unit and change the opacity of the group. We can also change the stacking order or move the content of any of the layers while they are still part of the group.

4.5.12.2 Removing a Layer From a Group and Removing a Group

To remove a layer from a group without deleting the group, drag the layer *above* the group; the moved layer will no longer be indented, indicating that it is no longer part of the group. To delete the entire group, select the group icon first, and then choose Delete Group from the Layer menu or the Layers panel menu, or Right/Control click the group icon and select Delete Group from the context-sensitive menu that appears. When the delete command is selected using any one of these methods, a dialog box will open to ask whether you want to delete the group only, or delete the group and its contents. An alternative to this if you want to keep the contents but not the group is to select Ungroup Layers instead of Delete Group from the Layer menu or by Right/Control clicking on the Group name and choosing Ungroup Layers from the context-sensitive menu that appears.

4.5.13 Deleting a Layer

At any time any layer except the Background layer can be deleted, even if it is linked with another layer or layers, or is part of a group. A selected layer can be deleted by

choosing Delete Layer from the Layer menu or the Layers panel menu, by Right/ Control clicking on the layer and selecting Delete Layer from the context-sensitive menu that appears, or by single clicking on the Delete Layer icon in the Layers panel. When a layer is deleted using any of these methods, a confirmation dialog box appears to ensure it is what we want. Let's use any one of the deletion methods to delete the Gull4 layer from the file.

4.5.14 Converting a Background Layer to a Regular Layer

Sometimes in our work we will want to convert a Background layer into a regular layer to be able to apply commands and effects that are applicable only to regular layers. To do this, when the Background layer of a file is selected, we can choose Layer>New>Layer from Background, or Right/Control click on the Background layer and choose Layer from Background from the context-sensitive menu that appears, or single click on its lock icon, or double click on the Background layer. When any one of these methods is applied, a dialog box will open, renaming the layer automatically to Layer 0.

If a Background layer has been converted to a regular layer, the command Layer from Background changes to Background from Layer. If a layer not at the bottom of the stack is selected for conversion to the Background layer, it will be moved automatically to the Background layer position, with any transparent areas it may have becoming filled with the current background color.

4.5.15 Aligning Layers

When multiple layers exist in a file, they can be multiselected and easily aligned using icons provided when the Move tool is chosen.

Let's choose to save, then close this Layers Practice.psd file now. We will work with it again later in this chapter. For now, we will reopen our Flower Selection.psd file, where we saved the selection of the sunflower. Once we have done that, let's open another file that we will bring our sunflower selection into—the file named Background for Sunflower.psd located in the Practice_Import 11 files folder inside the Practice Files folder you copied to your hard drive.

Once the files are both open, we will click the Layout button in the Taskbar and select All Column to display the images side by side. Once we have done that, we will need to make our Flower Selection.psd file the active image, then choose to load our saved selection by choosing Select>Load Selection and clicking OK to make the selection active. To add the sunflower selection into the Background for Sunflower. psd file, we will select the Move tool and drag the selection into the destination image. To appreciate the power of the Alignment feature, drag the sunflower into the Background for Sunflower.psd file; however, intentionally be sloppy with it, letting it hang off at the top, for example. Once the sunflower has been added to the background, we will close the Flower Selection.psd file. To align the flower to

the background, we will need to multiselect the layers: select one, then Shift-click to select the other. When both layers are selected and the Move tool is chosen, the Align options become active in the Tool Options bar. To easily align the right-hand side of the flower to the right and bottom edges of the background photograph, we

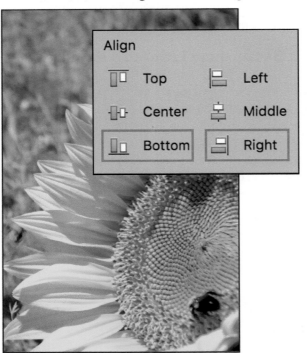

will click the Bottom and Right alignment icons as shown in Figure 4.33; the flower jumps and aligns perfectly to these edges as also shown in Figure 4.33. Because the Background for Sunflower.psd is a locked Background layer, the flower selection layer aligns to it. Choose to save this file if you would like, with a name of your choice. However, before closing it, let's use it to learn about the Lock options of the Layers panel.

Figure 4.33 Adding a selection and assigning alignment options for layers.

4.5.16 Lock Transparent Pixels Versus Lock All Pixels

Let's select the sunflower layer, then choose Edit>Fill Layer. In the dialog box that opens, we will choose to fill using the foreground color (whatever color is chosen will not matter here); the entire layer fills with the color. We will undo the fill, then click the Lock Transparent Pixels icon in the Layers panel, identified in Figure 4.26. The layer's position is not locked and can be moved using the Move tool; however, when we choose Edit>Fill Layer again and choose any color as the fill, the transparent areas of the layer are protected and are not affected by the fill. The Lock All Pixels option locks the transparent pixels *and* locks the position of the layer as well.

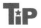

In your own work when the exact location of layer content is critical, after its positioning, choosing Lock All Pixels will assure that you do not accidentally move the layer inadvertently in the future when working with the file.

4.5.17 Using a Layer Mask

A Layer Mask is another way to create and save a selection for future use. A mask can be added to a layer by selecting the layer, then single clicking the Add a mask icon in the Layers panel, identified in Figure 4.26. We have already created one,

by choosing the New Layer With Layer Mask output option when saving our selection made using the Refine Edge dialog box for our Dog Selection.psd. Let's reopen that file now to learn how to work with a layer mask.

Figure 4.34 Layer Mask selected.

When we look at the Layers panel of the Dog Selection.psd file, we can see that the Background layer has been hidden, with a Background copy layer above it with a black and white linked silhouette next to the layer thumbnail. This silhouette represents the mask. When we click on it, it becomes highlighted with a cyan border as shown in Figure 4.34.

When the mask is highlighted, we can edit the mask which was generated from our selection, with the white area representing the selection. To edit the mask, the default colors in the Tools panel are used. When white is the foreground color, we are adding to the selection; when we click the curved arrow above the colors on the right, black

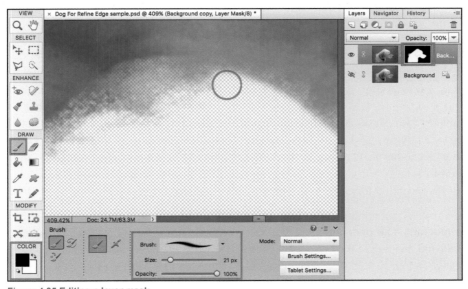

Figure 4.35 Editing a layer mask.

becomes the foreground color, and we are subtracting from the selection. The Brush tool is used to edit the mask (the first icon at the top left in the Draw section of tools). When the Brush tool is selected, a size and style of brush are assigned in the Tool Options bar, with Opacity set to 100%. We will not want to erase the critical fine fur details we were able to capture using the Refine Radius tool; however, content such as that appearing below the chin or around the nose of the dog may need addition or deletion refinements as shown in Figure 4.35. Here with black as the foreground color, extra content is easily cleaned up using a brush size appropriate to the task and magnification. Once the selection has been refined by editing the layer mask, we will save our changes. When we have done that, we are ready to use it.

Let's open the file named Water for Refine Edge.jpg located in the Practice_Import 11 files folder inside the Practice Files folder you copied to your hard drive, then place the two images side by side by choosing All Column from the Layout options. Using the Move tool, we will drag the dog Background copy layer into the water photograph. We can now close the Dog photograph.

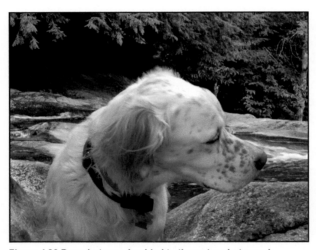

Notice that the mask came into the water photograph attached to the dog selection. This is great, in case we realize we still need to edit the mask some more. Study the edges of your selection for any areas that may still need to be cleaned up. Once satisfied with the selection, the mask should be permanently applied. We can choose to do that by choosing

Figure 4.36 Dog photograph added to the water photograph.

Layer>Layer Mask>Apply or Right/Control clicking on the mask in the Layers panel and selecting Apply Layer Mask from the context-sensitive menu that appears. These same locations also provide the opportunity to delete or temporarily disable the mask as well.

Once we have applied the mask, we can Shift click to select both layers, then apply the Align options of Bottom and Middle to place the dog perfectly within the photograph. Our hard work has been rewarded; with the wisps of his fur blowing in the wind, the dog looks like he was at the river when the photograph was taken, as shown in Figure 4.36. We will choose to save this file as River Dog.psd, as we will work with it again in Chapter Six.

4.5.17.1 Adding a Layer Mask to Refine a Selection

Any selection can be refined by using a layer mask, with or without using the Refine Edge dialog box. Once a selection has been made, the Add a Mask icon shown in Figure 4.26 can be clicked. The Layers panel will display the mask, which can be selected and edited using the Brush tool as we have just learned.

4.5.18 Merging Layers Versus Flattening a File

We have seen the flexibility that layers provide for us. While keeping all layers when working on any file is recommended, if you are *sure* that content on two or more layers will not need future individual manipulation, they can be merged to reduce file size. Alternatively the file can be flattened or saved as a flattened copy.

4.5.18.1 Merging Layers

Let's reopen the Layers Practice.psd file. Once it is open, we will choose to merge the three seagull layers. Let's first delete the group they are in, by Right/Control clicking on the Seagulls group and choosing Ungroup Layers. Once we have done that, we will multiselect only the three gull layers, then choose Merge Layers from the Layer menu or the Layers panel menu, or by Right/Control clicking on one of the selected layers and choosing Merge Layers from the context-sensitive menu that appears. All three seagulls are now on one layer. Let's rename the single gull layer to "Gulls," then save and close this file for now; we will reopen it and apply an adjustment layer to it in Chapter Five.

4.5.18.2 Merge Down Versus Merge Visible

While Merge Down will merge the selected layer with the layer below it, Merge Visible will do just as its name implies: any layers that do not have their visibility turned off will be merged. These options are available from the Layer menu, the Layers panel menu, or by Right/Control clicking on one of the selected layers and choosing the desired merge option from the context-sensitive menu that appears.

4.5.18.3 Flattening a File or Saving a Flattened Copy of a File

The Flatten Image command will merge all layers into the Background layer. File size will be reduced; however, the file will no longer feature the flexibility to manipulate its components. A safer alternative is to choose the Save>As a Copy option in the Save As dialog box. This option will add the word "copy" to the name and flatten the copy for you, keeping your original layered file intact.

4.5.19 Defringe a Layer

We have learned to expand or contract our selection and also how we can assign a Shift Edge to a selection in the Refine Edge dialog box. If a layer has been added to another file and still shows a slight "halo" effect against its new background, assigning the Defringe command may help.

Let's reopen our Lasso Selection.psd file we saved previously, with the sky saved as a selection with the file. We will also open the file named Sky.jpg located in the Practice_Import 11 files folder inside the Practice Files folder you copied to your hard drive, then place the two images side by side by choosing All Column from the Layout options.

We will first use the Move tool to add the sky image into the Lasso Selection image. Once we have done that, with both layers selected we will use the align options to align these layers Center and Middle. We will need to move the Lasso image above the sky. One way we could do that would be to turn the Background layer into a layer, then move it above the sky layer. However, we will instead choose to duplicate the Background layer, then move the *Background copy layer* above the sky layer, keeping the original Background layer intact. Once we have done that, with the Background copy layer selected, we will choose to load the sky selection. With this selection active, we will choose Select>Inverse to instead select the buildings instead of the sky, and then choose to delete the washed out sky to reveal our blue sky below it.

When we magnify in, however, to a view comparable to the one shown in Figure 4.37, we may see a slight halo effect along the edge of the buildings against the sky. If a halo effect still appears after a selection has been added to another file, the pixel edges of the imported layer can be improved using the Defringe command. To apply this command, with the Background copy layer selected, choose Enhance>Adjust Color>Defringe Layer, then assign Width: 2 px (a number between 1 and 3 px works well). Let's save this composite image now as Village.psd.

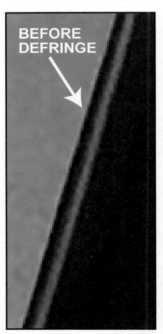 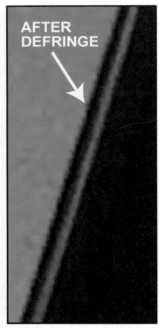

Figure 4.37 Applying the Defringe Layer command.

PRACTICE MAKES *PERFECT*✓

We are ready to move forward to working with color and tonal corrections. Before we do that, feel free to reinforce your Chapter Four learning by completing one or more of the practice projects provided.

PRACTICE PROJECT 1

1. Open the Village.psd file you created as a composite image.

2. Select the Background copy layer in the Layers panel.

3. With this layer chosen, load the saved selection of the doorway.

4. Use any combination of selection methods to refine this selection to make it as accurate as possible.

5. Assign a feather with Radius: 1 px.

6. Choose to save the updated selection as "Doorway" to replace the original rough selection.

7. Working on this same layer, select the door with the windows, using any combination of selection methods for accuracy. Select the door, without including the outer trim as shown in Figure 4.38.

8. Apply a small feather with Radius: 1 px.

9. Save this new selection as "Glass Door" (this adds a third saved selection to this file: Sky, Doorway, and Glass Door).

10. Select the Background copy layer and choose Merge Down to merge it with the sky below it, rename the merged layer "Village," then choose to lock the transparent pixels on the layer.

11. Save and close the file for now, we will adjust the tonal quality of the doors in Chapter Five.

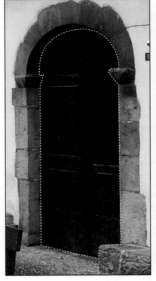

Figure 4.38 Selections of the two doorways.

PRACTICE PROJECT 2

1. Open the photograph of seals, IMG_3056.jpg, located in the Practice_ Import 2 folder inside the Practice Files folder you copied to your hard drive. This file has the sRGB color profile assigned. Converting this file to the Adobe RGB (1998) color profile is optional because we will not be printing it.

2. Save the image as Seals.psd.

3. Select the large standing seal using the most accurate selection method or combination of methods.

4. Apply a feather with Radius: 1 px.

5. Choose to contract the selection by 1 px (Select>Modify>Contract).

6. Save the selection as "Seal Selection."

7. With the selection active, choose Layer>New>Layer Via Copy.

8. Rename the new layer "Seal 1."

9. Duplicate the layer and rename the new layer "Seal 2."

10. Use the Move tool to arrange the layers as shown in Figure 4.39.

11. Save and close the file for now. We will learn to scale and rotate these seals in Chapter Six.

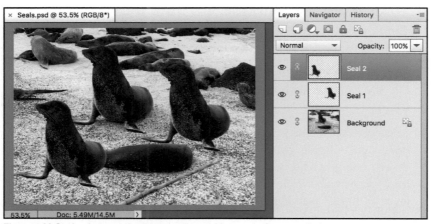

Figure 4.39 Seals photograph with selection and Layer via Copy applied.

PRACTICE PROJECT 3

A third exercise named "Chapter Four Practice Project 3.pdf" is available in the Additional Practice Projects folder on the companion DVD.

5

Getting the Color Right

In This Chapter

- Employ basic and advanced color and tonal correction commands, filters, and tools

- Utilize blending modes for tonal correction

- Learn multiple ways to convert a color photograph to a black and white photograph

- Master the Histogram panel

Our learning will include lighting and contrast correction, haze removal, color cast removal, skin tone correction, and applying corrections as adjustment layers. Corrections will be made as commands, as tool applications, and through the Camera Raw dialog box. Methods will range from basic Auto commands to complex user-controlled applications, providing you with the knowledge and expertise to employ the most effective and efficient correction techniques in your future work.

5.1 General Tonal Correction

The tonal range of a photograph refers to its highlights, shadows, and contrast. Sometimes an image has an overall underexposed appearance (too dark) or overexposed appearance (too light), or the image may be overall OK; it just has one or more areas *within* it that appear too dark or too light. Improvements can be made using a variety of basic tonal correction options, auto options, and advanced user input options. We will commence our learning in tonal corrections beginning with basic and auto tonal options.

5.1.1 Applying Basic Tonal Correction Options

Working in the Organizer, we can select a photograph, enter the Instant Fix editor, then click its Smart Fix or Light button to have the Organizer analyze the photograph and provide basic tonal correction options or its Color button to select an alternative degree of saturation intensity.

Working in the Editor Quick mode, three of its Adjustments panel options also allow the Editor to analyze an image for us and provide basic selections for improving its tonal quality: Smart Fix (select from options the Editor determines the photograph needs to improve it), Exposure (select an overall lightness/darkness adjustment), and Lighting (adjust basic Shadows, Midtones, and Highlights settings individually from the options provided or select Auto Levels or Auto Contrast). While these choices are great quick fixes, and sometimes doing an amazing or at least adequate job of tonal correction, many times they will not be enough. The Enhance menu options will oftentimes provide better results by more specifically targeting the type of tonal correction a photograph requires.

5.1.2 Applying Auto Tonal Correction Options

Let's open the photograph named Clarks.jpg located in the Practice_Import 12 files folder within the Practice Files folder you copied to your hard drive.

NOTE Although many of the correction techniques covered in this chapter can be performed in both the Quick and Expert modes, we will work exclusively in the Expert mode. The Guided mode provides a variety of color and tonal options that will be covered in the "Working With Color in the Guided Mode" section of this chapter. Additionally, all of the files in this chapter have the sRGB profile assigned to them (note the asterisk *inside* the file name parentheses if you have the Always Optimize for Printing color setting assigned). If you would like to print any of them, be sure to *first* choose Image>Convert Color Profile>Convert to Adobe RGB Profile for proper color management.

5.1.2.1 Auto Smart Fix

Auto Smart Fix works like the Auto button of the Smart Fix Adjustments panel option in the Quick mode. It is designed to improve *both* tonal and color quality. Sometimes just applying it, noting how the image has changed, then undoing the command can offer you direction on how to improve the photograph yourself if you want more correction control but need a little help identifying what is wrong with it.

When we apply this command to the Clarks.jpg image, minimal tonal improvement appears in the photograph. Let's delete its application using the Undo command or the History panel.

Sometimes the Auto Smart Fix command can be more effective if the Enhance>Adjust Smart Fix command is applied instead. This command provides a slider to assign the amount of the application of the Smart Fix, rather than an automatic Editor-controlled application.

TiP

5.1.2.2 Auto Smart Tone

When Auto Smart Tone is applied, the Editor analyzes the image, corrects it, and supplies us with four alternative "tonal directions" if we want to alter the result it provided for us. As we press and drag the directional icon toward one of the four corner presets, the image applies more and more of the appearance of the corner selection we have chosen. A Before button allows us to review improvements before clicking OK to assign the change; however, if the title bar of the Auto Smart Tone dialog box is dragged to expose the original image below it, we will be able to see our original and after versions simultaneously. A down arrow menu provides the ability to have the Editor "learn" from our choices for future applications, as well as the option to hide the four directional samples in the corners if desired. If the learn option has been applied, the Editor remembers our tonal preferences and applies them to future applications of the Auto Smart Tone command. This learning can be reset back to the default setting at any time by choosing Edit>Preferences>General in Windows or Adobe Photoshop Elements Editor>Preferences>General in Mac OS, then choosing Reset Auto Smart Tone Learning. A Reset button below the preview window allows us to start over if needed. Dragging the directional icon slightly to the lower right significantly improves the lighting of the image without completely

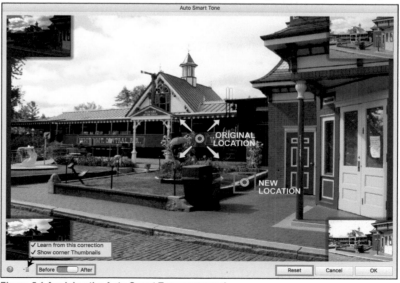

Figure 5.1 Applying the Auto Smart Tone command.

washing out the sky, as shown in Figure 5.1. Let's close this file, optionally choosing to save it, and open a different image to work with the Auto Levels and Auto Contrast commands.

 A copy of each figure shown in this chapter can be viewed in the companion files included with this book.

5.1.2.3 Auto Levels Versus Auto Contrast

Both of these commands affect the overall contrast of an image and are effective for both color and black and white photographs and are equivalent to the Auto Levels and Auto Contrast buttons provided when using the Lighting option of the Adjustments panel in the Quick mode. While the Auto Contrast command affects only the overall contrast, the Auto Levels command, because it performs this correction by adjusting the individual channels which comprise the image (Red, Green, and Blue), can also sometimes affect the color slightly as well as its contrast when working with a color photograph.

 Let's open the photograph named Auto Levels.jpg located in the Practice_Import 12 files folder within the Practice Files folder you copied to your hard drive. Let's choose Enhance>Auto Levels. Once we have done that, let's reverse our action using the Undo command or the History panel, and instead apply Enhance>Auto Contrast. When either one of these commands is applied, this image is significantly improved. However, when we examine the results of the Auto Levels versus the Auto Contrast closely, the blues of the Auto Levels are richer than those of the Auto Contrast—a positive result visible in Figure 5.2.

Let's choose to correct the image using Auto Levels, then choose File>Save As and name this file Straighten.psd. As we can see, the buoy is crooked: we will reopen this photograph in Chapter Six and learn how to straighten it.

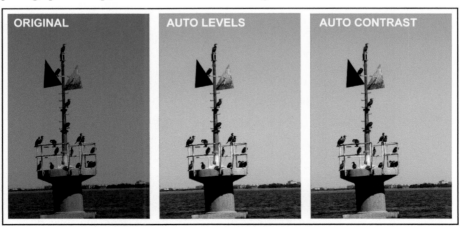

Figure 5.2 Applying the Auto Levels versus the Auto Contrast command.

NOTE▶ When applying these auto options, if one is ineffective, undo the command prior to applying the alternative auto correction command rather than attempting to apply one on top of the other. In this example, both of these commands were effective on the photograph provided. However, in your own work, because of how the Editor reassigns the lightest and darkest pixels in the image when these commands are applied, sometimes *neither one* of these commands will help. When that happens, undo the application, and choose a different tonal correction method.

5.2 Advanced Tonal Correction

The basic and auto correction options can be very helpful and sometimes improve an image adequately by themselves. When an image requires more tonal correction than any of the basic or auto commands can provide, choosing an advanced correction command may be needed. Tonal corrections can be achieved using the Shadows/Highlights command, the Brightness/Contrast command, the Levels command, the Curves command, the Haze Removal dialog box, and by applying a blending mode. When learning to apply these correction options, we will be introduced to how the Histogram panel can help.

5.2.1 Shadows/Highlights Command

The Shadows/Highlights command can be used to improve a photograph with underexposed areas, with overexposed areas, or a photograph that contains both. When an image suffers from areas that are underexposed or overexposed, the details in these areas are lost; the Shadows/Highlights command can help to restore them.

5.2.1.1 Applying the Shadows/Highlights Command to a Photograph

Let's open the photograph named Shadows Highights.jpg located in the Practice_ Import 12 files folder within the Practice Files folder you copied to your hard drive. When we study this photograph, we can see that the area inside the cell is too dark (underexposed), while the sunlight has overexposed the outside of the cell. Let's choose Enhance>Adjust Lighting>Shadows/Highlights. In the dialog box that opens, three sliders are provided: Lighten Shadows, Darken Highlights, and Midtone Contrast. While the Lighten Shadows and Darken Highlights options are self-explanatory, the Midtone Contrast slider can be used to add contrast back when areas of a photograph sometimes become washed out after the Lighten Shadows and/or Darken Highlights adjustments have been applied. By default, the Lighten Shadows slider will be pre-assigned to 35%. Feel free to slide it to a higher or lower percentage to watch its effect, then return it to 35%, which keeps the inside of the cell dark but allows us to discern some of its details inside. To tone down the highlights, let's move the Darken Highlights slider to 60%. If the Midtone Contrast slider is assigned too high, it will begin to darken the shadows; let's set it to +12%: we can see improvements, however we will click Cancel to exit the dialog without applying the command.

5.2.1.2 Applying the Shadows/Highlights Command to a Selection

Instead of applying the command uniformly to the entire photograph, if the dark interior of the cell is isolated so that corrections can be made independently only there, the Darken Highlights, Lighten Shadows, and Midtone Contrast sliders will be more effective. Using the Quick Selection tool, or the Polygonal Lasso tool, we will select just the area *inside* the cell as shown in Figure 5.3, then assign a feather with Radius: 1 px.

Once we have done that, when the Shadows/Highlights command is chosen, we will keep the same default Lighten Shadows amount of 35%, then click the OK button to close the dialog box without making any adjustments to the highlights or contrast. Now let's choose Select>Inverse to select everything in the photograph *except* the inside area of the cell. When the Highlights/Shadows command is applied this time, we will keep the Lighten Shadows setting at 35%, drag the Darken Highlights slider to 75%, and adjust the Midtone Contrast slider to +50%—our first introduction to

Figure 5.3 Selecting an area to apply the Shadows/Highlights command to.

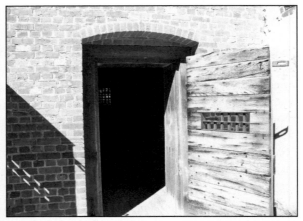

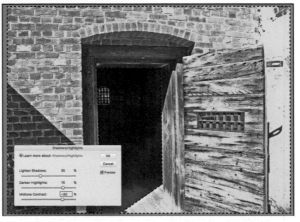

Figure 5.4 Before and after applying the Shadows/Highlights command to selected content.

the benefit of isolating selections for color and tonal adjustment. The before and after results of using a selection when applying the Shadows/Highlights command are shown in Figure 5.4.

5.2.2 Brightness/Contrast Command

The Brightness/Contrast command affects the overall brightness of an image, or a selection of an image if one is made prior to its application. We will explore both of these options beginning by applying the command to an entire image.

5.2.2.1 Applying the Brightness/Contrast Command to an Entire Photograph

Let's open the photograph named Brightness Contrast.jpg located in the Practice_ Import 12 files folder within the Practice Files folder you copied to your hard drive. Next, we will choose Enhance>Adjust Lighting>Brightness/Contrast. When the dialog box opens, we can assign separate Brightness and Contrast settings, starting from a neutral amount of 0. When the Brightness slider is dragged to the right, or a positive number is typed in the text field provided, the image is lightened. When the slider is dragged to the left, or a negative number is typed in the text field, the image is darkened. Following the same format, contrast is increased by dragging its slider to the right or typing a positive number in the field provided, or decreased by dragging its slider to the left or typing a negative number in the field provided.

With the settings shown in Figure 5.5 (Brightness: 70, Contrast: 30), the photograph is significantly lightened, but with the details of the sky still visible. Feel free to adjust these sliders higher and lower to further explore the power of this command; then close the file.

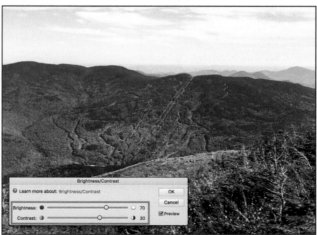

Figure 5.5 Applying the Brightness/Contrast command to an entire photograph.

5.2.2.2 Applying the Brightness/Contrast Command to a Selection

Let's reopen the Village.psd file we created in Chapter Four with its two saved selections of doors. If you chose not to complete Practice Project 1 in Chapter Four, a copy of the Village.psd file with the door selections saved and the Background copy layer and sky layers merged and locked is available in the Practice_Import 12 files folder within the Practice Files folder you copied to your hard drive.

Once the file is open, let's load the selection named "Doorway," then choose Enhance>Adjust Lighting>Brightness/Contrast. With settings of Brightness: 80 and Contrast: 15, the detail of the door which was lost in the original photograph, becomes visible. Once the adjustment has been made, the door can be deselected.

Now let's load the "Glass Door" selection. With this selection active, let's again choose Enhance>Adjust Lighting>Brightness/Contrast, then assign Brightness: 100, with no assignment for the contrast. In your own work, sometimes you will want to adjust only a photograph's brightness, sometimes only its contrast, and sometimes you will need to adjust both brightness and contrast.

The two doors are now much more visible, significantly improving the look of this photograph, as shown in Figure 5.6.

The doorway on the far right side of this photograph is also dark; however, the awning overhead makes this result logical. In your own work, always consider how natural light influences the tonal quality of an area in an image when making decisions on tonal adjustments so that the overall final appearance will still appear realistic. Choose to save and close this file.

Figure 5.6 Doors before and after applying the Brightness/Contrast command.

 When assigning values for tonal adjustments in the Shadows/Highlights dialog box and Brightness/Contrast dialog boxes, you can hold the Alt/Option key down at any time, which will convert the Cancel button to a Reset button you can click to start over without leaving the dialog box.

5.2.3 Understanding the Histogram Panel

 Let's open the photograph named Good Histogram.jpg located in the Practice_Import 12 files folder within the Practice Files folder you copied to your hard drive. We can tell when we look at this photograph that it has great tonal quality. However, let's learn why it does, how the Histogram panel displays the tonal range of any photograph we open in the Editor, and how the Histogram panel can help determine when some tonal correction is needed. We must first open the Histogram panel, which is only available in the Expert mode, by choosing More>Histogram or Windows>Histogram.

The Histogram panel displays an image's distribution of its tonal pixels ranging from its shadow on the left (starting with 0) to its highlight on the right (ending in 255).

When a photograph contains a full range of tones, it will display vertical bars across the entire graph, with the height of each vertical bar in the graph corresponding to the amount of brightness at that particular tonal range.

The more you use the Histogram panel, the more you will find it helpful. If you decide you want to have easy access to it all the time, separate it from its location with other panels and add it to your custom panel group of the Layers, Navigator, and History panels we learned to create in Chapter Four.

TiP

By default, the Histogram panel opens with its Channel menu displaying Colors. This drop down menu provides other methods of showing data: let's select RGB. A perfect histogram is one which includes data distributed from the far left to the far right, with the middle of the graph (midtones) rising up in a bell curve, as shown in Figure 5.7.

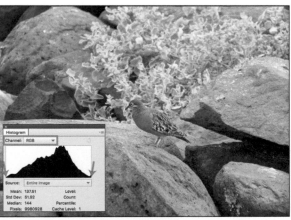

Figure 5.7 Histogram with tonal distribution across entire graph with a bell curve of its midtones.

However, what is more important than whether the image contains a perfect bell-shaped curve in the middle is whether there is content across the entire histogram. When no data appear on the left side of the histogram, it indicates that the image is overexposed. Conversely, when no data appear on the right side of the histogram, the image is underexposed. Let's learn how the Levels command can be used to correct the exposure when this happens.

5.2.4 Levels Command

Let's open the photograph named Levels Practice.jpg located in the Practice_Import 12 files folder within the Practice Files folder you copied to your hard drive. Once the photograph is open, we will save it as Cat.psd.

5.2.4.1 *Using the Levels Histogram*

When the Histogram panel is open with RGB selected from its Channel menu, we can see that although the photograph displays a bell curve, the right side of the histogram is empty: the reason the photograph is dark as shown in Figure 5.8.

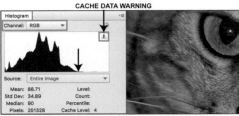

Figure 5.8 Histogram of cat photograph detailing missing data in the RGB channel.

Note that a Cache Data Warning triangle appears when changes are made to the photograph; when this icon is single clicked, the histogram updates to reflect the changes. Let's choose Enhance>Adjust Lighting>Levels to open the Levels dialog box. We can see when it opens that it replicates the Histogram panel, with three additional triangular sliders below the histogram: a black one for shadows on the left, a gray one for midtones in the middle, and a white one for highlights on the right. When the white triangle is dragged left to the edge of the content of the histogram, the photograph is lightened. With this adjustment applied, when the Histogram panel is open and the Cache Data Warning triangle is clicked, the histogram updates with a bell curve across the entire graph as shown in Figure 5.9. Although the Midtones triangle moves concurrently when either the Shadows or Highlights triangle is dragged, it can be moved independently if custom midtone adjustments are needed.

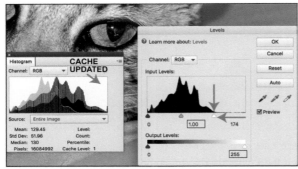

Figure 5.9 Levels applied to correct the tonal quality of the cat photograph, with cache updated in the Histogram panel.

Let's learn how the Levels command's eyedroppers can also be used for tonal correction. We will choose to undo our previous application of the Levels command to the cat photograph. To do that, without leaving the command dialog box, we can click the Reset button provided there.

NOTE▶ An Auto button is available in the Levels dialog box below the Reset button. This button works like the Enhance>Auto Levels command. Better results are usually achieved by the customization of its individual Shadows, Midtones, and Highlights Input Levels sliders. Additionally, Output Levels sliders are available below the Input Levels sliders. These sliders should be adjusted *only* if your printer does not produce dark or light enough tones.

5.2.4.2 Using the Levels Eyedroppers

Two eyedroppers in the Levels command allow us to specifically target a black or white point of an image for the Levels command to then reassign the tonal quality of the entire photograph based on the tone we sample. Its black eyedropper will allow us to click on an area that *should* be black, or we can select its white eyedropper and click on an area that *should* be white. (The gray eyedropper is used to remove a color cast, which we will learn to do later in this chapter.)

Because the photograph is dark, let's select the white eyedropper and click on the white area next to the nose of the cat: we are instructing the Editor to make this area "pure white." Once we do that, the tones are updated relative to this defined pure white area, and the image is significantly improved, with its histogram now

creating the bell curve shown in Figure 5.10. Conversely, if we were working with a photograph that was overexposed, we would want to click the black eyedropper on an area that needed to be converted to "pure black." Let's save this tonal correction and close this photograph for now, we will improve its color later in this chapter.

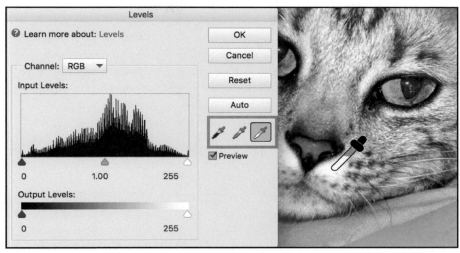

Figure 5.10 Using the Levels command white eyedropper to assign tonal quality to an image.

5.2.5 Curves Command

The Curves command improves the tonal quality of an image by allowing us to selectively adjust its highlights, brightness, contrast, and shadows. It is named "Curves" because an ideal application of the Curves command creates an "S" shape of points, as shown within its dialog box graph.

Let's open the photograph named Curves Practice.jpg located in the Practice_Import 12 files folder within the Practice Files folder you copied to your hard drive. Once this photograph is open and the Histogram panel is visible, we can see that there is missing data on the left side of the graph and a minimal amount on the right.

Let's choose Enhance>Adjust Color>Adjust Color Curves. When the dialog box opens, a variety of adjustment options appear on the left, referred to as Styles. Each of the style options applies changes to the Curves graph, with the ability to further adjust the application by dragging the sliders provided. It is important to note that more than one of the styles provided will often yield similar results; each one is simply a starting point. The exception to this is the Solarize style that will invert the colors. Feel free to scroll through the various styles, watching how the Histogram changes with each selection. Once you have done that, select the Default option, then adjust its sliders similar to those shown in Figure 5.11. The "S" curve is created, and the photograph is significantly improved. Once you have experimented with the tonal corrections available using the Curves command, close the file, optionally choosing to save it first if desired.

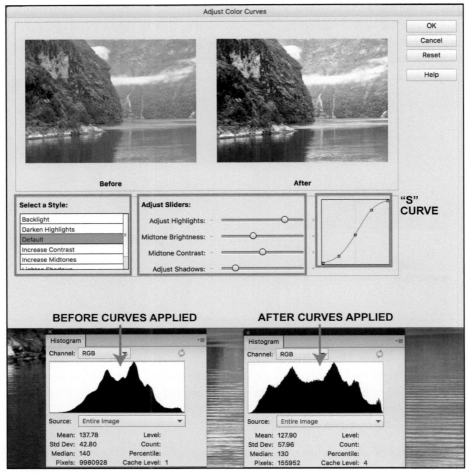

Figure 5.11 Using the Curves dialog box for tonal correction.

5.2.6 Using Blending Modes for Tonal Correction

Another way that the tonal quality of an image can be improved is to apply a blending mode to a duplicated Background layer. Applying a blending mode to a layer affects how the colors of the blending layer will mix with the layers below it. Although there are 24 blending modes available in the Layers panel to create a variety of special effects, two of them can be used for tonal correction: Screen to lighten and Multiply to darken. Let's open a photograph and apply a Multiply blending mode to improve its tonal quality.

Let's open the photograph named Multiply Blending Mode.jpg located in the Practice_Import 12 files folder within the Practice Files folder you copied to your hard drive. As we can see when this photograph opens, it contains only one layer but is slightly overexposed. Because a blending mode affects the layers below it, we will duplicate the Background layer by choosing Duplicate Layer from the Layer

menu or the Layers panel menu, or by Right/Control clicking the layer and selecting Duplicate layer from the context-sensitive menu that appears, or by simply pressing and dragging on the Background layer and releasing it on top of the Create a new layer icon.

Now with a second layer in this file, when we select the duplicated layer, the blending mode drop down menu becomes active. Let's press and hold on the word Normal and select Multiply from the blending mode choices. The photograph becomes darkened; however, we can reduce the effect of the blending mode by lowering the layer's opacity. Let's lower the Opacity setting for the Background copy layer to 50%, as shown in Figure 5.12.

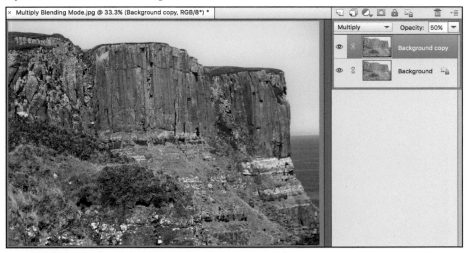

Figure 5.12 Using a blending mode to adjust tonal quality.

NOTE▶ If a photograph is underexposed, duplicate the Background layer, then with the Background copy layer selected, choose Screen from the blending mode drop down menu. Once the blending mode has been applied, the lightening effect can be reduced if desired by lowering the opacity of the Screen blending mode layer.

5.2.7 Haze Removal

Haze can be removed from a photograph using either the Auto Haze Removal command or the Haze Removal dialog box. Let's take a look at these two options using the photograph named Haze Removal.jpg located in the Practice_Import 12 files folder within the Practice Files folder you copied to your hard drive.

5.2.7.1 *Auto Haze Removal Command*

Once this photograph is open, when we look at the Histogram panel, we can see missing data on the left side of the graph. When we choose Enhance>Auto Haze Removal, the graph expands, and the photograph is significantly improved.

Sometimes this one click command can produce amazing results. Let's choose to undo this command and assign this correction instead using the Haze Removal dialog box.

5.2.7.2 Haze Removal Dialog Box

From the Enhance menu, we will select Haze Removal. The dialog box shown in Figure 5.13 opens. When we drag the Haze Reduction slider all the way to the right, the image becomes clearer and richer. We can adjust the Sensitivity slider as well, or keep it at the default setting. When we look at the Histogram panel now, data displays across the entire span of the graph.

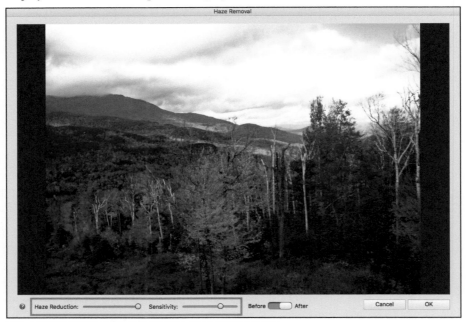

Figure 5.13 Applying settings in the Haze Removal dialog box.

 Although no Reset button is visible in the Haze Reduction dialog box, at any time you can hold down the Alt/Option key which will convert the Cancel button to a Reset button and you can click to start over without leaving the dialog box. The title bar can also be dragged to expose the original image below it so that you can compare before and after views of the effect simultaneously instead of using the Before/After button provided.

5.3 Using Adjustment Layers

Adjustment layers can be thought of as sheets of "cellophane" floating above an image that allow a correction command to be "tested" before being *permanently* applied. Although adjustment layers may initially sound similar to blending modes, they are actually duplicate correction commands of some counterparts available under the Enhance menu. What sets them apart, and makes them particularly

valuable to an expert, is their reversibility. Often described as "nondestructive," an adjustment layer is not actually applied until it is merged down. Applying corrections as adjustment layers provides the following additional advantages:

- The command settings can continue to be reassigned until the adjustment layer is merged down.

- A layer visibility icon provides the ability to turn the command off and on to easily evaluate its effectiveness.

- An adjustment layer's Opacity setting can be reduced to lower the effect of the correction command.

- A layer mask is applied by default when an adjustment layer is added, allowing further customization of the effect of the command if needed.

- An adjustment layer can be deleted at any time until it is merged down.

Two of the tonal commands we have already learned—Brightness/Contrast and Levels—can be applied as adjustment layers. As an expert, when a command can be applied as an adjustment layer, best practice will be to incorporate the flexibility and additional options it will provide for you.

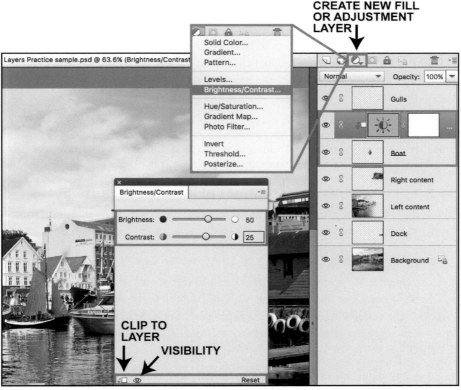

Figure 5.14 Applying a Brightness/Contrast adjustment layer clipped to affect only one layer.

We will reopen the Layers Practice.psd file we worked with in Chapter Four and add an adjustment layer to it. Once the file is open, we will select the Boat layer. Based on its distance in the photograph, it would be logical for it to be slightly

lighter in tone than it currently is. Let's press and hold on the Create new fill or adjustment layer icon and select Brightness/Contrast from its menu options, then assign Brightness: 50, Contrast: 25. (Alternatively, choose Window>Adjustments to open the

Figure 5.15 Assigning the Clip to layer option using the Alt/Option key.

Adjustments panel, then select Brightness/Contrast from its panel menu.) As soon as we do that, all of the layers below it become lighter. In your own work, sometimes you will want an adjustment layer to affect all of the layers below it and sometimes you will want it to affect *only* the layer directly below it. We will click the Clip to layer icon at the lower left of the adjustment layer panel to apply the effect to *only* the layer directly below it. Once we have done that, the adjustment layer icon in the Layers panel becomes indented, a small arrow is added to indicate the adjustment layer has been applied to only the boat layer, and an underscore is added to the boat layer's name, as shown in Figure 5.14.

In addition to the Clip to layer and visibility icons provided for an adjustment layer, a Reset button allows you to start over. However, once settings have been applied to an adjustment layer, if it is reopened and changes are made, the Reset button will return the settings to those applied when the adjustment layer settings were reopened, not to the original state.

 An alternative to clicking the Clip to layer icon to apply an adjustment layer to only the layer immediately below it is to hold down the Alt/Option key while clicking on the line between the adjustment layer and the layer below it. As soon as the box and down arrow icon shown in Figure 5.15 appears, single click to apply the clip.

5.3.1 Decreasing the Effect of an Adjustment Layer

The opacity of an adjustment layer can be reduced; moreover, areas of an adjustment layer can be removed or their opacity lowered.

5.3.1.1 *Reducing the Opacity of an Adjustment Layer*

Let's reopen the file named Tonal Correction.psd that we saved with a selection in Chapter Four. Once the file is open, we will load the saved selection named "Rocks," then choose to add a Levels adjustment layer (Create new fill or adjustment layer>Levels) to the selection. To improve the tonal quality of the rocks, we will drag the Highlights slider to 130. Notice that, because we applied an adjustment layer to a selection, the mask icon of the adjustment layer identifies the selected area in white. We can lower the opacity of an adjustment layer to reduce its effect on the layer(s) below it. With the adjustment layer selected, let's assign Opacity: 80%, as shown in Figure 5.16.

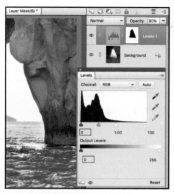

ADJUSTMENT LAYER
TO A SELECTION WITH
LAYER OPACITY REDUCED

ADJUSTMENT LAYER
MASK REDUCED

Figure 5.16 Lowering the opacity of an adjustment layer versus painting the mask of an adjustment layer.

5.3.1.2 Reducing the Mask Opacity of an Adjustment Layer

An alternative to reducing an adjustment layer's effect on the image below it, or to the selection it has been applied to, is to apply an adjustment layer to an entire layer, then reduce the opacity of some areas of its mask.

Let's use the History panel to return to the opening state of this file. This time we will choose not to load the saved selection. Without loading the selection, we will add a new Levels adjustment layer to the entire image. Although some content exists across the entire histogram, when the Highlights slider is dragged to the edge of the main content in the graph (Highlights: 120), the detail in the distance is lost. Let's select the Brush tool in the Tools panel. With an Opacity setting in the Tool Options bar of 100%, the default colors of black as the foreground color and white as the background color, and the *mask* selected in the adjustment layer, we will "paint" the background back in. Once we have done that, let's reduce the Opacity setting of the Brush tool to 50%, then paint over the rock formation on the right to reduce the effect of the adjustment layer in that area, without removing it completely. (Alternatively, a mask can be painted with gray at 100% opacity to also lower the effect of the mask: lighter shade to remove less, darker shade to remove more.) We can see that the mask icon of the adjustment layer now reflects the removal of the adjustment layer effect in the middle area (black) and its partial removal on the right (gray), as also shown in Figure 5.16.

NOTE▸ The layer mask that is added automatically when an adjustment layer is applied can be deleted, disabled, or unlinked by choosing Layer>Layer Mask, or in the Layers panel by Right/Control clicking on the adjustment layer mask and selecting Delete or Disable from the context-sensitive menu that appears, or unlinked by clicking the chain between the adjustment layer icon and its mask.

Close this file now, optionally choosing first to save the file with a Levels adjustment layer applied to it.

5.4 Color Correction

Working in the Organizer, we can select a photograph, enter the Instant Fix editor, then click its Smart Fix or Color button to have the Organizer analyze the photograph and provide basic color correction options that we can select from.

Working in the Editor Quick mode, three of its Adjustments panel options also allow the Editor to analyze an image for us and provide basic selections for improving its color: Smart Fix (select from options the Editor determines the photograph needs to improve it), Color (adjust basic Saturation, Hue, and Vibrance settings individually or select the Auto option), and Balance (adjust Temperature and Tint settings individually from the options provided).

Let's begin working in color correction in the Expert mode by understanding how the RGB color wheel works and how it relates to the color correction options available from the Enhance menu.

5.4.1 The RGB Color Wheel

The diagram shown in Figure 5.17 details the RGB color wheel, with the arrows provided identifying the relationship between the colors. For example, when a

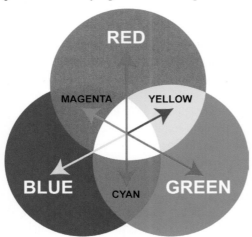

photograph appears to have an overall magenta appearance, it is corrected by adding the color directly across from it in the color wheel—green. Becoming familiar with the relationship these colors have to each other will help you become an expert at color correction.

Figure 5.17 RGB color wheel.

5.4.2 Understanding Color Cast

When an image is dominated by a color in the RGB color wheel that negatively shifts all of the rest of the colors in the photograph toward it, the image is described as having a color cast.

Let's open the photograph named Color Cast.jpg located in the Practice_Import 12 files folder within the Practice Files folder you copied to your hard drive. When this image opens, we can see that the photograph contains a yellow color cast. When studying the RGB color wheel, we can see that a yellow color cast will be corrected by adding blue to the image.

5.4.3 Applying the Auto Color Correction Command

We will begin correcting this photograph by choosing Enhance>Auto Color Correction. When we do that, the color is significantly improved. However even though the image no longer contains the yellow color cast, it now actually has a slight blue color cast identified by studying things like the bricks at the left side of the photograph and the sidewalk pavement color along the water.

Sometimes this single quick and easy command can provide great results. However, when it is unable to completely remove a color cast, or provides a new opposite cast by *overly* compensating, a more advanced method of color cast correction may be needed. Let's use the History panel to undo this application and apply user input into the color cast correction for this photograph.

5.5 Advanced Color Cast Correction

A color cast can typically be removed more effectively by specifically targeting an area within a photograph using either the Remove Color Cast command or the Levels command.

5.5.1 Using the Remove Color Cast Command

With the Color Cast.jpg image back to its original opening state, let's choose Enhance>Adjust Color>Remove Color Cast. An eyedropper appears, along with the directive to click on an area of the image that should be gray, white, or black.

Try clicking in a few different areas to watch how the color cast changes as different areas are selected. There is no need to click the Reset button each time; when a new area is clicked, it overrides the previous sampling. Once you have experimented with the eyedropper tool, click it on the cobblestone walkway at the left of the image, as shown in Figure 5.18.

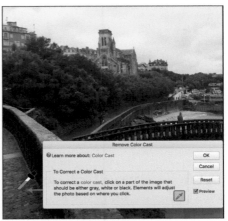

When you are done exploring the possibilities of this command, close the file, optionally choosing to save it first.

Figure 5.18 Using the Remove Color Cast eyedropper to correct color.

5.5.2 Using Levels for Color Cast Correction

The Levels gray eyedropper allows us to click an area of a photograph that "should" be gray and have all of the colors within the photograph be reassigned relative to the color we have selected to be true gray.

Let's open the photograph named Levels Color Cast.jpg located in the Practice_ Import 12 files folder within the Practice Files folder you copied to your hard drive. In this wooden shoe shop, the metal on the equipment in the foreground should be gray. Because we will always want the flexibility of applying a command as an adjustment layer, let's choose to apply the Levels command as one.

When the gray eyedropper is selected and then clicked on a variety of metal areas of the machinery in the foreground of this image, it becomes more and less blue—

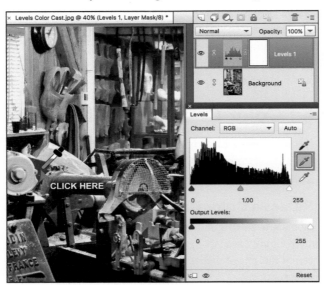

the color opposite to yellow in the RGB color wheel. After experimenting by clicking on different parts of the equipment, select an area comparable to the one shown in Figure 5.19, which effectively neutralizes the grays and removes the color cast. Close this file, optionally choosing to save it first if desired.

Figure 5.19 Using the gray eyedropper of the Levels command to remove a color cast.

5.5.3 Using the Hue/Saturation Command

The Hue/Saturation command can be used to remove a slight color cast, to add or remove saturation, or to colorize an image or a selection of an image.

5.5.3.1 Removing a Color Cast

Let's reopen the Cat.psd file we previously saved. Although the tonal quality was corrected in this photograph, it contains a slight red color cast. One way this can be removed is to lower the saturation of the photograph. The Hue/Saturation command is assigned by choosing Enhance>Adjust Color>Adjust Hue/Saturation or is available as an adjustment layer. Because we have learned that best practice is to apply a correction as an adjustment layer whenever possible, we will click the Create

new fill or adjustment layer icon and select Hue/Saturation from its down arrow menu. When the Hue/Saturation command dialog box opens, it contains sliders for Hue, Saturation, and Lightness.

One way we can remove the red cast is to drag the Saturation slider slightly to the left, which will remove the color cast; however, it will also lower the saturation of the entire photograph. Let's choose to specifically target the reds in this image instead. From the Channel drop down menu, instead of keeping it on the default

setting of Master, let's select Reds. Now when the slider is dragged to a negative number, we are affecting the reds in the image, not all of the colors of the image. With the Channel set to Reds and the Saturation slider dragged to –59, the red color cast is removed as shown in Figure 5.20. Let's choose to save and close this file.

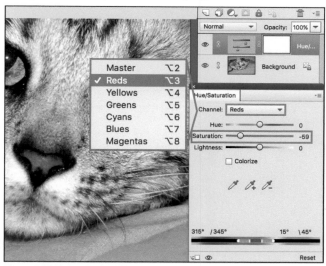

Figure 5.20 Using the Hue/Saturation command to adjust a color cast.

5.5.3.2 Adding or Removing Saturation From a Photograph

Sometimes a photograph is overly saturated or lacks saturation. Applied from the Enhance menu (Enhance>Adjust Color>Adjust Hue/Saturation) or as an adjustment layer, the Hue/Saturation command can provide quick and effective saturation correction.

Let's open the photograph named Adding Saturation.jpg located in the Practice_ Import 12 files folder within the Practice Files folder you copied to your hard drive and save it as Dunes path.psd.

When this photograph opens, we can see in the Histogram panel that the image is somewhat underexposed but is also dull. Although we will not want to add so much saturation to the image that it will appear fake, it can use some color enhancement. We will first lighten it by applying the Levels command as an adjustment layer. Once the adjustment layer has been added, we will assign Highlights: 214.

Multiple adjustment layers can be applied to an image. With the Levels adjustment layer selected, let's choose to add a Hue/Saturation adjustment layer above it. For this adjustment layer, with the Master channel selected, we will adjust the Saturation

slider only to +40. With this photograph significantly improved, we will save and close this file for now.

NOTE► When a photograph needs saturation removed, drag the Saturation slider of the Hue/Saturation dialog box to the left to assign a negative number. Be careful how far to the left the slider is dragged; dragging the slider all the way to the left is one way to *desaturate* a photograph. When a photograph appears overly saturated, a great number to start with is Saturation: −20, then raise or lower the number as needed until the colors in the image look natural.

5.5.3.3 *Shifting the Hue of an Image or Selection of an Image*

Sometimes you may want to apply a slight adjustment to the overall color of a photograph or selection of a photograph. The image may not actually have a color cast; it may just be more aesthetically pleasing with a slight hue shift.

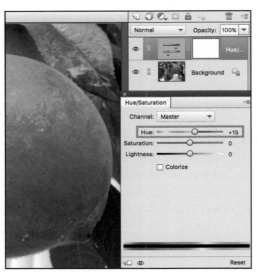

Figure 5.21 Applying a Hue adjustment using the Hue/Saturation command.

Let's open the photograph named Peaches.jpg located in the Practice_Import 12 files folder within the Practice Files folder you copied to your hard drive. When this image opens, the peaches are beautiful but appear red rather than orange in their color. This can be adjusted using the Hue/Saturation command, which we will apply as an adjustment layer. With the Channel drop down menu kept at the default setting of Master, when the Hue slider only is dragged to the right to a setting of +15, the leaves are still green; however, the peaches appear more natural as shown in Figure 5.21.

5.5.3.4 *Applying the Colorize Option of the Hue/Saturation Command*

The Colorize option of the Hue/Saturation command can be used to convert all the colors of an image or a selection of an image to lights and darks of a single selected color. Let's reopen the House Selection.psd file we saved in Chapter Four, then load its saved selection named "Roof Selection." Let's choose to brighten and unify the color of the tiles on this roof. We will need to check the Colorize radio button *first*; then, when the settings are applied (Hue: 10, Saturation: 21, and Lightness: 0), the roof color is changed to a unified rich tile color as shown in Figure 5.22.

Feel free to drag the Hue slider and watch how the roof color changes, or try the other sliders when the Colorize option is assigned, then close this file, optionally choosing to save it with this Hue/Saturation adjustment layer added to the file.

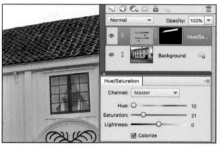

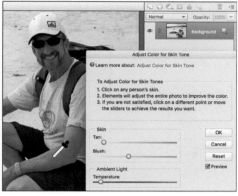

Figure 5.22 Applying the Colorize option of the Hue/Saturation command.

Figure 5.23 Assigning settings for the Adjust Color for Skin Tone command.

5.6 Adjusting Skin Tone

Skin tones can be adjusted using the Adjust Color for Skin Tone command or the Replace Color command.

5.6.1 Adjust Color for Skin Tone Command

Let's open a photograph that you will have in your Practice Catalog if you chose to incorporate the Organizer chapters in your learning. If not, located in the Practice_ Import 4 folder, open file 100_2684.jpg. When this photograph opens, we can see that the skin color is overly red in its appearance. The Adjust Color for Skin Tone command provides an eyedropper to select an area of skin. Using the sampled tone, the Editor adjusts *all* of the colors in the image, not only the skin tone we target. The newly assigned colors can be further adjusted by dragging the Tan slider to raise or lower the brown tone, the Blush slider to raise or lower the red tone, and a Temperature slider to apply an overall shift toward warmer or cooler colors throughout the photograph.

Let's click the eyedropper on the arm to target the skin tone and then adjust the Tan, Blush, and Ambient Light Temperature settings as shown in Figure 5.23. The colors have been shifted so that the skin color appears more natural but is still saturated. Let's undo this application and learn another way to shift skin tone colors, or any selected range of colors in a photograph using the Replace Color command.

When an Enhance menu command does not provide the option to assign it as an adjustment layer, by assigning the command to a duplicated Background layer, you will be able to lower the opacity of the effect as well as hide or delete the effect if desired.

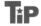

5.6.2 Replace Color Command

Because the Replace Color command is not available as an adjustment layer, let's choose to duplicate the Background layer, so that we will have more flexibility in its application. Once we have done that, with the Background copy layer

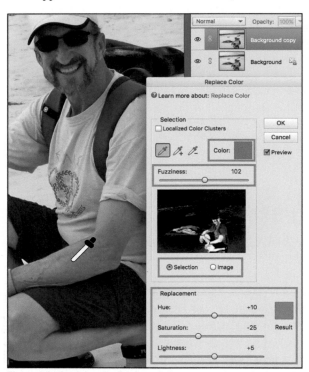

selected, we will choose Enhance>Adjust Color>Replace Color. When the dialog box opens, its eyedropper tool is used to select a color we want to replace. The eyedropper can be clicked within the dialog box in the preview area provided or clicked outside the dialog box on the image itself. When applied to either an entire image or a selection of an image, its Fuzziness slider can be thought of as a "fussiness" setting; the higher the number, the "less fussy" or the broader the range of colors that will be affected. The Selection radio button shows the affected colors

Figure 5.24 Applying the Replace Color command to a duplicated Background layer.

as light areas, with the Image radio button displaying the photograph in full color. Replacement sliders provide the ability to assign one or more correction options of Hue, Saturation, and Lightness.

Let's click the eyedropper on the lower half of the person's arm as shown in Figure 5.24, then assign a Fuzziness setting of 102. At this setting, all of the skin tones will be affected, without bleeding into the clothes or background colors. The color we selected displays at the top half of the dialog box and currently also at the bottom. As the replacement sliders are adjusted, the replacement color at the bottom updates dynamically to reflect the changes. We will assign Hue: +10, Saturation: –25, and Lightness: +5. The skin becomes more natural in its color and tone, with minimal effect on the rest of the colors within the photograph. When the Background copy layer's visibility is turned off, then on again, we can see the dramatic improvement in skin color provided by this command and the minor effect it had on the two seals in the foreground area of the image.

This command is not just helpful for skin tones but is effective for any color of a photograph that you want to alter. Feel free to brighten the sky by sampling the sky, lowering the Fuzziness slider to 50, then dragging its Saturation slider only to +60. The overcast sky becomes bright blue! **TiP**

Let's choose to close this file, optionally choosing first to save it as Replace Color. psd with its duplicated Background layer and Replace Color command applied.

5.7 Using Filters for Color Correction

Two filters available under the Filter>Adjustments menu can also be helpful for color correction: the Equalize filter for tonal adjustment and the Photo filter for color adjustment. Although these filters replicate other correction methods we have learned, they provide additional ways to achieve your correction goals. Let's explore each of these filters, beginning with the Equalize filter.

5.7.1 Applying the Equalize Filter for Tonal Adjustment

This filter provides an overall lightening effect by redistributing brightness values. It can be applied to an entire image or to a selection. When a selection is made prior to its application, a dialog box allows us to choose to apply the filter to only our selection, or use the pixels within our selection to determine the application of the filter to the entire image.

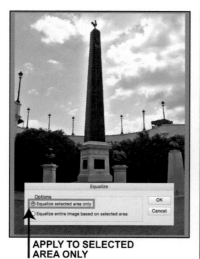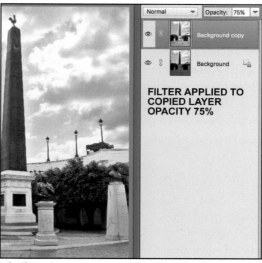

Figure 5.25 Applying the Equalize filter to a selection

Let's open the photograph named Equalize Filter.jpg located in the Practice_Import 12 files folder within the Practice Files folder you copied to your hard drive. When this image opens, we can see that the foreground is considerably darker than the sky. Let's first choose to duplicate the Background layer to allow us to be able to lower its effect if needed once the filter has been applied. Because the Equalize filter will

redistribute the brightness of this image, if no selection is made, the sky will actually get *darker* to match the foreground—not what we want. However, if a selection of the foreground is made, we will be telling the Editor what we want to affect and how we want to affect it.

As we have learned, the easiest way to do this will be to select the sky, then choose Select>Inverse. Using any selection method that works best for you, select the sky now, then invert the selection (the Magic Wand tool with a Tolerance setting of 60 when clicked in a blue area of the sky will work well). Once the selection is made, the Histogram details that the selection is underexposed. With the Background copy layer chosen and the selection active, let's choose Filter>Adjustments>Equalize. A dialog box opens with the options of Equalize selected area only and Equalize entire image based on selected area, as shown in Figure 5.25. Because the sky looks great, we will not want the filter to affect it. When we choose the Equalize selected area only option, the foreground selected area becomes immediately significantly lighter—a little too light actually. However, because we chose to duplicate the Background layer, we can reduce its effect. When the Background copy layer opacity is reduced to 75%, the overall tonal quality of the image looks great, with the results also shown in Figure 5.25.

5.7.2 Applying the Photo Filter for Color Adjustment

We have learned about color casts and how to remove them. Sometimes you may *want* an overall dominant hue for effect or to enhance color when it appears dull or slightly off.

Let's open the photograph named Photo Filter.jpg located in the Practice_Import 12 files folder within the Practice Files folder you copied to your hard drive. The Photo filter emulates adding a color filter to the lens of your camera. This photograph contains a great Histogram: an almost perfect bell curve. However, because of the colors of the lupines, let's enhance them a little with a filter by choosing

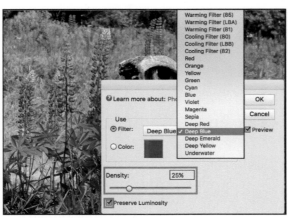

Figure 5.26 Applying a photo filter to an image.

Filter>Adjustments>Photo Filter. When the dialog box opens, a variety of color filter options are available from a drop down menu, as well as a Color option allowing us to select a custom color instead. With the Preview option checked, we will choose the Deep Blue filter to enhance the purple color of the lupines. Density can be thought of a percentage of application:

the higher the percentage, the more predominant the effect. The Preserve Luminosity checkbox is assigned by default to keep the filter application from darkening the image depending on the color chosen when the color shift filter effect is applied with the settings shown in Figure 5.26. Feel free to experiment with a variety of filter and color settings using this image, then close the file.

The Photo Filter command can also be applied as an adjustment layer by choosing Create new fill or adjustment layer, then selecting Photo Filter from the down arrow menu. When applied as an adjustment layer, you will have more control over its effect, with the ability to adjust the opacity of the filter application.

5.8 Converting a Color Photograph to Black and White

Black and White photography (hereafter referred to as "grayscale"), continues to be popular. The Editor provides the ability to create a grayscale image in all three of its editing modes. Three options are available in both the Quick and Expert modes: choosing Image>Mode>Grayscale, assigning the Remove Color command, and assigning the Convert to Black and White command. In the Guided mode, the Black and White option can be selected from its Black and White category. Let's examine the Quick and Expert options first, beginning with converting the color mode from RGB to Grayscale.

Let's open the photograph named Convert to B-W.jpg located in the Practice_Import 12 files folder within the Practice Files folder you copied to your hard drive.

5.8.1 Converting a Photograph to the Grayscale Mode

One way to eliminate color from a photograph is to convert its color mode from RGB to Grayscale by choosing Image>Mode>Grayscale. However, if this option is chosen, a dialog box warns that the color will be permanently discarded. If you click OK, the file size will decrease, with some of the features of the Enhance menu still available, while others that require a photograph to be in the RGB color mode will be grayed out.

Feel free to try this, noting the significant decrease in its document size in the Status bar once applied, the reduction of available commands under the Enhance menu, and the new great histogram, and then return to the opening state of the History panel.

5.8.2 Remove Color Command

Let's choose Enhance>Adjust Color>Remove Color. Simple and straightforward—the file is still in the RGB color mode and all of the Enhance menu commands are still available; however, the color is removed. Compared to the conversion to grayscale, this image now lacks lights, visible in the ceiling area and in the histogram. Let's return to the opening state of the History panel one more time.

5.8.3 Convert to Black and White Command

Let's choose Enhance>Convert to Black and White. Once we do that, the dialog box that opens provides a variety of settings referred to as Styles on the left, with intensity settings available on the right. These sliders put us in control of the tonal quality of the resulting grayscale photograph. The specific names given to the styles do not limit their application; any style that works can be applied to any type of image. The photograph remains as RGB, with the three channels of the image (Red, Green, and Blue) provided as intensity sliders to adjust their individual impact on the resulting grayscale appearance, plus a Contrast slider. Feel free to experiment with a variety of styles and settings; then try the settings shown in Figure 5.27 for a rich contrast grayscale appearance. Once you have done that, close this photograph, optionally choosing to save it.

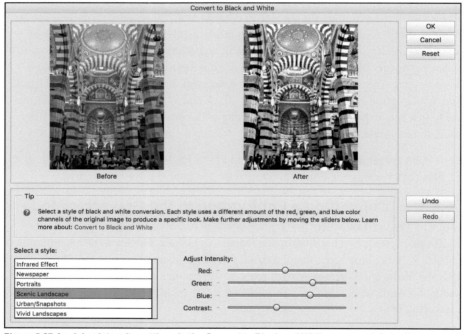

Figure 5.27 Applying intensity settings in the Convert to Black and White command dialog box.

Another way to convert an image to grayscale and retain some control over its resulting tonal quality is to apply the Hue/Saturation command with Saturation: −100 to the RGB photograph, then apply the Levels command to enhance the tonal quality of the grayscale appearance.

5.9 Processing Multiple Files

If you have multiple images that suffer from the same type of correctional needs, you can choose File>Process Multiple Files: the dialog box shown in Figure 5.28 opens. The source of the files and destination for the corrected files must be selected. Once

you have done that, Quick Fix, renaming, resizing, and watermark options can be assigned to apply to all of the images in the chosen source folder.

While many times your photographs will need individual custom corrections, when a group of photographs taken at an event are all underexposed or overexposed, this dialog box offers a quick way to batch adjust them. Another advantage of this dialog box is its easy file conversion feature. We have learned that working in the PSD file format is best. This dialog box offers a quick and easy way to save these corrected PSD files as high quality JPEG files once you are done working on them by choosing the File Type>Convert Files to>JPEG Max Quality option identified in Figure 5.28.

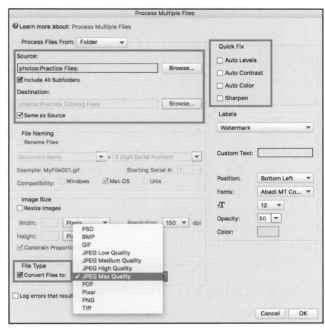

Figure 5.28 Process Multiple Files dialog box.

5.10 Using Tools for Color Correction

Another way that color correction can be applied to a photograph is by using one of the tools available in the Tools panel of the Expert mode. Rather than a correction command applied to an entire photograph or a selection, the Dodge, Burn, Sponge, Color Replacement, and Smart Brush tools allow us to "paint" the desired enhancement directly onto a specific area of a photograph. Let's experiment with each of these tools, beginning with the Dodge tool.

5.10.1 Using the Dodge Tool

Let's open the photograph named Dodge-Burn-Sponge.jpg located in the Practice_ Import 12 files folder within the Practice Files folder you copied to your hard drive. Once we have done that, let's duplicate the Background layer. Although this is not a requirement when using any of these tools, it will allow us to compare any improvements with the original unedited Background layer. In your own work, it also offers an easy way to delete applications and start over if needed.

In the Enhance section of the Tools panel, when the Sponge tool is selected, the Tool Options bar displays the Sponge tool, the Dodge tool, and the Burn tool as shown in Figure 5.29.

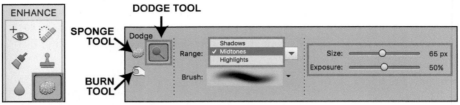

Figure 5.29 Choosing the Dodge tool and settings.

When we select the Dodge tool, its options of Range, Brush style, Size, and Exposure settings become available. Its default Range setting of Midtones typically works well; targeting Shadows or Highlights instead would be needed only when applying the tool to extreme dark or light areas. Exposure can be thought of as a "pressure" setting: although 50% is the default, lowering it to 20% or so provides more control when applying the tool.

The shadows on the rock formation could use some lightening. With the Range set to Midtones, the default Brush style assigned, a Size relative to the sample shown (325 px), and Exposure set to 20%, we will paint the dark areas as shown in Figure 5.30. We will want to lighten them, but not to the point that the shadows disappear.

5.10.2 Using the Burn Tool

Let's now select the Burn tool. We can see that it offers the same options in the Tool Options bar as the Dodge tool. We will keep the Range set to Midtones, keep the default Brush style, then assign Size: 100 px and Exposure: 20%. Let's brush across the rocks in the foreground to darken them as also shown in Figure 5.30.

5.10.3 Using the Sponge Tool

The Sponge tool can be used to saturate or desaturate an area. When the tool is chosen, its Mode setting menu toggles between Saturate and Desaturate. Its Brush and Size options echo those we have just used with the Dodge and Burn tools. Its Flow setting is also like a "pressure" setting; although the default setting is 50%, a lower amount such as 20% offers more control of its application.

5.10.3.1 Applying the Desaturate Mode

The rocks in the foreground appear to have a slight red color cast. Let's apply the Sponge tool, then assign Mode: Desaturate, Brush: default, Size: 65 px (designating a small brush to control its application), and Flow: 20%. It will be important to apply the brush just enough to eliminate the red cast without discoloring the brown tones of some of the rocks, as with the results shown in Figure 5.30.

5.10.3.2 Applying the Saturate Mode

When the Mode drop down menu is toggled to select Saturate, all the rest of the options in the Tool Options bar are identical to those for the Sponge tool in its Desaturate mode. We will apply the same brush style and size used to desaturate the rocks to now saturate the grass. Feel free to also saturate the foliage on the rock formation where we dodged its dark areas if you would like a result similar to that shown in Figure 5.30; then close this file, optionally choosing to save it.

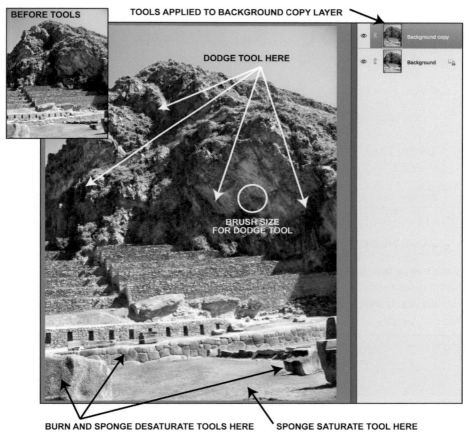

Figure 5.30 Applying the Dodge, Burn, and Sponge tools.

When using the Dodge, Burn, and Sponge tools, if a crisp edge is required, such as for coloring the rock formation without any splash-over into the sky, a selection should be made prior to applying one of the tools so that the tool's effect will be restricted to the inside of the selection.

5.10.4 Using the Color Replacement Tool

The Color Replacement tool allows us to select a color and paint over an area to enhance or replace the color while retaining all details, highlights, and shadows of the original color. It can be used to completely *change* the color of an object, such as

a car, clothing, etc., or be used to *enhance or adjust* an area of color when applying the Sponge tool does not give the color saturation desired.

The Color Replacement tool is grouped with the regular Brush tool in the Draw section of the Tools panel. Once the Brush tool is selected, the Color Replacement tool can be chosen and its settings assigned in the Tool Options bar. Let's take a look at its settings, as shown in Figure 5.31:

SIZE: Provides a slider to assign the brush size.

TOLERANCE: Assigns the range of the effect (lower for more similar colors); its default amount of 30% works well.

MODE: Provides a drop down menu with four choices for how the tool will blend with the colors it replaces; the default Color mode keeps the tonal quality of the original color and is usually the best choice.

LIMITS: Two radio buttons available to affect the size of the area the tool replaces; the default choice of Contiguous works well.

BRUSH SETTINGS: Controls for changing the hardness, size, and roundness of the brush.

SAMPLING METHODS: Continuous, Once, and Background Swatch options are provided, with the default of Continuous constantly sampling colors as you drag the tool working well.

ANTI-ALIASING: Provides the option to assign anti-aliasing and is checked by default.

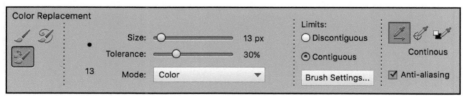

Figure 5.31 Options for the Color Replacement tool.

The tool paints with the foreground color. A color can be sampled from within the photograph by holding the Alt/Option key and single clicking on a color in the image you want to use. Alternatively, the foreground color in the Tools panel can be single clicked to open the Color Picker to select a color to paint with. If the original file 100_2684.jpg is reopened, feel free to paint the clothes with any colors of your choice. The sample shown in Figure 5.32 uses an RGB shirt color with values R: 118, G: 169, and B: 239; the shorts color uses values of R: 15, G: 61, and B: 123. The color application uses the default settings of Tolerance: 30%, Mode: Color, Limits: Contiguous, Sampling: Continuous, and Anti-aliasing checked, with brush styles and sizes as appropriate when painting.

NOTE▶ When painting with the Color Replacement tool, it is not necessary to be extremely accurate when painting the edges of an area you are filling with a new color. If you accidentally go outside the boundaries of the area you want to paint, sample the color it should be, and paint over the spillage; the new sampled color will replace the color painted in error.

5.10.4.1 Using the Color Picker

The Color Replacement tool is one of the tools that utilizes the Color Picker. When a custom color is desired for a new foreground color, single click the foreground color in the Tools panel to open the Color Picker. The color slider is dragged up or down to select a color. Once a color is chosen from the slider, the light to dark options on the left allow you to select a tint or shade of the color selected. The new color is identified with its RGB values, its HSB values, and its web equivalent, as shown in Figure 5.33. When using the Color Picker, if the pointer is moved outside of the Color Picker, it becomes an eyedropper to sample a color within the image. When one is selected, the color will be identified within the Color Picker and will replace the previously selected color.

Figure 5.32 Changing the color of clothing and skin tone using the Color Replacement tool.

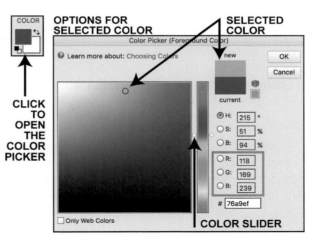

Figure 5.33 Selecting a color using the Color Picker.

The Color Replacement tool provides another method of adjusting skin color. If the original skin color is sampled first, in the Color Picker a slightly lighter color can be chosen (e.g., R: 247, G: 190, B: 176). This new color can be painted over all of the skin areas to remove the excess red cast, as also shown in Figure 5.32.

5.10.5 Using the Smart Brush and Detail Smart Brush Tools

The Smart Brush and Detail Smart Brush tools can be used to apply a variety of effects by simply painting them on. The Smart Brush tool is located in the Enhance section of the Tools panel in the Expert mode. When the tool is selected, the Tool

Options bar updates with the choice of the Smart Brush tool or the Detail Smart Brush tool with a down arrow menu of application presets. Additional options include assigning Brush Settings, Size, Inverse, and Refine Edge.

5.10.5.1 Using the Smart Brush Tool

The Smart Brush tool paints the preset effect chosen by creating a selection, with the ability to add or delete from the selection. The effect is added as an adjustment layer, offering the opportunity to hide it, lower its opacity, change its settings, adjust its mask, or delete it altogether. Although the Smart Brush tool can be used to add a variety of special effects such as textures and patterns, we will learn to use it by applying its color correction capabilities.

Let's open the photograph named Smart Brush.jpg located in the Practice_Import 12 files folder within the Practice Files folder you copied to your hard drive, then select the Smart Brush tool in the Tools panel. From the Presets menu, we will select the Nature preset from its drop down menu, then the preset named "Darken Skies." When a brush size such as 80 px is selected with its default settings chosen, we will drag from the edge of the sky above the trees to the top of the photograph. A small colored square called a "Smart Brush adjustment pin" appears at the beginning of the area we selected, and a Gradient Fill adjustment layer is added with a mask and an Opacity setting of 75%, plus a blending mode of Color Burn—all added for us. Each feature of this Smart Brush tool application can be edited. Although we have not yet learned about gradients, if the icon in the adjustment layer is double clicked, its colors and settings can be edited.

Let's add another Smart Brush tool application. To do that, we will select the Background layer first. Once we have done that, we will select the "Intensify Foliage" preset, also available from the Nature presets category. We will keep the same brush settings, then paint the water and trees along the shore, including the rails but excluding the path and bridge. We can see that the new adjustment layer includes the Hue/Saturation command. Let's double click the Hue/Saturation icon and increase the saturation a little, dragging its Saturation slider to 15%.

Let's select the Background layer again. We will add one more Smart Brush tool application. This time we will select Color from the Presets drop down menu, then the "Button Down Brown" color. With the same brush settings chosen, we will paint in the dirt path and bridge planks. Once we have done that, because the Smart Brush tool paints a selection, we can press the Control/Command key plus the letter "D" to deselect the selection. The ground and bridge planks are painted, but seem too fake and bright; this can be easily corrected by lowering the opacity of this layer to 50%.

NOTE▶ When a Smart Brush tool adjustment layer is selected in the Layers panel, a different Smart Brush preset can be chosen. As soon as a new choice is made from the Presets drop down menu, the selection with the original preset is replaced with the new preset you select.

5.10.5.2 Using the Detail Smart Brush Tool

The Detail Smart Brush tool works like the Color Replacement tool, except that it creates a selection of the preset fill applied. When we select it in the Tool Options bar, we can assign a brush appropriate to our task. We will be painting the rails of the bridge; choose a brush size that works best for you based on your magnification. As we can see in the Tool Options bar, plus and minus tool options are available. If we overspill with the application of the color, we can select the minus tool or press the Alt/Option key to temporarily switch to the minus tool to repaint. Let's select the Background layer first, then use the same color (Button Down Brown) when applying the brush. Once the rails have been painted, we will lower the Opacity setting for this adjustment layer to 60%, as shown in the Figure 5.34 completed sample. When we hide the four adjustment layers, we can see how significantly the image was improved. Choose to save this file if you would like, then close it.

If no Smart Brush or Detail Smart Brush layer is selected, when the mouse is Right/ Control clicked on the image, all Smart Brush tool adjustment layers appear in a context-sensitive menu, allowing you to select the one you want to make active. If you Right/Control click on a pin, or have an active selection when you Right/Control click on the image, additional options of Change Adjustment Settings, Delete Adjustment, and Hide Selection are available. The settings for any Smart Brush tool adjustment layer can also be opened by double clicking its pin.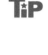

Figure 5.34 Smart Brush and Detail Smart Brush applied.

5.11 Working With Color in the Guided Mode

Although the Guided mode provides several categories of applications, at this time we will examine its color correction options: Brightness and Contrast, Correct Skin Tone, Levels, Lighten and Darken, Enhance Color, Remove a Color Cast, and Black and White.

To use the Guided mode, a photograph must be opened first. Let's reopen the original Brightness Contrast.jpg image. Once we do that, we will click the Guided tab, then Basics, then Brightness and Contrast. Sliders appear along with an Auto Fix option that all work as we have learned when applying the Brightness/Contrast command. When the sliders are dragged, their numerical equivalents display above them. Let's apply the same settings we did when we worked with this file earlier in this chapter (Brightness: 70, Contrast: 30). To complete the application, we must click the Next button. Once we do that, we can choose to save, continue to edit the file in either the Quick or Expert mode, or share it and then click the Done check mark; we will choose Continue Editing: In Expert, then close the file and do not save the changes when prompted.

Figure 5.35 Choosing to end a Guided Edit session.

When we reopen the 100_2684.jpg image from the Practice_Import 4 folder and select the Guided mode tab, followed by Basics, and then Correct Skin Tones, we can see that its settings echo those of the Enhance>Adjust Color>Adjust Color for Skin Tone command.

Rather than apply these settings again, let's click the Expert mode tab. When we have opened a photograph in the Guided mode, if we then click either the Quick or Expert tab, the dialog box shown in Figure 5.35 opens. We will choose Cancel, then click the small "X" at the top right of the edit pane to exit the file.

The Levels, Lighten and Darken, Enhance Color, and Remove a Color Cast Guided edits all provide simplified setting options that echo their Enhance menu counterparts that we have learned to apply in the Expert mode.

5.11.1 Converting a Photograph to Grayscale Using the Guided Mode

When the Black and White category is chosen in the Guided mode, the tonal quality or intensity of the conversion can be controlled by selecting one of four Black and White presets: Light, Lighter, Dark, Darker. A Diffuse Glow option is also available to brush on areas you want to accentuate, after assigning a brush size and opacity. When one preset is selected, then a different one, the new one overrides the original; it does not compound the effect. To do that, an Increase Contrast button is provided, with each click adding to the previous application.

In your own work, whether you choose to apply color adjustments using the Expert mode or prefer the options available in the Quick or the Guided mode will be a personal preference.

5.12 Using Camera Raw

If your camera provides the ability to save your photographs in its native "raw" format, they can be opened in Camera Raw. Raw files include all of the original data from the photograph, like a film negative. When a digital camera outputs your images as JPEGs, it performs some adjustments for you "behind the scenes" versus a raw file which includes all of the data your camera sensor recorded, giving you complete control while providing maximum flexibility and yielding the highest quality corrections. Many times more extensive corrections are possible to a raw file than a JPEG file, with fewer negative ramifications. Check your camera manual. If your camera provides this option, it is worth a try. Common camera raw file extensions include .cr2, and .crw (Canon), .nef (Nikon), .orf (Olympus) and .srw (Samsung).

5.12.1 Basic Camera Raw Settings

When a raw image is opened in Camera Raw, the following corrections are available under its Basic tab:

WHITE BALANCE: Removes a color cast by selecting a lighting preset or assigning custom settings.

TEMPERATURE: Adjusts the white balance using a slider ranging from Blue to Yellow (colors opposite each other in the RGB color wheel).

TINT: Provides additional white balance correction using a slider ranging from Green to Magenta (colors opposite each other in the RGB color wheel).

EXPOSURE: Adjusts the brightness and darkness; drag the slider to the right for a positive number to lighten or to the left for a negative number to darken.

CONTRAST: Adjusts the midtones; drag the slider to the right for a positive number to increase contrast or to the left for a negative number to reduce contrast.

HIGHLIGHTS: Adjusts data on the far right of the histogram when an image is overexposed.

SHADOWS: Adjusts data on the far left of the histogram when content is lost in shadowed areas.

WHITES: Adjusts white in an image, reducing clipping on the right side of the histogram.

BLACKS: Adjusts black in an image, reducing clipping on the left side of the histogram.

CLARITY: Increases contrast, resulting in sharper details.

VIBRANCE: Adjusts saturation of dull areas in a photograph without applying saturation to the entire image.

SATURATION: Increases or decreases the overall intensity of the colors in the image.

Let's open a raw file and examine the features of the Camera Raw dialog box.

5.12.2 Opening an Image in Camera Raw

A raw file can be opened from the Organizer by selecting the file, then clicking the Editor button in the Taskbar. The Editor will be launched, and the file will be opened in the Camera Raw dialog box. A raw file can also be opened in the Editor by choosing File>Open, by clicking its Open button and locating the file, by selecting a raw file outside of the Editor and Right/Control clicking and choosing Open With>Photoshop Elements Editor from the context-sensitive menu that appears, or, with the Editor open in any mode, by simply dragging a raw file and releasing it on the Edit pane.

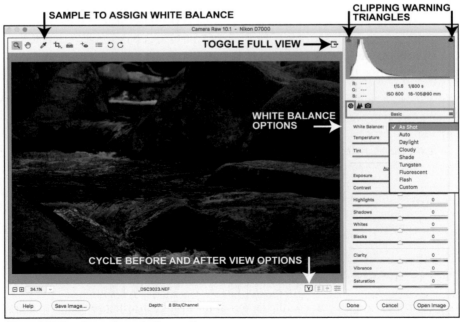

Figure 5.36 Opening an image in Camera Raw.

Using any one of these methods, open the raw file named _DSC3023.nef located in the Practice_Import 12 files folder within the Practice Files folder you copied to your

hard drive. We can see by its extension that it was taken using a Nikon camera and that when it opens in Camera Raw that it is underexposed, as shown in Figure 5.36.

Before making adjustments to this image, let's become familiar with the parts of the window identified in Figure 5.36:

TOOLS: Available at the top left, includes a White Balance tool that can be used to adjust the white balance by sampling a gray area in the image preview.

TOGGLE FULL SCREEN MODE: Toggles to provide a full screen view.

CLIPPING TRIANGLES: Triangles above the histogram that warn us when its endpoints lack detail. If a triangle turns color, it warns the channel is clipped; if the triangle turns white, all channels are clipped.

BASIC TAB: Provides the tonal and color adjustment settings.

WHITE BALANCE DROP DOWN MENU: Provides presets for lighting conditions.

RED AND BLUE AREAS: Red identifies areas that are overexposed when the letter "O" key is pressed, and blue identifies underexposed areas when the letter "U" key is pressed.

Let's explore the magic of Camera Raw on the underexposed photograph in Figure 5.36. Applying the expertise we gained using the Histogram panel in the Expert mode of the Editor, we will watch the Camera Raw histogram constantly update as we adjust its settings, with the ultimate goal of content extending across as much of the graph as possible with a "bell" curve in the middle, as shown in Figure 5.38.

We will begin by choosing the White Balance tool and sampling the gray area of the rocks in the upper right area of the image, as shown in Figure 5.37. This provides an initial starting point for the temperature setting; it does not affect the lighting of the image.

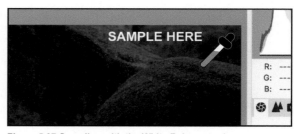

Figure 5.37 Sampling with the White Balance tool.

Once we have done that, the settings shown in Figure 5.38 can be applied— Temperature: 7050, Tint: +10, Exposure: +1.90, Contrast: –9, Highlights: +51, Shadows: +59, Whites: +9, Blacks: +15, Clarity: +12, Vibrance: +17, Saturation: 0.

When adjusting the Camera Raw settings, you can hold down the Alt/Option key to convert the Cancel button to a Reset button you can click to start over.

TiP

NOTE▶ The settings shown in Figure 5.38 provide considerable improvement to the photograph. It will be helpful when applying each slider to drag it to the far left, then far right, and watch how it affects the histogram as the slider moves while also noting the underexposed and overexposed color warnings. When assigning settings, feel free to adjust each slider higher or lower based on your personal artistic preference.

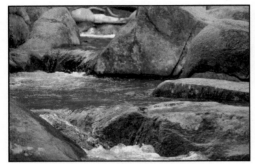

IMAGE WITH SETTINGS APPLIED

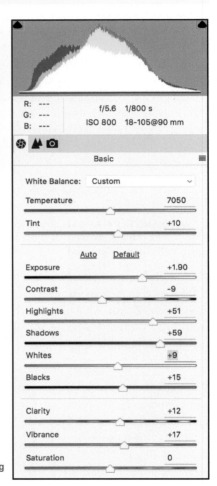

Figure 5.38 Assigning settings in the Camera Raw dialog box.

5.12.3 Assigning Sharpening and Luminance

Next to the Basics tab in the Camera Raw dialog box is a Detail tab that provides sharpening and luminance settings.

5.12.3.1 Assigning Sharpening

When we click the tab, we can see that some preset default sharpening has been applied to the image for us. Amount defines the intensity of the sharpening, Radius assigns how far the sharpening is applied from the edges, and Detail preserves the

edges, while Masking allows sharpening to be limited only to edges (the higher the setting, the more restricted the adjustment will be to edges—a setting of 0 applies the sharpening to the entire image).

5.12.3.2 Assigning Luminance

Color and Luminance sliders are available to help minimize noise in a photograph. Image noise is a combination of color noise (color spots) and luminance noise (grainy blotchy appearance) appearing on a photograph typically taken in low light. The Christmas tree photograph made out of lobster traps shown in Figure 5.39 was taken outside at night. Once the image is lightened, its noise is clearly visible. Default Presets of Color and Color Detail are pre-applied (although allowing further adjustment) along with sliders for correcting Luminance, Detail, and Contrast. When adjusting the Luminance Detail slider, a higher setting will preserve more detail but will also retain more noise; a lower number will lose detail but also eliminate more noise. In your own work, when working with a photograph with color noise, adjust each slider as needed to balance noise versus detail to achieve the best results.

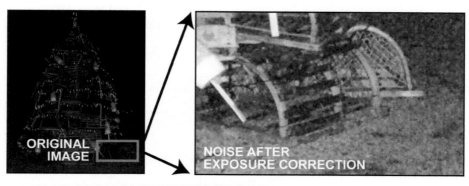

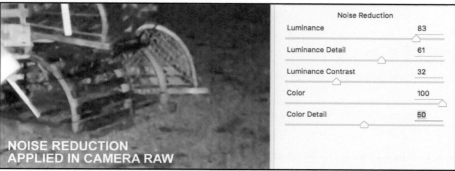

Figure 5.39 Applying noise reduction in Camera Raw.

5.12.4 Camera Calibration

A third tab is available in the Camera Raw dialog box that allows for a specific camera profile to be assigned. Adobe Standard is pre-chosen by default, but an alternative profile from the drop down menu can be selected if desired.

5.12.5 Output Settings of Camera Raw

When changes are made to a raw file in Camera Raw, the settings are nondestructive, recorded in an XMP file by default. Below the preview window are the output options for the corrected image and how the settings are handled, shown in Figure 5.40:

SAVE IMAGE: Saves the file in the DNG file format. This file format preserves the settings for future editing without the necessity of an external XMP file. A dialog box opens to assign destination, file naming, and format settings for the digital negative. If you hold down the Alt/Option key when clicking the Save Image button, you can bypass the assign settings dialog box.

DONE: Closes the Camera Raw window without opening the image, but saves the settings with an XMP file. If the image is reopened in Camera Raw, the assigned settings will still be applied and can be further edited.

OPEN IMAGE: Closes the Camera Raw window, saves the XMP file, and opens the image in the Editor. Once in the Editor, it can be edited and saved in any of the standard file formats provided in the Editor Save As dialog box. If you hold down the Alt/Option key, when choosing the Open Image button, it changes to Open Copy, which will open the Camera Raw file without creating the XMP file.

Figure 5.40 Output settings for Camera Raw.

TIP When working with a raw file, if you choose Done or Open Image, then decide you want to work with the original raw file again, when you open the original, it will have the Camera Raw settings applied. However, if you locate the matching file name with the .xmp extension and delete it, when you reopen the raw file it will be back to its original state.

NOTE▶ Although the best correction results are achieved working with a raw file in the Camera Raw dialog box, Camera Raw can also be used for JPEG, TIFF, and PSD files. To do that in the Editor, choose File>Open in Camera Raw, then locate the file. When you are done editing the file, you can click the Done button to save the Camera Raw edits or the Open Image button to open the file in the Editor.

PRACTICE MAKES *PERFECT*✓

With a wealth of knowledge in color correction, we are ready to learn transformation. Before moving forward to Chapter Six, feel free to further reinforce your skills first with one or more of the practice exercises provided.

PRACTICE PROJECT 1

1. Open the C-5 Project1.jpg file located in the Practice_Import 12 files folder within the Practice Files folder you copied to your hard drive.

2. Choose to apply a Levels adjustment layer with settings that adjust the histogram to span across the entire graph, with settings of Shadows: 100, Midtones: .70, and Highlights: 250.

3. Apply a Hue/Saturation adjustment layer, then drag the Hue slider to +14 and the Saturation slider to –20.

4. Select the Background layer, then select the sky using the Quick Selection tool or a different selection method of your choice, apply a feather radius of 2 px, then choose Select>Inverse.

5. Select the Sponge tool with its Mode set to Desaturate and its Flow set to 20%. Choose a brush size that allows you to easily paint over the rock formations only, not the green areas. There is no need to worry about applying the desaturation to the sky area; the selection restricts the Sponge tool application.

6. Deselect the selection.

7. Choose Flatten Image from the Layers panel menu.

8. Save this file as Poles.psd; we will use it for learning to eliminate content in Chapter Seven.

PRACTICE PROJECT 2

1. Open the Dunes path.psd file we worked on earlier in this chapter.

2. Choose Flatten Image from the Layers panel menu.

3. Choose the Smart Brush, then assign the Nature>Darken Skies preset and a brush size of 85 px.

4. Paint the sky from left to right, adjusting the application to affect only the sky area using the Add to selection and Subtract from selection tools as needed.

5. Change the Opacity setting for the adjustment layer that was created to 75%.

6. Double click the Hue/Saturation adjustment layer icon and change the settings to Hue: +33, Saturation: +10, and Lightness: 0 as shown in Figure 5.41.

7. Select the Background layer then select the Detail Smart Brush.

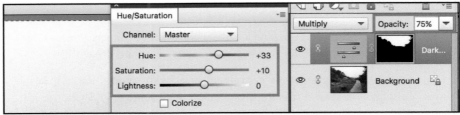

Figure 5.41 Adjusting the Hue/Saturation settings for the Smart Brush layer.

8. Choose the Color>Button Down Brown preset and a brush size and style of your choice.

9. Paint the Boardwalk, using the Add to selection and Subtract from selection tools as needed to refine the application.

10. Reduce the Opacity setting of the Detail Smart Brush adjustment layer to 40 % as shown in Figure 5.42.

11. Close the file, optionally choosing to save it if desired.

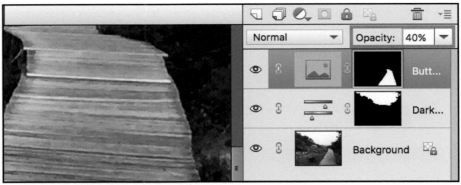

Figure 5.42 Assigning Opacity 40% to the Detail Smart Brush adjustment layer.

PRACTICE PROJECT 3

A third exercise named "Chapter Five Practice Project 3.pdf" is available in the Additional Practice Projects folder on the companion DVD.

6

Transformations and Adding Content

- Learn to straighten images
- Crop photographs using a variety of methods
- Explore multiple ways to correct perspective distortion
- Utilize drawing tools to add content to a photograph

As an expert, you will oftentimes need to apply transformations such as cropping, scaling, rotating, and distortion correction. We will examine these types of transformations, applying them to entire images as well as individual layers. We will also learn to add content by expanding canvas, by applying the Content-Aware command, and by painting.

6.1 Photograph Transformations

Transformations can be applied to an entire image, a selection, a layer, or a selection on a layer. We will begin our exploration of transformations with their applications to entire photographs.

Transformations can be applied to a photograph by flipping the image, straightening it, cropping, correcting the keystone effect, and changing perspective. While some of these transformations are available in multiple modes, others are found only in the Expert mode. We will explore each of them, beginning with the Flip Horizontal command.

NOTE Transformations which can be applied using the Guided mode will be covered in the "Transformations in the Guided Mode" section of this chapter.

6.2 Flip Horizontal Command

When a photograph does not have visible text, sometimes it can be more interesting or appealing by applying the Flip Horizontal command. Let's open a photograph that you will have in your Practice Catalog if you chose to incorporate the Organizer chapters into your learning. If not, located in the Practice_Import 8 folder, open the file named Squirrel.jpg. When we study the squirrel photograph, he appears to be ready to exit the image. In either the Quick, Guided, or Expert mode, we can choose Image>Rotate>Flip Horizontal to reverse his direction so that he appears to be entering the photograph, as shown in Figure 6.1.

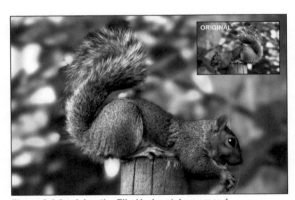

Figure 6.1 Applying the Flip Horizontal command.

A copy of each figure shown in this chapter can be viewed in the companion files included with this book.

6.3 Using the Straighten Tool

The Straighten tool, with its icon resembling a level, is available in both the Quick and Expert modes, and when working in the Camera Raw dialog box. Straightening can also be achieved in the Guided mode as part of its Rotate and Straighten option, which we will examine in "Transformations in the Guided Mode" later in this chapter.

Let's open the photograph named Straighten.psd that we saved in Chapter Five. With its tonal quality corrected, we can see it is a nice photograph that just needs to be straightened to become an even better one.

6.3.1 Straighten Tool in Quick Mode

Let's begin by opening this image in the Quick mode. When the Straighten tool is chosen here from the Tools panel, a drop down menu in the Tool Options bar provides two straightening options: Maintain Canvas Size and Maintain Image Size, along with an Autofill edges checkbox. "Canvas" is the name given to the surface an image sits on, which we will explore in more depth later in this chapter. For now, choosing Maintain Canvas Size means to *not* add any size to the photograph, therefore clipping the image as needed to straighten it. Conversely, Maintain Image Size allows the Editor to increase the canvas as needed so that all of the image pixels will display after straightening has been applied. The Autofill edges checkbox offers the ability to have the Editor "fill in" the Background canvas areas that became exposed with the straightening by copying adjacent content. If you have experimented with each of these options, return to the opening state of the History panel.

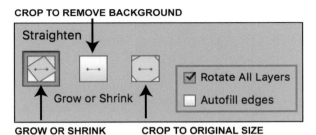

Figure 6.2 Assigning Straightening in the Expert mode.

6.3.2 Straighten Tool in Expert Mode

When we now click the Expert tab and select the Straighten tool from the Modify section of the Tools panel, three options appear in the Tool Options bar as shown in Figure 6.2, two of which replicate the options of the Quick Mode:

> GROW OR SHRINK: Enlarges or shrinks the image canvas as needed to display the entire straightened photograph. Exposed canvas areas will be filled with the current background color.

> CROP TO REMOVE BACKGROUND: Adjusts the image canvas as needed to clip away all background colored areas that are created when the photograph is straightened.

> CROP TO ORIGINAL SIZE: Crops the image content as needed to maintain the original canvas size, with exposed canvas areas filled with the current background color.

> AUTOFILL EDGES: When either the Grow or Shrink or Crop to Original Size option is chosen, the Autofill edges checkbox is available, identical to its use in the Quick mode.

Let's use the Expert mode to straighten this photograph. The original dimensions of this photograph are 6" × 9" at 300 ppi. We will choose the Grow or Shrink option, without Autofill edges checked. Although for this photograph we could drag the tool to create a vertical line up the center of the buoy, let's drag a horizontal line as shown in Figure 6.3.

The photograph becomes straightened with the background color visible in the exposed areas, the image expanded as needed for all of its content to display. When Image>Resize>Image Size is chosen, the dimensions are larger than the original 6" × 9" photograph. Let's undo this application, click the Autofill edges checkbox first, then apply the same option again. This time the image becomes straightened, the dimensions have increased to include all rotated content, and the background colored areas have been filled automatically to match the adjacent original content.

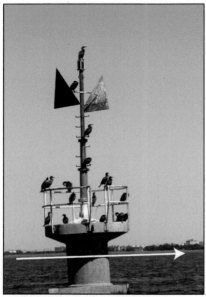

Figure 6.3 Assigning straightening.

Let's undo this application and choose the Crop to Remove Background option instead: the image becomes straightened with its canvas decreased by cropping away all background areas that would have been visible. Let's undo this application one more time and choose the Crop to Original Size option with the Autofill edges checked. The image maintains its original size, with matching content added as needed to fill in the canvas areas that become exposed when the straightening is applied. Let's close this photograph, optionally choosing to save it first if desired.

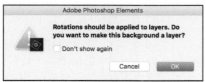

Figure 6.4 Converting a Background layer of a multilayered file to a regular layer to straighten it.

NOTE As we can see in Figure 6.2, the checkbox Rotate All Layers is chosen by default. If an image has only one layer, when the Straighten tool is applied, the Background layer is converted to Layer 0 automatically to allow the tool to straighten the image on the canvas. If a file has multiple layers and the Straighten tool is applied to the Background layer with Rotate All Layers *unchecked*, the dialog box shown in Figure 6.4 will open; click OK to convert the Background layer to a regular layer and then proceed with the transformation. When this command is applied Autofill edges will not be available: any visible canvas areas will be filled with the current Background color. With Layer 0 selected, Layer>New>Background From Layer can be assigned after the transformation if desired.

6.3.3 Straighten Tool in Camera Raw

When an image is opened in Camera Raw, the Straighten tool icon is identical to that of the Quick and Expert modes and is located at the top left of the Camera Raw dialog box, as shown in Figure 5.36. Once the tool is dragged across the image, straightening is applied by pressing the Enter/Return key.

6.4 Straighten Image Commands

Two commands are available under the Image>Rotate menu when working in the Quick, Guided, or Expert mode: Straighten and Crop Image or Straighten Image. These commands work well if a crooked image has been saved with visible canvas, such as a photograph that was scanned at an angle. While the Straighten and Crop Image command removes all visible background around the photograph by adjusting the size of the canvas as needed, the Straighten Image command straightens the content and keeps the original canvas size.

Let's choose to open the photograph named Crooked Photo.jpg located in the Practice_Import 13 files folder within the Practice Files folder you copied to your hard drive. Working in the Expert mode, when we choose Image>Rotate>Straighten and Crop Image, the photograph is straightened with all white areas removed as shown in Figure 6.5. Choose to undo, then apply the Image>Rotate>Straighten Image command. Once you have done that, close the file, optionally choosing to save it first.

Figure 6.5 Applying the Straighten and Crop Image command.

NOTE▶ To apply either the Straighten and Crop Image or Straighten Image command in the Guided mode, open the image first, then select any Guided mode category to enter the Guided mode. Once you are in the Guided mode, instead of applying the steps provided for the Guided mode category you selected, choose the desired straighten image command from the Image>Rotate submenu.

6.5 Cropping an Image

The Crop tool, with its icon depicted as two intersecting right angles, allows us to remove part of an image, typically to improve the artistic appearance of a photograph, so that the remaining content will be more visually interesting to the viewer. An image can be cropped using the Crop tool with or without assigning a specific size and resolution.

The Crop tool is available in the Organizer Instant Fix editor, the Editor Quick mode, Expert mode, and the Camera Raw dialog box. The Guided mode provides a specific Crop Photo category as one of its options that we will examine in "Transformations in the Guided Mode" later in this chapter.

6.5.1 Cropping in the Organizer

When a photograph is selected in the Organizer, the Instant Fix editor can be opened to crop the image, using a preset crop or a custom freeform crop. Once a preset has been selected, the location of the crop can be moved by pressing and dragging inside the bounding box that appears and resized by dragging the bounding box handles provided, as shown in Figure 6.6. When the check mark is clicked, the image is cropped maintaining the original resolution.

6.5.2 Cropping in the Editor

Let's open the photograph named Beta.jpg located in the Practice_Import 13 files folder within the Practice Files folder you copied to your hard drive. This image is 16" × 10", Resolution: 300 ppi.

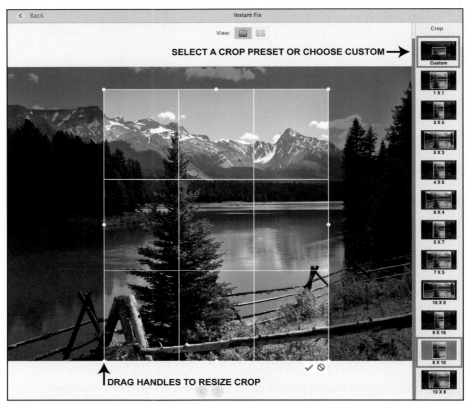

Figure 6.6 Cropping a photograph using the Organizer Instant Fix editor.

Working in either the Quick or Expert mode, when the Crop tool is chosen from the Tools panel, its options display in the Tool Options bar. Let's take a look at them in the Expert mode, as shown in Figure 6.7:

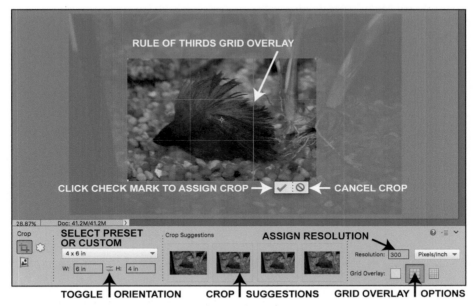

Figure 6.7 Tool Options bar when the Crop tool is chosen.

SHOW PRESET OPTIONS: Provides a drop down menu that allows us to select No Restriction (freeform crop), Use Photo Ratio (crops and assigns the same original dimensions), along with seven common preset sizes such as 5" × 7" and 8" × 10". When one of the seven preset sizes has been selected, if either the Width or Height field is changed, the preset drop down menu selection changes to Custom.

DOUBLE ARROW ICON BETWEEN THE WIDTH AND HEIGHT FIELDS: Toggles the orientation of the crop.

CROP SUGGESTIONS: Four suggested crops are provided such that, when the mouse is rolled over any one of them, its effect is shown in the crop preview.

RESOLUTION: Provides a text field to assign the desired resolution *prior* to drawing the crop.

GRID OVERLAY: Provides grid options of None, Rule of Thirds, and Grid with the Rule of Thirds overlay applied by default.

SHIELD: Displays a color outside the crop preview, referred to as the crop "shield," to help with visualizing the effect of the crop on the image.

CHECK MARK: Click the check mark to complete the crop or click the cancel icon.

 The color and opacity of the crop shield can be changed by choosing Edit>Preferences>Display & Cursors in Windows or Adobe Photoshop Elements Editor>Preferences>Display & Cursors in Mac OS. You can also temporarily hide the crop shield at any time by pressing the forward slash key. This key toggles its visibility; when the forward slash key is pressed again, the cropping shield reappears.

6.5.3 Creating a No Restriction Freeform Crop

The image of the beta fish is great, but the rest of the content around him severely detracts from his beauty. A No Restriction crop allows us to reshape the image by eliminating content. Begin with the Show Crop Preset Options drop down menu set to No Restriction. Let's then enclose the beta fish by dragging diagonally from the upper left area above him to the lower right area below him to select an area for the crop, similar to the shape shown in Figure 6.8, then click the check mark to complete

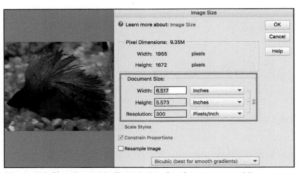

it. However, when its dimensions are reviewed in the Image Size dialog box, the resolution will still be 300 ppi, but the resulting crop dimensions will most likely not fit into a standard frame size, as shown in Figure 6.8. Because of this, let's choose to undo the No Restriction crop.

Figure 6.8 Creating a No Restriction freeform crop and its resulting dimensions and resolution.

 In addition to completing a crop by clicking the check mark, you can double click inside the crop preview to assign it or simply press the Enter/Return key.

6.5.4 Applying a Use Photo Ratio Crop

Let's select Use Photo Ratio from the Show Crop Preset Options drop down menu. As soon as we do that, the original Width and Height dimensions display along with the original resolution. When the Crop tool is dragged across the image this time, its movement is constrained to the ratio of the original dimensions. When the crop is completed and the Image Size dialog box is opened, whatever area (no matter how small) was selected for the crop, the image has been converted to the original dimensions of 16" × 10", Resolution: 300 ppi. Let's choose to undo this action.

6.5.5 Cropping Without Assigning Resolution

When we now select a size preset such as 6" × 4", no resolution is shown in the Resolution field by default. The Tool Options bar allows us to assign the size, orientation, and resolution for the crop. Let's examine what happens if a crop

SMALL AREA MADE LARGER

LARGE AREA MADE SMALLER

Figure 6.9 Comparing crops with no resolution assigned.

resolution is not assigned. To do that, we will create two separate crops. When a small area must be made larger to accommodate the defined crop, the resolution decreases (the pixels per inch are spread out, resulting in fewer pixels per inch). Conversely, if a large area of a photograph is cropped to a smaller size, the resolution is increased (the pixels are pushed together, resulting in more pixels per inch). A sample of each of these types of crops is shown in Figure 6.9.

6.5.6 Assigning Resolution When Cropping

Let's revert back in the History panel to the opening state of this image and apply one more crop to the beta photograph for now. We will select 6" × 4" from the Show Crop Preset Options drop down menu, then in the Resolution field type "300," with ppi selected from the drop down menu. Choose to crop to include all of the fish with a small amount of content around him. When the crop is completed and the Image Size dialog box is opened this time, the Document Size will be Width: 6", Height: 4", and Resolution 300 ppi—just what we want. Let's close this file for now and choose *not* to save it when prompted.

6.5.7 Cropping in Camera Raw

As we have learned, when working in Camera Raw, the original file is preserved. This provides the ability to reopen the original raw file to recrop if needed at any time in the future. When the Crop tool provided at the top left area of the Camera Raw dialog box is chosen (also shown in Figure 5.36), we can press and hold on the tool down arrow menu to access Normal (freeform), plus a variety of crop ratio presets, and a Custom option to type in a user-defined ratio. If you type in a new custom ratio in the fields provided, it will be added to the list of preset ratios. Additional options allow us to hide the crop shield or cancel the crop either by selecting Clear Crop from the down arrow menu or by pressing the ESC key.

6.5.8 Cropping and Straightening a Photograph

We have learned to use the Straighten tool and the Crop tool. When a photograph needs both, they can be combined by rotating a crop before applying it. The ability to rotate a crop to straighten it is available in the Quick and Expert modes as well as in the Camera Raw dialog box. Cropping and rotating a crop prior to its application can

also be achieved in the Guided mode, which we will examine in "Transformations in the Guided Mode" later in this chapter.

Let's open the photograph named Crop Rotate.jpg located in the Practice_Import 13 files folder within the Practice Files folder you copied to your hard drive. Let's study this photograph closely. We can only tell that it is crooked because there is furniture in the photograph; the rest of the image looks great. In your own work, a photograph may have been taken crooked, but if there is no content in it that should definitely *be* straight, there is no need to straighten it. Let's begin by assigning the Crop tool settings in the Tool Options bar as shown in Figure 6.10 (Show Crop Preset Options: 4" × 6", Resolution: 300 ppi).

Figure 6.10 Assigning settings for the crop.

Once we have done that, when the Crop tool is dragged across the little boy first, and then the pointer is placed outside the crop preview near one of its corners, a curved arrow indicates that the crop can be rotated clockwise or counterclockwise. When we choose to rotate it clockwise, a grid appears to help us align the rotated crop. Using the vertical lines of the furniture as our guide, we can straighten the image. We will choose to maximize the size of the crop without having any background content visible once the image is straightened, with the resulting crop shown in Figure 6.11. With the image straightened and cropped, we will close this file, optionally choosing to save it first if desired.

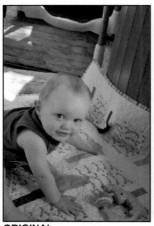
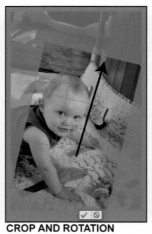
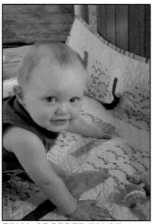

ORIGINAL **CROP AND ROTATION** **FINAL CROPPED IMAGE**

Figure 6.11 Original image, rotated crop preview, and final cropped image.

6.5.9 Creating an Artistic Crop

The Rule of Thirds grid overlay is designed to help create great composition in a photograph. Composition refers to the position of content in a photograph so that the focal point or main content is visually and aesthetically pleasing. The concept behind the Rule of Thirds is to shift the horizon to one of its top or bottom horizontal guides (rather than in the middle) and place the center of the content focus at the intersection of one of its vertical guides. We will learn how to improve the aesthetic appearance of a photograph by applying the Rule of Thirds.

Let's open the photograph named Artistic Crop.jpg located in the Practice_Import 13 files folder within the Practice Files folder you copied to your hard drive. When this photograph opens, we can see two issues: the horizon is in the middle, plus the photograph is also crooked. When we rotate and crop the image horizontally, setting the horizon at the top horizontal line of the grid, the image is improved. However, let's undo and create a vertical orientation instead. When we apply a vertical crop with the image rotated to straighten it, we can select an area of content with visual interest for the focal point. The boat with the tallest mast, and therefore longest shadow, falls right along one of the vertical lines of the grid shown in Figure 6.12.

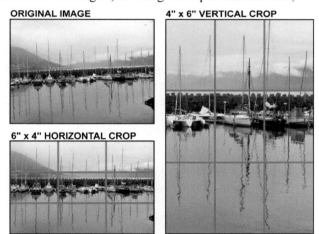

Figure 6.12 Assigning a Rule of Thirds horizontal and vertical rotation and crop.

NOTE▶ What about the tonal quality and color of the Artistic Crop photograph? We have learned how we could turn a dreary appearance into a bright full color day. Feel free to do that before closing the file if you would like, or choose to keep the more monochromatic overcast appearance that creates a certain ambience for the photograph. To change or not change the feeling that a photograph exudes will be one of the types of artistic decisions you will have to make as an expert.

Let's open another photograph that does not have a horizon line to adjust using the Rule of Thirds. If you completed Practice Project 2 at the end of Chapter Three, you have saved a photograph named Blue Heron.psd. If you chose not to complete that exercise, a copy of the completed Chapter Three Practice Project 2 named Blue Heron for Crop.psd file has been provided in the Practice_Import 13 files folder within the Practice Files folder you copied to your hard drive. Although this image does not have any horizon line to align to a Rule of Thirds grid, one solution for a more interesting image would be to crop away some of the water and reeds to make

the heron more of the focus of the image. However, let's choose instead to zoom in to his head for visual interest. As shown in Figure 6.13, we can use the vertical and horizontal guides of the crop grid overlay to focus on the bird's head and neck. Once the crop has been applied, save the file; we will work with this image again in later chapters.

Figure 6.13 Applying the Rule of Thirds to improve composition and visual interest.

6.6 Using the Crop Command

The Rectangular Marquee tool can also be used to crop an image when combined with the Crop command. When the Rectangular Marquee tool is selected, the Tool Options bar provides three choices under the Aspect drop down menu. With

Figure 6.14 Using the Rectangular Marquee tool and the Image>Crop command.

Normal pre-selected by default, Fixed Ratio and Fixed Size are alternatives that can be used to create a selection for a crop. Let's reopen the Beta.jpg image one more time. We will choose the Rectangular Marquee tool, then in the Tool Options bar select Fixed Size from the Aspect drop down menu, assign W: 5" and H: 7", then press Enter/Return to apply the dimensions. When we now single click on the image, the size marquee we defined appears on it. We can drag inside the moving dotted outline to position it for the crop shown in Figure 6.14. To complete the crop, we will choose

Image>Crop, then deselect the selection. As we can see in Figure 6.15, the image becomes cropped to 5" × 7", retaining the original image resolution of 300 ppi. With this crop applied we will close this file; choose to save it first if desired.

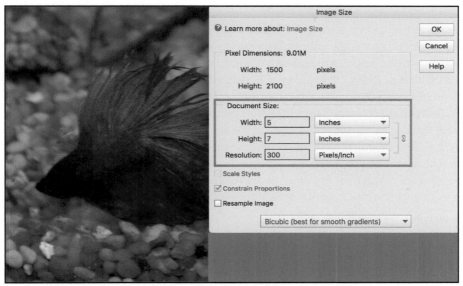

Figure 6.15 Image Size dialog box after the Image>Crop command has been applied.

NOTE When using the Rectangular Marquee tool, if the Aspect drop down menu is changed from its default of Normal to either Fixed Ratio or Fixed Size, the new aspect option becomes the default for the tool until Normal is reselected, or Reset Tool or Reset All Tools is chosen from the down arrow menu in the Taskbar, or the Editor preferences are reset.

6.7 Correcting the Keystone Effect

When we photograph a tall building, we typically must tilt our camera to include the entire structure. When that happens, the keystone effect will be visible in the image. The keystone effect is the name given to the appearance in a photograph where vertical structures appear to angle inward from their base to their highest point. Sometimes as an expert, you will *want* to leave this effect in a photograph for aesthetic purposes and emphasis. However oftentimes you will be disappointed by its effect in your photographs and want to remove it. The Editor provides three ways to eliminate the keystone effect: using the Perspective Crop tool, using the Distort command, and using the Correct Camera Distortion filter. We will explore each of these options beginning with the Perspective Crop tool.

6.7.1 Using the Perspective Crop Tool to Correct the Keystone Effect

In the Expert mode only, when the Crop tool is chosen, the Perspective Crop tool becomes available for selection in the Tool Options bar (shown below the Crop tool

in Figure 6.7). This tool can adjust the sides of a building, straightening them to eliminate the keystone effect. Let's learn how it works.

Let's open the photograph named Keystone.jpg located in the Practice_Import 13 files folder within the Practice Files folder you copied to your hard drive. When this image opens, we can see that the sides of the yellow building as well as the buildings on either side of it angle inward. With the Perspective Crop tool selected, we can assign a width, height, and resolution for the crop. The original image size is 9" × 12", with Resolution: 300 ppi; we will assign the same dimensions. Once we have done that, we will drag from the upper left corner of the image down diagonally to the lower right corner to select the entire image. When Show Grid is checked in the Tool Options bar, a grid will appear across the image, with bounding box handles. When the pointer is placed directly over one of the corner handles, it changes color to indicate the handle is selected, ready to be dragged as needed. When the top two handles are dragged inward until the grid aligns with the sides of the yellow building, we can click the check mark to assign the correction as shown in Figure 6.16.

The keystone effect has been removed, and the dimensions are still 9" × 12", with Resolution: 300 ppi; however, the building appears shorter and wider than the original, as also shown in Figure 6.16. Let's undo this correction and learn another method.

Figure 6.16 Perspective Crop tool applied and the resulting keystone effect correction.

6.7.2 Using the Distort Command to Correct the Keystone Effect

The Distort command is only available in the Expert mode. With the Expert mode active, let's choose Image>Transform>Distort. This command requires a layer; the Editor automatically converts the Background layer into a regular layer for us named "Layer 0" and adds eight bounding box handles around the image. When this command is chosen, the Tool Options bar provides additional options (Rotate, Scale, and Skew), along with W (width) and H (height) fields and a Constrain Proportions checkbox. We will choose not to assign anything in these fields and click the cancel icon. We will instead apply the Distort command by adjusting the bounding box handles manually to straighten the sides of the building. However, to help us know when we have straightened it, we will add guides first. To do that, as we learned in Chapter Four, we must first choose to show the rulers by choosing View>Rulers. We

will drag two vertical guides into the image as shown in Figure 6.17. Once we have done that, we will apply the Image>Transform>Distort command again, then drag the handles at the two top corners outward until the building is straight (sides align with the guides added), as also shown in Figure 6.17. To complete the transformation, the check mark is clicked. Although not required, best practice is to convert Layer 0 back to a Background layer by choosing Flatten Image from the Layer menu or the Layers panel menu.

Figure 6.17 Using the Distort command to manually correct the keystone effect.

Let's return to the opening state of the History panel and learn one more way to correct the keystone effect.

> To keep a building from appearing shorter and wider when the Distort command is used to correct the keystone effect, drag the top left and right bounding box handles up *above* the image as well as outward until the sides are straight and the height more closely resembles the original photograph, as also shown in Figure 6.17.

TIP

6.7.3 Using the Correct Camera Distortion Filter to Correct the Keystone Effect

The keystone effect is one of the types of distortions that can be rectified by the Correct Camera Distortion filter. This filter is available in the Quick and Expert modes, and also available when some of the category options are chosen in the Guided mode. Let's choose Filter>Correct Camera Distortion, then examine its dialog box options:

HAND AND ZOOM TOOLS: Allow magnified examination of the assigned corrections prior to applying them.

REMOVE DISTORTION: Corrects the curved appearance called "barrel" distortion that can result from the lens of your camera.

VIGNETTE: Corrects the coloring at the outer edges of a photograph that can result from the lens of your camera.

VERTICAL PERSPECTIVE: Corrects the keystone effect or can be used to create distortion as shown by the icons provided: dragging the slider to the left to pull the sides out (correct the keystone effect) or dragging the slider to the right to pull the sides in (create the keystone effect).

HORIZONTAL PERSPECTIVE: Corrects a horizontal angle distortion and can also be used to create one by dragging the slider as desired.

ANGLE: Allows the image to be rotated.

SCALE: Adjusts the size of the image content relative to the canvas when distortion corrections are applied.

SHOW GRID: Displays a grid over the image to aid in the correction, with the ability to hide it or change its color using the Color Picker.

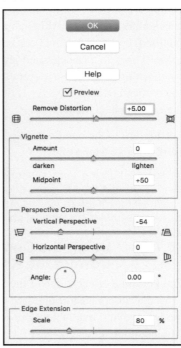

Figure 6.18 Correcting barrel distortion and the keystone effect using the Correct Camera Distortion filter.

We will apply the settings shown in Figure 6.18. We can see from the roofline and the edge of the road that the image suffers slightly from barrel distortion; we will assign Remove Distortion: +5.00 to correct it. Additional adjustments include Vignette Midpoint: +50, Vertical Perspective: –54, and Scale: 80%. With the Preview option checked, as these settings are applied, the preview updates dynamically to reflect the corrections.

Figure 6.19 Cropping after applying the Correct Camera Distortion filter.

Once we click OK to exit the dialog box, we can see that the Background layer has been converted to a regular layer, the distortion has been corrected, and transparent areas appear where pixel content no longer exists on the layer. With Use Photo Ratio and Resolution: 300 ppi assigned, let's choose to crop the image to remove the transparent areas without removing critical pixel content, as shown in Figure 6.19 (the Tool Options bar is shown to the right). Let's then close this file, optionally choosing to save it first.

6.8 Using the Perspective Command

The appearance of a photograph taken at an angle can be created or enhanced using the Perspective command.

Let's open the photograph named Perspective Command.jpg located in the Practice_Import 13 files folder within the Practice Files folder you copied to your hard drive. When this image opens, we can see that the photographer was standing directly in front of the building. The image might be more visually interesting if it appeared as though it was photographed from an angle instead. We will choose Image>Transform>Perspective, available only in the Expert mode. Once we do that, the Tool Options bar displays the same features that were available when the Image>Transform>Distort command was selected. When the pointer is placed over a corner bounding box handle, it changes color to indicate that the corner can be dragged up or down to adjust the appearance of the perspective. Let's begin by dragging the top left bounding box handle down. We can see that as it is moved down, the bottom handle correspondingly moves up, creating the appearance of looking at the building more to the side of it than in front of it. Now we will further enhance that appearance by dragging the top right bounding box handle upward, with the bounding box handles adjusted as shown in Figure 6.20.

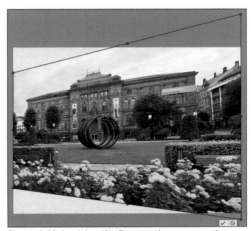
Figure 6.20 Applying the Perspective command.

Once the transformation has been applied, the image perspective has changed; however, to accommodate the change, the Background layer has been converted to a regular layer, with transparent areas of the layer now exposed. Let's save this image as Perspective.psd and close this image for now; we will fill these areas later in this chapter.

 This effect can also be created using the Correct Camera Distortion filter by dragging the Horizontal Perspective slider left or right as desired, then reducing the Scale percentage.

6.9 Adding Canvas

The dimensions of the canvas of a photograph can be enlarged to improve the composition of an image. Let's learn how.

 Let's open the photograph named Barcelona.jpg located in the Practice_Import 13 files folder within the Practice Files folder you copied to your hard drive. When this image opens, we can see that it is a great vertical photograph, except that the

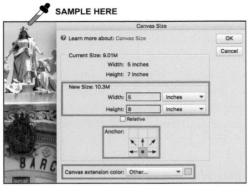

Figure 6.21 Assigning a new size in the Canvas Size dialog box and sampling a color to extend the canvas.

sculpture at the top of the building is a little too close to the border of the image; adding canvas can correct this.

Let's choose Image>Resize>Canvas Size. When the dialog box opens, it displays the original image dimensions, with fields to adjust its size. If the Relative box is unchecked, the original dimensions can be highlighted and changed. If this box is checked, the two fields begin with a value of zero, allowing us to assign the new size "relative" to the original dimensions. We will keep the default option of the Relative box *unchecked*, and assign new dimensions (Width: 5", Height: 8") to add canvas above the sculpture. The Anchor icon assigns how we want the new canvas area to expand. We will click the *bottom* center square

to assign the Anchor option so that our extended canvas will be added *above* the sculpture. To assign the Canvas extension color, when Other is selected from the drop down menu, the Color Picker opens with an eyedropper we can use to sample a color within the image. Let's sample directly above the top center of the sculpture as shown in Figure 6.21, then click OK to apply the new size.

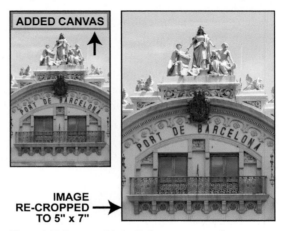

Figure 6.22 Canvas added with image recropped.

Once the canvas has been extended, we can apply the Crop tool with Tool Options bar settings of Show Crop Preset Options: 5" × 7", Resolution: 300 ppi. We have more flexibility this time for the positioning of the crop to create a better composition, with a suggested application shown in Figure 6.22.

NOTE▶ When determining how much canvas to add, it is always best to add more than you anticipate needing, which will provide ample flexibility when assigning the crop after the canvas has been increased.

The color we sampled most likely won't perfectly match *all* of the sky it has been added above. We will learn how to fix that in Chapter Seven. For now, let's save this image as Barcelona.psd and close it.

Another way canvas can be extended is when applying a crop. The background color in the Tools panel must first be clicked to access the Color Picker. Using the eyedropper that appears, a color is sampled within the image to use for the canvas extension. The Crop tool is then selected and a crop preview is drawn with its bounding box intentionally extending *outside* the existing canvas in the desired direction. When the crop is completed, the extended area will be filled with the background color that was sampled.

TiP

6.10 Transforming Layer Content

Layer content can be scaled, rotated, and distorted, whether in a single layer, multiple linked layers, a layer group, or a layer within a layer group. Let's begin by learning to scale layer content.

6.10.1 Scaling Layer Content

If you completed Practice Project 2 at the end of Chapter Four, you have saved a photograph named Seals.psd. If you chose not to complete that exercise, a copy of the completed Chapter Four Practice Project 2 named Seals_2.psd file has been provided in the Practice_Import 13 files folder within the Practice Files folder you copied to your hard drive. Working in the Expert mode, we can see in the Layers panel that this file contains three layers: its Background layer and two layers that contain copied selections of the standing seal in the foreground. With the Seal 2 layer selected, we will choose Image>Resize>Scale. As soon as we do that, the seal becomes enclosed within a bounding box, with the Tool Options bar displaying his current size at 100%. We will want to scale him up. We can do that by changing the Width and Height percentages or, with Constrain Proportions checked, by dragging the top left corner bounding box handle diagonally up and out or, with Constrain Proportions not checked, by holding down the Alt/Option key while dragging the top left bounding box handle diagonally up and out. Using any one of these methods, scale him up until the dimensions shown in the Tool Options bar are approximately W: 150% and H: 150%. Once we have done that, we will use the Move tool to drag him to the right to cover some of the original seal.

NOTE When scaling by changing percentages, we can change the default center transform point to select a specific corner to scale from in the Reference Point Location box as shown in Figure 6.23.

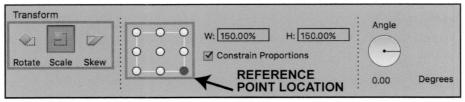

Figure 6.23 Assigning a reference point for a transformation.

Now let's select the Seal 1 layer. This time we will use any one of the scaling methods we just learned to assign a scale of W: 80% and H: 80%, then drag the seal to the front left side of the image. With the Seal 1 layer still selected, we will duplicate this layer by choosing the Duplicate Layer command from the Layer

Figure 6.24 Scaling layer content.

menu or the Layers panel menu, by Right/ Control clicking on the layer and selecting Duplicate Layer from the context-sensitive menu that appears, or by dragging the Seal 1 layer on top of the Create a new layer icon in the Layers panel. Once the layer has been duplicated, we will use the Move tool to drag the Seal 1 copy layer up to the top right sandy area, then scale this layer down (to W: 30% and H: 30%), with the transformed content shown in Figure 6.24.

6.10.2 Rotating Layer Content

Content on a layer can be rotated by applying the Flip Layer Horizontal or Flip Layer Vertical command, by selecting one of the predefined rotation angles provided, by dragging a bounding box handle to freely rotate a layer, or by assigning a specific degree of rotation.

Let's select the Seal 1 layer, then choose Image>Rotate>Flip Layer Horizontal. We will want to further rotate this seal so that he will appear to be realistically standing on the sand. With this layer still selected, we will choose Image>Rotate>Free Rotate Layer. We can drag a corner

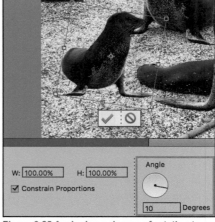

Figure 6.25 Assigning a degree of rotation to a layer.

bounding box handle and manually rotate the layer clockwise until the Degrees text field in the Tool Options bar reads 10, or highlight and type "10" in this field, then click the check mark or press Enter/Return to apply it as shown in Figure 6.25.

Now let's select the Seal 1 copy layer and apply the same command to rotate it counterclockwise to –8 degrees. With the seals scaled, rotated, and positioned to resemble Figure 6.26, let's save this file now but keep it open.

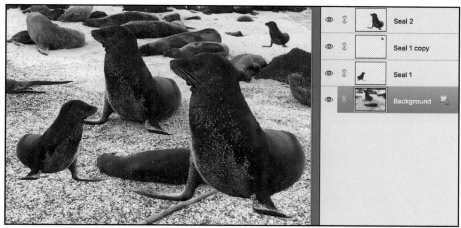

Figure 6.26 Seals scaled, rotated, and positioned.

6.11 Additional Transformation Options

In addition to the tools and commands we have learned for scaling, rotating, distorting, and adjusting perspective, the Image>Transform command submenu also provides a Skew and a Free Transform command. Just as we saw with the Distort and Perspective commands also available here, the Skew and Free Transform commands each require a layer. If one of these commands is applied to a Background layer, the Editor converts the Background layer to Layer 0.

6.11.1 Skew Command

The Skew command slants the layer vertically or horizontally, keeping the sides parallel. When the command is chosen and the pointer is hovered over one of the center bounding box handles, a double arrow appears that can be dragged to apply the skew.

6.11.2 Free Transform Command

This single command allows us to perform multiple types of transformations: scale, rotate, distort, skew, and perspective. Let's explore how to use this command to apply each of these types of transformations beginning with its use to scale content.

6.11.2.1 Free Transform Scale

With the Seals.psd file active, let's select the Seal 2 layer, then choose Image>Transform>Free Transform. As soon as we do that, bounding box handles surround the layer. The Tool Options bar updates with 100% for the W and H fields, and Constrain Proportions is checked. To scale the layer, we can drag the top left bounding box handle diagonally inward to scale the layer down. We will choose not to apply the transformation by choosing the cancel icon or by pressing the ESC key.

6.11.2.2 Free Transform Rotate

Let's select the Seal 2 layer and apply the Free Transform command again. When the bounding box handles surround the layer and the pointer is placed just outside one of the corner bounding box handles, a curved double arrow indicates that the image can be rotated clockwise or counterclockwise. The Reference Point Location box in the Tool Options bar allows us to click to select a specific corner point to rotate from versus the default of the center point. Once the layer has been rotated, we will choose not to apply the transformation by choosing the cancel icon or by pressing the ESC key.

6.11.2.3 Free Transform Distort

Let's select the Seal 2 layer then apply the Free Transform command again. Once the bounding box handles surround the layer, when the Control/Command key is held down and the pointer is placed over a corner bounding box handle, an arrow appears to indicate that the handle can be dragged independently of the other corners to distort the image. After the layer has been distorted, we will choose not to apply the transformation by choosing the cancel icon or by pressing the ESC key.

6.11.2.4 Free Transform Skew

Let's select the Seal 2 layer and apply the Free Transform command again. When the bounding box handles surround the layer, with the Control/Command key and the Shift key *both* held down and one of the middle bounding box handles selected,

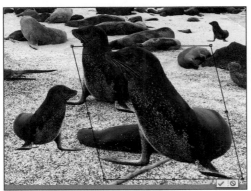

the double arrow Skew icon will appear and the layer can be skewed to the left or to the right. Let's select the top center bounding box handle and skew this layer slightly to the left, so that the seal appears to be leaning forward, as shown in Figure 6.27. Once the layer has been skewed to resemble the sample shown, let's save this file with the skew applied.

Figure 6.27 Skewed layer using the Free Transform command.

6.11.2.5 Free Transform Perspective

With the Seal 2 layer still selected, let's choose the Free Transform command one more time. When the Control/Command key, Shift key, and the Alt/Option key are all held down simultaneously and the pointer is placed over a corner bounding box handle, an arrow will appear and the handle can be dragged to create the perspective effect. Once you have experimented with this option, elect not to apply this transformation by choosing the cancel icon or by pressing the ESC key. With the file saved with *only* the skew transformation applied, we will close this file for now.

6.12 Transformations in the Guided Mode

The Guided mode provides a Rotate and Straighten option and also a Crop Photo option, with both of these options located under its Basics category.

6.12.1 Rotate and Straighten Guided Mode Option

When an image has been opened and the Rotate and Straighten option is chosen in the Guided mode, familiar Rotate buttons appear in the To Rotate a Photo section. When its Straighten tool button is clicked, radio button options echo those available in the Quick and Expert modes, except for the ability to rotate a layer versus all layers, even if it is a multilayered file. When selecting a straightening option, the results that the assignment will yield are described below the checkbox as shown in Figure 6.28.

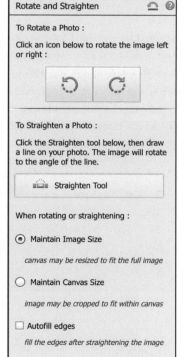

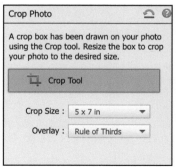

Figure 6.28 Rotate and Straighten and Crop Photo features of the Guided mode.

6.12.2 Crop Photo Guided Mode Option

The Crop Photo Guided mode option echoes the application of a crop in both the Quick and Expert modes, including the ability to rotate a crop preview prior to its execution, as also shown in Figure 6.28.

6.13 Adding Content to a Photograph

Content can be added to a photograph by importation, by applying the Content-Aware fill command, or by using the Content-Aware Move tool. Let's explore each of these ways to add content to an image, beginning with expanding our knowledge of adding content by importation.

6.13.1 Adding Content by Importation

We learned to import content from another file in Chapter Four by creating a selection and using the Move tool to drag the content into the destination file. However at that time, the content to import was pre-scaled to fit perfectly once it was imported. Let's reopen the River Dog.psd file saved in Chapter Four and add some transformations to it.

If the dog we imported is smaller than we want, we now know how we can scale him up. Let's decide that he should be larger. Let's select the dog layer first, then choose to scale the dog up to 115% using the Image>Transform>Free Transform command. Once we have done that, let's choose Image>Rotate Flip Layer Horizontal, then choose the Image>Transform>Free Transform command again and assign 20 in the Rotate Degrees field to rotate his head slightly clockwise. Once this is applied, drag him down as needed so that the bottom left edge of the dog image extends below the edge of the river photograph, with a completed sample shown in Figure 6.29. With the changes applied, optionally choose to flatten the file, then save and close it.

BEFORE SCALE AND ROTATE **AFTER SCALE AND ROTATE**

Figure 6.29 Transformations applied to imported content.

NOTE▶ In your own work, remember when combining images that they should always be the same resolution whenever possible. These same steps of creating an accurate selection, adding it to another file, then transforming the layer content as desired will allow you to change backgrounds, add people into a group photograph, place yourself on a beach riding your horse—the sky's the limit.

6.13.2 Adding Content Using the Content-Aware Fill Command

When we applied the Straighten tool, we had the option to select the Autofill edges checkbox to have the Editor analyze the image and fill the empty areas with surrounding matching content. This feature incorporates the Editor's Content-Aware technology. Let's learn how we can take advantage of this technology to intuitively fill transparent areas.

We will reopen the Perspective.psd file we saved earlier in this chapter, with the Perspective command applied. This file contains two transparent areas that appeared after the correction, both great candidates for the Content-Aware fill command.

Let's select the Polygonal Lasso tool, then trace the triangular transparent area in the sky. We can extend our selection a little into the pixel area as shown in Figure 6.30 to be sure that we fully enclose the area we want to affect. Once we have done that, we will choose Edit>Fill Selection>Use: Content-Aware. Like magic, the sky is filled to match the existing sky, as also shown in Figure 6.30.

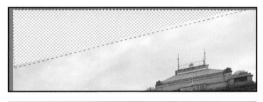
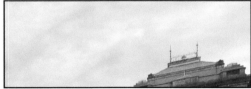
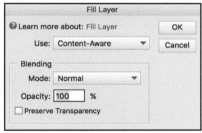

Figure 6.30 Creating a selection and applying the Content-Aware fill command.

When the pointer is placed inside an active selection, you can Right/Control click and choose Fill Selection from the context-sensitive menu that appears.

Let's deselect the sky selection and then, following the same format, select the transparent triangle at the lower left. We will again allow our selection a little overlap onto the image pixels, then choose Edit>Fill Selection>Use: Content-Aware, with the resulting adjusted image shown in Figure 6.31.

Figure 6.31 Image with the Perspective command and the Content-Aware fill command applied.

NOTE When applying the Content-Aware fill command, in the Fill Layer dialog box, we will always want Blending Mode: Normal, Opacity: 100%, and Preserve Transparency unchecked to effectively cover transparent areas we are applying the command to.

Additionally, although for the Perspective.psd file the Content-Aware fill command worked great, it is not perfect; depending on the proximity of content you do not want replicated, you may get unwanted results. In Figure 6.32 a vertical crop was applied to the ship photograph. After the crop was applied, selections of the white area were made with the Content-Aware fill command applied to them. As we can see, in both the sky and the water, some of the ship content has appeared in the sky and water replications. In your own work, when this happens, creating more *smaller* selections to apply the Content-Aware fill command to will help.

ORIGINAL PHOTOGRAPH

CROP
APPLIED **CONTENT-AWARE FILL APPLIED**

Figure 6.32 Content-Aware fill command applied resulting in unwanted replications.

 When cropping a photograph, if your crop inadvertently results in a thin strip of visible canvas on one or more sides of the image, you can select the edge of exposed canvas with the Rectangular Marquee tool, then apply the Content-Aware fill command; the edge will be quickly and easily filled with the adjacent content without having to redo the crop.

6.13.3 Adding Content Using the Content-Aware Move Tool

The Content-Aware Move Tool allows us to move and scale or duplicate and scale content driven by the Content-Aware technology we have just learned. The tool is

available only in the Expert mode and is located in the Modify section of the Tools panel. The tool is used to trace around the content we want to move, then drag it to a new location.

Let's open the photograph named Turtle.jpg located in the Practice_Import 13 files folder within the Practice Files folder you copied to your hard drive. When this image opens, the turtle is great, but perhaps we would like his position moved and resized a little for emphasis and composition.

Let's take a look at the options available in the Tool Options bar when the Content-Aware Move tool is selected as shown in Figure 6.33:

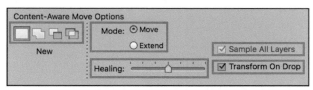

Figure 6.33 Tool Options bar when the Content-Aware Move tool is chosen.

EDITING: Options of Add to selection, Subtract from selection, and Intersect with selection are available.

MODE: Choices of Move (moves the selected content and fills the original location with adjacent content) and Extend (moves a copy of the selected content).

HEALING: Assigns the degree of texture blending around the moved content (dragging the slider left assigns less; dragging the slider right assigns more).

SAMPLE ALL LAYERS: Uses content only from the selected layer, or all layers when checked.

TRANSFORM ON DROP: Allows the moved content to be scaled prior to its application.

Let's take advantage of the ability to work on a separate layer. We will first click the Create a new layer icon. With the new layer active, we will select the Content-Aware Move tool, then in the Tool Options bar assign Mode: Move and keep the Healing slider at its default center location, with Sample All Layers *checked* and Transform On Drop checked. Let's press and drag around the turtle to trace him, leaving an approximately a half-inch area around him as shown in Figure 6.34. Because the tool uses surrounding texture, including a little extra content around the subject being selected usually provides better results. Once we have done that, let's drag the turtle down and to the right. Because we assigned Transform On Drop prior to applying the tool, scaling options now become active in the Tool Options bar. With Constrain Proportions checked, we will scale him up 125%, then click the check mark to assign the move as shown in Figure 6.34.

ORIGINAL PHOTO CONTENT-AWARE MOVE TOOL APPLIED WITH MOVE MODE ASSIGNED

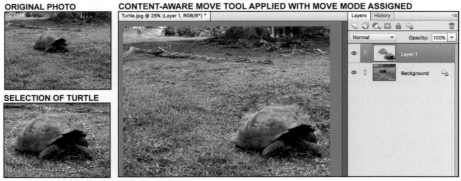

SELECTION OF TURTLE

Figure 6.34 Creating a selection and applying the Content-Aware Move tool with Mode: Move, Healing: default setting, Sample All Layers: checked, Transform On Drop: checked, Scale 125%.

With the turtle still selected, let's now select the Mode: Extend and use the Content-Aware Move tool to drag a copy of the turtle to the left. We will choose Image>Rotate>Flip Selection Horizontal to have our new turtle facing the opposite direction, then click the check mark to apply the transformation. With the turtle still

selected, let's apply the Extend mode one more time, drag the copied turtle to the back right corner of the image, apply a scale of 50% with Constrain Proportions checked in the Tool Options bar, then click the check mark to apply the extension. Once we deselect the selection, the image should resemble Figure 6.35. Let's save this file as Turtles.psd and keep it open.

Figure 6.35 Two turtles added and scaled using the Extend mode of the Content-Aware Move tool.

NOTE▶ When the Transform On Drop option is checked, in addition to being able to scale the selected content, the Tool Options bar that appears is identical to the one shown in Figure 6.23, providing the additional transformation options of Rotate and Skew as well as the ability to assign both the reference point for the transformation and a specific degree of angle rotation.

6.14 Using the Eraser Tool

When looking at Figure 6.35, we can see that the turtles blended nicely into their new locations, except for the right side of the turtle in the lower right area of the photograph. The Editor provides three eraser tools: Eraser, Background Eraser, and Magic Eraser. Let's take a look at each of them:

ERASER TOOL: Settings for Brush style, Size, Opacity, and Type can be chosen for how the tool will erase.

BACKGROUND ERASER TOOL: Converts the Background layer into a regular layer named "Layer 0" to allow its content to be erased. In addition to Size and Brush style options, Tolerance assigns the degree of similarity colors must have to be erased based on the spot selected (lower tolerance, lower range of colors), with Limits assigning whether the colors must be Contiguous (adjacent) or can be Discontiguous (anywhere within the image) to be affected by the eraser.

MAGIC ERASER TOOL: Selects and deletes content based on the Tolerance setting (color variation), similar to the Magic Wand tool with options of Tolerance, Opacity, Sample All Layers, Contiguous, and Anti-aliasing.

Because we have learned a variety of expert ways to select content for deleting pixels, we will only be using the regular Eraser tool in our work. However, the Background and Magic Eraser tools provide two additional ways to isolate and delete content, and are worth experimenting with to see if they complement your workflow.

Let's select the Eraser tool to eliminate the content around the turtle in the lower right area of the image that did not blend completely when the Content-Aware Move tool was applied. Because we used a separate layer to apply the Content-Aware Move tool, we can do that easily. With Layer 1 selected, magnify in to the area to erase, then assign a soft style brush, a size appropriate to the task, set a lower opacity for more control, such as Opacity: 80%, and Type: Brush. Press and drag over the area that you want to erase, being careful not to erase any of the turtle. When you are done, choose to save and close this file.

Any time you have created a selection, then converted it to a layer (such as bringing it into a destination file), if you realize after it has been imported that the content contains areas that were not removed well, you can select the layer, then select the Eraser tool, assign a small brush size, and trace around the perimeter of the pixel area to remove the unwanted content.

6.15 Adding Content With Drawing Tools

Content can be added to a file using the Brush tool, the Pencil tool, the Paint Bucket tool, and the Pattern Stamp tool, all located in the Draw section of the Tools panel in the Expert mode, with the exception of the Pattern Stamp tool grouped wih the Clone Stamp tool in the Enhance section.

6.15.1 Using the Brush and Pencil Tools to Add Content

The Brush tool can create either soft or hard edges, with the Pencil tool creating only hard edges.

6.15.1.1 *Using the Brush Tool*

When the Brush tool is selected, two modes are available: the Brush mode and the Airbrush mode, which replicates the appearance of airbrush strokes. The Tool Options bar provides settings for Brush style, Size, Opacity, Mode (this drop down menu provides the same blending modes we learned about in Chapter Five), Brush Settings (customize a brush), and Tablet Settings (when working with a pressure-sensitive tablet).

NOTE When the Brush tool is selected, the Tool Options bar also provides access to the Impressionist Brush tool that we will explore in Chapter Ten.

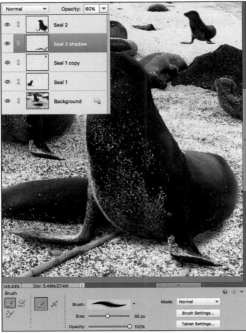

Figure 6.36 Seal with drop shadow added using the Brush tool with its layer Opacity: 60%.

Let's reopen the Seals.psd file and learn how to use the Brush tool. When we study this image, we can see that our added seals do not have shadows under them, unlike the original large seal we traced; we can use the Brush tool to add some.

Because we will want the flexibility to redo if needed, as well as control over the opacity of the shadow, we will add a layer, then place the new layer directly below Seal 2. When the Brush tool is selected, it paints with the current foreground color; let's select the default foreground color of black in the Color section of the Tools panel. With a soft brush style selected from the Brush drop down menu (Size: 50 px, Opacity: 100%, Mode: Normal), let's press and drag to create a shadow under the body and flippers of the seal, then lower the opacity of the layer to 60% so that it appears to match that of the original seal we traced in Chapter Four, as shown in Figure 6.36. Any areas that fall outside of what we want can easily be erased on the shadow layer using the Eraser tool.

TiP Any time you are painting with the Brush tool in your own work, you can press the Alt/Option key to temporarily convert the Brush tool into the Eyedropper tool to sample a color to paint with within an image.

NOTE The light shadow appearance of the brush could also be achieved by setting a lower Opacity for the brush in the Tool Options bar. However, by using the Layers panel to assign the opacity, you will have more flexibility in its assignment.

Let's also add shadow layers below each of the other two seal layers, lowering the opacity for each as needed, and adjusting the brush size based on the size of the seal it will be used for with the completed image resembling that shown in Figure 6.37.

We will save and close this file for now with all of its layers; we will work with it again in Chapter Seven.

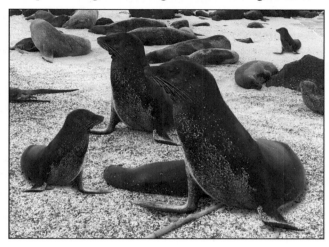

Figure 6.37 Shadows created using the Brush tool on layers with lowered opacity.

6.15.1.2 Using the Pencil Tool

When the Pencil tool is selected, the Tool Options bar updates to provide settings for Size, Opacity, Mode (blending mode), and Auto Erase. The Pencil tool also applies the current foreground color chosen in the Tools panel. When the Auto Erase feature is turned on and the Pencil is redrawn over an existing line, it will replace it with the current background color. Straight lines can be created using the Pencil tool by holding down the Shift key while drawing. A hard-edged line created with the Pencil tool is compared to a brush stroke applied with the Brush tool in Figure 6.38.

Figure 6.38 Comparing a Pencil line to a Brush stroke.

6.15.2 Using the Paint Bucket Tool

The Paint Bucket tool can be used to quickly fill an area with the current foreground color or a pattern without having to create a selection first. When the Paint Bucket tool is selected in the Draw section of the Tools panel, its options display in the Tool Options bar. We can see familiar settings here that work like their counterparts in other tools: Opacity, Tolerance, Mode (blending mode), All Layers, Contiguous, and Anti-aliasing. When the Pattern option is selected, an additional menu appears to select a pattern to apply with the tool.

6.15.2.1 Applying a Fill Color Using the Paint Bucket Tool

Let's open the photograph named Paint Bucket.jpg located in the Practice_Import 13 files folder within the Practice Files folder you copied to your hard drive. The Paint Bucket tool fills the color you click with the current foreground color, based on the Tolerance setting assigned, and is most effective when filling solid or near solid colors, such as those typically found in clip art.

With the Paint Bucket tool selected, let's single click the foreground color to open the Color Picker. Select any color you like, or type in RGB values (R: 23, G: 12, B: 245). In the Tool Options bar, we will keep most of the default settings (Opacity: 100%, Tolerance: 32, Mode: Normal, All Layers unchecked, Anti-aliasing checked; however, we will uncheck Contiguous), then single click outside the cats. As soon as we do that, because we unchecked Contiguous, the entire background, including the area between the body and the tail of the black cat, becomes filled with the chosen foreground color. If we had not unchecked Contiguous, we could simply single click a second time to the area which was not filled to apply the color to it. Let's now fill one of the cats with a new color (R: 114, G: 188, B: 7) or a color of your choice.

6.15.2.2 Applying a Pattern Using the Paint Bucket Tool and the Pattern Stamp Tool

A pattern can be applied using the Paint Bucket tool and the Pattern Stamp tool. Using the Paint Bucket tool, when the Pattern fill option is selected and the Pattern picker drop down menu is pressed, we can select a pattern from a variety of pattern categories provided. Feel free to select any patterns under any of the categories to fill the remaining two cats. The sample shown in Figure 6.39 has the Animal Fur Zebra and Sand patterns applied to it.

The Pattern Stamp tool (the stamp tool with the checkered pattern next to it grouped with the Clone Stamp tool in the Enhance section of the Tools panel) applies a

pattern from the Pattern picker using a brush. When chosen, in addition to the Pattern picker drop down menu, settings for Brush style, Size, Opacity, Mode, and Aligned can be assigned in the Tool Options bar.

ORIGINAL CATS

CATS WITH PAINT BUCKET APPLIED

Figure 6.39 Paint Bucket tool applied using foreground colors and patterns.

6.15.2.3 *Creating a Custom Brush or Custom Pattern*

The Rectangular Marquee tool can be used to convert any selection into a custom brush or pattern. When a selection is made, either Define Brush From Selection or Define Pattern From Selection can be chosen from the Edit menu. A dialog opens to assign a name for the custom brush or pattern. Once you click OK, the brush or pattern will be added at the end of the selected brush or pattern picker. When a custom brush is applied, it applies the custom brush using the current foreground color. To see the customized shape of the brush when it is applied, the Spacing option of the Brush Settings should be set to 100% or higher as shown in Figure 6.40.

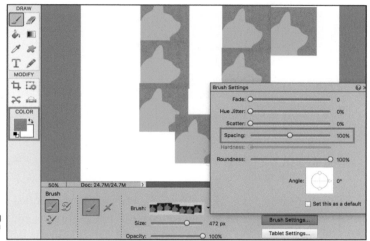

Figure 6.40 Applying a custom brush with Spacing 100%.

PRACTICE MAKES *PERFECT*✓

Before moving forward to Chapter Seven, feel free to reinforce your expertise in transformation and adding content by completing one or both of the practice projects provided.

PRACTICE PROJECT 1

1. If you completed Practice Project 1 in Chapter Three, you saved a file named Cave.psd.

2. Choose to reopen it now. (A copy of the file named Cave for Transformation. psd is included in the Chapter 13 files folder within the Practice Files folder you copied to your hard drive with the Chapter Three corrections applied to it if you did not do the exercise in Chapter Three but want to practice this transformation exercise now).

3. Select the Crop tool, then in the Tool Options bar assign a vertical crop (W: 8", H: 10", Resolution: 300 ppi).

4. Press and drag to create the crop, so that it extends from edge to edge of the image.

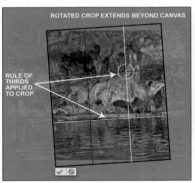
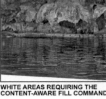
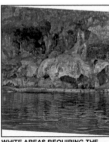

Figure 6.41 Rotated crop extending beyond the canvas with the Rule of Thirds applied.

Figure 6.42 Applying the Content-Aware fill command; completed project with areas filled and the Flip Horizontal command applied.

5. Rotate the crop preview to straighten the image using the grid that appears as your guide.

6. Before applying the crop, use the Rule of Thirds to move the crop preview to align the water's edge with the horizontal grid line and the light colored rock formation with the vertical grid line (the lower left and upper right corners of the image should extend beyond the canvas), as shown in Figure 6.41, then apply the crop.

7. Select the Polygonal Lasso tool and trace the exposed canvas, then apply the Edit>Fill Selection>Use: Content-Aware command.

8. Choose Image>Rotate>Flip Horizontal, with the exposed areas and completed project shown in Figure 6.42.

PRACTICE PROJECT 2

1. Reopen the Fish for Transformation.psd file we saved in Chapter Four.

2. Choose to load the saved selection named "Fish Selection."

3. Copy the selection as a new layer by choosing Layer>New>Layer Via Copy, or Right/Control click inside the active selection and choose Layer Via Copy from the context-sensitive menu that appears.

4. With Layer 1 selected, choose Image>Rotate>Flip Layer Horizontal.

5. With the layer still selected, choose Image>Transform>Free Transform, then in the Tool Options bar choose Constrain Proportions and scale the image (W: 75%, H: 75%).

6. Choose Image>Transform>Free Transform again then in the Tool Options bar assign Angle: 30 degrees.

7. Position Layer 1 as shown in Figure 6.43.

8. Select the Crop tool, then in the Tool Options bar assign a vertical crop (W: 5", H: 7", Resolution: 300 ppi), cropping the image to resemble the sample in Figure 6.44.

Figure 6.43 Scaled and rotated Layer 1.

9. Add a new layer and position it between the Background layer and Layer 1.

10. Select the Brush tool, assign the default foreground color of black, then paint a shadow on the larger fish behind the smaller one.

11. Assign Opacity: 20% to the shadow layer.

12. Apply the Eraser tool with a size and opacity as needed to touch up the painted shadow to look natural, as shown in Figure 6.44.

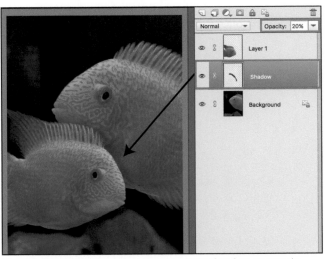

Figure 6.44 Image cropped and drop shadow painted on a separate layer with Opacity: 20%.

7

Making Good Photographs Great
by Removing Unwanted Content

In This Chapter

- **Utilize the Content-Aware fill command for content removal**
- **Apply the Healing tools and the Clone Stamp tool**
- **Explore practical applications of the Recompose tool**
- **Cover unwanted content using the Layer Via Copy command**

Removing unwanted content from a photograph can sometimes be achieved with a single tool or command, while other times a combination of methods may be required for efficient, accurate, professional results. This chapter will examine multiple removal techniques including recomposing content within an image without distorting it.

7.1 Tools and Commands for Removing Unwanted Content

Sometimes a great photograph contains some content that spoils it: one of the photographer's fingers over the lens, a no parking sign, a utility pole and/or lines, a stranger walking by, or a car passing through when the photograph was taken, etc. The Editor provides a variety of tools and commands that can remove unwanted content: the Content-Aware fill command, the Healing tools, the Clone Stamp tool, the Layer Via Copy command, and the Recompose tool and command. Although the Healing tools are available in both the Quick and Expert modes, the rest of the options are available exclusively in the Expert mode. We will work with each of these removal techniques in the Expert mode, beginning with the Content-Aware fill command.

NOTE ▶ The Guided mode provides options for healing and recomposing that will be covered in the "Removing Content in the Guided Mode" section, later in this chapter.

7.2 Removing Content Using the Content-Aware Fill Command

We have used the Content-Aware fill command to add content to our photographs after transformations. As we have learned, the command fills selected areas with surrounding content. While this is great for filling empty canvas areas, it is also great for removing unwanted content.

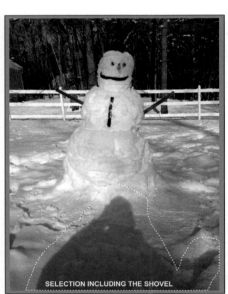

SELECTION INCLUDING THE SHOVEL

Figure 7.1 Creating a selection of content to remove using the Content-Aware fill command.

Let's choose to open the photograph named Content-Aware Fill.jpg located in the Practice_Import 14 files folder within the Practice Files folder you copied to your hard drive. When this image opens, we can see the shadow of the person who built the snowman in the foreground holding a shovel. Let's learn how to remove it.

We will need to select the shadow first. The selection we make around the shadow does not require accuracy; however it *does* require a generous amount of space between the edges of the selection and the content to be removed. The Lasso tool will work great to do this, with no feather radius required, as shown in Figure 7.1.

A copy of each figure shown in this chapter can be viewed in the companion files included with this book.

With the selection active, we will choose Edit>Fill Selection>Use: Content-Aware or Right/Control click inside the selection and choose Fill Selection from the context-sensitive menu that appears. When we click OK, the shadow is magically and effectively removed.

Let's also choose to eliminate the barn shown through the fence in the upper left corner of the photograph. Although we could again use the Lasso tool, let's select the area this time with the Rectangular Marquee tool, including the fence, as shown in Figure 7.2. When the Content-Aware fill command is applied, the woods effectively replace the barn, with the fence and snow extending realistically to the edge of the photograph, as also shown in Figure 7.2.

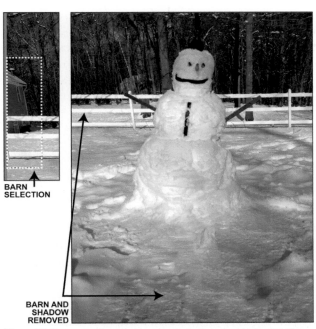

Figure 7.2 Barn selection plus barn and shadow removed using the Content-Aware fill command.

With the shadow and barn effectively removed, choose to close this file, optionally saving it first if desired.

NOTE▸ The final appearance of your snowman photograph will most likely differ slightly from the sample shown. Because the command searches for surrounding content based on a selection, both the size and proximity of the selection relative to the content covered affect the results of the application.

7.3 Using the Healing Tools to Remove Content

In contrast to the Content-Aware fill command that requires a selection, the Healing tools remove content using a brush. We will learn to apply each of them, beginning with the Spot Healing Brush tool.

7.3.1 Using the Spot Healing Brush Tool

The Spot Healing Brush tool is identified by the bandage icon with a selection added to it located in the Enhance section of the Tools panel. When it is chosen, the Tool Options bar updates, with its features shown in Figure 7.3. Let's take a look at them:

TYPE: Provides options (hereafter referred to as modes) for how we want the tool to work for us—Proximity Match (uses the pixels at the outer edges of the brush stroke to patch the selected area), Create Texture (uses the adjacent pixels to create a pattern to fill the area you brush over), and Content-Aware (uses neighboring content to patch the area beneath the brush), with its Proximity Match mode selected by default.

BRUSH: Provides a drop down menu to select a brush style; the default style or another hard-edged brush style usually works best.

SIZE: Assigns a brush size by dragging the slider or by typing in a specific size in the field provided. When assigning a brush size, its diameter should be just *slightly* larger than the content you want to remove.

SAMPLE ALL LAYERS: Allows content to be sampled from one layer and applied to a different layer.

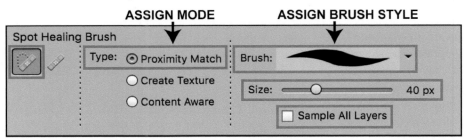

Figure 7.3 Tool Options bar when the Spot Healing Brush tool is chosen.

7.3.2 Applying the Spot Healing Brush Tool Using the Proximity Match Mode

Let's reopen the Seals.psd file we last worked on in Chapter Six. Because this is a multilayered file, we will select the Background layer, then choose to temporarily hide the rest of the layers. The Spot Healing Brush tool can be applied in two ways—by single clicking over a small area of content to remove it or by pressing and dragging over a larger area of content to remove it.

7.3.2.1 Applying the Spot Healing Brush Tool by Single Clicking

We will first experiment with applying the tool by single clicking. Let's magnify in to the seal laying down in the foreground, as shown in Figure 7.4. With the mode set to Proximity Match, select a brush size just larger than the sand particles on the seal based on your view and, with Sample All Layers unchecked, single click on some of them one at a time to remove them, as also shown in Figure 7.4.

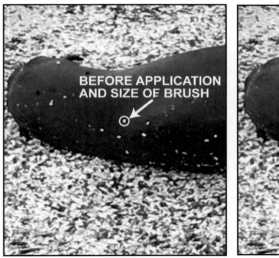
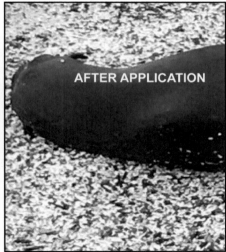

Figure 7.4 Using the Spot Healing Brush tool to single click and remove content.

7.3.2.2 *Applying the Spot Healing Brush Tool by Pressing and Dragging*

Let's choose to remove the small stick on the ground located in the lower right area of the photograph, behind the seal we have just been working on. With the mode still set to Proximity Match, and with a brush size chosen just slightly larger than the width of the stick and Sample All Layers unchecked, we will press and drag over the stick, following the direction of its shape as we drag. While dragging over the

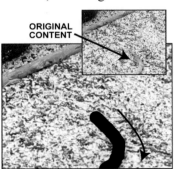

stick, the tool displays the application as a black selection; as soon as we complete the drag, the black selection disappears along the content we dragged over, as shown in Figure 7.5.

Figure 7.5 Dragging over content with the Spot Healing Brush tool and the resulting content removal.

SPOT HEALING BRUSH
DRAGGING OVER STICK

CONTENT REMOVED AFTER
DRAGGING OVER STICK

Figure 7.6 Seals.psd with sand and sticks removed.

Let's remove the larger stick using the same technique. Because this stick is wider than the first one, we will keep the same settings except that we will need a larger brush, choosing one again just slightly wider in diameter than the content to be removed. When removing a larger area, there is no need to try to cover the content in a single drag. We can stop and start as often as we want, as well as drag over the same area more than once if needed. Once the content has been removed, with all of the layers visible, your Seals.psd file should resemble the sample shown in Figure 7.6. Let's save and close this file for now.

Choose to reopen your completed Chapter Five Practice Project 1 named Poles. psd. If you did not complete the Poles.psd practice project, a copy of the file has been provided in the Practice_Import 14 files folder within the Practice Files folder located on your hard drive.

Let's save this file now as Poles Removed.psd. We can see that the utility poles detract from the photograph; let's remove them. We will need to magnify in enough to clearly view the details of the poles, keep the mode set to Proximity Match, choose a brush size just slightly larger than the content to cover, then press and drag the tool over the vertical and horizontal parts of the poles. Once we have done that, we will need a smaller brush to remove the poles' supporting cables. With little effort, the poles and their supports are removed.

7.3.3 Applying the Spot Healing Brush Tool Using the Content-Aware Mode

Let's magnify in to the lower left area of the image so that we can clearly see the power lines. As we have learned, we will select a brush size only slightly larger than the width of one of the lines. Let's drag across a small section of one of the power lines with the Proximity Match mode chosen. Now we will choose the Content-Aware mode, then drag over another power line near the one with the Proximity Match mode applied. Sometimes when power lines are removed using the Proximity Match mode, the resulting replacement content can be blurry. The Content-Aware mode may provide more realistic content replacement results. Let's use the History panel to undo the application of the Spot Healing Brush tool using the Proximity Match mode. We will choose to remove all of the power lines as shown in Figure 7.7 using the Spot Healing Brush tool with the Content-Aware mode assigned.

 When using any one of the Spot Healing Brush tool modes, you can assign Sample All Layers in the Tool Options bar, then add a layer to work on *above* the content to be removed, providing the ability to erase some of your work as well as delete the layer and start over if needed.

NOTE In your own work, sometimes content you will want to eliminate using the Spot Healing Brush tool will be effectively removed using *either* the Proximity Match mode or the Content-Aware mode. Other times because of the surrounding content, one mode will be more effective than the other. Before proceeding to remove a large amount of distracting content such as *multiple* power lines, it will be advantageous to begin by applying each mode to a small area of the content first to see which mode most easily and effectively removes it.

Figure 7.7 Utility poles removed using the Proximity Match mode, and power lines removed using the Content-Aware mode.

Let's save and close this file for now; we will work with it again later in this chapter.

7.3.4 Using the Healing Brush Tool

When the Spot Healing Brush tool is selected in the Tools panel, we can access the Healing Brush tool instead with a single click on its icon in the Tool Options bar. When we do that, its settings replace those of the Spot Healing Brush tool. Let's take a look at them, shown in Figure 7.8:

SIZE: Assigns a brush size by dragging the slider or by typing in a specific size in the field provided.

BRUSH SETTINGS: Assigns hardness, application spacing, and shape, with default presets of Hardness: 100%, Spacing: 25% (how often the brush begins again which allows the brush to evenly cover destination content), and Roundness: 100%.

ALIGNED: Determines where the replacement source point originates from; as the mouse is moved, the source moves along with it, constantly resampling new content. When Aligned is unchecked the initial sampled source point is reused as the starting point each time the mouse is clicked, until a new source point is sampled.

SOURCE: Assigns the source for healing as Sampled or Pattern; we will always assign the default setting of Sampled for image content replacement.

MODE: Assigns a blending mode for how the source content will affect the destination pixels; we will always assign the default setting of Normal for content replacement.

CLONE OVERLAY: Provides Show Overlay and Clipped cloning options that together create a preview of the source content inside the brush width cursor display. These default settings are particularly helpful when details within the source content need to align with similar details within the destination area; we always keep them checked.

SAMPLE ALL LAYERS: Allows content to be sampled from one layer and applied to a different layer.

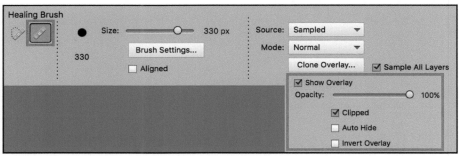

Figure 7.8 Tool Options bar when the Healing Brush tool is selected with the Clone Overlay button options displayed.

The Healing Brush tool samples texture from a source area and blends it with the colors of the destination area. Let's reopen the Barcelona.psd file that we added canvas to in Chapter Six. When we magnify in to the sky area we added above the building, we can see a slight difference in color and texture between the original sky and the added sky. We can fix this easily using the Healing Brush tool.

7.3.4.1 *Using the Healing Brush Tool With the Aligned Option Checked*

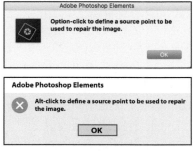

Figure 7.9 Warning dialog box that a source point must be defined prior to applying the Healing Brush tool.

We will begin working with the Aligned option checked and a brush size approximately half the width of the content we will be covering, with Hardness: 75%. When we single click on the image, one of the warning messages shown in Figure 7.9 appears.

Because the Healing Brush tool uses source content, we must define it before applying the tool. Alt/Option click in the upper left area

of the original image area to define the source content for the brush, as shown in Figure 7.10. Now press and drag; notice how the crosshair moves as we drag along with its location each time we click with the mouse. Frequent sampling of new content close to the area we want to affect will provide the best results.

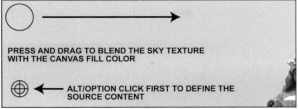

Let's use the History panel to undo this

Figure 7.10 Sampling a color for the Healing Brush tool and applying it.

application, sample the same location for source content, uncheck Aligned in the Tool Options bar, then press and drag across the sky again. With each mouse click, we can see that the crosshair begins at the initial source location, with these two options illustrated in Figure 7.11.

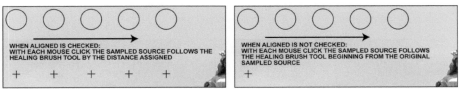

Figure 7.11 Illustrations of applying the Healing Brush tool with Aligned checked and with Aligned unchecked.

Because of the inherent nature of how the tool works, if it is applied too close to content you do not want it to affect, the edge of the content may become blurred. Creating a selection first will help to constrain the tool application, as shown in Figure 7.12.

Figure 7.12 Selection drawn prior to applying the Healing Brush tool to constrain its application.

Let's use the History panel again to undo this application. We will choose instead to create a generous selection around the statue, as shown in Figure 7.12, then select the Healing Brush tool, check the Aligned option one more time, then complete the sky texture application.

Before closing this file, let's also remove the cables and the antenna that detract from the sculpture at the top of the building, using the Spot Healing Brush tool in its Proximity Match mode, with the resulting sky texture applied and distracting content removed, as shown in Figure 7.13.

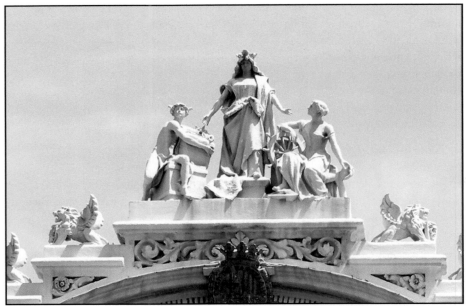

Figure 7.13 Healing Brush tool applied to the sky, with the Spot Healing Brush tool applied to the antenna and wires.

7.3.4.2 *Using the Healing Brush Tool Without the Aligned Option Checked*

As we have just seen, in some instances it will make no difference whether you have Aligned checked or not checked. However, when only a *limited* area of useful source content is available, applying the Healing Brush tool without the Aligned option checked may provide better results.

Reopen your Poles Removed.psd file one more time. When we magnify in to the top left area of the sky, we can see some blotchy areas in the sky color, which can sometimes occur when a significant amount of color correction has been applied to a photograph. When we study the area of sky in the lower right, we can see that it is much better. This area will be a great location to sample source content with the Aligned option unchecked. We can further customize our application by choosing to check Sample All Layers, then create a working layer above the Background layer to apply the healing to. Assigning Hardness: 75% in the Brush Settings drop down menu and a size comparable to the one shown in Figure 7.14, with Aligned unchecked, sample the area identified in the figure, then paint over the blotchy areas, frequently clicking and dragging the mouse to always restart the sampling from the same good source content. Once the blotchy color has been removed, let's lower the opacity of the working layer to 70% to more naturally blend the source content with the destination areas, as also shown in Figure 7.14. With the sky repaired, we will save and close this file.

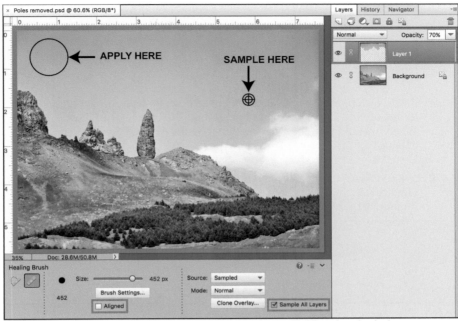

Figure 7.14 Applying the Healing Brush tool on a working layer with Aligned unchecked.

7.4 Using the Clone Stamp Tool to Remove Content

We have learned that the Healing Brush tool melds selected source pixels with destination pixels, blending texture and colors to achieve content removal. Sometimes instead of mixing source content with destination content, better results are achieved by *covering* the unwanted content with replacement content. The Clone Stamp tool combines accuracy and opacity control with sampling and brush application. In the Tools panel of the Expert mode, we will select the Clone Stamp tool, which, like the Spot Healing Brush tool, is also located in the Enhance section of the Tools panel (not the Pattern Stamp tool grouped with it that we learned about in Chapter Six). Once we have done that, the Tool Options bar updates with its settings shown in Figure 7.15:

BRUSH STYLE: Provides a drop down menu of soft and hard brushes to choose from; most types of content removal require a soft brush.

SAMPLE ALL LAYERS: Allows content to be sampled from one layer and then applied to another.

SIZE: Assigns a brush size by dragging the slider or by typing in a specific size in the field provided.

OPACITY: Assigns an opacity for content coverage, with 100% chosen by default.

MODE: Assigns a blending mode for how the source content will affect the destination content, with the default setting of Normal used for content replacement.

ALIGNED: Determines the replacement content origin, with its operation identical to that of the Aligned option of the Healing Brush tool (see Figure 7.11). When working with the Clone Stamp tool, the Aligned option is checked by default.

CLONE OVERLAY: Assigns the Overlay and Clipped options, with its operation identical to that of the Clone Overlay features of the Healing Brush tool (see Figure 7.8).

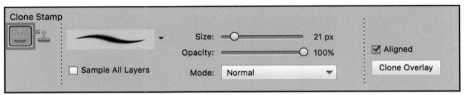

Figure 7.15 Tool Options bar when the Clone Stamp tool is selected.

7.4.1 Using the Clone Stamp Tool With the Aligned Option Checked

Let's choose to open the photograph named Zebra.jpg located in the Practice_Import 14 files folder within the Practice Files folder you copied to your hard drive. When this photograph opens, we can see that the head view of the zebra would look even better if the small portion of the second zebra was removed. If we attempt to eliminate it by using either the Content-Aware fill command or one of the Healing tools, the results are disappointing. Because the Clone Stamp tool allows us to cover over unwanted content with the content we select, it should work well to achieve our goal.

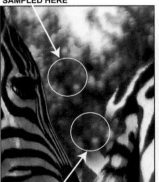

Figure 7.16 Sample content applied using the Clone Stamp tool with Aligned checked.

Let's first save this file as Zebra.psd and then add a working layer above the Background layer. Although not required, adding a working layer is a great practice to embrace. Once we have done that, we will want to select the working layer (Layer 1), then select the Clone Stamp tool. We

will assign Brush style: Soft, Size: 250 px, Opacity: 100%, Mode: Normal, with the Sample All Layers, Aligned, Show Overlay, and Clipped options all checked.

We will single click to sample content in the area shown in Figure 7.16, then single click to apply the content in the destination area also shown in Figure 7.16. The key to successful clone work is to sample *frequently*, sample matching content, and apply it with a single click, *not* pressing and dragging to apply it as a brush stroke. We will continue to sample and apply new content, selecting various areas for source content so that the results will not inadvertently create a "pattern." When applying the content, we will want to leave an area of original content in front of the zebra's nose for now, and also leave the original grass area for now, with the results at this stage also shown in Figure 7.16.

If you take a peek at your History panel now, you will most likely no longer see the original opening state. Every click of the mouse generates a history state. If you have kept the default number of history states at 50, you may want to increase that number now—if not permanently, at least temporarily—while working on a project that requires extensive Clone Stamp tool use. To do that now if desired, choose Edit>Preferences>Performance in Windows or Adobe Photoshop Elements Editor>Preferences>Performance in Mac OS.

TiP

Let's now magnify in to the area in front of the nose of the zebra. At this magnification, we will want to use a small 30 px brush, with a hard brush style. One can be selected from the drop down brush panel list of presets or from the panel menu that appears when the Brush style menu is pressed. From here we can select Small List to easily choose a hard style brush from the menu. With Aligned still checked, we will want to sample and apply matching content along the edge of the nose. Once we have done that, we can fill in the remaining area in front of the nose using Brush style: Soft and Size: 100 px, keeping Aligned checked.

To replace the grass area, we will keep the same soft style brush with Size: 250 px, then sample a variety of colors and textures, following the original ground height, with a suggested completed removal as shown in Figure 7.17. When you are satisfied with your work, choose to flatten the file, then save and close it for now. We will work with this photograph again in Chapter Nine.

Figure 7.17 Zebra with content removed.

7.4.2 Using the Clone Stamp Tool Without the Aligned Option Checked

To cover the zebra, we needed a variety of colors and textures in close proximity, making it a great candidate for the Aligned option. Let's work with a file that requires the Aligned option to be unchecked.

Let's choose to open the photograph named Dish Antenna.jpg located in the Practice_Import 14 files folder within the Practice Files folder you copied to your hard drive. When this photograph opens, we can see how much nicer it would look without the dish antenna attached to the building. Let's select a magnified view comparable to the one shown in Figure 7.18, then assign Brush style: Soft, Size: 200 px, Opacity: 100%, Mode: Normal, Aligned *unchecked*, with the Sample All Layers, Overlay, and Clipped options all checked. We will sample the area on the left of the overhang as shown in Figure 7.18, then click frequently to place the sampled content over the destination content, overlapping each application slightly while *following* the detail of the building. Because the Overlay and Clipped options have been checked, we can see the sample content within the brush width

Figure 7.18 Sampling and applying source content with Aligned unchecked.

Figure 7.19 Edges of overhang cloned to cover the dish antenna.

preview, helping us to align the source content with the destination content. We will want to remove the shadow of the dish on the overhang as well.

Aligning source and destination content in this manner takes practice, but you will be an expert at it in no time. However, until then, when alignment of source and destination content is critical as in this image, sometimes you may need a little more help than the History panel can provide. Placing each cloned section (top, middle, and bottom overhang edges) on its own layer with Sample All Layers checked, may be helpful to easily start one over if needed. Alternatively, if you save frequently, you can choose Edit>Revert to revert to the last saved version to redo your most recent Clone Stamp tool work.

Once we have done that, we will sample new content centered over the top edge of the roof above our original source content by centering the sample preview over the

edge we want to use. We can then click to apply it over the roof edge covered by the dish antenna, repeating the process for the lower edge, with both applications shown in Figure 7.19.

7.4.2.1 Lowering the Opacity of the Clone Stamp Tool

To unify the color of the cloned edge of the roof, the Opacity setting of the Clone Stamp tool can be lowered in the Tool Options bar to 65%, then reapplied over these areas, allowing for new coverage with some of the original content underneath it remaining visible.

7.4.3 Combining Content Removal Tools and Commands

If desired, a selection of the sky can be made with the Content-Aware fill command applied, if the selection created is far enough away from the building edge to not blur with it. You may also find the Healing Brush tool helpful to unify the coloring on the underside of the overhang. The nail holes and wires can be removed with the Clone Stamp tool—or the Spot Healing Brush tool—with the resulting image shown in Figure 7.20. When you are satisfied with your results, you can choose to save and close the file—or perhaps choose *not* to save it, so that you can redo this project another time: practice makes perfect when learning to align source content with destination content.

Figure 7.20 Before and after dish antenna removal.

NOTE In your own work, some content removal tasks will require a specific tool, while for others multiple different methods may all yield satisfactory results. Best practice as an expert will be to always choose the tool or method that provides the fastest and most efficient content removal, remembering that sometimes a combination of methods will streamline your results.

7.5 Using the Layer Via Copy Command to Remove Content

When content cannot be satisfactorily removed using the Content-Aware fill command, one of the Healing tools, or the Clone Stamp tool, a great solution is to cover it with content copied from another area of the photograph. Let's compare two scenarios. In Figure 7.21, the car was easily and effectively removed by making a generous selection around the car, then applying the Content-Aware fill command. The car could be effectively removed because enough similar content existed in close proximity for the Editor to accurately replicate it.

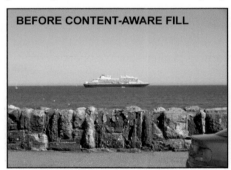
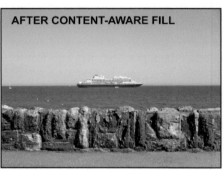

Figure 7.21 Car removed using the Content-Aware fill command.

However, when the same command is applied to the car shown in Figure 7.22, we can see unwanted results; when the car is removed, water and shoreline fill the car area where the stonewall content should be.

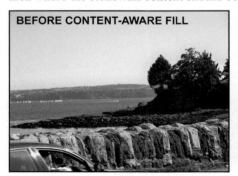
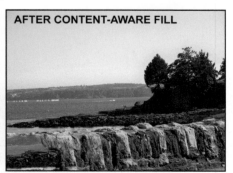

Figure 7.22 Car removed with the Content-Aware fill command yielding unwanted results.

Let's open this file, named Car.jpg, located in the Practice_Import 14 files folder within the Practice Files folder you copied to your hard drive and learn how we can use the Layer Via Copy command to easily and effectively replace the car with appropriate content.

We will first need to select the car with extra content around it using the Lasso tool and then apply a feather with Radius: 5 px to the selection. Placing the tool *inside* the selection so that we can move it without deselecting it, we will drag it to the

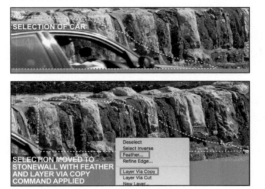

right to place it over the content we will want to copy. Once we have done that, we will choose Layer>New>Layer Via Copy or Right/Control click inside the selection and choose Layer Via Copy from the context-sensitive menu that appears as shown in Figure 7.23.

Figure 7.23 Selection of the car for the Layer Via Copy command.

Figure 7.24 Car removed by using the Layer Via Copy command.

Once the command has been applied, the copied content can be dragged *back* to the left to cover the car using the Move tool. To assure that the car is completely hidden, the copied content can be scaled up slightly if needed.

With the car removed as shown in Figure 7.24, we will close this file, optionally choosing to save it first if desired.

NOTE When using the Layer Via Copy command to cover unwanted content, as soon as you have successfully applied it, the copied content layer should be merged down, if working with a multilayered file, or flattened if it is the only layer in addition to the Background layer. This will assure that it does not accidentally get moved out of place later in your work. Alternatively, you can choose to lock the copied content layer until you are sure you want to permanently apply it.

7.6 Using the Recompose Tool to Remove Content

When a photograph needs to be cropped, such as to create a 5" × 7" or 8" × 10" standard frame size, critical content will sometimes be compromised when resizing is required. The Recompose tool can help. This tool allows us to select what critical content we will want to keep and what we will want to eliminate in a photograph when it is resized. The tool can be used to remove content prior to applying a crop or to adjust content to fit within a crop without distorting it. We will explore both options, beginning with removing content prior to applying a crop.

7.6.1 Using the Recompose Tool to Remove Content Prior to Applying a Crop

Let's choose to open the photograph named Deer.jpg located in the Practice_Import 14 files folder within the Practice Files folder you copied to your hard drive, then

Figure 7.25 10" × 8" crop preview using original content layout.

Figure 7.26 Tool Options bar when the Recompose tool is chosen.

save it as Deer Recompose.psd. When this photograph opens we can see that the young deer on the left will be cut off if the image is cropped to a 10" × 8" photograph using the composition shown in Figure 7.25.

The Recompose tool can be used to bring the young deer closer to the rest of the group. The tool can be selected by choosing Image>Recompose or accessed from the Modify section of the Tools panel. Once it has been selected, the Tool Options bar updates with its settings shown in Figure 7.26:

MARK FOR PROTECTION/ERASE (highlights material marked for protection): Options to paint over the areas you want protected when the image is recomposed or paint over areas with the eraser tool to remove the content from protection.

MARK FOR REMOVAL/ERASE (highlights material marked for removal): Options to paint over areas you want removed when the image is recomposed or paint over areas with the eraser tool to undo the mark for removal designation.

SIZE: Assigns a brush size to apply the Recompose tool by dragging the slider or by typing in a specific size in the field provided.

THRESHOLD: Assigns a threshold for application, with the default assignment of 100% required to completely eliminate content for accurate recomposing without distortion.

RECOMPOSE IMAGE TO A DESIRED PRESET DROP DOWN MENU: Provides a presets menu of ratios for the recompose. These presets use the photograph ratio, not its dimensions; by leaving the default choice of No Restriction, the width and height fields are updated as the image is recomposed, without assigning the constraints of a defined ratio.

HIGHLIGHT SKIN TONES: Protects skin tones when an image is recomposed when selected. Once selected, you can Right/Control click on the image and select Clear Protect Highlights from the context-sensitive menu that appears.

Let's begin by selecting the Mark for Protection brush, assign Size: 250 px, Threshold: 100%, and No Restriction, then paint over all of the deer. Accuracy in the coverage is not required; therefore, a large brush size such as 250 px will make the task quick and easy. If we accidentally go over the area in between the young deer and the group, we can use the Erase protection option. Once we have done that, we will switch to the Mark for Removal brush and roughly paint a stripe between the young deer and the group and also paint over the extra foliage to the right of the group of deer. Once again if needed, we can apply the Erase removal option to assure that we have correctly identified the area for removal, with our image at this point resembling Figure 7.27.

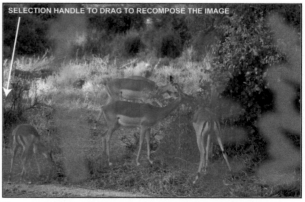

Figure 7.27 Marking content to be protected and removed when the Recompose tool is applied.

TiP When using the Recompose tool, if you Right/Control click on the image, you can select Use Quick Highlight from the context-sensitive menu that appears to be able to simply drag around a shape and have the Editor complete the highlight for quicker content selection if desired.

Once we have done that, when we move the pointer over the center handle provided at the left side of the image, also identified in Figure 7.27, a double arrow appears that we can drag to the right. As we drag the handle, the distance between the young deer and the group as well as the width of the area of foliage on the right shrinks. Because the deer were protected, they remain unaffected. However, even though they have been marked for protection, if we drag the recompose handle *too* far to the right, the content will begin to distort anyway. We can watch the Width field in the Tool Options bar update as we drag. When the width is slightly more than 10", we will stop, as shown in Figure 7.28.

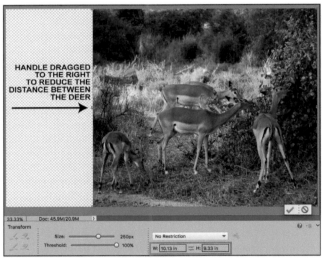

Figure 7.28 Dragging to reduce the distance between the deer.

Once the distance is reduced, we can click the check mark to apply the recompose. When the Editor has finished the recompose (the process can take a few seconds), we will crop the image using the Crop tool, assigning the 10" × 8" crop preset with Resolution: 300 ppi, as shown in Figure 7.29, then save and close the file.

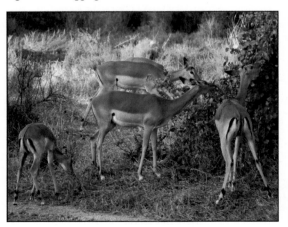

Figure 7.29 Final 10" × 8" crop with Resolution: 300 ppi applied after the Recompose tool adjustments along with the Spot Healing Brush tool's removal of the seam.

After a recompose has been applied, occasionally the "seam" where protected areas join needs a little help to blend naturally. When that happens, applying the Spot Healing Brush tool over the seam will help to remove it.

TïP

7.6.2 Using the Recompose Tool to Adjust Content Within a Crop

Let's choose to open the photograph named Elephants.jpg located in the Practice_ Import 14 files folder within the Practice Files folder you copied to your hard drive. We can see in the Image Size dialog box that the dimensions of this image are Width: 16 Inches, Height: 9 Inches, Resolution: 300 ppi. If we wanted to crop this image to fit into a 10" × 8" frame, no matter how the crop was applied, some of the elephants would have to be all or partially cropped out. A common amateur solution is to *distort* the content by *stretching* it to fit the frame size. As an expert, let's learn how we can apply the Recompose tool to resize the image to 10" × 8" and still include all of the critical content *without* distorting the image.

With this image open, we will create a new document to move the image of elephants into. Let's choose File>New>Blank File or choose New Blank File from the down arrow menu next to Open. In the dialog box that opens, we will define

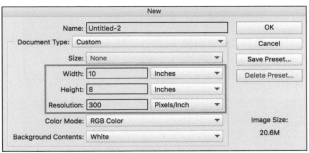

Figure 7.30 Assigning dimensions, Unit of measurement, and Resolution for a new blank document.

parameters (Width: 10, Height: 8, Unit of measurement: Inches, Resolution: 300 ppi) and keep the rest of the options at their default settings, as shown in Figure 7.30. Although a file can be named when created in the New>Blank File dialog box, it still must be saved in the Save As dialog box.

Once we have done that, we will need to select All Row or All Column from the Layout drop down menu to view the two files simultaneously. Using the Move tool, we will drag the image of elephants into the blank document, then close the original photograph without saving any changes if prompted. Because the dimensions of the original photograph are larger than those of the destination file, with the elephants layer selected in the Layers panel, we will choose Image>Resize>Scale, keep Constrain Proportions checked in the Tool Options bar, and scale the image of elephants down until all of its content displays *proportionately* within the 10" × 8" destination document. (Align the image of elephants with the left side of the blank document, then drag the handles to scale the image down, or type 63% in the W and H fields of the Tool Options bar with Constrain Proportions checked.) We can now apply the Recompose tool Mark for Protection brush over the elephants using the

same settings as those we assigned for the deer (Size: 250 px, Threshold: 100%, and No Restriction), then apply the Mark for Removal brush to cover the ground below them and the foliage above them as shown in Figure 7.31.

When the horizontal Recompose tool handles are dragged to the top and bottom edges of the document, the background foliage above the elephants and the ground cover below them are both extended, with the elephants kept intact. Once the check mark is clicked and the content is recomposed, the file should be flattened, with the resulting 10" × 8" photograph shown in Figure 7.32. With the recompose applied, let's choose to save the file as Elephant group.psd, then close it.

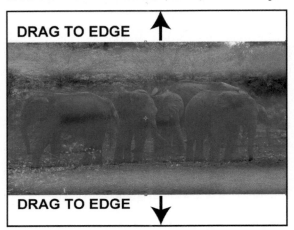

Figure 7.31 Elephants image scaled proportionately to fit, with the elephants marked for protection and the ground and foliage areas marked for removal.

Figure 7.32 Content above and below the elephants recomposed to fit a standard 10" × 8" frame.

7.7 Removing Content in the Guided Mode

The Guided mode provides two options for removing content, both located under its Special Edits category: Scratches and Blemishes, and Recompose.

7.7.1 Using the Scratches and Blemishes Option of the Guided Mode

If the original Poles.psd file is reopened and the Guided mode is selected, we will see familiar tool settings for the Spot Healing Brush tool and the Healing Brush tool. Each tool in the Guided mode provides a Brush Size slider to drag to assign the brush application, with the Spot Healing Brush tool offering only its default type of execution, as shown in Figure 7.33.

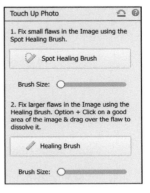

Figure 7.33 Choosing settings in the Scratches and Blemishes option of the Guided mode.

7.7.2 Using the Recompose Option of the Guided Mode

If the original Deer.jpg image is reopened and the Recompose option is selected in the Guided mode, Protect, Remove, and Eraser buttons are provided to assign the recompose, along with a slider to select the brush size for the application, as shown in Figure 7.34.

Above these buttons is the Recompose Tool button. This button can be selected to adjust the bounding box handles for recomposing *without* isolating content. This feature is also available in the Expert mode; however, because no content is pre-marked for protection, it quickly begins to distort the content within the image and is not recommended.

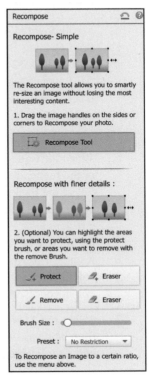

Figure 7.34 Choosing settings in the Recompose option of the Guided mode.

PRACTICE MAKES *PERFECT*✔

Before proceeding to Chapter Eight, feel free to reinforce your expertise in content removal by completing one or more of the practice projects provided.

PRACTICE PROJECT 1

1. Open the photograph named Covered Bridge.jpg located in the Practice_ Import 14 files folder within the Practice Files folder you copied to your hard drive, and save it as Covered Bridge.psd.

2. Create a working layer above the Background layer.

3. With the working layer selected, magnify in to the large power lines in the upper left area of the sky. Choose the Spot Healing Brush tool, keep the default brush style, assign a size just slightly wider than the lines, then, with the Proximity Match mode selected and Sample All Layers checked, drag across the lines to remove them.

4. Scroll down to view the smaller power lines. Choose to remove these lines one at a time, using the Spot Healing Brush tool, keeping the default brush style and assigning a size just slightly wider than the lines, with the Content-Aware mode selected and Sample All Layers checked.

5. Scroll down to view the content in the lower left of the image. Using the Spot Healing Brush tool, keep the default style, assigning a larger brush size such as 32 px, with the Proximity Match mode selected and Sample All Layers checked. Remove the telephone pole, the power pedestal, the black planter, the water pipe, and the shadows on the grass. After the power pedestal is removed, you may need to reapply the Spot Healing Brush tool over the foliage to remove the dark area.

6. When the water pipe is removed, the left edge of the foundation may no longer be straight. Select the Background layer *first*, then choose the Rectangular Marquee tool. Draw a rectangle on the foundation to the right of the edge to be covered, apply a feather with Radius: 1 px, then assign the Layer Via Copy command. Drag this copied content layer *above* your working layer in the Layers panel.

Figure 7.35 Portion of the foundation copied and applied using the Layer Via Copy command.

7. Select the Move tool and drag the selection to redefine the edge of the foundation as shown in Figure 7.35. When you have placed it satisfactorily, choose to merge this layer down onto the working layer.

8. Magnify in to the paper sign on the fence rail. Select the Clone Stamp tool, using Brush style: Soft and Size: 30 px, with Aligned unchecked; then sample to the left and right of the sign aligning with the edge of the rail.

9. To create the left edge to the post, select the Background layer *first*, then choose the Polygonal Lasso tool. Trace the area you need to cover, move this selection onto the post, apply a feather with Radius: 1 px, then assign the Layer Via Copy command. Drag the copied content layer above your working layer in the Layers panel.

10. Select the Move tool and drag this selection over to define the edge of the post as shown in Figure 7.36. If needed, choose to scale and/or distort the copied content to cover the sign and create a straight side for the post. When you have placed it satisfactorily, choose to merge this layer down onto the working layer.

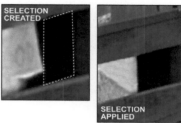

Figure 7.36 Selection of the post with the Layer Via Copy command applied to cover the sign.

11. Select the Background layer *first*, then choose the Fit on Screen view. Choose the Lasso tool, assign a feather with Radius: 5 px, then trace a section of the road without the power line shadows, as shown in Figure 7.37; next apply the Layer Via Copy command, then drag this copied content layer above your working layer in the Layers panel.

12. Select the Move tool, then drag the copied content over to cover the shadows. If necessary, choose to duplicate the layer, then drag the new copy to cover more

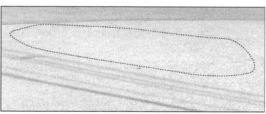

Figure 7.37 Selection of road to cover the power line shadows.

content. When you are satisfied with your covered shadows, merge all of these layers with your working layer. (Alternatively, choose to cover all of the power lines' shadows using the Spot Healing Brush tool.)

13. With the working layer selected, remove any remaining road spots, power line shadows, and the signs on the right using the Spot Healing Brush tool, keeping the default brush style and assigning a brush size such as 40 px, with the Proximity Match mode selected and Sample All Layers checked.

14. When all of the distracting content has been removed, choose to flatten the file, with the completed covered bridge project resembling the sample shown in Figure 7.38.

Figure 7.38 Completed Covered Bridge.psd project.

PRACTICE PROJECT 2

1. Reopen the Blue Heron.psd file we last worked on in Chapter Six, then optionally choose to create a working layer above the Background layer. If you choose to work on a separate layer, be sure each time you apply the Spot Healing Brush tool and the Clone Stamp tool that you have Sample All Layers checked.

2. Magnify in to the top third of the photograph. Single click to remove the spots with the Spot Healing Brush tool using the default brush style, a size just slightly larger than the spots, with the Proximity Match mode selected as shown in Figure 7.39.

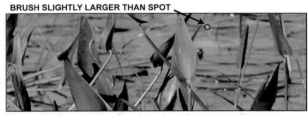

BRUSH SLIGHTLY LARGER THAN SPOT

Figure 7.39 Spot Healing Brush tool used to remove the spots on the water.

3. Magnify in to the neck of the heron. The light area has a small amount of pink discoloration. Choose the Clone Stamp tool, assign parameters

(Brush style: Soft, Size: 50 px, Opacity: 20%, with Aligned unchecked), then select the area above and below the discolored area for the source content to cover it, applying just enough to remove the pink discoloration.

4. Magnify in to the body area just below the neck. The lump and brown patch on the bird can be removed using the Spot Healing Brush tool, with its default brush style, a size just slightly larger than the areas to remove, with the Proximity Match mode selected.

5. Now magnify in to the area of his beak. The protruding content on his beak can be removed using the Clone Stamp tool, assigning Brush style: Soft, Size: 30 px, Opacity: 100%, and Aligned unchecked. Sample source content to the left of the area, then apply it aligning the sampled clone source with the beak.

6. Lower the opacity setting of the Clone Stamp tool to 50%, then reapply the tool with a source sampled to the right of the area; the neck, beak, and completed Blue Heron.psd samples are all shown in Figure 7.40.

7. Save and close the file, we will work with it again in Chapter Nine.

Figure 7.40 Neck area cloned, beak cloned, and completed Blue Heron.psd project.

PRACTICE PROJECT 3

A third exercise named "Chapter Seven Practice Project 3.pdf" is available in the Additional Practice Projects folder on the companion DVD.

8

Using the Editor for Photograph Restoration

In This Chapter

- Combine scans to create a composite image
- Apply sharpening and blurring tools and filters
- Learn procedures unique to the restoration of photographs
- Explore ways to create a sepia tone

Photograph restoration combines many of the tools and commands we have already learned with the incorporation of some additional tools, commands, and filters. While restoring photographs in this chapter, you will learn a variety of tips and techniques for professional results in your future restoration work.

NOTE Although this chapter focuses on photograph restoration, it will introduce the following tools and commands which have a variety of applications in addition to their use for restoration: the Sharpen, Smudge, and Blur tools; the Auto Sharpen, Unsharp Mask, Adjust Sharpness, Gaussian Blur, Surface Blur, and Smart Blur commands; the Dust & Scratches filter; and the Monotone Color Effect.

8.1 Tools and Commands for Photograph Restoration

We have already mastered many of the components required for professional photograph restoration: accurate selections, using layers, color correction tools, commands, filters, and transformations, plus the Spot Healing Brush, Healing Brush, Clone Stamp, and Eraser tools, and the Content-Aware fill and Layer Via Copy commands. However, to professionally restore photographs the application of some additional tools and commands are oftentimes required, along with some general knowledge and procedures unique to restoration. We will address all of these by completing two restoration projects in the Expert mode, which together include many of the typical challenges of restoration work.

NOTE The Guided mode provides three content restoration options that will be covered in the "Restoration in the Guided Mode" section later in this chapter.

8.2 Before Beginning a Photograph Restoration

When beginning a restoration project, best practice is to scan the photograph at a resolution appropriate to the desired final print size and to print a reference copy before beginning to work on it.

8.2.1 Scanning Based on the Final Print Size

Let's choose to open the photograph named Restoration1.jpg located in the Practice_ Import 15 files folder within the Practice Files folder you copied to your hard drive. Once we have done that, let's choose File>Save As and name the file Restoration1_ restored.psd.

When we choose Image>Resize>Image Size, we can see that the original photograph is not a standard frame size, as shown in Figure 8.1. However, based on our learning in Chapter Three, the photograph was scanned at 600 ppi in anticipation of its enlargement. When we assign Resolution: 300 ppi with Resample Image unchecked, the image dimensions are increased but are still not standard frame dimensions, as also shown in Figure 8.1.

A copy of each figure shown in this chapter can be viewed in the companion files included with this book.

Image Size	
ⓘ Learn more about: Image Size	OK
	Cancel
Pixel Dimensions: 17.7M	Help
Width: 2002 Pixels ▾	
Height: 3085 Pixels ▾	
Document Size:	
Width: 3.337 Inches ▾	
Height: 5.142 Inches ▾	
Resolution: 600 Pixels/Inch ▾	
Scale Styles	
☐ Constrain Proportions	
☑ Resample Image	
Bicubic (best for smooth gradients) ▾	

Image Size	
ⓘ Learn more about: Image Size	OK
	Cancel
Pixel Dimensions: 17.7M	Help
Width: 2002 pixels	
Height: 3085 pixels	
Document Size:	
Width: 6.673 Inches ▾	
Height: 10.283 Inches ▾	
Resolution: 300 Pixels/Inch ▾	
Scale Styles	
☑ Constrain Proportions	
☐ Resample Image	
Bicubic (best for smooth gradients) ▾	

Figure 8.1 Original photograph document size with Resolution: 600 ppi versus enlarged document size with Resolution: 300 ppi, Resample Image unchecked.

If a 5" × 7" crop is applied to the enlarged image document size, critical content is excluded, as shown in Figure 8.2. To accommodate that, we will instead apply a crop which will *add* content to the sides of the image, allowing us to have a resulting

5" × 7" standard size photograph with no image content compromised. With the default colors of black as the foreground color and white as the background color, let's select the Crop tool, then select 5" × 7" from the Show Crop Preset Options drop down menu in the Tool Options bar. When creating the crop, we will need to drag the bounding box handles out beyond the image and offset the content to have more canvas extension on the left side of the image. This will accomplish two things: it will center the figure, and it will be easier to replicate the content on the left than the window details on the right, as also shown in Figure 8.2.

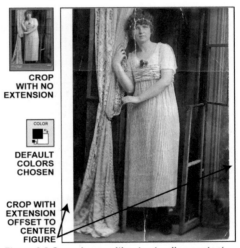

CROP WITH NO EXTENSION

COLOR

DEFAULT COLORS CHOSEN

CROP WITH EXTENSION OFFSET TO CENTER FIGURE

Figure 8.2 Crop shown without extending content, default colors selected, and crop applied with its bounding box handles extended to create a standard 5" × 7" photograph.

NOTE ▸ If a 5" × 7" crop is applied to this photograph with no resolution assigned, the resulting image resolution will be 441 ppi. In the Image Size dialog box with Resample Image *checked*, the resolution can then be lowered to 300 ppi. Alternatively, if a resolution of 300 ppi is assigned in the Resolution field of the Tool Options bar *before* the Crop tool is applied, the resulting crop will automatically be 5" × 7" at 300 ppi. In this instance, either solution will work. In your own work, you may prefer to *not* assign a resolution in the Tool Options bar when cropping, so that when the Image Size dialog box is opened after the crop has been applied, you can confirm that you originally scanned the image with a high enough resolution so that the cropped resolution is equal to or greater than the final resolution desired.

8.2.2 Creating a Reference Print Prior to Beginning a Photograph Restoration

Once an image has been cropped to the final desired document size with a resolution of 300 ppi, a reference print at that size should be made. At a magnified view, many more imperfections will be visible that will *not* be apparent at the final print size: if they will *not* be visible, there is no need to fix them. You should print the reference copy with the same final size and quality paper you will use for the completed restoration; some types of photo paper will tend to show surface damage more distinctly than others.

8.3 Converting a Sepia Tone Image to Black and White for Restoration

When working on an aged sepia tone photograph, oftentimes the paper has also yellowed, making the resulting color no longer a true sepia tone. Removing the color in its entirety, restoring the image, then adding a sepia tone back to the image at the completion of the restoration process will create a more true sepia tone photograph.

8.3.1 Removing the Color Prior to Restoring a Photograph

As we have learned, there are four ways to convert an image to a grayscale photograph in the Editor: by choosing Image>Mode>Grayscale, by choosing Enhance>Convert to Black and White, by choosing Enhance>Adjust Color>Remove Color, or by using the Hue/Saturation command. We have learned that the Convert to Black and White command provides the ability to adjust the individual channels for customized control over the conversion. In your own work, it will be advantageous to try each conversion method first to decide which one provides the best starting point based on the overall tonal quality produced in the conversion.

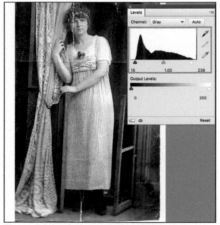

For this project, we will choose Image>Mode>Grayscale. In the warning dialog box that opens, we will confirm that we do in fact want to discard the color information. We can see once this is done that the Histogram indicates the image is lacking in shadows and highlights. Using a Levels adjustment layer we will assign values (Shadows: 15, Midtones: 1.0, Highlights: 238) to enhance the tonal quality of the image, as shown in Figure 8.3. Once the Levels adjustment layer has been applied, we will merge it down.

Figure 8.3 Applying a Levels adjustment layer to the grayscale image (Shadows: 15, Midtones: 1.0, Highlights: 238).

When scanning photographs for restoration, even if the original image is a grayscale photograph, scanning in the RGB color mode provides the flexibility to choose how you want to remove the color within the Editor. Once the conversion has been made, if the final image will be grayscale, choosing Image>Mode>Grayscale before continuing with the restoration work will retain the tonal settings you have applied, but will significantly reduce the file size.

TiP

8.4 Spot Healing Brush Tool Applications

We have learned how to use the Spot Healing Brush tool. With sizes appropriate to the tasks using the Proximity mode, many of the flaws in this photograph can be removed using this tool. Before beginning to remove them, be sure you have printed a test 5" × 7" copy to refer to, then magnify in to most accurately remove only the flaws that are visible in the reference print.

8.5 Precision Repair

For repairs requiring precision such as the tear near the eye, better control will be available by magnifying in, choosing the Clone Stamp tool, then assigning appropriate values (Brush style: Soft, Size: Small, Aligned unchecked, Opacity: 100%,) optionally choosing to temporarily create a working layer, then choosing Sample All Layers as shown in Figure 8.4.

Figure 8.4 Using the Clone Stamp tool to repair the eye.

8.6 Using the Smudge Tool

The Smudge tool does just as its name implies. While it can be used for special effects such as stretching and distorting content, it is also oftentimes useful for repairing small flaws in photograph restoration by blending them with the surrounding content.

The tool is grouped with the Blur tool and the Sharpen tool located in the Enhance section of the Tools panel. When the

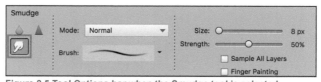

Figure 8.5 Tool Options bar when the Smudge tool is selected.

default Blur tool is chosen, the Smudge tool becomes available for selection in the Tool Options bar, as shown in Figure 8.5. Let's take a look at its features:

MODE: Assigns Normal by default, with the ability to select a blending mode option of Darken or Lighten.

BRUSH: Provides a drop down menu of soft and hard brush styles to choose from, with most applications working best with a soft brush style.

SIZE: Assigns a brush size by dragging the slider or by typing in a specific size in the field provided.

STRENGTH: Assigns the degree of intensity of the smudge effect you want to apply.

SAMPLE ALL LAYERS: Allows content to be selected on one layer but applied to a different layer.

FINGER PAINTING: Smudges content with each stroke, beginning with the application of the current foreground color. When using this tool for restoration, this feature should always be unchecked.

Let's assign the settings shown in Figure 8.5 (Mode: Normal, Brush style: Soft, Size: 8 px, Strength: 50%), then magnify in to the horizontal pleated area of the woman's dress. In this particular image at the final print size of 5" × 7", these flaws are not

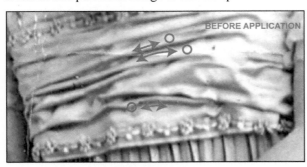

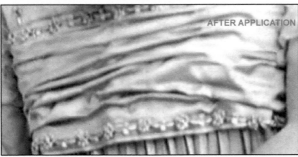

actually visible; however they provide a great opportunity to learn how the Smudge tool can help in your future restoration projects. We will apply the brush by dragging back and forth over each flaw one at a time, following the direction of the pleat the flaw is on, with results shown in Figure 8.6.

Figure 8.6 Applying the Smudge tool to remove flaws.

8.7 Using the Layer Via Copy Command in Restoration

With the canvas extended on the left side of the photograph, content will need to be added to complete the drapery. The easiest and most realistic way to do that is to use the Layer Via Copy command. Using the Polygonal Lasso tool, we will select around the right side of the drapery, as shown in Figure 8.7, then apply a feather with Radius: 5 px to the selection.

Figure 8.8 Applying the Distort command to align the copied content with the existing content and partially erasing some of the content after the transformation.

Figure 8.7 Selecting the drapery to apply the Layer Via Copy command.

We will apply the Layer Via Copy command, choose Image>Rotate>Flip Layer Horizontal, then drag it into position using the Move tool. To align with the existing drapery, we will choose Image>Transform>Distort. This will allow us to adjust the top bounding box handles to align the copied content with the original content, as shown in Figure 8.8.

Once the drapery edges are aligned, the transformation can be completed and the Eraser tool applied to some areas to blend the drapery even more naturally with the original content below it, as also shown in Figure 8.8. Once the drapery appears natural, the layer should be merged down.

8.8 Applying the Sharpen Commands and the Sharpen Tool

The Editor provides multiple ways to create the "appearance" of sharpening an image. Each option achieves the sharpening by increasing the contrast of edges, making them visually appear crisper. We will explore three sharpening commands

Figure 8.9 Selection of the drapery with a feather applied (Radius: 5 px).

Figure 8.10 Applying the Unsharp Mask command.

available under the Enhance menu: Auto Sharpen, Unsharp Mask, and Adjust Sharpness, plus the Sharpen tool.

NOTE When a photograph is selected in the Organizer and opened in the Instant Fix editor, a Clarity button provides preset assignments to increase or reduce the sharpness of the image.

8.8.1 Auto Sharpen Command

Let's select the lower half of the drapery as shown in Figure 8.9, using the Polygonal Lasso tool, then apply a feather with Radius: 5 px. Rather than sharpening the entire photograph, we will want to restrict the sharpening to this area. As we can see in Figure 8.9, the selection does not have to be accurate and should not extend out to the edges of the drapery, allowing the sharpening application to gradually transition back to the outer edges of the drapery.

Let's choose Enhance>Auto Sharpen. A small preset amount of sharpening is applied, allowing no user input as to the strength of the application. To increase the sharpening effect, the command can be applied again. Let's use the History panel to undo this application, keeping the selection and feather applied, then select a method which will allow us more control over the application of the sharpening.

8.8.2 Unsharp Mask Command

With the selection active, we will choose Enhance>Unsharp Mask. A dialog box opens that provides three sliders: Amount, Radius, and Threshold.

> AMOUNT: Assigns the intensity of the sharpening. As the percentage is increased, the contrast between edge pixels is increased, with typical percentages applied ranging from 100 to 200%.

> RADIUS: Assigns the width of the edges to be affected, with typical assignments between 2 and 3 px.

> THRESHOLD: Assigns how different the tonal quality of the adjacent pixels must be before the sharpening is applied to them; a lower value requires very little contrast, with a higher value requiring more. The setting of 0 levels is assigned by default and typically works well.

Let's assign the settings shown in Figure 8.10 (Amount: 175%, Radius: 2.6 Pixels, and Threshold: 0 levels).

When assigning sharpening, in addition to the ability to click the minus and plus magnifying glass icons to examine the effects of your settings, you can press and hold on the dialog box preview window to view the original image to compare it to the settings you are selecting.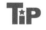

8.8.3 Adjust Sharpness Command

Let's use the History panel to undo this application, then with the selection still active, choose Enhance>Adjust Sharpness. A dialog box opens providing the following options:

> PRESET: Defaults to Custom, with the ability to save sharpening settings as presets for future use.

> AMOUNT: Assigns the intensity of the sharpening. As the percentage is increased, the contrast between edge pixels is increased, with typical percentages applied ranging from 100 to 200%.

> RADIUS: Assigns the width of the edges to be affected, with typical assignments between 2 and 3 px.

> REMOVE: Provides a drop down menu to assign how you want the Editor to apply the sharpening, with three options: Gaussian Blur, Lens Blur, and Motion Blur. The Lens Blur identifies details and can sometimes produce better results than the default Gaussian Blur option by allowing higher Amount and Radius settings. The Motion Blur adjusts sharpening based on movement, with the ability to assign the angle of the movement.

SHADOWS/HIGHLIGHTS: Provides a down arrow menu to assign shadow and highlight areas to have less sharpening applied to them if desired, with the default settings of full application to these areas usually working well.

Let's assign the settings shown in Figure 8.11 (Amount: 200%, Radius: 2.3 px, Remove: Lens Blur).

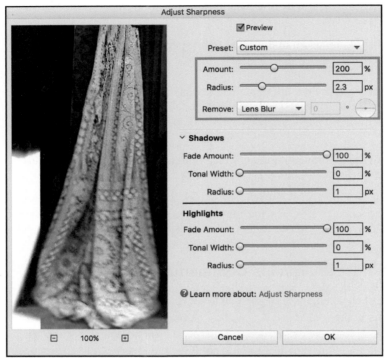

Figure 8.11 Assigning sharpening in the Adjust Sharpness dialog box.

NOTE A common error is to oversharpen an image, creating a grainy appearance and/or an undesirable halo effect. When applying sharpening, the amount you will need to be effective is relative to the resolution of the photograph; low resolution images require lower settings whereas high resolution images require higher settings.

Choose to apply the sharpening to this drapery selection using either the settings provided for the Unsharp Mask command or those of the Adjust Sharpness command, then deselect the selection. In your own work, although one method will quickly become your favorite, they both provide effective results.

8.8.4 Applying the Sharpen Tool

Also grouped with the Blur and Smudge tools, the Sharpen tool allows you to selectively paint over areas to sharpen them. When either the Blur tool or Smudge tool is selected, the Sharpen tool can then be chosen in the Tool Options bar, as shown in Figure 8.12. Let's take a look at its features:

MODE: Assigns Normal by default, with the ability to select a blending mode option of Darken or Lighten.

BRUSH: Provides a drop down menu of soft and hard brush styles to choose from; most applications work best with a soft brush style.

SIZE: Assigns a brush size by dragging the slider or by typing in a specific size in the field provided.

STRENGTH: Assigns the degree of intensity of the sharpening effect you want to apply.

SAMPLE ALL LAYERS: Allows content to be selected on one layer but applied to a different layer.

PROTECT DETAIL: Enhances details while helping to minimize the negative effects of oversharpening. Because it is easy to oversharpen, this option is checked by default and should always be applied.

With the settings shown in Figure 8.12 (Mode: Normal, Brush style: Soft, Size: 55 px, Strength: 65%, Sample All Layers unchecked,

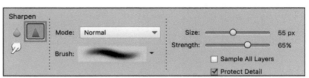

Figure 8.12 Tool Options bar when the Sharpen tool is selected.

and Protect Detail checked), let's magnify in to the drapery above the tie. While the tie area is sharp, the area above it is slightly blurred. With a single brush stroke applied across each fold, the details become sharper. If you use the History panel to *temporarily* return to the state just prior to applying the Sharpen tool, then return to the state of your application of the tool, you will see the subtle but effective improvement the Sharpen tool creates when it is applied.

8.9 Filling the Canvas Areas

The Content-Aware fill command can be applied to the upper portion of the added canvas on the left side and the area below the window brackets on the right side. (If you attempt to apply this command to the full length of canvas on each side, it will replicate some unwanted content.) Once applied, the Clone Stamp tool with Aligned unchecked can be used to fill in the remaining canvas area on the left side. The Clone Stamp tool or the Healing Brush tool can then be applied to evenly distribute the tonal and textural quality of the rest of the dark area on the left side.

The right side of the canvas will have to be first filled by selecting the wallpaper below the window brackets and then applying the Layer Via Copy command to the content, assigning a feather with Radius: 2 px. If needed, a Levels adjustment layer can be added clipped to affect only the copied content layer directly below it to

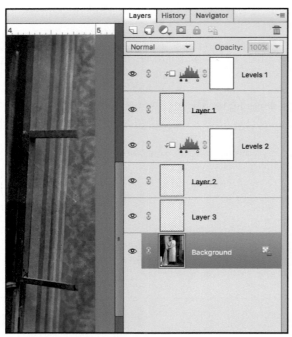

Figure 8.13 Using content to fill the wallpaper and then adjusting its tonal quality to match its destination.

lighten the copied content to match its destination. This can be repeated two more times to fill all of the remaining wallpaper areas on this side. Any uneven tonal quality areas can be adjusted by applying the Dodge and Burn tools, with the resulting appearance shown in Figure 8.13.

To extend the window brackets, the Clone Stamp tool can be applied with Aligned unchecked. If the cloning is added to a working layer above the Background layer with Sample All Layers checked, any extra unwanted content that is sampled in addition to the bracket can be easily erased on the working layer; then the layer can be merged down. When using the Clone Stamp tool, the dark areas of the baseboard on the lower right can also be covered at this time, sampling the content to its left.

8.10 Applying the Dust & Scratches Filter

The area of the photograph that contains the woman's feet is grainy. Let's create a rough selection of this area and assign a feather with Radius: 5 px, then choose Filter>Noise>Dust & Scratches. This filter is a great way to remove small imperfections by blending them with surrounding content. When the dialog box opens, we can see that it provides two sliders:

RADIUS: Assigns the intensity of the blur you want to create.

THRESHOLD: Assigns the amount of contrast required before the content is blurred.

Feel free to drag each slider, watching how it affects the content, then assign Radius: 2 Pixels and Threshold: 0 levels. In your own work, because this filter blurs content, a low number for the Radius value combined with a Threshold value of 0 usually works well, as shown in Figure 8.14.

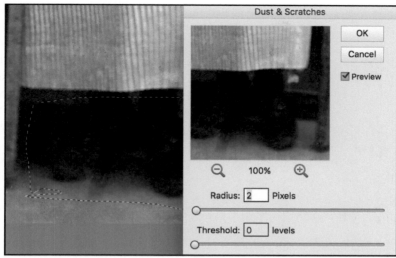

Figure 8.14 Applying the Dust & Scratches filter.

NOTE An alternative to the Dust & Scratches filter for removing small imperfections is the Filter>Noise>Reduce Noise filter. When its dialog box is opened, typically a high Strength setting combined with a low Preserve Details setting will work best. Its Reduce Color Noise option works similarly to the Luminance feature of Camera Raw that we learned about in Chapter Five. Because it works with color noise, it will not be available when working on a grayscale photograph.

8.11 Applying the Blur Tool

Grouped with the Smudge and Sharpen tools, when either of these tools is chosen, the Blur tool becomes available in the Tool Options bar. Let's take a look at its features:

MODE: Assigns Normal by default, with the ability to select a blending mode option of Darken or Lighten.

BRUSH: Provides a drop down menu of soft and hard brush styles to choose from; most applications work best with a soft brush style.

SIZE: Assigns a brush size by dragging the slider or by typing in a specific size in the field provided.

STRENGTH: Assigns the degree of intensity of the blur effect you want to apply.

SAMPLE ALL LAYERS: Allows content to be selected on one layer but applied to a different layer.

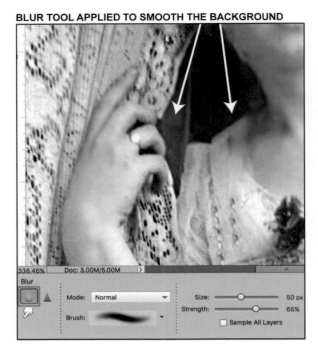

BLUR TOOL APPLIED TO SMOOTH THE BACKGROUND

+When we magnify in to the background to the left of the woman's face, we can see more grain. Although this will not be visible when printed at the final output size of 5" × 7", it offers a great opportunity to learn how grain can be removed with the Blur tool versus with a noise filter. Let's assign appropriate settings (Mode: Normal, Brush style: Soft, Size: 50 px, Strength: 65%), Sample All Layers unchecked, then brush over the grain to remove it, as shown in Figure 8.15.

Figure 8.15 Applying the Blur tool.

NOTE ▶ In your own work, it is important to avoid applying the tool over features such as eyes, nose, or mouth, as well as over any area more times than needed, as details are softened each time the blur is applied.

8.12 Removing Unknown Content

A small white area exists next to one of the woman's shoes. Is it a tear in the original photograph? Is it a part of the hem of her dress that has come apart? Let's cover it with neighboring content using the Clone Stamp tool. In your own work, when content seems distracting, is unidentifiable, or appears as though it may be damage, "when in doubt, take it out."

8.13 Applying a Sepia Tone to a Photograph

Before finishing this restoration by applying a sepia tone, the file should be flattened if you have any working layers above the Background layer. With only the Background layer remaining, a second reference print at the final output size is recommended. If all content has been satisfactorily repaired, the sepia tone can be restored by applying the Tint Sepia Monotone Color Effect or by applying the Hue/Saturation command.

8.13.1 Applying the Tint Sepia Monotone Color Effect

Let's choose Window>Effects>Monotone Color>Tint Sepia. The color mode is changed to RGB and a layer is created automatically above the Background layer, with the tone applied. However, as we can see, it is overly saturated. One way to solve this is to add a Hue Saturation adjustment layer above it and reduce the saturation of the color. However, let's apply an easier and more effective solution: lower the opacity of the copied layer until the sepia tone appears natural, with a suggested setting of Opacity: 50%, as shown in Figure 8.16.

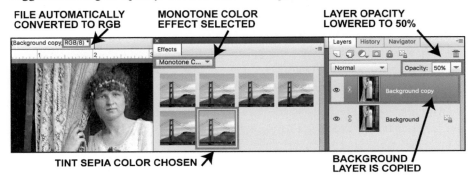

Figure 8.16 Applying the Tint Sepia Monotone Color effect, with Opacity: 50% assigned to the layer.

8.13.2 Applying a Sepia Tone Using the Hue/Saturation Command

Let's use the History panel to revert to the state prior to applying the Tint Sepia Monotone Color effect. To apply a sepia tone using the Hue/Saturation command, the image must be converted to the RGB color mode by choosing Image>Mode>RGB Color. Once we have done that, we will add a Hue/Saturation adjustment layer. For the sepia tone to work, we will need to check the Colorize box *first*, then assign appropriate values (Hue: 42, Saturation: 12, Lightness: 0), as shown in Figure 8.17.

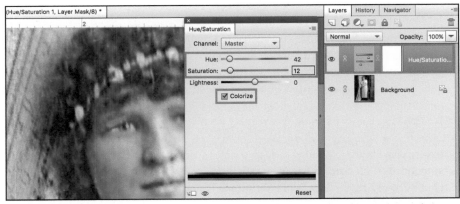

Figure 8.17 Applying a Hue/Saturation adjustment layer with Colorize assigned to create a sepia tone.

Once a sepia tone has been applied by using either the Monotone Color effect or a Hue/Saturation layer, the file should be flattened, saved, and closed.

NOTE Although a Saturation value of 12 creates a popular sepia tone, any value between 10 and 20 can be assigned based on your personal preference.

8.14 Preparing a Photograph for Restoration That Is Larger Than Your Scanner Bed

The second photograph we will restore has dimensions of 10" × 13". Oftentimes you will want to restore a photograph that is larger than the bed of your scanner. When that happens, the photograph must be scanned in two or more sections and then combined together in a separate larger destination document.

We will first need to create the destination document. We learned in Chapter Seven how to create one by choosing File>New>Blank File or by choosing New Blank File from the down arrow menu next to Open. It is always best to create a destination document with extra width and height that can be cropped away after the scans

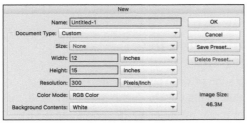

have been spliced together. In this dialog box, let's assign our values (Width: 12, Height: 15, Unit of measurement: Inches, Resolution: 300 ppi, keeping the defaults of Color Mode: RGB Color and Background Contents: White), as shown in Figure 8.18.

Figure 8.18 Creating a destination document for a photograph restoration with two or more scanned sections.

8.14.1 Combining Scans to Create a Composite Photograph

Let's locate the folder named Restoration2 files in the Practice_Import 15 files folder within the Practice Files folder you copied to your hard drive. Inside the folder, we will open the two files named Top.jpg and Bottom.jpg. Once the three files are open, we will choose All Column from the Layout menu and then use the Move tool to drag the two photograph sections into the destination document; afterward, close the original Top.jpg and Bottom.jpg files without saving any changes if prompted.

When scanning sections of a photograph to be combined together, overlap the content of each scan by at least 25%. The overlap provides a fudge factor when aligning the sections together in the destination document.

In the destination document, with the top section selected in the Layers panel we will choose Image>Rotate>Rotate Layer 90 degrees Left, then select the bottom section in the Layers panel and choose Image>Rotate Layer 90 degrees Right.

We will select the top content, then in the Layers panel rename the layer "Top" and place it at the top of the stacking order. Once we have done that, we will select the bottom content, rename the layer "Bottom" and then place it in between the Background layer and the Top layer. Using the Move tool, we will need to adjust the Top layer until it appears to align with the content on the Bottom layer when its visibility icon is turned off, then back on in the Layers panel. Using the Up, Down, Left, and Right arrow keys will help with this alignment.

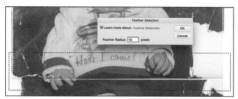

Figure 8.19 Creating a selection using the Rectangular Marquee tool and applying a feather with Radius: 10 px.

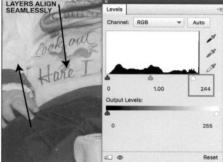

Figure 8.20 Applying a Levels adjustment layer to the Bottom layer to match the Top layer.

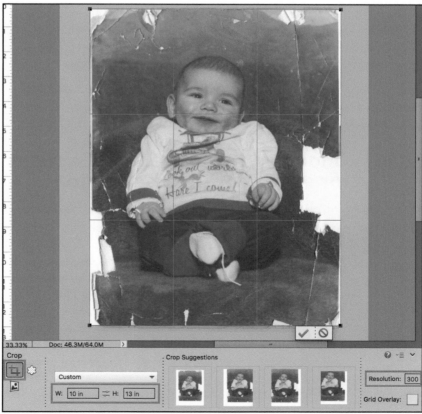

Figure 8.21 Cropping the composite image to the final print size.

When the layers are aligned, with the Top layer selected, we will choose the Rectangular Marquee tool and make a generous selection over the area where the two layers overlap and assign a feather with Radius: 10 px, as shown in Figure 8.19.

We can now delete this content from the Top layer and then deselect the selection, exposing more of the Bottom layer content. Once we have done that, we can see that the Bottom layer is slightly darker in color than the Top layer. With the Bottom layer selected, we will apply a Levels adjustment layer with the Highlights slider only changed to 244, as shown in Figure 8.20. With this Levels adjustment applied, the content and color of the two scans should align seamlessly.

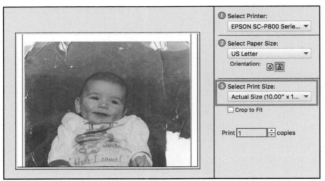

Figure 8.22 Printing an oversized image at actual size.

Once the layers are aligned and their colors match, the photograph can be cropped. With the Crop tool chosen, in the Tool Options bar assign values (W: 10 in, H: 13 in, Resolution: 300 ppi), then crop the image as shown in Figure 8.21.

Once the image has been cropped, the file should be flattened, saved as Restoration2_restored.psd, and a reference copy printed at actual size. If your printer cannot print a proof at actual size, print it as two images, with the top half shown in Figure 8.22.

8.15 Choosing the Correction Sequence for a Photograph Restoration

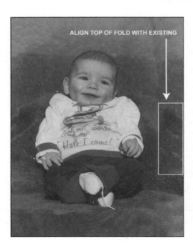

When a photograph requires both color and damage correction, a decision must be made whether to adjust the color first or repair the damage first. Which process is applied first can in some instances be simply a matter of preference, while other times for the best results one process should be completed before the other. With an image such as our Restoration2_restored.psd file, the *major* white torn areas should at least be repaired prior to attempting to

Figure 8.23 Major torn areas repaired using the Content-Aware fill command, the Spot Healing Brush tool, and the Layer Via Copy command, with content aligned with the original fold.

adjust the color so that the Editor will interpret the colors as accurately as possible. To repair them, the content can be filled using the Content-Aware fill command and the Spot Healing Brush tool, with the Layer Via Copy command used to borrow the content on the left to replace the missing content on the right, with the restoration at this stage resembling Figure 8.23.

8.16 Applying a Blur Filter

When we magnify in the background above the child, we can see more imperfections. These could be painstakingly removed using the Spot Healing Brush tool or improved using the Dust & Scratches filter. Applying a blur filter to this content instead is a great solution that will be helpful in your future work. When we choose Filter>Blur, nine blur options are available from its submenu. The Average filter (blends all colors to the main color in the selection), the Blur filter (applies a small amount of blur), and the Blur More filter (applies a stronger blur than the Blur filter) all assign their blurs using presets, not allowing for user input. Let's take a look at the Gaussian Blur, Surface Blur, and Smart Blur filters that each allow us to customize their applications. We will examine the Lens Blur filter in Chapter Nine and the Motion and Radial Blur filters in Chapter Ten.

> GAUSSIAN BLUR: Provides a Radius slider to assign the "radius" or distance the filter searches for pixels to blur; assigning a higher number removes more details, increasing the blur effect.

> SURFACE BLUR: Blurs the selected content without blurring edges, providing options of Radius to assign distance the filter searches for pixels to blur and Threshold for how different the pixel color must be to blur, helping to preserve edges and details.

> SMART BLUR: Provides a Radius slider to assign distance the filter searches for pixels to blur, a Threshold slider for how different the pixel color must be to blur (which helps to preserve edges and details), a Quality drop down menu, and a Mode drop down menu to optionally assign edges to be defined in black or white.

8.16.1 Applying a Gaussian Blur

Because we only want to blur the background, the Gaussian Blur filter will work great. We will use the Lasso tool to create a general selection of the background, without getting too close to the child or the blanket. Once the selection is made, we will apply a feather with Radius: 10 px, as shown in Figure 8.24.

With this selection active, we will choose Filter>Blur>Gaussian Blur. In the dialog box that opens we will assign Radius: 5.0 Pixels, which will be just enough blur to remove the minor flaws while keeping the original textural pattern intact, as shown in Figure 8.25.

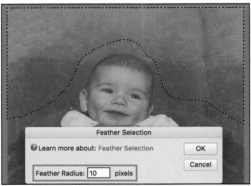

GAUSSIAN BLUR

Figure 8.24 Selecting the Background and applying a feather with Radius: 10 px.

SURFACE BLUR

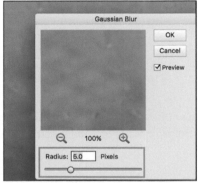

Figure 8.25 Applying the Gaussian Blur filter to the background.

SMART BLUR

Figure 8.26 Comparing the results of the Gaussian Blur, the Surface Blur, and the Smart Blur filters applied to content with edge details.

Once the blur has been applied and the selection deselected, when magnified in, the Healing Brush tool can be used with appropriate values (Brush style: Soft, Size: 170 px, Aligned unchecked, Source: Sampled, Mode: Normal, Clone Overlay checked), to bring the blur in closer to the child and the blanket without actually touching them.

8.16.2 Comparing Blur Filters

Figure 8.26 compares the applications of the Gaussian Blur, Surface Blur, and Smart Blur filters to some jail chains. We can see that while the Gaussian Blur filter blurs all content it is applied to equally, the Threshold options of the Surface Blur and the Smart Blur filters allow edges to better retain their details while the rest of the content becomes blurred based on the radius setting applied, with the results from these two filters being almost identical. When your future work requires blurs with edges protected, whether you choose to apply the Surface Blur or the Smart Blur will be a personal preference.

8.17 Correcting Color in a Photograph Restoration

Returning to our Restoration2_restored.psd photograph, we can see that this image has a strong red color cast. We have learned that a color cast can be improved using the Auto Color Correction command, the Remove Color Cast command, or by adding a Levels adjustment layer, then refining the colors using the Color Replacement tool.

8.17.1 Improving Color Using the Auto Correction Command

Let's begin by choosing Enhance>Auto Color Correction. Although not completely returned to its original colors, the photograph is significantly improved.

8.17.2 Improving Color Using the Remove Color Cast Command

Let's use the History panel to undo the application of the Auto Color Correction command, then choose Enhance>Remove Color Cast. In the dialog box that opens, we can try its suggestion—to use the eyedropper supplied to sample content within the image. Feel free to apply the eyedropper to a variety of areas. The colors are minimally improved, with the Auto Color Correction command providing better results.

8.17.3 Improving Color Using the Levels Command

Let's use the History panel to undo the Remove Color Cast command. Once we have done that, we will apply a Levels adjustment layer instead, then select its gray eyedropper, and sample the underside of the shoe as shown in Figure 8.27.

Although the results of these three color correction methods differed, none of them were able to completely return the original colors; however, two provided enough improvement to clearly indicate what the colors *should* be. Let's choose to apply the Levels correction method and merge the adjustment layer down.

SAMPLE HERE WITH THE LEVELS GRAY EYEDROPPER

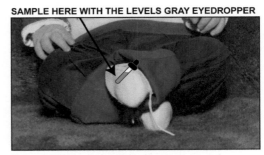

Figure 8.27 Sampling with the Levels command gray eyedropper to correct a color cast.

NOTE We also learned in Chapter Five that we could remove a color cast by applying a Hue/Saturation adjustment layer, then selecting the Reds Channel and dragging the Saturation slider to a negative number. While helpful with a minor color cast, this will not work well for a photograph with a severe color cast such as our Restoration2_restored.psd image.

When correcting a photograph which contains a severe color cast, try applying each color correction method one at a time—the Auto Color Correction command, the Remove Color Cast command, and the Levels command—before deciding which one to use to restore the color. By duplicating the Background layer three times *first*, you can apply each command to a separate layer, then turn the visibility off and on for each test layer to determine which correction method works best. Once you have made your decision, the unused layers can be deleted and the correction layer you decide to use can be kept as a working layer above the Background layer if desired or merged down onto the Background layer to continue the restoration process.

8.17.4 Using the Color Replacement Tool for Color Correction

We learned how to use the Color Replacement tool in Chapter Five. For this restoration project, by sampling existing colors and adjusting them using the Color Picker, we can paint to further refine the colors the Levels command was able to restore for us. Although the size of the brush you will need will vary depending on the details you are painting, the rest of the following Tool Options bar settings will work great for all of the color replacement: Tolerance: 30, Mode: Color, Limits: Contiguous, Sampling: Continuous, Style: Soft, with Anti-alaising checked.

Feel free to use any colors of your choice; however, the following colors will restore the photograph back to its original coloring:

BLANKET: By sampling one color such as the blanket area at the lower left (R: 63, G: 87, B: 52), the entire blanket can be painted with it to unify its color.

BACKGROUND: Sampling the color at the top center of the background (R: 116, G: 146, B: 146) provides a great color to unify it.

PANTS: If a color needs to be adjusted more than the Levels command was able to provide, the "closest" color can be sampled, then adjusted further in the Color Picker; we will use R: 6, G: 15, B: 68.

SHIRT TRIM: Just as with the pants, we will sample the trim on the sleeve, then adjust it to R: 126, G: 73, B: 66.

SHIRT AND SHOES: With a selection of these areas made first, a Levels adjustment layer can be added, with the white eyedropper used to sample the shirt. Once the area has been sampled, assigning appropriate values (Shadows: 42, Midtones: 1.0, Highlights: 255) to the adjustment layer will reduce the lightness slightly for a more natural appearance, as shown in Figure 8.28; then the adjustment layer can be merged down.

SKIN TONE: R: 232, G: 205, B: 194.

HAIR: R: 68, G: 39, B: 31.

LIPS: R: 197, G: 151, B: 158. When a lip color is chosen that is too red, it will not appear realistic.

EYES: The pupil color can be left as it is or assigned the hair color (R: 68, G: 39, B: 31).

TiP In your own work when using the Color Replacement tool, duplicating the Background layer *first* so that you can paint on a working layer provides the ability to delete it and start over if needed. Additionally, once the application has been completed, the opacity of the working layer can optionally be lowered to reduce the intensity of its colors, allowing some of the colors of the Background layer to meld with those of the working layer.

We are almost done. To remove both the "seam" where the blanket was copied and the dark streak in the background, the Healing Brush tool using a large brush with Aligned checked in the Tool Options bar will work great. Additionally, the blanket on the left side of the child can be darkened slightly to match the fold on the right using the Burn tool.

8.17.5 Adding Adjustment Layers to Finalize Color

Sometimes once all replacement colors have been applied, a final adjustment layer or layers is helpful to tweak them—a Levels adjustment layer if the tonal quality should be lighter or darker and/or a Hue/Saturation adjustment layer if the colors should be brighter or duller. Let's add a Hue/Saturation layer with the Saturation slider *only* adjusted to +10, with the completed restoration shown in Figure 8.28.

At this point, a second reference print should be made, reviewed, and any remaining flaws fixed; then the file can be saved and closed. Remember in your future work to check before printing that the file has the Adobe RGB (1998) profile assigned and that you have the Always Optimize for Printing color setting selected to achieve the best color matching output.

Figure 8.28 Completed Restoration2_restored. psd file.

NOTE In your own work, if the Auto Color Correction command, the Remove Color Cast command, or the Levels command is unable to restore some of the colors true enough to know what they should be, you may need to consult your client for details such as hair and eye color or the exact colors of the clothes if a perfect color match is required for them.

8.18 Restoration in the Guided Mode

Let's reopen the original Restoration1.jpg file, then select the Guided mode. The Guided mode provides a Sharpen option under its Basics category and two restoration options: Scratches and Blemishes and Restore Old Photo located under its Special Edits category.

8.18.1 Using the Sharpen Option of the Guided Mode

When this option is selected, an Auto Fix button is furnished to assign a preset amount of sharpening, with the ability to use the slider provided to manually increase the sharpening effect.

8.18.2 Using the Scratches and Blemishes Option of the Guided Mode

Let's choose to cancel the sharpen application. The Scratches and Blemishes option that we explored in Chapter Seven can also be effective for restoration projects. We can see how its Healing tools could improve some of the areas in this photograph.

8.18.3 Using the Restore Old Photo Option of the Guided Mode

Let's choose to cancel the Scratches and Blemishes application and instead select the Restore Old Photo option. This option provides five categories of familiar tools, commands, and filters as clickable buttons on the right: the first contains the Crop tool and the second includes the Spot Healing Brush tool, the Healing Brush tool, the Clone Stamp tool, and the Blur tool. Although no brush size slider is provided when any of these repair tools are selected, their size can be adjusted by pressing the left (smaller) or right (larger) bracket key on the keyboard. Directions for their application and use are also provided above each tool button.

The third category consists of a Dust Remover button. When this button is clicked, the dialog box that opens is identical to the Dust & Scratches dialog box we have learned to use.

The fourth category includes color and contrast correction options with Auto Levels and Auto Contrast buttons to improve the tonal quality of the image and Auto Color Correction and Convert to Black and White buttons for color adjustment.

The fifth category provides a Sharpen button. When clicked, the image is sharpened by a preset increment, with each additional click increasing the sharpness by the same amount. Once you have explored these categories, click the Cancel button at the lower right area of the Taskbar to exit the Guided mode, and choose not to save the file if prompted.

PRACTICE MAKES *PERFECT* ✓

Congratulations, you have learned skills that will help you restore a wide variety of damaged and discolored photographs. Before proceeding to Chapter Nine, feel free to complete the following two additional restoration practice projects to further reinforce your expertise.

PRACTICE PROJECT 1

1. Open the photograph named C-8 Practice Project 1.jpg located in the Practice_Import 15 files folder within the Practice Files folder you copied to your hard drive, and save it as C-8 Practice 1_restored.psd.

2. Print a reference copy at its actual size of 5" × 7".

3. Remove its color by choosing Image>Mode>Grayscale, confirming in the warning dialog box that opens that you do want to discard the color information.

4. Apply a Levels adjustment layer, adjusting the Shadows slider only to 70, then merge the adjustment layer down.

5. Most of the damage to the little girl and the baby can be removed using multiple methods but will be most easily removed using the Spot Healing Brush tool in its Proximity mode. Remember when applying it to refer frequently to the reference print, so that you are *only* removing damage that will show at the 5" × 7" final output size.

6. The siding can also be repaired more than one way, with the easiest and most effective method being with the application of the Clone Stamp tool using Brush style: Hard, Size: approximately half the width of the siding, Mode: Normal, Aligned unchecked, optionally creating a working layer to apply Sample All Layers with the Clone Overlay options checked. Each piece of siding should be repaired individually, one at a time, resampling frequently as shown in Figure 8.29.

Figure 8.29 Applying the Clone Stamp tool to repair the siding and the Burn tool for the wood.

7. To repair the hand, the Clone Stamp tool will work best using Brush style: Soft, Size: Small, Mode: Normal, Aligned unchecked, optionally creating a working layer to apply Sample All Layers with the Clone Overlay options checked.

8. The wood support can be darkened using the Burn tool, also shown in Figure 8.29, with settings of Range: Midtones, Brush style: Soft, Size: Small, Exposure: 20%. By leaving the uneven coloring of the wood and darkening it, the wood texture will appear natural, but its darker tone will also make it more visible against the siding it is attached to.

9. The broom in the background can be lightened using the Dodge tool, with settings of Range: Midtones, Brush style: Soft, Size: Small, Exposure: 20%.

10. When all of the corrections have been made that are visible in the reference print, choose Image>Mode>RGB Color.

BEFORE RESTORATION

Figure 8.30 Before and after the restoration, with a sepia tone applied.

11. Apply a Hue/Saturation adjustment layer, *check the Colorize box first*, then assign Hue: 42, Saturation: 12, Lightness: 0.

AFTER RESTORATION

12. Once a test print confirms that all corrections have been made, choose to flatten the file in the Layers panel, then save and close it, with a completed sample shown in Figure 8.30.

PRACTICE PROJECT 2

1. Open the photograph named C-8 Practice Project 2.jpg located in the Practice_Import 15 files folder within the Practice Files folder you copied to your hard drive, and save it as C-8 Practice 2_restored.psd.

2. Print a reference copy at the final size of 8" × 10".

3. Create a rectangle that includes the white bottom edge of the photograph, then apply the Content-Aware fill command to cover it.

4. Use the Spot Healing Brush tool in Proximity mode to repair the crack across the image as well as the large damage spots.

5. Once the crack has been repaired, the Healing Brush tool can be applied to eliminate any remaining "line" that may still appear where the original crack was, with settings of Brush style: Soft, Size: 80 px, Aligned unchecked, Source: Sampled, Mode: Normal, and Clone Overlay checked, optionally

choosing to create a working layer, with Sample All Layers checked.

6. Select the background using the Quick Selection tool.

7. Apply a feather to the selection with Radius: 5 px, then choose Filter>Blur>Surface Blur, with settings of Radius: 9 Pixels, Threshold: 6 levels, as shown in Figure 8.31.

8. Select the uniform using the Quick Selection tool, then *subtract* the buttons and pins from the selection.

9. Apply Filter>Noise>Dust & Scratches, with settings of Radius: 3 Pixels and Threshold: 0 levels, as shown in Figure 8.32.

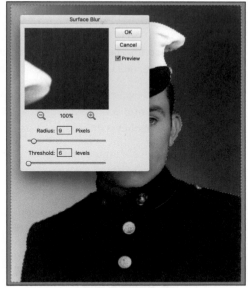

Figure 8.31 Surface Blur applied to the background.

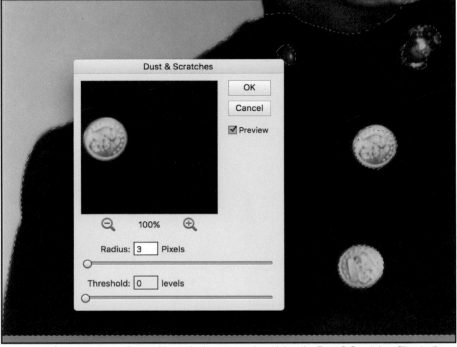

Figure 8.32 Selecting the uniform without the buttons and applying the Dust & Scratches filter to the selection.

10. Apply the Sharpen tool to the buttons and detail on the hat, with settings of Mode: Normal, Brush style: Soft, Size: Small, Strength: 50%, and Protect Detail checked.

11. Magnify in to the Marine Corps emblem on the hat, and remove the yellow tint on the hat that appears around it using the Clone Stamp tool, with Brush style: Hard, Size: Small, Mode: Normal, and Aligned unchecked, with the Clone Overlay options checked.

12. Create an accurate selection of the man's head (excluding his hat) using any selection tool (the Quick Selection tool will work great), and then apply a feather with Radius: 2 px.

13. Add a Levels adjustment layer, drag the Highlights slider *only* to 235 to lighten the selected area, and then merge the layer down.

12. Once a test print confirms that all corrections have been made, choose to save and close the file, with a completed sample shown in Figure 8.33.

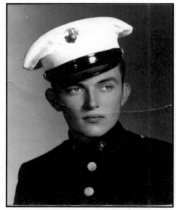

BEFORE RESTORATION

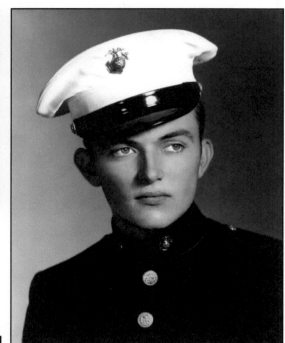

AFTER RESTORATION

Figure 8.33 Before and after military photograph restoration.

9

Tricks
of
the
Trade

In This Chapter

- **Open closed eyes**
- **Examine ways to enhance depth of field**
- **Learn to create and apply gradients for special effects**
- **Employ cosmetic tricks to enhance portraits**

Improving a portrait by eliminating a few wrinkles or modifying a figure with a little tummy tuck are just a couple of the potpourri of tricks included in this chapter designed to help you transform ordinary snapshots into extraordinarily professional photographs.

9.1 Tricks for Professional Results

Professional photographers oftentimes produce great photographs with the help of a few tricks of the trade incorporating many of the tools and commands we have already learned, as well as a few additional ones. Let's explore these tricks beginning with learning to remove red eye.

NOTE Although some of these tricks can be performed in the Quick mode, we will work exclusively in the Expert mode. The Guided mode also provides a few of these tricks that will be covered separately in the "Tricks of the Trade Using the Guided Mode" section of this chapter.

9.2 Removing Red Eye

When a portrait photograph is taken using a camera flash in low light, the resulting image may have the effect called "red eye." Photoshop Elements 2018 provides a variety of tools and commands to eliminate this effect in both its Organizer and its Editor modules. In addition to exploring all of these techniques, we will also learn how to remove red eye manually.

9.2.1 Removing Red Eye in the Organizer

The Organizer provides two options for removing red eye from images when importing them, plus the ability to remove it from images after their importation using the Instant Fix editor.

9.2.1.1 Removing Red Eye When Importing Images Into the Organizer

When choosing File>Get Photos and Videos>From Files and Folders or Import>From Files and Folders in the Organizer, the dialog box that opens to locate the files for import provides a checkbox, Automatically Fix Red Eyes, as shown in Figure 1.11. When using the Organizer Photo Downloader with its Advanced Dialog box open, the same checkbox is available when the Advanced Options down arrow menu is clicked, as shown in Figure 1.19.

Figure 9.1 A Version Set is created if the Automatically Fix Red Eyes option is checked when the image is imported.

When photographs are imported into the Organizer using either of these methods with the Automatically Fix Red Eyes option checked, it analyzes and corrects the red eye images as they are added. A dialog box displays a progress bar as they are being corrected and puts each original and its corrected copy into a Version Set, as shown in Figure 9.1.

A copy of each figure shown in this chapter can be viewed in the companion files included with this book.

9.2.1.2 Removing Red Eye Using the Instant Fix Editor in the Organizer

When a photograph is selected in the Organizer and then opened in the Instant Fix editor, a Red Eye adjustment is one of the tools provided in the Instant Fix pane, as shown in Figure 2.48. When the tool is chosen, the Organizer will analyze the photograph and correct the red eye effect. As we learned in Chapter Two, when the Save button and the Done check mark are clicked to return to the Media view, a Version Set is created automatically including the original and its corrected copy.

If you have been following along in the Organizer, click the Editor button in the Taskbar below the Media pane now to switch to working in the Editor.

9.2.2 Removing Red Eye in Camera Raw

With the Editor active in the Expert mode, let's choose File>Open then, locate the file named _DSC3251.nef located in the Practice_Import 16 files folder within the Practice Files folder you copied to your hard drive (if you completed the Organizer chapters, this is the original Nikon raw file that was imported as a .jpg file in the Practice_Import 4 folder in Chapter Two). When the image opens in Camera Raw, Red Eye Removal is one of the tools located at the top left of the Camera Raw window, as shown in Figure 9.2. To apply the tool here, it will be helpful to first magnify in closer to the eyes we want to correct. We will select the Red Eye Removal tool, then draw a rectangular marquee around each of the child's eyes. If the rectangle is not drawn large enough for Camera Raw to detect the red eye, the dialog box also shown in Figure 9.2 appears. If it appears, click OK, then draw a *larger* rectangle that encompasses more of the face around the eye.

When Camera Raw has detected the red eye, a small dotted rectangle will appear over the red eye area in the preview. Sliders are available to the right of the preview to adjust the size of the area to affect and to darken the adjusted pupil color if needed as shown in Figure 9.3. We will choose Cancel to disregard this application, then close the Camera Raw window and learn to remove red eye in the Editor.

Figure 9.2 The warning dialog that appears after the Red Eye Removal tool is applied in Camera Raw when a red eye selection is not large enough for Camera Raw to detect it.

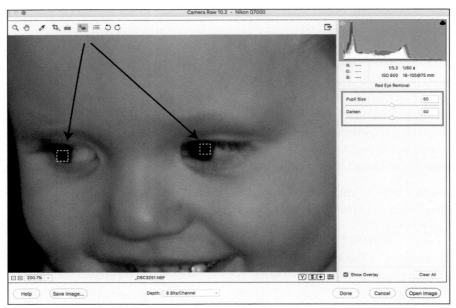

Figure 9.3 Camera Raw dialog box with red eye corrected.

9.2.3 Removing Red Eye in the Editor

The Editor provides both an Auto Red Eye Fix command and an Eye tool to correct an image with red eye not fixed during importation. Red eye can be removed in both the Quick and Expert modes, however the Expert mode also provides removal using the Sponge and Burn tools. We will explore each of these methods in the Expert mode, beginning with the Auto Red Eye Fix command.

9.2.3.1 Correcting Red Eye Using the Auto Red Eye Fix Command

Let's open the file named Red Eye.jpg located in the Practice_Import 1 files folder within the Practice Files folder you copied to your hard drive, or locate it in the Organizer and then click the Editor button in the Taskbar if you chose to complete the exercises provided in Part One. Once the image is open, we will save the file as Corrections.psd first, then choose Enhance>Auto Red Eye Fix. Once we do that, the Editor detects the red eye and automatically corrects it for us. Let's choose to undo this application and learn to apply the correction using the Eye tool instead.

9.2.3.2 Correcting Red Eye Using the Eye Tool

Let's select the Eye tool, with its icon identical to the red eye tools provided in both Camera Raw and the Organizer, then examine the Tool Options bar shown in Figure 9.4:

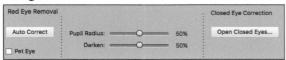

Figure 9.4 Tool Options bar when the Eye tool is chosen.

AUTO CORRECT: Automatically identifies and corrects red eyes just as the Auto Red Eye Fix command does.

PET EYE: Converts the correction features to those required for pet eyes.

PUPIL RADIUS: Provides a slider to enlarge the size of the pupil application.

DARKEN: Provides a slider to darken the pupil color application.

OPEN CLOSED EYES: Provides a dialog box to select open eyes to replace closed eyes.

NOTE We will explore the Eye tool pet eye correction and closed eye correction features separately later in this chapter.

Let's apply the tool by single clicking on the Auto Correct button in the Tool Options bar: the tool successfully corrects both eyes for us with this single click. However, because any "auto" feature asks the Editor to make decisions for us, sometimes this button application may not remove the red eye effectively. We will choose to undo this application and learn another application method.

Let's apply the tool by pressing and dragging a rectangular marquee around each eye, one at a time, just as we learned to do in Camera Raw; the eyes are individually and accurately corrected. If needed, the pupil size and tonal quality can be adjusted after each application using the sliders provided in the Tool Options bar. We will choose to undo this application, and apply the tool another way.

If the Alt/Option key is held down when drawing the marquee around each eye, the marquee will be drawn from the center outward to more accurately identify the red eye area for the Editor.

TiP

The Eye tool can also correct red eye by single clicking on the pupil. Let's choose to correct the red eye this time by magnifying in first, then single clicking on each pupil one at a time, keeping the default settings (Pupil Radius: 50%, and Darken: 50%). Let's undo this application one more time and learn to apply the Sponge and Burn tools manually to eliminate red eye.

9.2.3.3 *Correcting Red Eye Using the Sponge and Burn Tools*

Sometimes even when the Darken slider is dragged to a lower percentage than the default setting of 50%, the pupil color may still not look natural. When that happens you can choose instead to control the color and tonal quality of the red eye removal by using a combination of the Sponge and Burn tools.

Let's magnify in to the eyes and then select the Sponge tool. We will choose Mode: Desaturate, Brush style: Soft, Size: approximately equal to the pupil size based on your view (the sample view shown in Figure 9.5 uses a 45 px brush), and Flow:

50%. With repetitive clicks on the same spot, we will apply the tool until the red has naturally been eliminated. Sometimes just applying the Sponge tool in this manner is enough. However when needed, the

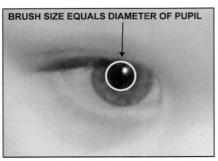

BRUSH SIZE EQUALS DIAMETER OF PUPIL

Burn tool can be added to darken the pupil color by applying Range: Midtones, Brush style: Soft, Size: approximately equal to the pupil size based on your view (the sample provided uses a 45 px brush), Exposure: 50%, and using repetitive clicks on the same spot, with the result shown in Figure 9.5. Once the red eye has been naturally removed from both eyes, we will save and close this file for now.

Figure 9.5 Choosing a brush size for the Sponge and Burn tools to remove red eye.

9.3 Removing Pet Eye Reflection

A camera flash can sometimes change the color of an animal's eyes, creating an eerie sinister appearance. Let's learn how we can use the Editor to rescue a photograph with pet eye reflection by removing it using the Eye tool, or, alternatively, using the Brush tool.

9.3.1 Removing Pet Eye Reflection Using the Eye Tool

Choose to reopen your completed Chapter Four Practice Project 3 exercise named Dog Portrait.psd, in which an accurate selection of the dog was saved with the file. If you did not do the exercise at that time, a completed Chapter Four version named Dog Portrait With Selection Mask.psd has been provided for you in the Practice_ Import 16 files folder within the Practice Files folder you copied to your hard drive. We can see when this file opens that the dog's eyes suffer from the pet reflection issue "eyeshine" caused by a camera flash.

MAGNIFIED VIEW FOR ACCURATE APPLICATION

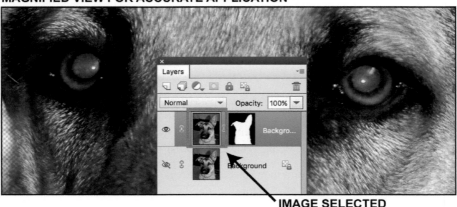

IMAGE SELECTED

Figure 9.6 Magnified view with image selected on copied Background layer.

The Layers panel has a Background copy layer with a mask applied to it. We will need to select the image, not the mask on that layer, as shown in Figure 9.6 (double click the image thumbnail to select it if needed).

Let's select the Eye tool and then select the Pet Eye checkbox in the Tool Options bar shown in Figure 9.4, keeping the default settings (Pupil Radius: 50%, Darken: 50%). We will need to magnify in, then single click on the green area of one of the dog's eyes. Most likely, the entire green area will not change color—and possibly only the white highlight spot. Not what we want. Let's undo, drag the Pupil Radius slider to 100%, then apply the tool again. This time, the green pupil color is changed to black, and the original highlight spot is removed, with a new highlight spot added. When we now click the second eye, our results should match the sample shown in

Figure 9.7. The eyes are much improved; however, the highlight spot is small and faint. Let's choose to save and close this file for now; we will add more sparkle to the dog's eyes later in this chapter.

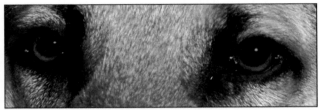

Figure 9.7 Eyeshine removed using the Pet Eye option of the Eye tool.

9.3.2 Removing Pet Eye Reflection Using the Brush Tool

Let's choose to open the photograph named Pet Eyes Manual.jpg located in the Practice_Import 16 files folder within the Practice Files folder you copied to your hard drive, then save the file as Pet Eyes Manual.psd. As we can see, this photograph suffers from even more severe eyeshine. Rather than apply the Pet Eye option of the Eye tool with maximum settings to cover the reflection, let's choose to paint over it instead.

Figure 9.8 Painting out eyeshine in a pet's eyes.

We will first add a working layer above the Background layer. With this new layer active, we will select the Brush tool, with the default colors of black as the foreground color and white as the background color. In the Tool Options bar assign Brush style: Soft, Size: 20 px, Opacity: 100%, Mode: Normal, then paint over the eyeshine areas of each eye as shown in Figure 9.8. If you prefer, choose to create a separate layer for each eye rather than painting both eyes on one working layer. Once you have done that, choose to save and close this file for now; we will add highlight spots to the cat's eyes later in this chapter.

9.4 Enhancing Eyes With Highlights

Although they are oftentimes clearly visible in a photograph, sometimes highlight spots on eyes are small and faint, or nonexistent. Adding this "twinkle in the eyes" trick when it is not visible, or enhancing it if the spots are small and faint, can have a dramatic effect, bringing people and pet portraits to life.

9.4.1 Adding Highlight Spots to People's Eyes

Let's open the file named Highlights.jpg located in the Practice_Import 4 files folder within the Practice Files folder you copied to your hard drive, or locate it in the Organizer, then click the Editor button in the Taskbar if you chose to complete the exercises provided in Part One.

When this image opens and we magnify in to the child's eyes, we can see that highlight spots exist on each eye, but are very faint. Let's enhance them. We will want to add a working layer above the Background layer first. With this working layer active, we will select the Brush tool, with white as the foreground color in the Tools panel. In the Tool Options bar assign Brush style: Soft, Size: 6 px, Opacity: 100%, Mode: Normal, then single click to add a dot of color over the existing highlight spot on each eye. To make the highlights appear natural rather than fake, we will need to drop the opacity of the working layer; a typical highlights layer opacity setting is 70% to appear realistic, as shown in Figure 9.9, then close the file, optionally choosing to save it first if desired.

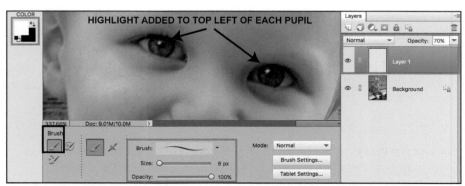

Figure 9.9 Adding highlight spots to eyes using a working layer with Opacity: 70%.

The double arrow located above the colors in the Tools panel can be single clicked to reverse the current foreground and background colors.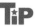

NOTE▶ When highlight spots are not visible in a photograph, the typical location to add a highlight spot is on the left or right side of the pupil above its center, making sure it is added in the same location of the pupil on each eye.

9.4.2 Adding Highlight Spots to Pet Eyes

Highlight spots on a pet's eyes can be enhanced where they already exist or added when they are not visible or were removed if eyeshine was corrected manually.

9.4.2.1 Enhancing Existing Highlights on Pet Eyes

Let's reopen the Dog Portrait.psd file in which we removed the eyeshine. When we applied the Pet Eye option of the Eye tool, a small highlight spot was also automatically added to the eye for us. Let's choose to enhance it a little by making it slightly larger and brighter for more sparkle.

We will first want to create a working layer above the masked layer. Once we have done that, let's magnify in to the eyes, then select the Brush tool and assign white as the foreground color in the Tools panel. In the Tool Options bar, we will assign Brush style: Soft, Size: 16 px, Opacity: 100%, Mode: Normal, then single click over the existing highlight on each eye, as shown in Figure 9.10. Once the highlight spots have been added, we will save and close this file for now.

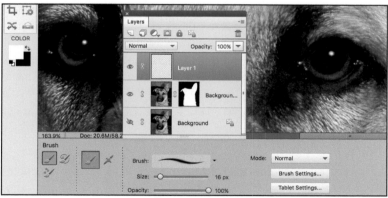

Figure 9.10 Enhancing existing highlights in pet eyes.

With pet highlight spots, in most cases it is most effective to *not* reduce the layer opacity of the highlights layer. In your own work, if the highlights appear too stark, reduce the opacity of the highlights layer gradually until they appear natural.

9.4.2.2 Adding Pet Eyes Highlights

Let's reopen the Pet Eyes Manual.psd file. We previously created a working layer (or two) to paint over the eyeshine. We will want to add another layer (or two if desired) to add highlight spots to the cat's eyes. Once we have done that, we will

need to magnify in to the eyes and then select the Brush tool. In the Tool Options bar, we will assign Brush style: Soft, Size: 20 px, Opacity: 100%, Mode: Normal, then single click to add a highlight spot on each eye. When adding highlight spots where none were visible originally, they will be typically located on the dark area of the

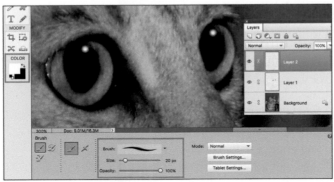

eye near the top, always in the same location on each eye, as shown in Figure 9.11. Once the highlights have been added to the cat's eyes, we will save and close this file, optionally choosing to flatten it first.

Figure 9.11 Adding highlight spots to a pet's eyes.

9.4.3 Adding Highlight Spots to Wildlife Photographs

Love the twinkle? It can be added to the eyes of any animal photograph. Let's reopen the Blue Heron.psd and the Zebra.psd files from Chapter Seven. Using the same format we have just learned, we will add a small white highlight spot appropriate to the eye size on each animal, as shown in Figure 9.12, then save and close these files.

Figure 9.12 Adding highlight spots to wildlife photographs.

9.5 Opening Closed Eyes

We have all taken photographs of a person who blinked when the photograph was taken. The Editor provides an easy fix for this malady.

Let's choose to open the photograph named Closed Eyes.jpg located in the Practice_ Import 16 files folder within the Practice Files folder you copied to your hard drive, then save the file as Tourist.psd.

Let's select the Eye tool, then choose the Open Closed Eyes button in the Tool Options bar, as shown in Figure 9.4, or alternatively choose Enhance>Open Closed Eyes to access the Open Closed Eyes dialog box. When the dialog box opens, our subject is enclosed in a selection circle, with a few sample pairs of eyes that can be used, as well as the option to instead locate a photograph of our own to use from our

computer or from the Organizer. We will choose the Computer option, then select the file named Opened Eyes.jpg located in the Practice_Import 16 files folder within the Practice Files folder you copied to your hard drive. Once the source is added to the dialog box, we can single click on it to apply its eyes to our photograph.

If the source file is not satisfactory, we can click the small "X" that appears when the pointer is rolled over the upper right corner of the source image to delete it and search instead for a different eye source. We will choose to click OK to complete our eye replacement and exit the dialog box, as shown in Figure 9.13.

EDITOR IDENTIFIES FACE FOR CORRECTION WITH CYAN CIRCLE

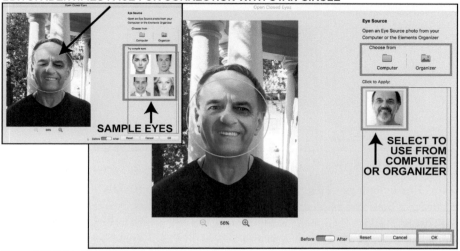

Figure 9.13 Using the Open Closed Eyes dialog box.

NOTE▶ If multiple people appear in the photograph, the Editor will enclose one in the cyan circle, with the others enclosed in gray circles. If the person you need to correct is not the one identified, click the circle of the person you want instead. The original circle will turn gray, and the person you have selected will become enclosed in the cyan circle, now identified as the active image to correct.

Let's choose to stop and save this file first before learning how to remove a few years from our tourist.

9.6 Age Reversal Trick

We learned to use the Healing Brush tool in Chapter Seven. At that time, we used it for covering and blending content. A great application of the Healing Brush tool is age reversal. Wrinkles can be removed by blending them with surrounding facial texture and color. Let's take some years off of our tourist.

We will first want to magnify in to his face, then select the Healing Brush tool in the Tools panel. To most effectively control our age reversal, let's create a working layer above the Background layer. With the working layer selected, let's assign Size:

Figure 9.14 Sampling and applying the Healing Brush tool to remove wrinkles.

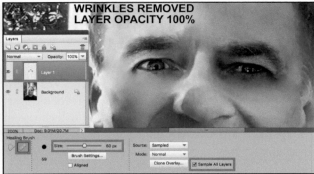

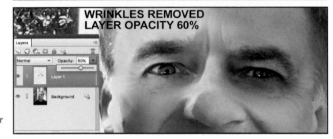

Figure 9.15 Removing wrinkles using the Healing Brush tool on a working layer with Opacity: 60%.

60 px, Brush Settings—Hardness: 100%, Spacing: 0%, Roundness: 100%; Aligned unchecked; Source: Sampled; Mode: Normal; Clone Overlay checked; Sample All Layers checked. Sampling nearby content, we will brush to cover the wrinkles around his eyes, as shown in Figure 9.14.

When all of the "crow's feet" and forehead wrinkles have been removed, most likely our tourist's skin will no longer look natural. Because we removed the wrinkles on a *working* layer, we can now lower its opacity, *choosing* how many years we want to subtract. Let's reduce the opacity of the working layer to 60%, with a suggested resulting age reduction shown in Figure 9.15.

9.7 Whitening Teeth

Teeth can be whitened using the Whiten Teeth tool in the Quick mode, or by using the Smart Brush tool, the Hue/Saturation command, or the Replace Color command in the Expert mode.

9.7.1 Using the Whiten Teeth Tool

With our Tourist.psd file still open, let's whiten his teeth. We will first merge our age reduction working layer down onto the Background layer. Once we have done that, we will choose the Quick mode, then select the Whiten Teeth tool with its icon resembling a toothbrush. Once it is chosen, the Tool Options bar updates with the tool icons of the Smart Brush tool. A Size slider allows us to choose a size for our

selection, with the default size working well. We will want to magnify in first for accuracy, then drag across the tourist's teeth; they become selected and lightened by a preset amount. Plus and Minus Smart Brush tools are provided to enlarge or decrease the selected area as needed. Let's choose to undo this application, then choose the Expert mode to learn additional ways to whiten teeth.

9.7.2 Using the Smart Brush Tool

In the Expert mode, let's select the Smart Brush tool and then in the Tool Options bar select its Pearly Whites preset, as shown in Figure 9.16.

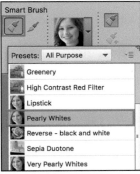

We will drag across the teeth using the default brush size, just as we did in the Quick mode. As soon as we do that, the Layers panel updates with an adjustment layer. Let's click on the adjustment layer icon to edit the color applied. We will lighten the color (R: 244, G: 237, B: 223), as shown in Figure 9.17. Once we have done that, we will choose to undo this application and learn another whitening method using the Hue/Saturation command.

Figure 9.16 Assigning the Pearly Whites preset for the Smart Brush tool.

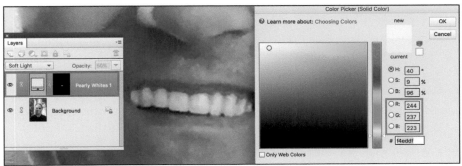

Figure 9.17 Adjusting the color applied by the Smart Brush tool for whitening teeth.

9.7.3 Using the Hue/Saturation Command to Whiten Teeth

Still working in a magnified view, we will first need to create an accurate selection of our tourist's teeth; the Quick Selection tool will work well for this, using a small brush size such as 13 px. Once we have done that, we will add a Hue/Saturation

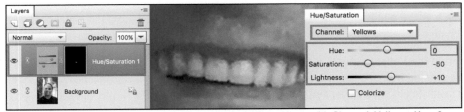

Figure 9.18 Whitening teeth using a Hue/Saturation adjustment layer with Channel: Yellows, Hue: 0, Saturation: –50, and Lightness: +10.

adjustment layer. With the adjustment layer settings active, let's select the Channel: Yellows from the Channel drop down menu, then assign Hue: 0 and Saturation: –50, optionally choosing to also assign Lightness: +10, as shown in Figure 9.18. Let's then use the History panel to return to the state of our selection of the teeth and learn one more way to whiten them.

9.7.4 Using the Replace Color Command to Whiten Teeth

With the teeth selection still active, choose Enhance>Adjust Color>Replace Color. In the dialog box that opens we will keep the default Fuzziness at 40, choose the Image preview, then click the eyedropper on the teeth in the dialog box or in the image, as shown in Figure 9.19. Then we will assign Hue: 0, Saturation: –39, and Lightness: +23.

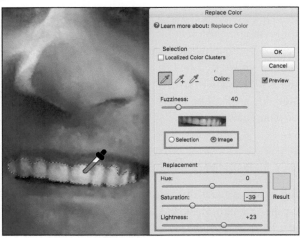

Figure 9.19 Whitening teeth using the Replace Color command, with Hue: 0, Saturation: –39, and Lightness: +23.

All of these methods satisfactorily whiten the tourist's teeth. In your own work, choose the method that provides the most professional results for you and best fits your working style. If you used one of the methods that incorporated an adjustment layer, choose now to flatten the file.

TiP In your own work, with any of the whitening methods that allow user input, always choose a tone or color that whitens the teeth but does not overly lighten them so that they no longer appear natural. Duplicating the Background layer first will provide the flexibility to lower the opacity of the whitened layer once the adjustment has been applied, if needed.

9.8 Adjusting Facial Features Command

The Adjust Facial Features command allows subtle adjustments to facial features such as the width of a pair of eyes or the height of a nose. Rather than make physical changes to our tourist's features, we will simply increase his smile just a bit.

From the Enhance menu, we will select the Adjust Facial Features command. When the dialog box opens, categories are available for adjusting lips, eyes, nose, and face (head shape). Let's select only the Lips option then adjust the Smile slider *slightly* to the right, with the results shown in Figure 9.20.

BEFORE SMILE ADJUSTMENT

AFTER SMILE ADJUSTMENT

Figure 9.20 Adjusting the Smile option in the Lips category of the Adjust Facial Features command.

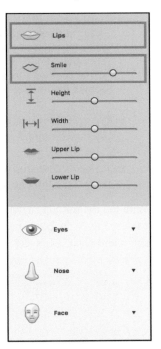

9.9 Correcting Camera Shake

Sometimes a photograph is slightly out of focus due to camera shake. We have learned how the Sharpen tool or the Unsharp Mask and Adjust Sharpness commands can help correct a blur. However in addition to these, the Editor provides a special command specifically designed to address camera shake that can be remarkably effective.

Let's reopen the file we named Corrections.psd, from which we removed red eye earlier in this chapter. When we magnify in, we can see that this photograph is slightly blurred. To correct this problem, we will first apply the Enhance>Auto Shake Reduction command; the photograph becomes significantly sharper. We will choose to undo this application, however, and instead select Enhance>Shake Reduction for more control over the command's application. The Shake Reduction dialog box opens and immediately begins to analyze the photograph to correct its blur. Let's take a look at its features, shown in Figure 9.21:

SHAKE REGION BOUNDING BOX: Assigns the area to analyze for correction. This location can be moved by dragging its center point or enlarged by dragging its bounding box handles.

SENSITIVITY SLIDER: Assigns the intensity of the correction; drag the slider to the left when a photograph is less blurry or to the right when more correction is needed.

ADD ANOTHER SHAKE REGION: Adds more shake regions by pressing and dragging across the preview. When two or more shake regions exist, clicking the center dot of one turns it solid gray and the region is turned off. To eliminate it entirely, click the "X" in the top right corner of the region. More shake regions can be added by simply pressing and dragging the pointer across the image, without first selecting the Add another shake region button.

ZOOM TOOL: Provides magnification to analyze how the image will be affected by the command settings.

BEFORE/AFTER: Buttons allow you to analyze how effectively the command has addressed the blur in the photograph.

With the default Sensitivity setting and the bounding box enlarged slightly and centered over the boy's head, when we click OK to exit the dialog box, the image is sharp and clear. Let's save and close this photograph.

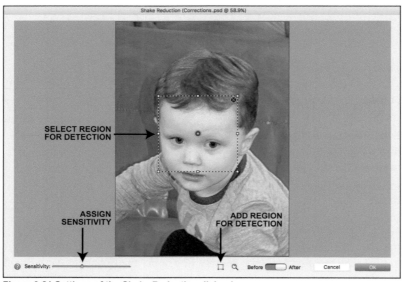

Figure 9.21 Settings of the Shake Reduction dialog box.

NOTE▶ While the Editor is analyzing the image for shake reduction, a warning triangle will appear temporarily in the top right corner of the preview that will disappear when the preview is updated with the correction. If it remains, it indicates that the command has not found enough data to apply the correction; selecting a larger shake region will help.

9.10 Enhancing Depth of Field

Depth of field refers to the content within a photograph that is in focus. When both the foreground and background content of an image are in focus, it is described as having a large or wide depth of field. When only a small area of the foreground or background is sharp and clear, with the rest of the image out of focus, the photograph

is described as having a shallow or narrow depth of field. With some subjects a large depth of field is desired; with others a shallow depth of field is more effective. A camera's aperture setting can achieve this effect, but sometimes you may want to further enhance it, or the camera you used at the time may not have had the capability to assign a shallow depth of field. The Editor can enhance an existing shallow depth of field, create one by blurring the background around the focal point, using either the Surface Blur or Gaussian Blur filter, or create aerial perspective by decreasing the depth of field using the Lens Blur filter.

9.10.1 Enhancing an Existing Shallow Depth of Field

Let's choose to open the photograph named Sharpen Bee.jpg located in the Practice_ Import 16 files folder within the Practice Files folder you copied to your hard drive. When this photograph opens, its focal point of the bee is sharp and clear, with its

background blurred. Great. But let's choose to enhance the clarity of the bee just a little more. First, duplicate the Background layer so that we can easily compare the enhancement effect. We will select the Sharpen tool, then in the Tool Options bar assign Mode: Normal, Brush style: Soft, Size: 70 px, Strength: 70%, Sample All Layers unchecked, Protect Detail checked. When we magnify in and add just a *few* strokes across only the head and front legs of the bee and the flower petals directly in front of him, the clarity of the content in focus becomes even more pronounced within the area identified by the circle shown in Figure 9.22. Feel free to turn the Background copy layer off, then on again, to see how the subtle additional sharpening has enhanced the photograph, then close the file, optionally choosing to save it first if desired.

BEFORE SHARPENING

AFTER SHARPENING

Figure 9.22 Before and after sharpening to enhance the shallow depth of field.

9.10.2 Creating a Shallow Depth of Field

Let's choose to open the photograph named Blossom.jpg located in the Practice_ Import 16 files folder within the Practice Files folder you copied to your hard drive. When this image opens, we can see that the apple blossoms appear sharper than the slightly blurred grass behind them, but the close-up would be much more impressive if the background was more noticeably blurred, creating a shallow depth of field.

We will need to first make an accurate selection of just the blossoms, their leaves, and their stems to isolate them from the background, using any combination of selection methods you prefer, assign a feather to the selection with Radius: 2 px, then

choose Select>Inverse to select the background instead of the blossoms. Once we have done that, we will choose Filter>Blur>Surface Blur, assign the settings shown in Figure 9.23 (Radius: 65 Pixels, Threshold: 106 levels), then deselect the selection.

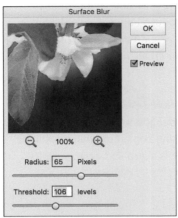

Figure 9.23 Assigning Surface Blur settings of Radius: 65 Pixels and Threshold: 106 levels to create a shallow depth of field.

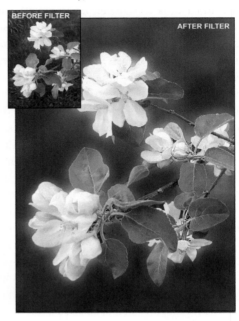

Figure 9.24 Blossom with the Surface Blur filter applied to the background and the Sharpen tool applied to the blossoms.

Let's heighten the effect by applying the Sharpen tool to the petals, leaves, stamens, and stems of the blossoms, assigning the same settings we used for the bee, adjusting the brush size as needed for the stems, with the completed enhancement shown in Figure 9.24. When you are satisfied with the depth of field, close the file, optionally choosing to save it first if desired.

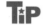

This effect can also be achieved by creating a selection of the blossoms, leaves, and stems, adding a feather with Radius 1 px, and then applying the Layer Via Copy command. With the content preserved on a separate layer, the Background layer can be selected and then a Gaussian blur can be applied to the entire layer. To add the sharpening details, select the copied content layer, then apply the Sharpen tool.

9.10.3 Creating Aerial Perspective

Sometimes you will want a landscape photograph to have sharp detail in the foreground as well as the background, while other times you may want to create aerial perspective by gradually converting the sharpness of the foreground into a blurred background, enhancing its sense of depth.

Let's choose to reopen the photograph we saved as Sculpture.psd in Chapter Four, then duplicate the Background layer. With the copied layer active, we will choose Select>Load Selection, then load the Sculpture selection we saved with the file. With this selection active, we will choose Edit>Cut to delete it from the duplicated layer.

It will still be visible, as the copy of it on the original Background layer will remain intact, but it will display as transparent on the copied layer in the Layers panel. Now with the copied layer still active, we will choose to add a Layer Mask (single click the Add a mask icon in the Layers panel). Once we have done that, with the *mask selected—not the thumbnail*—we will choose the Gradient tool located in the Draw section of the Tools panel. In the Tool Options bar we will want to be sure its default Linear gradient style is selected. With the default colors of black as the foreground color and white as the background color, let's drag the Gradient tool from the bottom edge of the photograph to the top. Once the gradient has been applied to the mask, we will double click the *image thumbnail—not the mask*—to select it on the duplicated layer, then choose Filter>Blur>Lens Blur. The settings we will apply are shown in Figure 9.25—Source: Layer Mask, Blur Focal Distance (in focus depth): 25, Shape: Hexagon, Radius (amount of blur): 50, Distribution: Uniform. When we click OK and exit the Lens Blur filter dialog box, the clarity of the photograph has changed to mimic an aerial perspective, with a gradual transition from clear in the foreground to hazy in the background, as also shown in Figure 9.25. Once applied, close the file, optionally choosing to save it first if desired.

Figure 9.25 Selecting the thumbnail to apply the blur, blur settings, and results of the application.

When working in the Lens Blur filter dialog box, if the Preview option is kept unchecked, the filter will be applied more quickly.

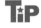

NOTE The sculpture was deleted from the layer we applied the Lens Blur filter to because, although it is in the foreground, it is tall. If it had not been removed, the filter would have blurred the top half of the sculpture along with the buildings in the background. In your own work, duplicate the Background to create a working layer to apply the Lens Blur filter to, then delete any content on the working layer that you do not want affected by the filter prior to assigning it.

9.11 Replacing a Blown Out Sky

"Blown out" is the term given to a sky that is washed out in a photograph, appearing white or nearly white in color, with little or no blue in it. We have already learned three ways to remedy this problem: in Chapter Four we deleted a blown out sky to reveal a bright blue sky photograph underneath it, and in Chapter Five we learned how the Replace Color command and Smart Brush tool can each improve sky color.

Another way to replace a blown out sky is to apply a gradient. This technique does not create clouds; instead it can create the effect of a day when "there is not a cloud in the sky." Let's reopen the Zebra.psd file we worked on first in Chapter Seven and then again earlier in this chapter (adding a highlight spot to the zebra's eye). We can see that the sky is nearly completely blown out in this photograph; moreover, the trees do not cover the main area of sky in the photograph. Thus, this scenario is a perfect candidate for a gradient sky.

9.11.1 Creating a Gradient for a Sky

We will first need to create a working layer for the gradient. Applying a gradient to a working layer is best practice, as it allows you the flexibility to lower the opacity of the application, as well as redo or delete it. With the working layer active, we will

Figure 9.26 Tool Options bar when the Gradient tool is selected.

select the Gradient tool. As soon as the Gradient tool is selected, the Tool Options bar updates to display its features, shown in Figure 9.26:

GRADIENT: Displays a gradient using the current foreground and background colors.

PRESETS DOWN ARROW MENU: Provides a variety of pre-made gradients.

EDIT: Opens the Gradient Editor dialog box to create a custom gradient.

MODE: Assigns a blending mode for the gradient, with Normal the default.

OPACITY: Provides a slider to assign the opacity of the application.

REVERSE: Reverses the order of the colors of the gradient.

TRANSPARENCY: Allows the gradient to display transparency if the gradient has been created with it. This checkbox should always be selected for gradients with a lowered transparency to display as designed.

DITHER: Helps the gradient to display smoothly without a banding effect. This checkbox should always be selected for gradients to display and print as designed.

GRADIENT STYLE: Provides icons to choose the style of the gradient, with the Linear option chosen by default.

We will want to create a custom gradient by first single clicking the Edit button in the Tool Options bar to access the Gradient Editor dialog box. Once we have done that, we will click the color stop icon on the left below the gradient bar, then click the Color down arrow menu to select a starting color for the gradient. With the colors displayed as Small List, we will choose Light Cyan Blue. For the right color stop below the gradient bar we will select white, then click the color stop icon *above* the right color stop to assign Opacity 0%. With the working layer selected, press and drag from the top of the image down to the top of the ear of the zebra, as shown in Figure 9.27, then assign Opacity: 50% to the layer. Feel free to try other shades of blue and other layer opacity settings, then save and close the file.

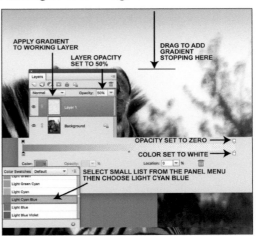

Figure 9.27 Creating and adding a Linear style gradient to a blown out sky on a working layer with Opacity: 50%.

9.12 Creating the Appearance of a Studio Portrait

When a portrait photograph's background content is distracting, it can be substituted with a gradient to create the appearance of a studio portrait for people and pet images.

9.12.1 Creating Studio Portraits of People

Let's open the file named DSC_0060.jpg located in the Practice_Import 5 files folder within the Practice Files folder you copied to your hard drive, or locate it in the Organizer and click the Editor button in the Taskbar if you chose to complete the exercises provided in Part One, then save the file as Portrait.psd.

We will need to first select the woman to isolate her from the background. Beginning with the Quick Selection tool and then using the Refine Edge dialog box will work great to capture the fine details of the woman's hair in our selection. Once the selection has been made, best practice is to always save an intricate selection such as the one we have just made. Let's choose Select>Save Selection, then name the selection "Portrait." With the selection active, we will choose Layer>New>Layer Via Copy.

We are ready to create our background gradient. Let's add a working layer *between* the Background layer and the copied content layer, then select the Gradient tool. In the Tool Options bar, let's click the Edit button to create a custom gradient. In addition to choosing from swatches provided by the Editor, when the pointer is moved outside of the Gradient Editor, an eyedropper allows us to sample colors within the image. Although any colors can be used for the background gradient, sampling colors within the image works well to complement the portrait. We will select the left color stop below the gradient bar first, then use the eyedropper that appears to sample the dark blue top of the lighthouse on the woman's jacket, or optionally double click the color stop and assign R: 54, G: 82, B: 111 in the Color Picker that appears. Now let's select the right color stop below the gradient bar and sample a light blue color in the woman's jacket or use the Color Picker to assign R: 175, G: 193, B: 219. We will keep the default Linear style gradient, then press and drag from the top edge of the photograph to the bottom to apply the gradient; the resulting photograph with its studio appearance is shown in Figure 9.28. Let's save and close this file, optionally choosing to experiment with different gradient colors and applications first if desired.

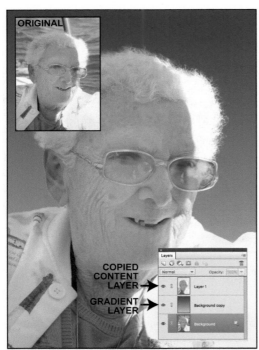

Figure 9.28 Studio portrait appearance created with a Linear style gradient.

NOTE▶ Custom gradients can have more than two colors. To add a color stop to an existing gradient, single click below the gradient bar in the Gradient Editor when the "hand" icon appears. To remove an existing color stop, select and drag it down and out of the gradient bar in the Gradient Editor.

9.12.2 Creating Studio Portraits of Pets

Let's reopen our Dog Portrait.psd. We have an accurate selection already made and saved with a mask. Gradients for animal portraits follow the same format as those for people. However, to choose colors for the background, oftentimes it works well to sample colors within the fur of the animal. By choosing colors within the existing photograph, the background will blend and complement the pet and not overpower the image, which can take the focus away from your furry friend. Although Linear gradients can also be used for pet portraits, Radial gradients complement their head shapes and work well.

When we reopen this file, let's first merge the highlights layer down onto the masked layer. Although we can leave the mask active, because we no longer need it, let's choose to apply it by selecting Layer>Layer Mask>Apply. As we have learned, we will now want to add a working layer for the gradient *between* the original Background layer and the selection of the dog. With our gradient layer selected in the Layers panel, we will choose the Gradient tool, then in the Tool Options bar assign the Radial style for the gradient and click the Edit button. We will select the left color stop below the gradient bar to sample a dark color, such as R: 32, G: 17, B: 8, then select the right color stop below the gradient bar and sample a lighter color,

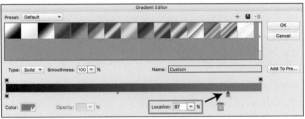

Figure 9.29 Creating a custom Radial style gradient with its right color stop moved to Location: 87%.

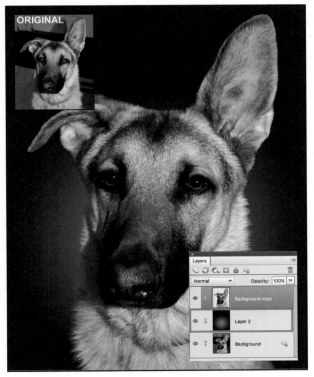

Figure 9.30 Adding a Radial style gradient to create a pet studio portrait.

such as R: 145, G: 110, B: 32. We can also adjust how the colors are distributed within the gradient. Let's drag the right color stop to the left until the Location field displays 87%, as shown in Figure 9.29, then click OK to exit the Gradient Editor.

Before applying the gradient, we will click the Reverse check box in the Tool Options bar (our lighter color now will be on the left in the gradient thumbnail). To apply the Radial gradient, we will begin by placing the pointer in the middle of the photograph both horizontally and vertically (between the dog's eyes), then press and drag outward to the right edge of the image, with the resulting portrait shown in Figure 9.30. When you are satisfied with the dog portrait, save and close the file.

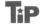 When applying a Linear or Radial style gradient, holding the Shift key down as you drag the Gradient tool will constrain its application.

9.13 Using the Liquify Filter

The Liquify filter provides tools for manipulating pixel content, with the ability to provide a little tummy tuck for the friends, family, and clients in your photographs, or intentionally distorting content for fun.

9.13.1 Using the Liquify Filter for Weight Loss

Let's choose to open the photograph named Weight Loss.jpg located in the Practice_ Import 16 files folder within the Practice Files folder you copied to your hard drive. Once we have done that, let's duplicate the Background layer to create a working layer. This will allow us the flexibility to start over if needed, but also allows us to monitor the weight loss of our subject. With our working layer selected in the Layers panel, we will choose Filter>Distort>Liquify. The magic weight loss tool is its Warp tool, the first one at the top of the tools provided in the Liquify dialog box.

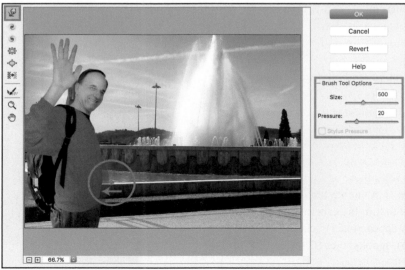

Figure 9.31 Before and after applying the Liquify filter for weight loss.

This tool is controlled by two settings: Size and Pressure. For Size, the best results will come when using the largest size brush you can based on the content you want to adjust; we will assign Size: 500. For Pressure, keeping the amount assigned to a low number such as 20 works well. The pressure setting determines the intensity of the application; a low number will require more applications, but will also provide more control when applying the correction. In addition to using the Warp tool when performing weight loss magic, three additional tools in the Liquify dialog box are used for weight loss: the Reconstruct tool (allows us to reverse our application), the Zoom tool, and the Hand tool.

When we select the Warp tool, a small crosshair is visible in the center of the circle that represents the diameter of the chosen brush size. We will want to place the crosshair right on the *outer edge* of the subject's stomach, then press and drag inward to pull his stomach in, as shown in Figure 9.31. When you are satisfied with your weight reduction, close the file, optionally choosing to save it first if desired.

NOTE The Liquify filter performs its magic by warping and distorting content. When using this filter for weight loss, it is important to be mindful of walls, fences, etc., that are adjacent to the person you are editing. When applying the filter to the Weight Loss.jpg photograph, drag the content of the wall so that it expands at the same direction and angle as the original content and does not appear warped.

9.13.2 Using the Liquify Filter for Fun

The Liquify dialog box also contains clockwise and counterclockwise Twirl tools, a Pucker tool (pulling content in), a Bloat tool (pushing content out), and a Shift Pixels tool (moving pixels left or right by dragging up or down, respectively). Sometimes it can be creative and fun to *intentionally* distort your friends, family, or pets. Like the Warp tool, each of these tools is controlled by Size and Pressure settings. In the sample shown in Figure 9.32, these additional tools were combined with the Warp tool to turn the ears into a devilish appearance (Pucker and Warp), spooky eyes (Bloat),

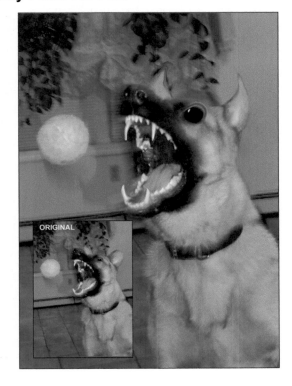

Figure 9.32 Using the Liquify filter for intentional distortions.

and extra long "fangs" (Warp). Feel free to use the Liquify Fun.jpg file provided in the Practice_Import 16 files folder within the Practice Files folder you copied to your hard drive to experiment with these additional tools, or use a photograph of your own. There is no right or wrong here; it is all about creativity and just having fun!

9.14 Tricks of the Trade Using the Guided Mode

The Guided mode includes three options that provide some of the enhancements we have learned in this chapter: Perfect Portrait, Depth of Field, and Tilt-Shift. Let's take a look at each of these, beginning with its Perfect Portrait option.

9.14.1 Using the Perfect Portrait Option of the Guided Mode

Let's choose to open the photograph named Opened Eyes.jpg located in the Practice_ Import 16 files folder within the Practice Files folder you copied to your hard drive, click to enter the Guided mode, then select Perfect Portrait located under its Special Edits category. This option provides seven steps for enhancements that include some familiar terms and tools. Steps one through four allow us to apply blur to soften the skin texture, alternatively return to the original and selectively blur the skin, and increase the clarity of the image. (The Apply Smart Blur button must be clicked first to activate access to blur steps two, three, and four). The fifth step includes buttons for Spot Healing, Red Eye Removal, Brighten Eyes (Dodge tool), Darken Eyebrows (Burn tool), and Whiten Teeth (press and drag to select and lighten). The sixth step— Add Glow—assigns a glow effect (we will learn more about applying effects in Chapter Ten), with the seventh step providing a Slim down button (assigns a pre-set liquifying effect). When the Blur Brush, Spot Healing Tool, Brighten Eyes, Darken Eyebrows, and Whiten Teeth buttons are chosen, pressing the left or right bracket key will shrink or enlarge the size of the brush that appears when the option has been selected. Feel free to experiment with this option, then close the file.

9.14.2 Using the Depth of Field Options of the Guided Mode

This Guided mode option is also located under its Special Edits category and provides two methods for creating depth of field. Let's open the *original* Auto Selection.jpg file located in the Practice_Import 11 files folder within the Practice Files folder you copied to your hard drive, then select the Guided mode Depth of Field option. Once we have done that, two buttons are provided: Simple and Custom.

9.14.2.1 *Using the Simple Depth of Field Option of the Guided Mode*

When the Simple button is clicked, an Add Blur button allows us to assign a blur, with a slider to control the intensity of the application. The Add Focus Area button must then be clicked to drag from the direction we want the blur to start, then release

it where we want the blur to end. If we choose Next>Continue Editing: In Expert to analyze the results of this application in the Expert mode, we can see that the Guided mode automatically duplicated the Background layer, applied a Radial style gradient mask, then applied the blur as shown in Figure 9.33.

9.14.2.2 *Using the Custom Depth of Field Option of the Guided Mode*

Let's Revert when in the Expert mode, click the Guided tab, then select the Depth of Field option again and choose Custom. This time we can see that a Quick Selection Tool button allows us to select the area we want to protect; then the Add Blur button is applied to the unprotected area, with a Blur slider to assign the intensity. If we once again choose Next>Continue Editing: In Expert, we can see that the Guided mode has automatically duplicated the Background layer, then isolated the selection to apply the blur to the rest of the image, as also shown in Figure 9.33.

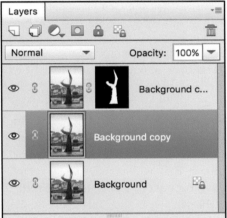

Figure 9.33 Simple and Custom Depth of Field Guided mode options viewed in the Expert mode.

9.14.3 Using the Tilt-Shift Option of the Guided Mode

Let's choose Revert, then open the Auto Selection.jpg image using the Guided mode Tilt-Shift option, also located under its Special Edits category. We can see that this feature is similar in application and results to the Simple category of the Guided mode Depth of Field option. Its Add Tilt-Shift button applies the blur, with its Modify Focus Area button allowing some control over the direction and size of the blur. What sets it apart from the Depth of Field option is its Refine Effect button. When clicked, in addition to the ability to increase the intensity of the blur, the contrast of the image can be enhanced and/or its saturation adjusted if desired.

PRACTICE MAKES *PERFECT*✓

You have learned a variety of tips for enhancing the professionalism of your photographs. Feel free to apply these new skills to the practice projects provided before moving forward to Chapter Ten.

PRACTICE PROJECT 1

1. Open the photograph named C-9 Project Eyes Closed.jpg located in the Practice_Import 16 files folder within the Practice Files folder you copied to your hard drive, and save it as Practice Project Corrections.psd.

2. Choose the Eye tool, then click the Open Closed Eyes button in the Tool Options bar, or choose Enhance>Open Closed Eyes to access its dialog box.

3. Click the Computer option, then choose the C-9 Project Eyes Open.jpg file located in the Practice_Import 16 files folder within the Practice Files folder you copied to your hard drive to select the eyes to use, click to apply them, then click OK to exit the dialog box.

4. Add a working layer above the Background layer, then choose the Brush tool. Select white as the foreground color, then in the Tool Options bar assign Brush style: Soft, Size: 10 px, Opacity: 100%, Mode: Normal. Single click in the top right area of the pupil in each eye to add a highlight spot, then assign Opacity: 70% to the working layer, as shown in Figure 9.34.

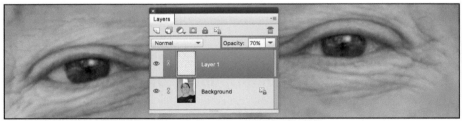

Figure 9.34 Adding highlight spots to a working layer with Opacity: 70%.

5. Merge the highlight spots layer down, then select and whiten the teeth using any one of the methods we have learned. If you choose to whiten the teeth using one of the methods that creates an adjustment layer, merge the layer down before continuing on to step six.

6. Create a new working layer above the Background layer, then choose the Healing Brush tool. In the Tool Options bar assign Size: 60, Aligned unchecked, Source: Sampled, Mode: Normal, Clone Overlay checked, and Sample All Layers checked. With the working layer selected, remove

all the wrinkles above and below the eyes, as well as the "crow's feet" wrinkles.

7. Reduce the opacity of the working layer to 55% as shown in Figure 9.35.

8. Select the Background layer *first*, then choose Enhance>Adjust Facial Features, then select its Lips category. Drag the Smile slider slightly to the right to add a subtle increase in the smile, as shown in Figure 9.35. Choose to merge the working layer down, and then save and close the file.

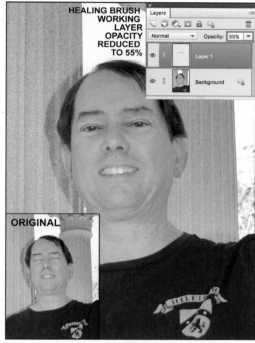

Figure 9.35 Healing Brush tool applied to a working layer, with completed sample including eyes opened and highlighted, teeth whitened, wrinkles reduced, and smile enhanced.

PRACTICE PROJECT 2

1. Open the photograph named Hippo.jpg located in the Practice_Import 16 files folder within the Practice Files folder you copied to your hard drive, and save it as Hippo.psd.

2. Duplicate the Background layer to create a working layer.

3. With the working layer active, create an accurate selection of the hippo. It will not be necessary to trace around the grass that appears in front of his feet, as this area will not be affected by the application of the Lens Blur.

4. With this selection active, choose Edit>Cut to delete it from the working layer.

5. With the working layer still active, choose to add a Layer Mask.

6. With the *mask selected—not the thumbnail*—choose the Gradient tool then in the Tool Options bar assign the default Linear style gradient. With the default colors of black as the foreground color and white as the background color, drag the Gradient tool from the bottom edge of the photograph to the top.

7. Once the gradient has been applied to the mask, double click the *image thumbnail—not the mask*—to select it on the working layer, then choose Filter>Blur>Lens Blur.

8. In the Lens Blur dialog box assign Source: Layer Mask, Blur Focal Distance: 150, Shape: Hexagon, Radius: 50, Distribution: Uniform.

9. Once the blur has been applied, optionally choose to merge the working layer down, then save and close the file, with a copy of the settings and blur application shown in Figure 9.36.

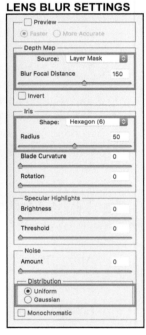

LENS BLUR SETTINGS

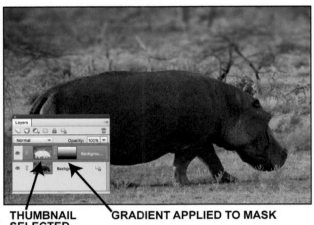

THUMBNAIL SELECTED TO APPLY BLUR **GRADIENT APPLIED TO MASK**

Figure 9.36 Selecting the thumbnail to apply the blur, blur settings, and results of the application.

10

Adding Special Effects to Photographs

- Apply filters, effects, graphics, and styles to photographs

- Examine the Shape tools

- Learn to add regular text, warped text, masked text, and text to paths

- Utilize the Guided mode to assemble a panorama photograph

This chapter launches your creativity by combining tools, commands, and features you have already learned with several new ones to enhance your photographs and help build artistic creations from scratch. We will also learn to replicate advanced photography techniques such as panning and double exposures with just a few clicks of the mouse.

10.1 Applying Painting and Textural Filters

We have used some of the Editor's filters already, such as the Dust & Scratches filter, the Surface Blur filter, and the Liquify filter. The Editor also provides filters that mimic drawing, painting, and textural surfaces, which can be applied to an entire image, a layer, or a selection. These filters can be chosen from the Filters panel available in the Expert mode, as well as from the Filter Gallery and the Filter menu available in both the Quick and Expert modes. We will examine the various ways to access and apply these filters so that, on your own, you can explore each filter in more depth as desired.

10.1.1 Applying Filters Using the Filters Panel

 Working in the Expert mode, let's open the photograph named Filters.jpg located in the Practice_Import 17 files folder within the Practice Files folder you copied to your hard drive, then choose Window>Filters or select Filters from the More down arrow menu in the Taskbar. If you have not created a custom workspace, the Filters panel can also be accessed by single clicking the Filters icon in the lower right area of the Taskbar. The Filters panel opens, with a drop down menu providing an alphabetized list of the filter categories. When a category is selected, each filter within the category is displayed with a small thumbnail sample of its effect. When a filter is selected, customizable features will display, with some of the filters also providing an Advance Options button to access additional features. Below these settings, the check mark will apply the filter, with the cancel icon undoing the application. The application can also be canceled by pressing the Reset icon at the top right of the Filters panel.

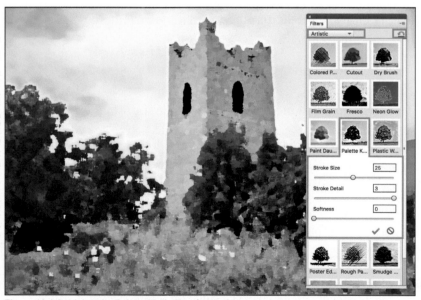

Figure 10.1 Applying the Palette Knife filter in the Filters panel.

Let's select Artistic>Palette Knife. Options for Stroke Size, Stroke Detail, and Softness appear; we will keep the default settings, then click the check mark to apply them, as shown in Figure 10.1.

A copy of each figure shown in this chapter can be viewed in the companion files included with this book.

Multiple filter applications can be applied to an image one at a time, adding the same filter again, or adding other filters. Let's now choose to add the Rough Pastels filter on top of the Palette Knife filter. We can see that this is one of the filters that also provides an Advance Options button. Feel free to click it and further customize the application, or simply click the check mark to apply this additional filter with its default settings.

10.1.2 Applying Filters Using the Filter Gallery

Let's use the History panel to return to the opening state of this image, or choose Edit>Revert, then choose Filter>Filter Gallery. A dialog box opens which provides access to many of the filters provided in the Editor. Thumbnails again display the filter effects, selected from six down arrow menu categories. When a filter is selected from one of the categories, its name and customizable features appear on the right. The name is listed above the features in a drop down menu that provides alphabetized access to every filter available in the Filter Gallery.

What makes this method of applying filters unique is the lower right area of the Filter Gallery dialog box. When a filter is applied, it is listed here. Multiple filters can be applied, which will be stacked sequentially above the previous filter. A filter can be dragged to *change* its stacking order of application, which will change the resulting effect of the multiple filters, sometimes dramatically.

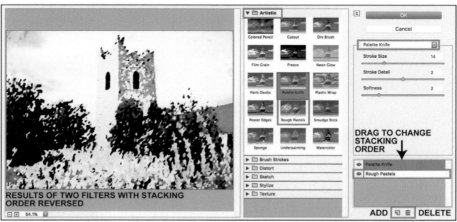

Figure 10.2 Applying two filters using the Filter Gallery and changing their stacking order of application.

Let's use the Filter Gallery to apply the Palette Knife filter located in the Artistic category, using its default settings. To add another filter on top, we will click the

New effect layer icon (folded page) in the lower right area of the dialog box. Initially, the previous filter is reapplied; however, with it highlighted, we will click to select the Rough Pastels filter also located in the Artistic category, and the Rough Pastels filter is added on top of the Palette Knife filter. Let's now change the stacking order of the filters by dragging the Palette Knife filter *above* the Rough Pastels filter, with the results shown in Figure 10.2.

10.1.3 Applying Filters Using the Filter Menu

Let's use the History panel to return to the opening state of this image, or choose Edit>Revert, then choose Filter>Artistic>Palette Knife. We can see that the Filter

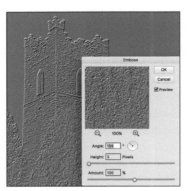

Gallery dialog box opens for us to apply this filter. If a chosen filter is part of the Filter Gallery, it will open automatically within the Filter Gallery dialog box. If not, an individual dialog box to apply settings for the chosen filter will appear instead, as shown in Figure 10.3 when the Filter>Stylize>Emboss filter is selected (Angle: 135, Height: 3, Amount: 100).

Figure 10.3 Dialog box for the Filter>Stylize>Emboss filter.

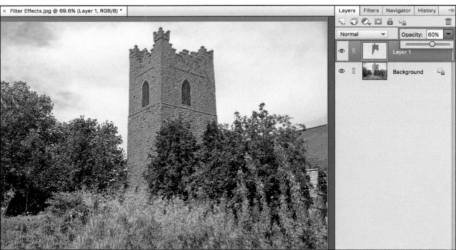

Figure 10.4 Applying the Emboss filter to a layer created from a selection, with the layer changed to Opacity: 60%.

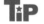

By duplicating a layer or by creating a layer from a selection first, a filter can be applied with the opacity of the layer lowered, as shown in Figure 10.4.

10.2 Applying the Impressionist Brush Tool

Let's use the Revert command or the History panel to return to the opening state of the Filters.jpg file one more time. When the Brush tool is selected in the Tools panel, the Impressionist Brush tool can be chosen in the Tools Options bar. Let's duplicate the Background layer of the Filters.jpg file, then select the Impressionist Brush tool.

This tool can be used to paint strokes resembling an Impressionist painting, based on the settings chosen. In addition to assigning Size, Opacity, and Mode, three additional settings are used to customize the Impressionist effect, as shown in Figure 10.5:

Figure 10.5 Choosing and applying settings for the Impressionist Brush tool.

> STYLE: Assigns the shape of the strokes to be applied, with Tight Short chosen by default.

> AREA: Delineates the size of the area the brush will cover with each stroke (a higher number generates more strokes within the area applied).

> TOLERANCE: Sets how similar neighboring pixels must be in color before they are affected by the stroke.

Paint across some of the flowers in the foreground (or as much of the image as you like), applying different Style settings to explore how this tool works, then close the file, optionally choosing to save it first if desired.

10.3 Applying Effects

NOTE▶ Some effects are available in both the Organizer and the Quick mode, and some of the Guided mode options incorporate effects; however, there are several available in the Expert mode. While some of the results of the effects available in each of these modes are the same or similar, others are unique to the mode they are selected in. This chapter will not cover every effect that is available in Photoshop Elements 2018. It will instead introduce how to access and apply effects, which should serve as a springboard for further creative discovery on your own time.

10.3.1 Applying Effects in the Organizer

We learned in Chapter Two that when an image is selected in the Media view and the Instant Fix button is then clicked in the Taskbar, the image opens in the Instant Fix editor, with Effects as one of the editing tool options that appears. When the

Effects icon (*fx*) is single clicked, thumbnail views of the image selected appear as an alphabetized scrollable list of color and tonal effects, with descriptive names such as "Moonlight" and "Vintage." When one is selected, the image updates to reflect the applied effect. If a different effect is chosen, the new effect replaces the previous application.

10.3.2 Applying Effects in the Quick Mode

The Quick mode provides an Effects icon in the lower right area of the Taskbar. When this button is clicked, an Effects panel appears to the right of the edit pane. Effects here are shown in thumbnail views divided into categories, with variations of the effect accessible from a down arrow menu. After an effect has already been applied and a new one is selected, the new effect replaces the previous application. The effects are applied as layer masks. If an effect is applied to an image in the Quick mode, when the image is then opened in the Expert mode, the mask can be edited.

Working in the Quick mode, let's choose to open the photograph named Effects. jpg, located in the Practice_Import 17 files folder within the Practice Files folder you copied to your hard drive, then single click the Effects button in the Taskbar. In the Effects panel that appears, we will select the Pencil Sketch effect, then select the Colored Pencil variation from its down arrow menu. Once it has been applied, when we click the Expert tab to view this image in the Expert mode, we can see that a new layer has been created automatically above the Background layer in the Layers panel, with a layer mask applied to it. With the *mask* thumbnail selected and the default

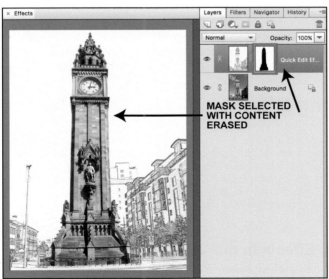

colors of black as the foreground color and white as the background color selected in the Tools panel, we will paint over the clock tower to reveal its original full color. Choose a brush size and hardness that works well to erase the mask, with the resulting effect shown in Figure 10.6.

Figure 10.6 Colored Pencil effect applied in the Quick mode, with its mask edited in the Expert mode.

If you are painting back the original image and accidentally paint outside the tower, use the double arrow above the colors in the Tools panel to switch the foreground and background colors, then repaint the effect. Alternatively, you can create a selection of the content you want to reveal in full color and then, with white as the foreground color in the Tools panel, press the Backspace/Delete key to remove the mask selection and reveal the original image.

10.3.3 Applying Effects in the Expert Mode

If you like the effect created in the previous exercise, save the sample, then reopen the original Effects.jpg file, or choose Revert or the History panel to return to the opening state.

Working in the Expert mode, the Effects panel is accessible by choosing Window>Effects, by choosing Effects from the More down arrow menu in the Taskbar if you created a custom workspace, or by single clicking the Effects button in the Taskbar if working in the default workspace.

When the Effects panel opens, categories of effects are accessible from an alphabetized drop down menu, with the ability to view all of them at once by choosing Show All.

An effect can be applied by selecting it, then choosing Apply from the Effects panel menu, by double clicking on the effect in the panel, or by dragging the effect icon with the pointer and releasing it on top of the image. Effects applied in the Expert mode are cumulative. Let's add three effects one on top of the other: Watercolor Painting, Zig Zag, and Tint Blue, with the results shown in Figure 10.7.

Figure 10.7 Applying multiple effects in the Expert mode.

NOTE ▸ When combining effects, some effects require the file to be flattened. If a file has layers and an effect that requires a flattened file is applied, a warning dialog box will open with the prompt "Flatten Layers?" prior to the flattening of the file and the application of the effect.

Feel free to try other combinations of effects then close the file, optionally choosing to save it first if desired.

10.4 Adding Textures, Frames, and Graphics

Panels for Textures and Frames are provided in the Quick mode, with a panel named "Graphics" available in the Expert mode that includes backgrounds, frames, text features, and clip art shapes and graphics.

10.4.1 Adding Textures and Frames in the Quick Mode

Located to the right of the Effects icon in the Quick mode Taskbar, icons to access the Textures and Frames panels are available. When the Textures panel is active, a surface texture can be single clicked to apply the texture to the background of the open image. The texture is applied as a mask, allowing its effect to be altered when the image is opened in the Expert mode.

When a frame is selected from the Frames panel, the open image is automatically centered within the chosen frame design. To select a different frame, single click on the new design; the new frame will replace the previous selection. To change the size and location of the image within the frame, double click the image. Bounding box handles as well as a sizing slider will appear, with a check mark and cancel icon to apply or dismiss the changes. The image can also be moved within the frame by dragging it with the Quick mode's Move tool. If the image is later opened in the Expert mode, the features of the frame design can be edited in the Layers panel.

The image shown in Figure 10.8 first had the Canvas texture applied in the Quick mode, with its Opacity setting lowered to 65% in the Layers panel of the Expert mode. Returning then to the Quick mode, the Performance Stage frame was applied with its colors, then altered in the Layers panel of the Expert mode. If you would like to try this yourself, this file, named Frame.jpg, has been provided in the Practice_ Import 17 files folder within the Practice Files folder you copied to your hard drive.

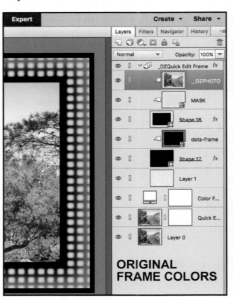
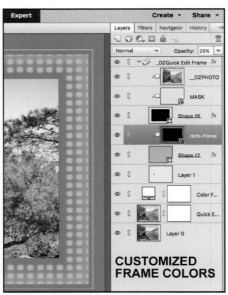

Figure 10.8 Using the Layers panel in the Expert mode to customize the colors of the Performance Stage frame applied in the Quick mode.

If a frame design contains multiple layers, such as the sample shown in Figure 10.8, sometimes it can be confusing as to which layer you need to select to customize the frame effect you want to alter. By sequentially turning each layer of the frame effect off, then on again, you will be able to identify the specific feature you want to change, such as its color or opacity, or identify whether you want to hide or remove it from the frame design altogether.

10.4.2 Adding Graphics in the Expert Mode

Working in the Expert mode, the Graphics panel is accessible by choosing Window>Graphics, by choosing Graphics from the More down arrow menu in the Taskbar if you created a custom workspace, or by single clicking the Graphics button in the Taskbar if working in the default workspace.

This panel includes categories for Backgrounds, Frames, Text, and Graphics and Shapes (both of these providing a variety of clip art graphics), all displayed as thumbnails. A category can be selected from the drop down menu or Show All can be selected to display all of the thumbnails in all of the categories. To apply one, select the desired thumbnail and choose Apply from the Graphics panel menu, or double click the thumbnail, or press and drag it with the pointer and release it on top of the image.

10.4.2.1 Adding a Graphic to an Image

Graphics panel components can be added to an existing image or to a blank document. When a background graphic is added from its Background category, it replaces the original Background layer of the image. To avoid its replacement, the original Background layer can be converted into a regular layer or duplicated before adding the new background graphic. If the image's original Background layer is converted to a regular layer or duplicated, its opacity can then be lowered to expose some of the new Background layer while still keeping some of the original one visible.

When artwork is selected from any other category of the Graphics panel, it is added to the file on its own layer in the Layers panel, providing the flexibility to be scaled or have its opacity reduced—or deleted altogether.

10.4.2.2 Adding a Frame to an Image

If a file contains only a Background layer, when a frame is added to the photograph, the image will automatically be enclosed and cropped to fit into the frame. If the frame is selected in the Layers panel, when a new frame design is dragged onto the image, it will replace the previous design. If a frame is added to a layered file, you will be prompted to insert an image into the frame, allowing you to have a framed image *inside* another image. If you are working with a layered file and want to simply add a frame around the perimeter of the image, flatten the layered file prior to the application of the frame.

10.4.2.3 Adding Graphics Panel Components to a Blank Document

Backgrounds, Frames, Text, and Graphics and Shapes Graphics panel components can all be added to a blank document. To do this, a blank document must be created first by choosing File>New>Blank File or by choosing Open, then selecting New Blank File from its down arrow menu. In the New dialog box that opens, Size, Unit of measurement, Resolution, Color Mode, and Background Contents must be assigned. Once the OK button is clicked, the creativity begins. A frame can be added and an image dragged into it from the Photo Bin, or any combination of a background, multiple graphics, text, and shapes can be added to create signs, banners, cards, etc. When Graphics panel components are added to a document, each one is added on its own layer and can be positioned and scaled as desired. The Valentine's Day sample shown in Figure 10.9 includes Background: Hearts, Graphic: Valentine Lasso, and Text: Gradient Red Medium. Although the Editor contains multiple Type tools that we will learn to use later in this chapter, here in the Graphics panel when the Text category is selected, a font design can be chosen and further customized in the Tool Options bar.

Figure 10.9 Adding components from the Graphics panel to a blank document.

10.5 Adding Layer Styles

Drop shadows and bevels are two of the most popular layer styles that can be easily added to content on a layer. When working in the Expert mode, the Styles panel is accessible by choosing Window>Styles, by choosing Styles from the More down arrow menu in the Taskbar if you created a custom workspace, or by single clicking the Styles button in the Taskbar if working in the default workspace. To apply a layer style, select the layer you want to apply the style to in the Layers panel *first*, then click the desired layer style thumbnail and choose Apply from the Styles panel menu, or double click the style thumbnail, or select the layer style in the Styles panel and drag it with the pointer, releasing it on top of the layer.

Working in the Expert mode, let's choose to open the file named Valentines.psd located in the Practice_Import 17 files folder within the Practice Files folder you copied to your hard drive, or choose to recreate this design instead, or even create your own design including a background, images, and text selected from the Graphics panel.

In the Layers panel, we will select the Valentine Lasso layer, then select Soft Edge from the Drop Shadow category of the Styles panel. The image is instantly updated with the drop shadow effect, and a small *fx* appears to the right of the layer name. When the layer is selected, we can choose Layer>Layer Style>Style Settings. A

dialog box opens where we can customize the settings for the chosen drop shadow style, as well as add styles of Glow, Bevel, and Stroke. Let's click the check mark next to the Bevel category, then assign Size: 21 px and Direction: Up. These effects are dynamic: if the Preview box is checked, we can watch the effects being applied and updated, with the results shown in Figure 10.10.

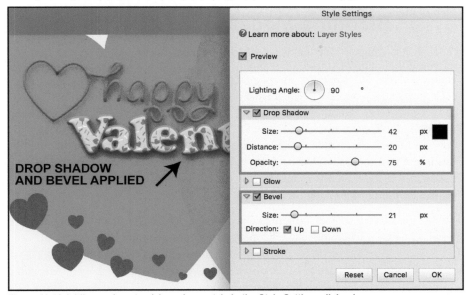

Figure 10.10 Adding and customizing a layer style in the Style Settings dialog box.

NOTE When we select Layer>Layer Style, additional available submenu options include the ability to copy or clear the style. You can also edit the style settings by double clicking on the *fx* icon in the Layers panel, as well as copy a style from one layer to another by Alt/Option dragging the *fx* icon from the layer it is applied to onto the layer you want to add it to. Another way to copy or clear a style is to Right/Control click the layer with the style applied, then choose Copy Layer Style or Clear Layer Style from the context-sensitive menu that appears.

10.6 Saving Favorite Effects, Graphics, and Styles

If you find that you use a particular Effect, Graphic, or Layer Style frequently in the Expert mode, you can Right/Control click on it in the respective panel and select Add to Favorites from the context-sensitive menu that appears to add a copy of it to the Favorites panel. This panel initially includes a few common favorites and provides a Delete icon to remove any favorites you later no longer want saved in it. The Favorites panel can be opened by choosing Window>Favorites or by choosing Favorites from the More down arrow menu in the Taskbar.

In your own work, if you use one or more of these panels frequently, you can add them to your custom workspace for one click access at any time. Following the same format we learned for creating our original custom workspace, press and drag the name tab of the desired panel and release it on top of your custom panel group.

10.7 Creating Special Effects Using Blending Modes

We learned in Chapter Five that when a blending mode is applied to a layer, it affects how the colors in that layer "blend" with the colors of the layers below it. In Chapter Five, blending modes were used to affect the tonal quality of an image. Here we will use them to create special effects.

Working in the Expert mode, let's open the files named Blending Mode1.jpg and Blending Mode2.jpg located in the Practice_Import 17 files folder within the Practice Files folder you copied to your hard drive. With Layout>All Column selected in the Taskbar, we will use the Move tool to drag the Blending Mode1.jpg file and center it over the Blending Mode2.jpg file, then close the original Blending Mode1.jpg file.

Initially, the Blending Mode2.jpg image is no longer visible, until a blending mode is applied—that is when the magic happens. By default, Normal is chosen from the "Select a blending mode for the layer" drop down menu; however, there are 24 additional modes to choose from. Because the colors of the blending layer mix with the colors of the layers below it, not every blending mode will have a significant impact on the results of the blend.

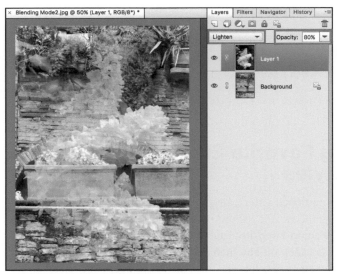

Figure 10.11 Applying the Lighten blending mode with layer Opacity: 80%.

Let's select the lilac layer (Layer 1) then choose Overlay from the Select a blending mode for the layer drop down menu. The lilacs become partially visible, mixing with the image colors below them. For a different look let's now select the Lighten blending mode, then lower the opacity of the layer to 80%, as shown in Figure 10.11.

NOTE▸ Although two separate photographs were used in this project, any content on a layer that is located above another layer in the Layers panel can have a blending mode applied to it. For example, a selection can be created on a Background layer, and the Layer Via Copy command with a blending mode can then be applied, allowing only a specific area of an image to be affected by the blending mode. Once you have experimented with a variety of blending modes and layer opacity settings, close this file, optionally choosing to save it first if desired.

10.8 Creating Emphasis With Grayscale and Color

Although we will learn to create emphasis with grayscale and color in the Expert mode, this effect is also available as an option in the Guided mode Black and White category named B&W Selection. We will learn two ways to create this effect: selecting and removing color from a photograph and painting color onto a grayscale photograph.

10.8.1 Selecting and Removing Color From a Photograph

Working in the Expert mode, let's open the file named Butterfly_Color.jpg located in the Practice_Import 17 files folder within the Practice Files folder you copied to your hard drive. Once the image is open, we will want to make an accurate selection of just the butterfly, flower, and leaves in the foreground. To maximize the effect of this technique, we will want to accurately subtract the area between the petals of the flower around the butterfly from the selection as best as possible. Once this area has been accurately selected, we will apply a feather with a radius of 2 px to it, choose Select>Inverse, then choose Enhance>Adjust Color>Remove Color. That's it! Alternatively, instead of using the Remove Color command, the color can be removed using the Hue/Saturation command, allowing you to lower the saturation of the selected area but not remove its color entirely if you prefer. With the color removed or desaturated, close this file, optionally choosing to save it first if desired.

10.8.2 Painting Color Onto a Grayscale Photograph

Still working in the Expert mode, let's open the file named Butterfly_Grayscale.jpg located in the Practice_Import 17 files folder within the Practice Files folder you copied to your hard drive. We will be painting colors onto this image. However, in order to do that, the color mode must be converted from Grayscale to RGB first; let's choose Image>Mode>RGB Color. Although not required, let's duplicate the Background layer to create a working layer to paint on.

To begin painting, we will select the Brush tool in the Tools panel, select the Color Replacement tool in the Tool Options bar, then assign Size: 50 px, Tolerance: 30%, Mode: Color, Limits: Contiguous, Sampling: Continuous, Anti-aliasing checked. As we have learned, the Color Replacement tool paints with the current foreground color. Let's single click the foreground color in the Tools panel and select R: 247, G:

16, B: 228 from the Color Picker, then paint over the flower petals. Once the petals have been painted, we can temporarily switch to black as the foreground color, to paint back over any areas that were accidentally painted by mistake, magnifying in and using a smaller brush as needed for accuracy.

On the same working layer, we will select R: 227, G: 124, B: 38 in the Color Picker, then paint the wings of the butterfly. The Color Replacement tool will not affect the black areas, so we can paint right over them; however, it will be important to keep the white spots on the wings unpainted.

Artistic emphasis has been created with just these two colors. If desired, the leaves in the foreground area only can also be painted, using R: 85, G: 107, B: 23. Which final appearance is more aesthetically pleasing to you? The Guided mode version replicates the Selecting and Removing Color From a Photograph method. Most likely the effect you choose will be a personal preference, with the results of both applications shown in Figure 10.12. Close this file, optionally choosing to save it first if desired.

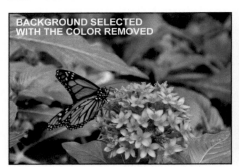
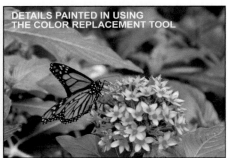

Figure 10.12 Color image with background desaturated and Grayscale image with foreground color added.

10.9 Creating a Vignette Effect

This popular effect will be created in the Expert mode; however, an option named "Vignette Effect" is provided in the Basics category of the Guided mode as well.

Let's open the file named Giraffe.jpg located in the Practice_Import 17 files folder within the Practice Files folder you copied to your hard drive. The vignette can be created to completely hide the content around the focus area or designed to allow some of this area to peek through. We will explore both effects.

10.9.1 Creating a Vignette Effect With an Opaque Background

Although a vignette can be created on a Background layer, duplicating the Background layer and applying the vignette effect to a working layer provides more flexibility and reversibility if needed. Let's duplicate the Background layer and then, with the working layer active, add guides to the image. Guides will ensure that when

the vignette is added, it will be centered vertically and horizontally on the image. As we have learned, to add guides we will need to display the rulers first by choosing View>Rulers, then assign vertical guides at 1" and 4", and horizontal guides at 1" and 6".

With the guides in place, we will select the Elliptical Marquee tool to draw the oval for the vignette. With the Alt/Option key held down as we draw, we will be able to create the ellipse from the center outward. To accurately align the selection with the guides, we will choose Select>Transform Selection. Once the selection is aligned with the guides, we will assign a feather with Radius: 50 px, then choose Select>Inverse and delete the selection. To complete the vignette effect, when the Background layer is selected, we will choose Edit>Fill Layer>Use>White (or choose Color and select the color of your choice using the Color Picker).

10.9.2 Creating a Vignette Effect With a Visible Background

Let's use the History panel to return to the state just prior to entering the Edit>Fill Layer dialog box. By default, the Opacity field in this dialog box will be set to 100%. When this command is applied, if the opacity is lowered in the Fill Layer dialog box, some of the original Background will still be visible. However let's create this appearance another way. We will add a layer between the vignette working layer and the Background layer and then, with the new layer selected in the Layers panel, choose Edit>Fill Layer>Use>White, keeping the Opacity setting at 100%. Once

ORIGINAL IMAGE

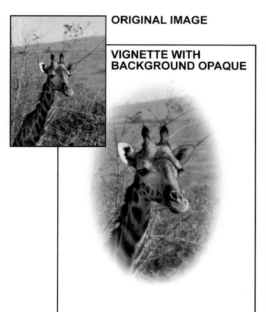

**VIGNETTE WITH
BACKGROUND OPAQUE**

**VIGNETTE WITH BACKGROUND
PARTIALLY VISIBLE**

Figure 10.13 Vignette with an opaque background and vignette with a partially visible background.

we have done that we will lower the Opacity of this layer to 75%. With the guides deleted (View>Clear Guides), these two versions are shown in Figure 10.13. Choose to save one or both versions of this vignette project, then close the file(s).

NOTE▶ When creating a vignette, the radius of the feather required is relative to the resolution of the image. A low resolution image will only need Radius: 20 px to appear the same as a high resolution photograph such as the giraffe with Radius: 50 px applied.

10.10 Adding Shapes to Photographs

All of the work we have done thus far has been with pixel graphics, referred to as bitmap or raster graphics. When enlarged, their individual pixels display. The Editor also provides a variety of shape tools that produce vector graphics that are created mathematically. Because they are not composed of pixels, they remain sharp and crisp when scaled.

Let's open the file named Golden.jpg located in the Practice_Import 17 files folder within the Practice Files folder you copied to your hard drive, then save this file as Golden.psd. The Shape tools are located in the Draw section of the Expert mode and include a Custom Shape tool, a Rectangle tool, a Rounded Rectangle tool, an Ellipse tool, a Polygon tool, a Star tool, a Line tool, and a Shape Selection tool. When applying a Shape tool, the shape drawn is created on a new layer by default. When the active Shape tool is selected in the Tools panel, the Tool Options bar updates to provide access to all of the Shape tools. When a specific Shape tool is then selected from it, the unique settings of the chosen tool such as assigning the number of points for a star or the radius of the corners of a rounded rectangle, etc., become active in addition to the following features available for all of the Shape tools:

SET COLOR FOR NEW LAYER: Assigns a color for the shape drawn.

STYLE: Adds a layer style to the shape.

ADD TO SHAPE AREA, SUBTRACT FROM SHAPE AREA, INTERSECT SHAPE AREAS, EXCLUDE OVERLAPPING SHAPE AREAS: Allows multiple shapes to be added to the same layer with additional options to subtract, intersect, and exclude some of their content.

SIMPLIFY: Converts a vector graphic into a bitmap/raster graphic.

Let's select the Custom Shape tool. Once we have done that, the Custom Shape Picker in the Tool Options bar provides a down arrow to access a drop down menu of default clip art shapes, along with a variety of categories of shapes including one named All Elements Shapes, which will display every custom shape available in the

Editor. With its Default category active, let's select the Heart Card shape, then assign the settings shown in Figure 10.14 (Color: RGB Red, Styles: Bevels>Simple Inner, Set Geometry Options: Fixed Size>W 1 in, H 1 in, From Center checked).

Let's add a small heart to the right of the dog's nose. We can see, once it is added, that it appears in the Layers panel on its own layer, that it contains a small square in the lower right corner of the layer thumbnail identifying it as a shape layer, and that it displays the *fx* indicating that it has a style applied to it. We will add two more hearts created the same way, one with Fixed Size>W .5 in, H .5 in, and one with Fixed Size>W .75 in, H .75 in. Shape layers can be transformed. Select each layer one at a time, choose Image>Transform Shape>Free Transform Shape, then manually rotate as desired.

Figure 10.14 Assigning settings for the Heart Card Custom Shape tool in the Tool Options bar.

With the Custom Shape tool still active in the Tool Options bar, we will select the Bone shape from the Animals category of the Custom Shape Picker, with Color: Black, Styles: Bevels>Simple Inner, Set Geometry Options: Unconstrained, From Center unchecked. Press and drag to create a couple of bones to the left of the dog's head, then rotate and scale them as desired, with the resulting hearts and bones resembling those shown in Figure 10.15.

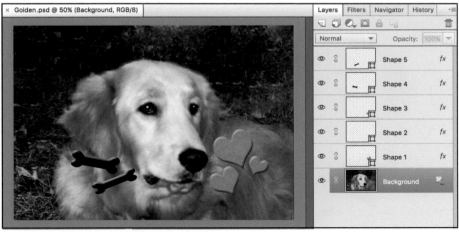

Figure 10.15 Adding custom shapes to an image.

NOTE In order to apply a gradient or a filter to a shape layer, the vector shape must first be converted to a bitmap/raster graphic, referred in the Editor as "simplified." When a shape layer is selected, the Simplify Layer command can be chosen from the Layer menu or the Layers panel menu, or, if the layer is selected and the Tool Options bar currently displays the Shape tools, the Simplify button can be single clicked to rasterize the layer. If you attempt to apply a gradient or filter without first simplifying the layer, the Editor will prompt you that the layer must first be simplified/rasterized and offer to convert the layer for you.

10.11 Creating a Clipping Mask

A clipping mask does just as its name implies: it "clips" layer content to fit within the shape of a chosen "mask" below it. Because the Shape tools create vector graphics with crisp edges, they work great for creating clipping masks.

With the Golden.psd file still open, we will select the Background layer, then with the Custom Shape tool active in the Tool Options bar choose Crop Shape 29 from the Custom Shape Picker. With the Set Geometry Options assigned to Unconstrained and From Center checked, we will press and drag to create the heart shape across the dog's head. When the layer is active in the Layers panel, the shape's location can be tweaked using either the Shape Selection tool or the Move tool, with its size adjusted by choosing Image>Transform Shape>Free Transform Shape if needed.

The masking shape layer must be *below* the clipping content layer; we will want to clip the dog to fit inside the Crop Shape 29. To do that, let's double click on the Background layer to convert it to a regular layer, then drag it directly *above* the Crop Shape 29 layer in the Layers panel stacking order. To apply the clipping mask, we will choose Layer>Create Clipping Mask or, alternatively, Right/Control click the dog layer and choose Create Clipping Mask from the context-sensitive menu that appears. The thumbnail for this layer becomes indented in the Layers panel, with an arrow icon indicating that it has been clipped to the masking layer below it. To fill

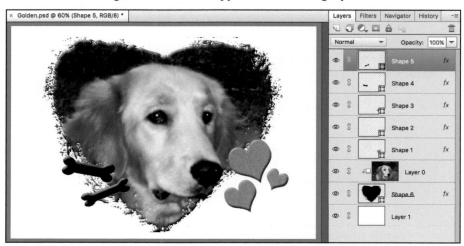

Figure 10.16 Clipping mask created using the Crop Shape 29 custom shape with a background fill layer added below it.

the transparent area created by the mask, we will add one more layer, drag it *below* the masking layer, choose Edit>Fill Layer, and fill it with the color of your choice, as shown in Figure 10.16; then save and close the file.

Another quick and easy way to apply the Create Clipping Mask command is to hold down the Alt/Option key and place the pointer over the border between the clipping content layer and the masking shape layer. When a down arrow with a box icon appears, single click to create the clipping mask.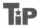

Visibility of the clipped content can be adjusted within the "window" created by the clipping mask shape. To adjust how the dog appears within the heart crop shape, select the clipped content layer (the dog image), then use the Move tool to drag it left, right, up, or down, as desired.

If multiple layers are selected first, when the Create Clipping Mask command is applied to the topmost layer, all of the layers will be clipped to the masking shape below them. To release a clipping mask, select the clipped content layer, then choose Release Clipping Mask from the Layer menu, or Right/Control click on the layer and select Release Clipping Mask from the context-sensitive menu that appears.

NOTE The Shape Overlay Effect available in the Fun Edits category of the Guided Mode utilizes a clipping mask to create its effect, combining it with fill layers that can have their opacity reduced, allowing some of the original image to be visible outside of the masking shape. To create this effect in the Expert mode, simply duplicate the Background layer *first* then create a clipping mask using the steps we have just learned. Once the mask has been applied, the fill layer added below the masking layer can have its opacity lowered, with this effect shown in Figure 10.17 (a drop shadow and a bevel effect were optionally added to enhance the appearance of the clipping mask). The file used to create the sample shown in Figure 10.17 is named Pumpkin.jpg and has been provided in the Practice_Import 17 files folder within the Practice Files folder you copied to your hard drive, if you would like to try this on your own.

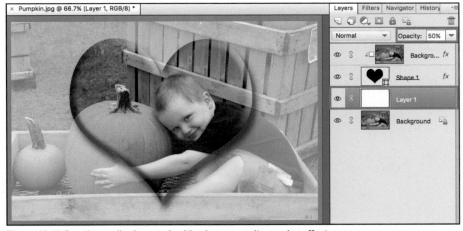

Figure 10.17 Creating a clipping mask with a lower opacity overlay effect.

10.12 Using the Cookie Cutter Tool

Unlike a clipping mask which clips content to be visible only *within* a masking shape, the Cookie Cutter tool *crops* an image in the form of a chosen shape. Although the results appear similar, it will be important for us to learn how these two features differ so that, in your own work, you can select the best method based on your needs and personal preferences.

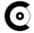

Let's open the file named Ireland.jpg located in the Practice_Import 17 files folder within the Practice Files folder you copied to your hard drive, then save it as Ireland. psd. We will select the Crop tool in the Tools panel of the Expert mode. Once we have done that, the Cookie Cutter tool appears in the Tool Options bar. When we select it, a familiar down arrow menu appears—the Custom Shape Picker. Let's select the Shamrock shape from the Foliage and Trees category. A Set Geometry Options drop down menu and a From Center checkbox are provided, along with the ability to soften the edge of the cropping shape by applying a feather radius to it. The Set Geometry Options menu provides four choices: Unconstrained, Defined Proportions, Defined Size, and Fixed Size. We will select Fixed Size and assign W: 3.5 in, H: 3.5 in, with From Center and Crop unchecked, and Feather: 1 px. Let's single click to create the shamrock crop on the image. Before the commit check mark is clicked, the crop can be moved and rotated as desired to adjust how the image

appears within the shape, as shown in Figure 10.18. At this stage, a mask is visible in the Layers panel; however, unlike when creating a clipping mask, as soon as the check mark is clicked to apply the crop, the mask is gone and the surrounding pixels become permanently removed.

To add color to the transparent areas, we will add a layer and place it below the shamrock layer, then choose Edit>Fill Layer>Use>Color, then assign R: 74, G: 88, B: 52 in the Color Picker. To emphasize the shamrock, we will add the Simple Outer bevel layer style to the shamrock layer, also shown in Figure 10.18.

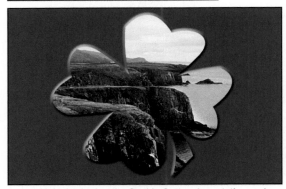

Figure 10.18 Assigning the Cookie Cutter size rotation and placement and applying a bevel and background.

10.12.1 Combining Crop Tools

The Crop tool can be combined with the Cookie Cutter tool. Let's select it now, then assign Show Crop Preset Options: No Restriction and Resolution: 300 ppi. We will press and drag the tool to create an equal distance around the shamrock on all four sides, apply the crop, then stop and save the file.

10.13 Adding the Puzzle Effect

With the Ireland.psd file still open, let's now click the Guided mode tab, then select the Puzzle Effect option from its Fun Edits category.

For step one, three puzzle piece sizes are available; we will choose the Medium option. For step two, we will select the puzzle piece shown in Figure 10.19 (or any puzzle piece you would like within the image using the selection tool provided), then click the Extract Piece button to move it. For step three, we will optionally choose to move the piece closer to its original location. Instead of completing step four, let's click the Next button and choose to finish editing the puzzle in the Expert mode.

We can see in the Layers panel of the Expert mode that several new layers were created above our original background fill and Cookie Cutter crop layers to achieve the puzzle effect, with our single extracted piece active at the top of the stacking order. With it selected, let's choose Image>Transform>Free Transform, then rotate the puzzle piece slightly to enhance its "removed" appearance, as shown in Figure 10.19, then save and close the file.

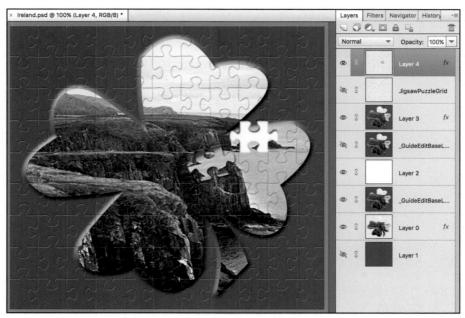

Figure 10.19 Applying the Guided mode Puzzle Effect and editing it in the Expert mode.

10.14 Adding Type for Special Effects

Although text can be added in both the Quick and Expert modes of the Editor, we will learn to add it in the Expert mode. When the Type tool is chosen, the Tool Options bar updates with the type features shown in Figure 10.20:

Figure 10.20 Tool Options bar when the Type tool is chosen in the Tools panel of the Expert mode.

HORIZONTAL TYPE TOOL: Creates horizontal regular text.

VERTICAL TYPE TOOL: Creates vertical regular text.

HORIZONTAL TYPE MASK TOOL: Creates horizontal text in the form of a selection.

VERTICAL TYPE MASK TOOL: Creates vertical text in the form of a selection.

TEXT ON SELECTION TOOL: Allows text to be added around the outside or the inside edge of a selection.

TEXT ON SHAPE TOOL: Allows text to be added around the outside or the inside of a chosen shape.

TEXT ON CUSTOM PATH TOOL: Allows text to be added along a pre-drawn path.

FONT SELECTION: Provides a drop down menu with access to all of the available fonts on your computer.

FONT STYLE: Provides a drop down menu of all of the font styles available for the chosen font on your computer.

SIZE: Assigns a size for the text.

LEADING: Adjusts the distance between lines of text.

BOLD, ITALIC, UNDERLINE, STRIKETHROUGH: Adds an underline or strikethrough to text or creates the appearance of a Bold or Italic style if the chosen font does not provide it.

ALIGNMENT: Assigns an alignment of left, center, or right to the text.

TOGGLE TEXT ORIENTATION: Provides the ability to switch the orientation of the text from horizontal to vertical or from vertical to horizontal without retyping it.

CREATE WARPED TEXT: Provides a drop down menu of warping options for text.

ANTI-ALIASING: Creates type with smooth edges and should always be checked.

Type is created in the Editor as mathematically generated vector type and can be added as point text or paragraph text. When the Horizontal Type tool is single clicked on an image, point text is created, which continues on the same line until the Enter/Return key is pressed to begin a new line. When the Horizontal Type tool is instead pressed and dragged to create a box *first*, paragraph text is created and wraps to fit within the box defined. If more room is needed for the paragraph than the box provides, a plus sign icon appears inside the bottom right corner of the bounding box, indicating that the box must be enlarged for all of the text to display.

10.14.1 Adding Regular and Warped Type

Working in the Expert mode, let's open the file named House of Dragons_Spain. jpg located in the Practice_Import 1 files folder within the Practice Files folder you copied to your hard drive, or locate it in the Organizer, then click the Editor button in the Taskbar if you chose to complete the exercises provided in Part One. We will select the Horizontal Type tool, then single click on the image and type a word or two. With the text highlighted, assign any font you would like, including its size, style, color, and alignment in the Tool Options bar, then click the check mark to commit the type. Color can be chosen from the down arrow menu provided, or by single clicking the foreground color in the Tools panel and assigned using the Color Picker. In the Layers panel, we can see that when text is added to a file, it is added on its own layer and that the layer's name reflects the words typed.

A quick and easy way to highlight text to edit its content is to double click directly on the T icon of the text layer in the Layers panel. If you want to change text attributes such as font and size but do not need to edit its content, select the text layer in the Layers panel, then click the Type tool; the Tool Options bar will update and changes can be made without the need to highlight the text first.

When text is selected and the Type features are active in the Tool Options bar, the Create warped text icon can be clicked to open a dialog box with a drop down menu of text warp styles, each providing sliders for customization. Let's duplicate the original text layer twice, then select one text layer and click the Toggle text orientation icon in the Tool Options bar to change its orientation to vertical type. Once we have done that, we will select the other duplicated text layer, then click the Create warped text icon to apply any style warp you would like to add, as shown in Figure 10.21. The text layer in the Layers panel updates to display the T icon with a curve under it, indicating that it has a warp applied to it. Both the text content and the warp remain editable—the text can be highlighted and changed—or if the layer

is selected in the Layers panel and the Tool Options bar displays type features, the Create warped text icon can be single clicked to reopen its dialog box to change or delete the style applied.

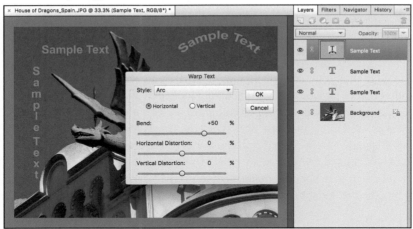

Figure 10.21 Adding horizontal, vertical, and warped text.

10.14.2 Using the Type Mask Tools

Let's choose Revert or use the History panel to return to the opening state of the House of Dragons_Spain.jpg file. We will learn to create text in the form of a selection, working in the Expert mode. Text in the form of a selection (referred to in this book as "image text") can be added into another photograph, added with styles applied to it on top of the original image, or added against a solid background.

10.14.2.1 Adding Image Text Into Another Photograph

When the Horizontal Type Mask tool is single clicked on an image, the image is covered in a red mask, with the text cursor flashing at the font size chosen in the Tool Options bar. The desired size can be assigned before typing, or with the text highlighted changed after typing; however, it *must* be assigned prior to clicking the check mark to apply the changes. Once the check mark is clicked, the text is no longer editable: it is converted to a selection that can be dragged into another open file using the Move tool.

10.14.2.2 Adding Image Text on Top of the Original Photograph With Styles Added

Let's first duplicate the Background layer of the House of Dragons_Spain.jpg file. When text is created using either one of the type mask tools, it is *not* created on its own layer. With the duplicated layer selected and the Horizontal Type Mask tool chosen, let's single click on the House of Dragons_Spain.jpg file, then type "SPAIN" (all caps). We will highlight the text with the Horizontal Type Mask tool, then in the Tool Options bar, assign Font: Arial, Style: Bold, Size: 175 pt, Leading: Auto, Alignment: Center, then click the check mark to commit the type.

As we have learned, once the check mark is clicked, the text is converted to a selection and is no longer editable. However, because our text is now a selection, we can use any selection tool to move it, as well as choose Select>Transform Selection to resize it, either proportionately or by distorting its dimensions if desired. We will choose to move and transform the selection so that it encompasses most of the image inside the letters, add a feather with Radius: 2 px, choose Select>Inverse, press the Backspace/Delete key, then deselect the selection.

The text becomes invisible, until one or more layer styles are added to the image text. With its layer active, we will apply both a drop shadow and a bevel layer style from the Styles panel, with the settings of your choice.

10.14.2.3 *Adding Image Text Against a Plain Background*

If you prefer to see the image text against a solid background, select the original Background layer, then choose Edit>Fill Layer>Use>, then choose a color from the Color Picker or assign one of the default colors in the Fill Layer dialog box, with

both effects shown in Figure 10.22. With the image text applied, close the file, optionally choosing to save one or both versions if desired.

Figure 10.22 Using the Type Mask tool with bevel and drop shadow layer styles applied with the original Background layer visible and filled with a color.

NOTE► This same image text appearance can be accomplished using a clipping mask, with the masking layer created using regular type or warped type. It can also be created in the Guided mode by selecting its Fun Edits category, then selecting the option named "Photo Text."

10.14.3 **Adding Text to a Shape, a Selection, or a Drawn Path**

Three type tools apply text to a path, whether the path is created using a shape, a selection, or a drawn line.

Working in the Expert mode, let's open the file named Pigs.jpg located in the Practice_Import 17 files folder within the Practice Files folder you copied to your hard drive.

10.14.3.1 *Using the Text on Shape Tool*

When the Type on Shape tool is selected in the Tool Options bar, a shape must first be drawn to apply the text to. Let's select the Heart shape, then press and drag across the image to add the shape. Once we have done that, when the type tool is placed

over the edge of the shape, the text cursor appears with a line under it, indicating that, when the mouse is clicked, you will be adding text to the edge of the shape using the type attributes assigned in the Tool Options bar.

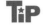

TiP When drawing the heart shape to apply the text onto, if the Shift and Alt/Option keys are both held down when the shape is drawn, its proportions will be constrained and it will be drawn from the center outward.

The type can be added inside or outside the shape. When the text layer is selected in the Layers panel, the side and position of the text on the shape can be adjusted using the Shape Selection tool (grouped with the Shape tools). When the tool is placed over the active text path, the text cursor with a small arrow on its side will appear; it can be dragged to flip the text from the outside to the inside of the shape or from the inside to the outside (its arrow will appear on one side or the other, depending on the direction of the text). To move the starting point of the text, drag the small "X" that appears; to adjust the ending point when more room is needed for all of the text to display, drag the small "circle," as illustrated in Figure 10.23. The sample shown in Figure 10.24 was created with Font: Arial, Style: Bold, Color: RGB Red, Size: 30 pt, Alignment: Left, with a bevel layer style applied to the text layer.

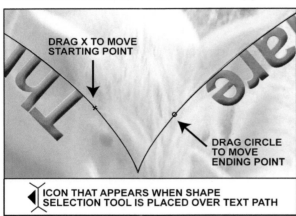

Figure 10.23 Moving the starting and ending points of text on a path; icon when the Shape Selection tool is placed over a text path.

10.14.3.2 Using the Text on Selection Tool

When the Text on Selection tool is chosen, a selection is first drawn to attach the text to, using the Text on Selection tool. The selection is created first by pressing and dragging inside the shape you want to type around, with the tool's selection method replicating that of the Quick Selection tool. Add and Delete icons provided in the Tool Options bar help to create a more accurate selection. An Offset slider allows the path to be expanded slightly beyond the shape being selected. Once you are satisfied with the path and the commit check mark is clicked, the selection becomes converted to a path to type on. The text curser will display the line under it, indicating you will be typing on a path, and can be clicked anywhere along the edge of the path to begin adding text to it. The text can be moved along the path using the Shape Selection tool, as shown in Figure 10.23. In the Text on Selection sample shown in Figure 10.24, a selection was made of only the pig in the top left area of the image, with the type added using Font: Arial, Style: Bold, Color: RGB Red, Size: 36 pt, Alignment: Left, with a drop shadow layer style added to the text layer.

10.14.3.3 Using the Text on Custom Path Tool

When the Text on Custom Path tool is selected in the Tool Options bar, a pencil icon appears to draw the path for the text to be applied to. It is helpful when using this path tool to limit the complexity of the line drawn. The beginning and ending points for the text can be adjusted using the Shape Selection tool, as shown in Figure 10.23. The Custom Path sample also shown in Figure 10.24 was created using Font: Arial, Style: Bold, Color: RGB Red, Size: 36 pt, Alignment: Left, with the Wow Neon Red Off layer style added to the text layer.

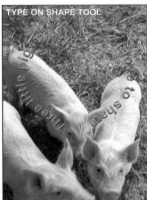

Figure 10.24 Creating type on a shape, a selection, or a custom path.

NOTE▸ When path text is created using the Text on Selection tool or the Text on Custom Path tool, the path is composed of connecting points. Oftentimes there are extra points generated which can make the added text twist to try to follow the path and become hard to read. If text has been added to a selection or a drawn path, when the Text on Custom Path tool is selected, its Modify tool can be used to eliminate some of these points. Magnify in and select the layer with the text path. When the Modify tool is chosen in the Tool Options bar and the Alt/Option key is held down, its icon displays a minus sign, allowing you to then single click on the points to delete, as shown in Figure 10.25.

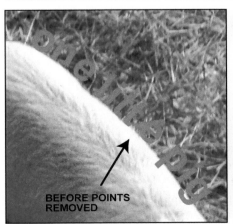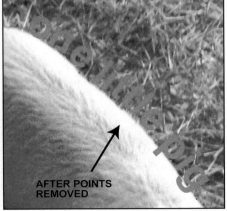

Figure 10.25 Removing points to create a smoother text path using the Modify tool.

Because text is vector type, if you choose to add a filter or a gradient to it, the Editor will prompt you that the text must first be simplified/rasterized. If you choose to accept the prompt, the Editor will rasterize the text for you; however, because it will be converted into image pixels, it will no longer be editable. Alternatively, you can select the type layer, then choose Layer>Simplify Layer or select Simplify Layer from the Layers panel menu. Feel free to recreate and save one or more of these type path samples before closing this file.

10.15 Creating a Double Exposure

This Guided mode effect combines two images into one. Let's select the Guided mode, then choose Open to locate the file named Favory.jpg provided in the Practice_Import 2 files folder within the Practice Files folder you copied to your hard drive (alternatively, if you completed the exercises in Part One, select the file in the Organizer, click the Editor button in the Taskbar, then select the Guided mode). Once the image displays in the Photo Bin, we will select the Fun Edits category, then choose the Double Exposure option.

Step one allows us to crop the photograph if needed; however, we will skip this step and proceed to step two. The head of the horse must be selected, as our double exposure image will be placed inside of it. The Quick Selection tool option provided will work well, allowing us to add or delete from our selection as needed for accuracy. We will want to be sure to also delete the area between the reins and

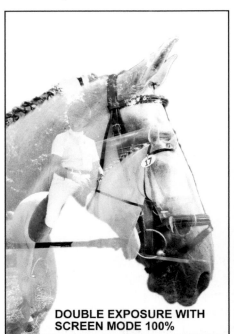
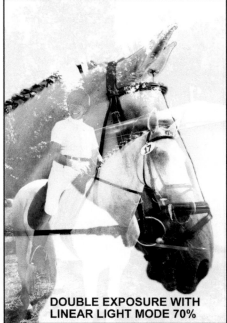

Figure 10.26 Creating a double exposure in the Guided mode with its effect altered in the Expert mode.

the horse's head/neck area when making our selection. Once we have created our selection, we can optionally add a feather with Radius: 5 px to soften the outer edge of the selection while still in the Guided mode, by Right/Control clicking on the selection and choosing Feather from the context-sensitive menu that appears. To import the second photograph for step three, we will select the Rider.jpg image located in the Practice_Import 4 files folder within the Practice Files folder you copied to your hard drive. An Intensity slider is provided to lower the visibility if desired, but we will keep the default slider setting of 100. This image contains the exact same dimensions and resolution as the Favory.jpg image, so it will not be necessary to apply step four that allows us to reposition this photograph within the masked shape. Step five optionally adds colors to the double exposure; we will skip this step as well.

The double exposure has been created; however, let's click the Next arrow, then Continue Editing>In Expert to examine the image in the Expert mode. When the Layers panel is selected, we can see that the double exposure effect was created using duplicated layers with blending modes applied. The specific blending modes assigned can be changed, deleted, or their layer opacity reduced. For example, if the Screen mode layer is selected and the blending mode is changed from Screen to Linear Light with its layer Opacity: 70%, more of the original image displays, with both effects shown in Figure 10.26. Feel free to keep the default blending mode settings created by the Guided mode for this double exposure, or use the Expert mode to customize them to your liking, then save and close the file.

10.16 Creating Speed

Although capturing speed with a camera takes practice, the effect of panning and motion can be easily and convincingly created in the Guided mode.

10.16.1 Using the Guided Mode Speed Pan Option

Panning is a photographic technique in which the camera follows the moving subject, so that the subject remains clear but everything else becomes blurred by the movement.

With the Guided mode active, let's choose Open, then locate the file named Speed.jpg in the Practice_Import 17 files folder within the Practice Files folder you copied to your hard drive. Once it has been added to the Photo Bin, we will select the Fun Edits category, then the Speed Pan option.

Before beginning our edit, we will save the file as Speed.psd. This photograph was taken of a car stopped by the side of the road. For step one, the car must be selected using the Quick Selection tool provided. Options for adding, subtracting, and assigning the brush size will help us to create an accurate selection of the car. When step two, Add Motion Blur, is clicked, we can assign the "speed" and direction by dragging its Intensity slider and adjusting the angle of the speed if needed. Choose to

increase the speed any amount, keeping the default angle. We can see that the motion is applied to everything except our selected area. Step three allows us to tweak the application if needed.

Once applied, let's click the Next button, then choose to further edit our effect in the Expert mode. It will be more convincing if the wheels appear to be spinning. We can see that a layer was added, with a layer mask applied to protect the car from the application of the blur. With the image thumbnail of this layer selected—*not* the

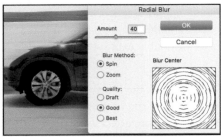

Figure 10.27 Adding a Radial Blur to wheel rims in the Expert mode.

mask thumbnail—let's select the front wheel rim using the Elliptical Marquee tool, apply a feather with Radius: 1 px, then choose Filter>Blur>Radial Blur. We will assign Amount: 40, Blur Method: Spin, Quality: Good, as shown in Figure 10.27, then click OK to apply the blur. Once we apply the same blur to the rear wheel rim, our motion becomes even more convincing.

Once the pan has been applied and the image is opened in the Expert mode, if parts of the car have not been accurately selected, select the mask thumbnail, then using the Brush tool and the default colors in the Tools panel, you can add or subtract from the car mask as needed.

10.16.2 Adding the Guided Mode Speed Effect Option to the Speed Pan Effect

We have created panning, but let's have some more fun with speed effects. With the radial blur added to the wheels of the car, let's return to the Guided mode, then select the Speed Effect option of the Fun Edits category to add it to the car image.

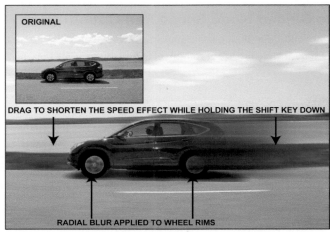

Figure 10.28 Speed Pan and Speed Effect options applied in the Guided mode, with a radial blur applied to the wheel rims in the Expert mode.

We will again need to select the car, then click the Add Speed Effect, with Increase/Decrease and Angle options available; however, we will keep the default application. The critical step for realism when adding this effect is the Add Focus Area button in step three. This will control the

application using a gradient mask. We will want to hold the Shift key down as we drag the left and right sides of the blur inward to reduce its length and positioning until it looks natural. The Refine Effect button can help if needed with the results of combining these two speed effects, shown in Figure 10.28. With both the panning and speed effects applied, save and close the file.

10.17 Creating a Panoramic Image Using the Guided Mode

A panoramic image can be created using the Guided mode to combine two or more photographs.

10.17.1 Taking Photographs for a Panoramic Image

The Editor combines your multiple photographs into one composite image. When taking your photographs for a panorama, the following tips will help:

- Overlap the images you take by 20 to 40%.

- Use a tripod to keep the camera steady as you rotate to take the multiple overlapping images.

10.17.2 Using the Photomerge Panorama Option of the Guided Mode

A panorama is created in the Guided mode using source files that must be opened first. The images we will use are located in the folder named Panorama Images in the Practice_Import 17 files folder within the Practice Files folder you copied to your hard drive. We can open them first then choose the Guided mode, or in the Guided mode click its Open button then locate them. Once the images have been added to the Photo Bin, Shift-click to select them then choose Photomerge>Photomerge Panorama. (In your own work, if the images you want to create a panorama with have been added to the Organizer, you can Shift-click to select them in the Organizer, then choose Edit>Photomerge>Photomerge Panorama.)

In the Guided mode Photomerge Panorama panel that opens, six layout styles are available for how we want the panorama created; we will choose Auto Panorama, which usually works well. Below this menu, a Settings down arrow menu provides options for combining the images:

BLEND IMAGES TOGETHER: Adjusts borders and colors to smoothly blend the images together.

VIGNETTE REMOVAL: Corrects for edges of images that may be darker than the main content.

GEOMETRIC DISTORTION CORRECTION: Corrects distortions from a camera lens.

CONTENT-AWARE FILL TRANSPARENT AREAS: Fills transparent areas automatically for you using neighboring content and the Content-Aware technology.

Let's click the Blend Images Together and Vignette Removal checkboxes, then click the Create Panorama button at the lower right of the Photomerge Panorama panel.

NOTE ▶
When creating a panorama using your own images, try each layout option to determine which one generates the best panorama based on your images. It will also be helpful to create one with and one without the Geometric Distortion Correction setting checked, to see which setting renders the most natural panorama.

The Content-Aware Fill Transparent Areas feature can be checked here or assigned later in the Clean Edges dialog box that appears when the Editor is assembling the panorama. Although choosing to have the Editor automatically fill any transparent areas for us is quick and easy, we will not select this option, so that we can have more control over *how* the areas are filled and *how* the final image is cropped. In your future work, try both ways. Depending on the images used, in some instances the automatic fill option will work great, while other times you will want user control to crop, rotate, and fill the resulting panoarama as needed.

The Editor applies masks to each photograph layer as needed to seamlessly create the panorama. Because we chose not to fill the transparent areas, when the Clean Edges dialog box prompts us to fill them, we will choose No. Once the panorama has been created, we will select to further edit it in the Expert mode. Here we can see the multiple images as individual masked layers in the Layers panel. We will select

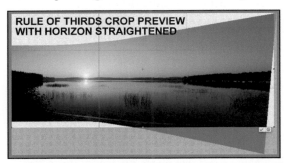

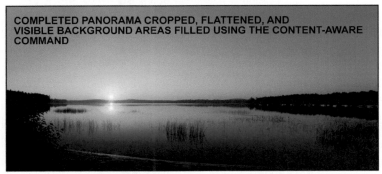

Figure 10.29 Crop preview straightened and adjusted for the Rule of Thirds and final panorama with visible background areas filled.

the Crop tool, then in the Tool Options bar assign Show Crop Preset Options: No Restriction and Resolution: 300 ppi. Because we chose not to autofill the transparent areas, we can crop to apply the Rule of Thirds and straighten the panorama (when needed) at the same time, as shown in Figure 10.29. Once the crop has been applied, the file must be flattened. To fill the background areas visible in the flattened file, creating selections and then applying the Edit>Fill Selection>Use>Content-Aware command will work great; the completed panorama is also shown in Figure 10.29.

PRACTICE MAKES *PERFECT* ✓

Chapter Ten has been an exciting introduction to many special effects. Feel free to reinforce some of these effects in the practice projects provided before proceeding to Chapter Eleven.

PRACTICE PROJECT 1

1. Working in the Guided mode, single click the Open button, then select the three images provided in the folder named Panorama Practice located in the Practice_Import 17 files folder within the Practice Files folder you copied to your hard drive.

2. Shift-click to select the three images in the Photo Bin, choose the Photomerge category, then the Photomerge Panorama option.

3. In the Photomerge Panorama panel, choose Auto Panorama and Blend Images Together, leaving the additional settings unchecked. In the Clean Edges dialog box that appears, choose No.

4. Once the panorama has been created, choose to edit it in the Expert mode.

5. Select the Crop tool and then, in the Tool Options bar, assign Show Crop Preset Options: No Restriction and Resolution: 300 ppi. In the Crop tool preview, straighten the panorama, shift the horizon line, and adjust the crop dimensions to minimize the transparent areas, as shown in Figure 10.30.

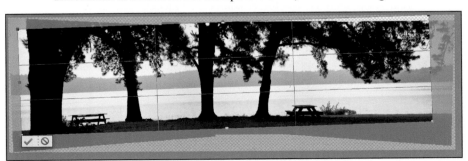

Figure 10.30 Rotating and adjusting the horizon line in the Crop tool preview.

6. Flatten the file, then fill the background exposed areas using the Edit>Fill Selection>Use>Content-Aware command.

7. Choose Filters>Artistic, then apply the Neon Glow filter with the settings shown in Figure 10.31 (Glow Size: 10, Glow Brightness: 30), click the color field to access the Color Picker to assign R: 61, G: 102, B: 236, then click the check mark to apply the filter.

Figure 10.31 Neon Glow filter applied to the panorama.

8. Select the Horizontal Type tool, then, in the Tool Options bar, assign Font: Arial, Style: Bold, Color: White, Size: 72 pt, Alignment: Left, then type "MASSABESIC LAKE" (all caps).

9. Use the Move tool to position the text in the lower right area of the water, apply the Noisy drop shadow from the Drop Shadow category of the Styles panel, as shown in Figure 10.32, then save and close the file.

Figure 10.32 Completed panorama with the Neon Glow filter, text, and drop shadow applied.

PRACTICE PROJECT 2

1. Working in the Expert mode, open the file named Africa.jpg located in the Practice_Import 17 files folder within the Practice Files folder you copied to your hard drive.

2. Duplicate the Background layer, then with the original Background layer active in the Layers panel, select the Africa Map background from the Background category of the Graphics panel.

3. Choose to display the rulers (View>Rulers), then add horizontal guides at 1" and 6", and vertical guides at 1" and 4".

4. Select the duplicated layer, then use the Elliptical Marquee tool to draw an oval within the guides added, using the Select>Transform Selection command if needed to refine the size and shape of your selection.

5. Apply a feather to the selection with Radius: 50 px, choose Select>Inverse, press the Backspace/Delete key, then deselect the selection.

6. Clear the guides added (View>Clear Guides).

7. Select the Horizontal Type tool, then assign Font: Arial, Style: Bold, Color: R: 168, G: 176, B: 136, Size: 72 pt, Alignment: Center, then type "AFRICA" (all caps).

8. With the text selected, choose Create warped text, then assign Style: Arc, Horizontal Bend: +30%, Horizontal Distortion: 0%, Vertical Distortion: 0%.

9. With the Horizontal Type tool still selected, type "ADVENTURES" (all caps), then assign Font: Arial, Style: Bold, Color: R: 168, G: 176, B: 136, Size: 36 pt, Alignment: Center.

10. With the text selected, choose Create warped text, then assign Style: Arc, Horizontal Bend: –20%, Horizontal Distortion: 0%, Vertical Distortion: 0%.

11. With the ADVENTURES text layer still selected in the Layers panel, apply the Soft Edge drop shadow from the Styles panel, then in the Style Settings dialog box assign Size: 25 px, Distance: 15 px, Opacity: 75%. Click the checkbox to also add the Bevel style, then assign Size: 5 px, Direction: Up, as shown in Figure 10.33.

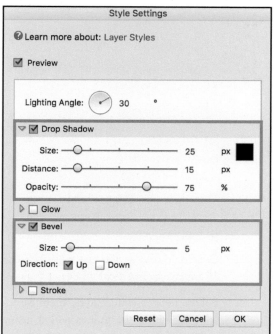

Figure 10.33 Adding and customizing the drop shadow and bevel for the ADVENTURES text.

12. Select the AFRICA text layer in the Layers panel, apply the Soft Edge drop shadow from the Styles panel, then in the Style Settings dialog box assign Size: 42 px, Distance: 20 px, Opacity: 75%. Click the checkbox to also add the Bevel style, then assign Size: 10 px, Direction: Up.

13. Select each text layer one at a time in the Layers panel, then use the Move tool to position the text as shown in Figure 10.34, then save and close the file.

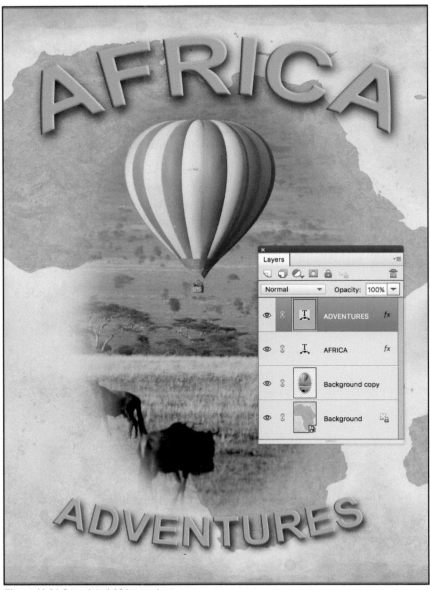

Figure 10.34 Completed Africa project.

11

Creating Projects and Sharing Photographs

- **Produce a slide show including customized audio and edited video**

- **Create and print picture packages and contact sheets**

- **Learn how to share your photographs and projects on social media**

- **Examine file exporting and web graphic optimizing options**

This chapter will explore some of the options of the Create menu that focus on sharing your photographs with your family and friends. When creating projects such as a photo collage and a Facebook cover, we will enhance them in the Expert mode resulting in professional, polished, and personalized photographs and projects you will be proud to view, print, and share on social media.

NOTE Some of the Create and Share commands we will explore in this chapter are only available in the Organizer, with others only available in the Editor. If you have not been using the Organizer module in your work with this book thus far, note that when a file is opened in the Editor that requires the Organizer for its completion, the Organizer will be launched and the file will be opened in it. Chapter One can help you become comfortable within the workspace of the Organizer module now if needed.

11.1 Create Menu in the Organizer and the Editor

In the Editor module, when we single click on the word "Create" or its down arrow above the Panel Bin, we can select a project option from the list. The Organizer's Create menu contains these same options, plus four more: Instant Movie, Video Story, Video Collage, and DVD with Menu, which each require Adobe Premiere Elements to complete them. Using the Create menu, we will produce a slideshow, explore additional print options, build a photo collage, and create a Facebook cover.

11.2 Producing a Slideshow

If you completed Chapters One and Two, you learned that when working in the Organizer, when media thumbnails are selected and then the View>Full Screen command is chosen, a slideshow is created which includes transitions and audio. However this type of slideshow is only for viewing selected media on your hard drive. To produce a savable, exportable, and shareable slideshow, we will use the Create>Slideshow option.

11.2.1 Choosing the Create>Slideshow Option

The Create>Slideshow option uses the Organizer to generate a slideshow. If you are working in any mode of the Editor, when open images are multiselected in the Photo Bin and the Create>Slideshow option is chosen, a message will appear that the Elements Organizer workspace is loading. Once the Organizer is open, the slideshow will be created from the pre-selected images, and the images will be added to the Organizer's active catalog if they were not previously imported into it. However, even if no images are open when working in the Editor, we can still choose Create>Slideshow and the Organizer will open in its Media view. We can create a slideshow three ways: from the Auto Curate option, from all of the media in the active catalog, or from selected media.

11.2.2 Producing a Slideshow Using Auto Curate or Using All Media in the Active Catalog

If no thumbnails have been pre-selected when the Create>Slideshow option is chosen from the Create menu in the Organizer, the message shown in Figure 11.1 will appear, asking if we would like a slideshow produced for us using the Auto Curate's

"Pick the best" method. If this button is clicked, the Organizer's Auto Curate technology selects the media to use and generates a slideshow. Alternatively, we can choose Use all media. If this option is selected, all media in the active catalog will be used to produce a slideshow.

Figure 11.1 Auto Curate Create Slideshow dialog box.

A copy of each figure shown in this chapter can be viewed in the companion files included with this book.

11.2.3 Producing a Slideshow From Selected Media in the Active Catalog

To produce a slideshow using only selected media when working in the Organizer, they are chosen prior to assigning the Create>Slideshow option. We will create a slideshow using seven images (with the sRGB color profile assigned for on screen viewing) and an .mp4 video clip provided in a folder named "Slideshow with video" located inside the Practice_Import 18 files folder within the Practice Files folder you copied to your hard drive. We will add them by choosing File>Get Photos and Videos>From Files and Folders, or choose Import>From Files and Folders, then locating the folder, or by simply selecting the folder, then dragging and dropping it with the pointer into the Organizer's Media view pane. The imported media appear as thumbnails in the Last Import view. We can select all of them here, then choose Create>Slideshow, or alternatively if they are added to the All Media pane, press and drag the pointer across them to select all of the thumbnails (or click to select the first one, then Shift-click to select the last one), then choose Create>Slideshow.

When media is selected in the Organizer, a slideshow can also be created by single clicking the Slideshow button in its Taskbar or by Right/Control clicking any one of the selected thumbnails, then choosing Create a Slideshow from the context-sensitive menu that appears.

11.2.4 Customizing the Features of a Slideshow

Once Create>Slideshow is chosen, a slideshow is generated and immediately begins to play using default settings, with three buttons provided to customize it: Media, Themes, and Audio.

11.2.4.1 Choosing a Theme

Let's click the Themes button first to select a different theme for the slide show. Six themes are provided; we will choose the Pan & Zoom theme, then click the Apply button provided below the list. Once we have done that, the slideshow updates with a new opening slide design and audio track, both of which we will learn to customize.

11.2.4.2 *Choosing Media*

Let's click the Media button to enter its editing mode. Here the sequence of the slides can be changed. To move a slide, single click to select it first, then press and drag it with the pointer to the new location (a line will appear between the slides to indicate

where the slide will be inserted when the pointer is released). If a slide needs to be rotated, Right/Control click the slide and choose Rotate Clockwise or Rotate Anti-clockwise from the context-sensitive menu that appears. We will change the appearance of the opening slide and the wording by Right/Control clicking on it and choosing Edit from the context-sensitive menu that appears. Once we do that, left and right arrows provide access to additional background designs and text fields to change the title and subtitle. We will keep the original background but change the title to "Franconia Notch" and the subtitle to "New Hampshire." Above the editing area on the right, a checkbox allows captions to be added and two buttons provide further customization of the slideshow: Add text slide and Add photos and videos as shown in Figure 11.2.

Figure 11.2 Customizing the opening text slide and adding media to an existing slideshow.

Instead of choosing the Add text slide button, let's add one more slide with text already applied to it. We will single click the Add photos and videos button, then select the Add Photos and Videos from Folders option to locate the file named Franconia 7a.jpg inside the Practice_Import 18 folder, then click Get Media to add it to the slideshow.

The Franconia 7a.jpg file was created in the Editor by adding a layer above the default Background layer, filling it with white, lowering its opacity, and then adding a text layer above it. In your own work, an alternative to using one of the opening text slides the theme provides is to create your own text slides to further customize your slideshows if desired. The opening text slide and any text slides you would like the slideshow to include can be created in the Editor and imported with the rest of your slideshow media. To delete the default theme opening text slide, Right/Control click on it, then select Remove from the context-sensitive menu that appears.

Once the Franconia 7a.jpg file has been added to the slideshow, adjust the sequence of the slides, as shown in Figure 11.3. The video should be the last slide, identified by a small filmstrip icon in its top right corner.

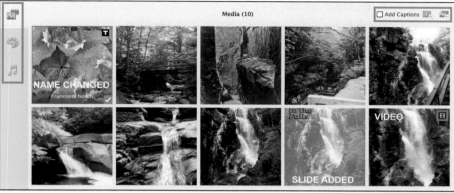

Figure 11.3 Customizing the text on the opening slide, changing the slide sequence, and adding a slide.

11.2.4.3 Editing Video

Video clips that have been added to a slideshow will play the first ten seconds by default when the slideshow runs; however, their play time can be edited. Once the Media button is clicked, when we Right/Control click on the video thumbnail, three options appear: Trim Video, Remove, and Mute Audio track. Let's choose the Trim Video option to open the video clip in a special editing dialog box. Above its preview on the right a Mute Audio track checkbox provides another way to mute the video audio if desired; we will keep it unchecked. Below the preview a timeline displays the default playing duration of 00:10 seconds. Let's drag the ending marker to the right, watching the duration extend as we do that, until the time displayed at the right reads "00:00/00:12," as shown in Figure 11.4. Although we will keep its default starting point, the starting marker can also be dragged to begin playing at a different

Figure 11.4 Editing a video imported into a slideshow.

location on the timeline. We can see that a slider is also provided to adjust the volume of the video. We will choose not to lower it, allowing it to play at its original recorded volume level. Once we have adjusted the playing time, we will click the Done button to exit the Trim Video dialog box.

11.2.4.4 *Choosing Audio Tracks*

When a slideshow theme is selected, its default .mp3 audio track plays during the slideshow. This music can be changed to a different track supplied in the Organizer (or an .mp3 track located on your hard drive), it can be deleted, or it can have additional audio tracks added as needed based on the length of the slideshow.

Let's single click the Audio button to enter the Audio dialog box. The six tracks provided with the slideshow themes display, including their durations, along with the additional free audio tracks provided by Adobe that were imported when the active catalog was created. Play buttons to the left of each track allow us to preview the selected music. The Add Audio button can be single clicked to locate a track you have saved on your hard drive. Let's change the default audio track. We will first click the minus symbol to delete the Captainzero track in the Selected Tracks

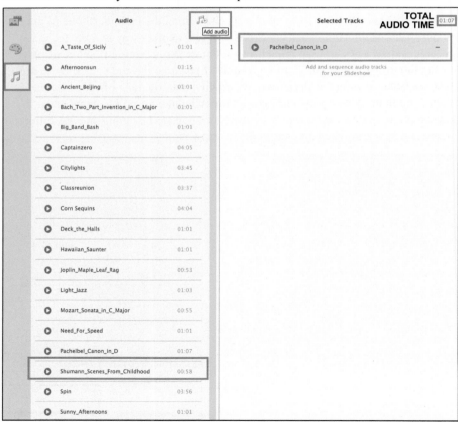

Figure 11.5 Selecting an audio track for a slideshow.

column. With the Captainzero track deleted, we will select the Pachelbel_Canon_in_D track from the Audio list on the left and single click its plus sign to add it to the Selected Tracks column on the right, as shown in Figure 11.5. Although this one track will work perfectly for us, additional tracks can be selected and added to the Selected Tracks column, with the time of all combined tracks displaying above it. When two or more tracks have been added to the Selected Tracks column, the playing order can be changed by selecting a track and pressing and dragging it with the pointer above or below another track on the list. Once we have assigned the new audio track, we can select the Themes or the Media button to edit either one of them. Because no other edits are needed, we will click the Audio button again to toggle and close its dialog box, or alternatively click anywhere on the slideshow window to exit the audio dialog box and return to the slideshow.

11.2.4.5 *Saving and Exporting a Slideshow*

At the top right of the slideshow, two down arrow options are available: Save and Export. When the Save down arrow is clicked, the project can be named and will be saved in the Organizer in the Photo Project Format (.pse). Any Photoshop Elements 2018 project that is saved in this format can be reopened and reworked at any time. Let's choose to save the project as Franconia.pse. Once a project has been saved, Save As can be selected here to save a separate version of the slideshow if desired. To edit a slideshow project that has been saved in the Organizer, double click its thumbnail in the Media view or Right/Control click its thumbnail and select Edit from the context-sensitive menu that appears. When the Export down arrow is clicked, the choices shown in Figure 11.6 appear.

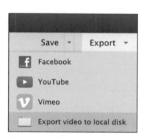

Figure 11.6 Menu options for exporting a slideshow.

NOTE To have the Franconia.pse project display in the Media view of the Organizer, Projects must be checked under View>Media Types.

When either Facebook, YouTube, or Vimeo is selected, the Organizer first converts the slideshow to the required file format, then prompts you to log in to share the video you have created. (The Facebook log in authentication process will be covered later in this chapter.) When the Export video to local disk option is selected, the dialog box shown in Figure 11.7 opens.

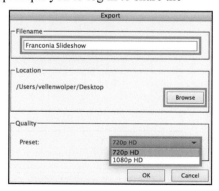

Figure 11.7 Assigning settings when exporting a slideshow to your hard drive.

A name and location to save the video are assigned, along with a quality. The default quality of 720p HD is pre-selected, with the video saved in the .mp4 file format. If the 1080p HD option is selected, a higher resolution video will be created, with a significantly larger file size. Once the OK button is clicked, a dialog box provides the option to also import the exported video into the Organizer. Choose Export video to local disk, browse to choose a location to save the video to on your hard drive, select a quality setting, click the OK button, then locate and play it if desired.

11.3 Additional Printing Options

When Photo Prints is selected from the Create menu in either the Organizer or the Editor, three options become available: Local printer, Picture Package, and Contact Sheet. Local printer will open the same dialog box that opens when File>Print is selected, with its settings covered in Chapter Three.

NOTE▶ Because the steps to create a Picture Package and those required to create a Contact Sheet are unique to the operating system they are generated in, their execution will be covered separately for Windows and for Mac OS. Feel free to skip to the sections applicable to your work environment.

11.3.1 Creating a Picture Package in Windows

If a thumbnail is selected in the Organizer, choosing File>Print or Create>Photo Prints>Picture Package will open the dialog box shown in Figure 11.8. If Create>Photo Prints>Picture Package is chosen when an image is open in the Editor, a message will appear that the Organizer workspace is loading. Once it has finished,

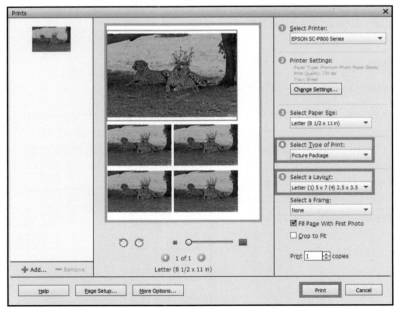

Figure 11.8 Creating a picture package in Windows.

the selected photograph will appear in the print dialog box with the Select Type of Print drop down menu already set to Picture Package.

Whether opened through the Organizer or through the Editor, once the Picture Package option is selected, the desired combination of prints can be selected from the Select a Layout drop down menu. The checkbox to Fill Page With First Photo will be pre-selected by default. Additional options include adding a frame pattern, Crop to Fit, and number of copies. If multiple images were selected in the Organizer when this option was chosen, or additional images were open in the Editor, they will be shown in the Add/Remove column. When the Print button is clicked, the package is printed.

11.3.2 Creating a Picture Package in Mac OS

In Mac OS, the Picture Package option is executed in the Editor. If a thumbnail is selected in the Organizer and then Create>Photo Prints>Picture Package is chosen, a dialog box will alert you that the feature is available in the Editor and ask if you want to continue. When you choose Yes, the Editor will open with the selected image in the Picture Package dialog box. If you are working in the Editor, the feature can be accessed by choosing File>Picture Package or Create>Photo Prints>Picture Package. When selected from the File menu, you can choose Source, then locate a file to use. If selected from the Create menu, at least one image must already have been added to the Photo Bin prior to choosing the command.

Once the Picture Package dialog box is open, the source to print is selected from the Source Images>Use drop down menu. Once the file appears, the Page Size, Layout

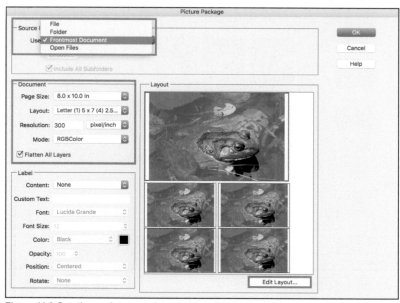

Figure 11.9 Creating a picture package in the Editor in Mac OS.

(select the combination desired from the drop down menu provided), Resolution, Mode, and Flatten All Layers options are assigned as shown in Figure 11.9. If desired, a label can be added to each copy and the Edit Layout button can be clicked to customize the zones (sizes) of the images in the package. When the OK button is clicked in the Picture Package dialog box, the package is created and opens in the Edit pane, ready to print.

When the Mac OS picture package is viewed in the Expert mode, each copy of the image has been placed on a separate, named layer in the Layers panel. The file can be saved for future use, and its individual layers can be moved, scaled, copied, or deleted.

11.3.3 Creating a Contact Sheet in Windows

A contact sheet can be initiated either within the Organizer or the Editor; however, in Windows it is created using the Organizer. If working in the Organizer, thumbnails should be selected first, and then the Create>Photo Prints>Contact Sheet option can be chosen. If thumbnails are not selected prior to choosing to create a contact sheet, a dialog box will alert you that all of the photographs in the Organizer will be printed. If one or more photographs are open in the Editor, when the option is assigned either by selecting File>Print and then choosing Contact Sheet from the Select Type of Print drop down menu or by choosing Create>Photo Prints>Contact Sheet, a dialog box will prompt you that the feature is available in the Organizer and launch it if needed. The same print dialog box we have used opens, this time with the Contact Sheet option pre-selected from the Select Type of Print drop down menu. If Crop to Fit is checked, the contact sheet images will be cropped to square thumbnails. The Select a Layout field allows the thumbnails to be larger or smaller based on the

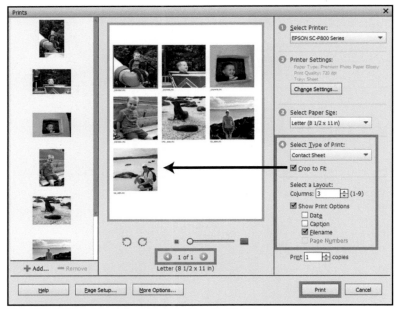

Figure 11.10 Choosing settings for a contact sheet in Windows.

number of columns you define. If more images have been selected than there is room for based on the layout chosen, additional pages will be generated automatically as needed. Information about the thumbnails can be added below each one by selecting the desired checkboxes from the Show Print Options, then the Print button is clicked to print the contact sheet, as shown in Figure 11.10.

11.3.4 Creating a Contact Sheet in Mac OS

A contact sheet can be initiated either within the Organizer or the Editor; however, it is executed through the Editor in Mac OS. If thumbnails are selected in the Organizer and the Create>Photo Prints>Contact Sheet option is chosen, a dialog box will prompt that the feature is available in the Editor and require a confirmation. Once the Yes button is clicked, the Contact Sheet dialog box opens with the Use>Current Open Documents chosen in the Source Images section. If you are beginning in the Editor, the feature can be accessed by choosing File>Contact Sheet II or Create>Photo Prints>Contact Sheet. When chosen from the File menu, the Source Images section provides a drop down menu to select a folder of images from any location or to create a contact sheet from open images. If chosen from the Create menu, at least one image must already be in the Photo Bin prior to choosing the option.

When the Contact Sheet dialog box opens, in addition to selecting the source images, the document size for the layout, its resolution, its color mode, and its thumbnail layout can be chosen. When changes are made to the Columns and Rows fields in the Thumbnails section, the thumbnail layout preview updates dynamically as they are changed. When Use Auto-Spacing is checked, the Editor creates equal distance between the thumbnails in the rows, based on their dimensions. Because the images may vary in orientation, the Rotate for Best Fit checkbox can help maximize the size of the thumbnails based on the layout specifications that are assigned. If desired, the file names can also be added as captions

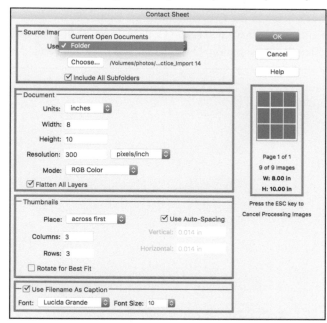

Figure 11.11 Assigning settings for a contact sheet in Mac OS.

that will appear below each thumbnail, using the font and size selected, as shown in Figure 11.11. A document with a default name of ContactSheet-001.psd will be created that can be printed or saved to print later.

NOTE▶ Working in either Windows or Mac OS, once Photo Prints has been chosen from the Create menu, you must click the Cancel button provided below the panel to exit it to return to the Create main menu.

11.4 Building a Photo Collage

Whether the Create>Photo Collage option is chosen in the Organizer or in the Editor, the collage will be built in the Editor. If images have been opened in the Editor or pre-selected in the Organizer before the option is chosen, the Editor will add them into the collage automatically. If no images have been pre-selected when the option is chosen from the Create menu, an empty default collage layout will open that images can be added into.

Let's learn how to build one. For this project, the images located in a folder named "Collage" inside the Practice_Import 18 files folder within the Practice Files folder you copied to your hard drive can be used; however, feel free to use eight photographs of your own instead. A collage can be built for us with the Editor choosing where the images will be placed, or a template can be opened in which we can choose where to place the images. We will explore both options.

11.4.1 Building a Collage Using the Autofill Option

Let's begin in the Expert mode of the Editor, then choose File>Open. Inside the Collage folder we will select Collage 1.jpg, Shift-click to select Collage 8.jpg, then click the Open button. Once the images have been added into the Photo Bin, we will

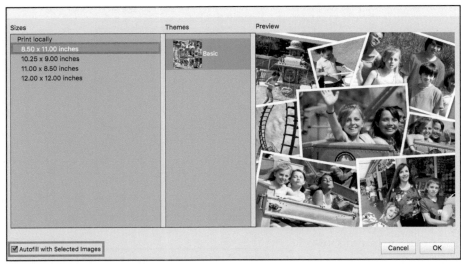

Figure 11.12 Choosing settings for a photo collage.

Shift-click to select them all *first*, then choose Create>Photo Collage. A dialog box opens to select the size we want for the collage; we will choose the default letter size of 8.50 × 11.00 inches, keep the Autofill with Selected Images checked, then click the OK button, as shown in Figure 11.12; the Editor builds the collage for us. Each image can be double clicked to adjust its size within its frame, using the slider that appears, followed by the commit check mark or cancel icon as desired. We can also adjust the image within the frame when we Right/Control click on it, as well as replace it, adjust its rotation, its stacking order, and its style. In the Taskbar, Save and Close buttons appear, as well as an Advanced Mode button at the top left above the edit pane. Let's click the Close button in the Taskbar to delete this collage. In the Save dialog box that opens we will choose Don't Save.

11.4.2 Building a Collage With the Autofill Option Unchecked

Working in the Expert mode of the Editor with the eight images still open in the Photo Bin, let's choose Create>Photo Collage. In the dialog box that opens, we will again choose the default size of 8.50 × 11.00 Inches, but *uncheck* Autofill with Selected Images, then click the OK button to build the collage.

This time a blank collage opens with directions to click to add or drag to add a photo inside each of the eight frames that appear in the layout template. Drag and drop each of the images from the Photo Bin onto the collage in any arrangement that you like. After an image has been added to a frame, you can drag and drop a different image on top to replace it.

We will choose to click the Advanced Mode button to access the features of the Expert mode. Once we have done that and click the Layers panel button in the Taskbar, we can see that each image is part of a layer group, as shown in Figure 11.13. We can customize the layout of the collage by hiding some of these layer groups or deleting them. Let's choose to delete any two layer groups of your choice so that the collage will have only six images instead of eight. When we Right/Control click on a layer group icon and select Delete Group from the context-sensitive menu that appears, a dialog box opens asking if we want to delete the group and its contents or only the group; we will choose Group and Contents, as also shown in Figure 11.13. Now we can

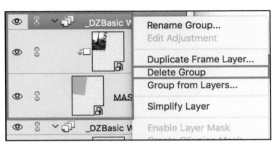

Figure 11.13 Deleting a layer group and its contents from a collage layout.

select each remaining layer group one at a time with the Move tool, collapse the group, then choose to move, scale, or rotate it using the Image>Transform>Free Transform command.

In the Taskbar, the Graphics button provides easy access to change the background of the collage. (To be able to access *all* of the Graphics panel's artwork, we must be in the Advanced Mode.) When a background is selected in the Graphics panel, double click to add it, or drag and drop it onto the collage.

Text can be added to a collage when working in either the Basic or Advanced mode to enhance and personalize it. The sample shown in Figure 11.14 used the default eight-frame collage template, but with two layer groups deleted; the remaining frames were repositioned, transformed, and their content adjusted, with the background pattern changed, the style edited, and text added.

TIP Below the Create menu in the Taskbar, a button is provided named "Layouts." When we single click on it, a variety of additional collage layout templates are available, any of which can be double clicked to substitute for the eight-image template that opens by default. Feel free to try other layouts and select one that best suits your images.

NOTE When a graphic or layout thumbnail has a small blue triangle in its upper right corner, the message "Downloading Content" appears when it is chosen. The triangle indicates that the item is not actually installed on your hard drive; when selected it is downloaded from Adobe.

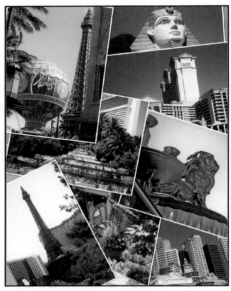

DEFAULT LAYOUT FILLED BY DRAG AND DROP

CUSTOM LAYOUT, WITH TEXT, NEW BACKGROUND, AND DROP SHADOWS

Figure 11.14 Default collage built using selected images and collage customized using images removed and repositioned, with background changed, text added, and drop shadows applied.

When we click the Save button in the Taskbar, the Save As dialog box opens with the file format pre-set to the Photo Project Format (.pse). As we have learned, saving in this file format will allow us to reopen and redesign the project at any time. Choose to save the project if you would like, keeping the Layers option checked, then close the collage.

11.5 Creating a Facebook Cover

NOTE▶ Because Facebook is your social connection to family and friends, complete this project by choosing any two of your own photographs you would like to use, one for the cover image and one for the profile image. The photographs to create the following cover project have not been included with this book.

When the Facebook Cover option is selected from the Create menu in either the Organizer or the Editor, the cover is created in the Editor with all the Facebook sizing and optimization requirements for the images done for us; we just have to have fun adding them. The images we choose can be automatically placed into the cover design for us, or we can choose to position them ourselves. Let's explore both ways.

11.5.1 Creating a Facebook Cover Using Autofill With Selected Photos

Because the cover is created in the Editor, if the option is selected from the Create menu in the Organizer, a message alerts us that the Editor is loading. Although we can create a cover in any mode of the Editor, we will start in the Expert mode, then open the two images we will want to use. Once the images have been added to the Photo Bin, let's choose Create>Facebook Cover. A dialog box opens with a variety of theme templates using one or multiple images. When a theme is selected from

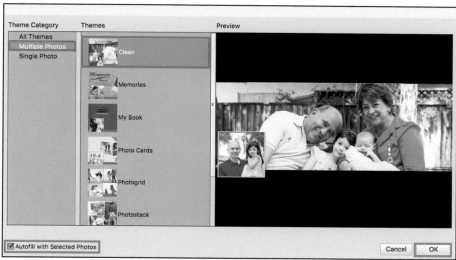

Figure 11.15 Selecting a Theme and Autofill with Selected Photos.

the scrollable list, a larger preview appears on the right. We will choose Theme Category>Multiple Photos>Clean, then in the lower left corner of the dialog box, we will keep Autofill with Selected Photos checked, then click the OK button to create the cover, as shown in Figure 11.15.

The cover is created but may not have the images in the specific locations or positions we want. The Move tool that is provided here can be used to adjust the positioning, and each image can be double clicked to provide a slider to adjust its size. In the Taskbar, three buttons are available: Upload, Save, and Close. Let's click the Close button. When we do that, a dialog box asks us if we want to save the file; we will choose Don't Save.

When we Right/Control click an image in a Facebook cover design that we want to affect, we can select to rotate it, replace it, delete it, change its stacking order, adjust its position, and even apply corrections and styles from the context-sensitive menu that appears. When Edit Quick is chosen, the selected image will open in the Quick mode, with a Back to Creations button at the top left of the edit pane to return to the Facebook cover.

11.5.2 Creating a Facebook Cover With Autofill With Selected Photos Unchecked

Let's choose Create>Facebook Cover again. In the dialog box that opens, we will select the same theme; however, this time we will *uncheck* Autofill with Selected Photos, then click the OK button to create the cover. This time default images fill the spaces, with directions to click and locate the photographs to insert inside of each of them, or drag and drop onto them. We will choose to drag and drop them from the Photo Bin, placing one in the large area (our cover photo) and the other in the small square (our profile photo). Once we have done that, with the Move tool selected, we can drag to position each photograph better within the area it displays, as well as double click it, use the slider to enlarge it and reposition it, then click the check mark as shown in Figure 11.16.

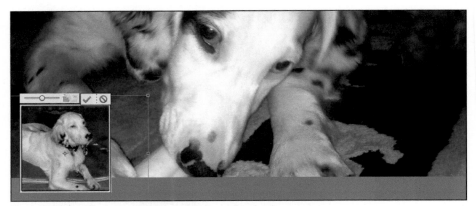

Figure 11.16 Positioning and scaling content on a Facebook cover.

We can select the Horizontal Type tool provided to add some text to the cover. When chosen, the Tool Options bar appears for us to customize its orientation, font, font style, color, size, leading, alignment, style, and warp.

11.5.3 Enhancing a Facebook Cover Project in the Expert Mode

Above the edit pane let's click the Advanced Mode button. As we have learned, this allows us to access all of the Expert mode's panels. In the Advanced mode, we will click the Graphics panel button in the Taskbar to open it. Select any graphic you like; the sample shown in Figure 11.17 uses the Love Thought Bubble graphic. Double click the chosen graphic or use the pointer to press and drag it onto the cover design, then choose Image>Transform>Free Transform to scale and rotate the graphic as desired.

If you chose to add some text or a graphic or both, try adding a drop shadow. Right/Control click the text or graphic, then choose Edit Layer Style from the context-sensitive menu that appears. In the Style Settings dialog box, check Drop Shadow, then assign Lighting Angle, Size, Distance, and Opacity.

11.5.4 Saving and Uploading the Facebook Cover Design

When the Save button is clicked, the Save As dialog box opens with the .pse file format chosen. We will want to be sure Layers is checked. If you have been using the Organizer, you can click the checkbox to include the completed cover design in

it. As we have learned, by saving this project in the .pse file format, we can return to it at any time to make changes and improvements to the design. When the Upload button is clicked in the Taskbar, if you have already completed the authorization process, Facebook will open a dialog box to choose to upload the Cover, the Profile Photo, or both, with this dialog

Figure 11.17 Choosing images to upload and the resulting Facebook page.

box and the resulting uploaded Facebook page both shown in Figure 11.17. (Setting up authorization is covered in the next section of this chapter.)

NOTE> The rest of the Create menu options are all produced using the same basic format: choosing a template layout, adding images, clicking the Advanced Mode button to access to all of the Expert mode panels, and using the buttons in the Taskbar to access additional Layouts and Graphics.

11.6 Sharing Your Photographs and Projects

Sharing options are available in both the Organizer and the Editor. When working in the Editor, we can choose Share, then press the down arrow menu to select saving an open file to Facebook, Flickr, or Twitter. When working in the Organizer, if one or more thumbnails have not been selected *first*, when Facebook, Flickr, or Twitter is selected from the Share menu, an All Displayed Items Chosen dialog box will open asking us if we want to upload all of them. Each of these Share sites requires a one-time authorization prior to the first upload to give Photoshop Elements 2018 permission to do so. The log in authorization process follows the same basic format for Facebook, Twitter, Flickr, Vimeo, and YouTube; we will examine the authorization and uploading process for Facebook.

11.6.1 Authorizing Photoshop Elements 2018 to Share Media on Facebook

When an image is open in the Editor or has been selected in the Organizer, when Share>Facebook is selected, the log in window shown in Figure 11.18 opens. Once your information has been entered and the Log In button is clicked, Photoshop Elements 2018 and Facebook connect, and the confirmation message also shown in Figure 11.18 appears.

Figure 11.18 Log In dialog box and authorization confirmation for Facebook.

You will stay logged in automatically until you choose to log out. When logged in and an image is selected, then the Share>Facebook option is chosen, and the dialog box shown in Figure 11.19 opens, allowing you to assign where you want to share to, to whom, and what quality you want to use for the upload. That's it!

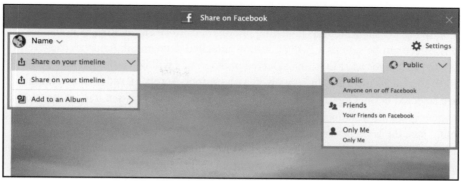

Figure 11.19 Choosing settings for a Facebook upload.

11.6.2 Sharing Through Email

Attaching photographs to email within Photoshop Elements 2018 allows you to assign the quality you want for sending the photograph. This share feature is only available in the Organizer. To use it, your email account must be validated first. With the Organizer open, choose Edit>Preferences>Email in Windows or Elements Organizer>Preferences>Email in Mac OS. Once a profile and email provider have been selected and your email address and password have been entered, the Validate button is clicked. (In some instances, you may need an app-specific password issued by your service provider if your regular password will not validate.)

Once the Validation Passed message appears and the OK button is clicked to exit the Preferences dialog box, the Organizer is ready to send images as attachments. When one or more files are selected, then Share>Email is chosen, and the images will appear in the Email Attachments bin. Below the bin a file format, size, and quality can be assigned, as shown in Figure 11.20. When the Next button is clicked, recipients can be set up as contacts, with a subject and message added as also shown in Figure 11.20.

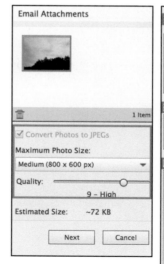

Figure 11.20 Assigning quality, recipient, subject, and message for an email attachment.

11.6.3 Sharing Photographs as a PDF Slideshow

Following the same steps as attaching photographs to an email, images in the Organizer can be sent as a PDF slideshow attached to an email. As an alternative to attaching images as JPEGs, the selected photographs will be combined into a single PDF slideshow file that can be viewed using Adobe Acrobat Reader. When images are selected in the Organizer and Share>PDF Slideshow is chosen, the images will appear in a bin, with the ability to assign a size, quality, and name field below the bin. Once the Next button is clicked, the same Select Recipients pane shown in Figure 11.20 opens. Once the recipient information is assigned and the Next button is clicked, a progress message appears as the email is being sent, followed by a Sharing successful confirmation.

NOTE The PDF Slideshow option is only available for photographs. If other types of media are selected when Create>PDF Slideshow is chosen, an Unsupported Media Included message warns that video, audio, PDF, and PSE files will not be included in the PDF slideshow.

11.7 Exporting Files

Sometimes you may need to convert multiple photographs from one file format to another. We learned we could do this using the File>Process Mulitple Files dialog box in the Editor. We can also choose the File>Export as New File(s) command in the Organizer. When one or more thumbnails are selected and this command is

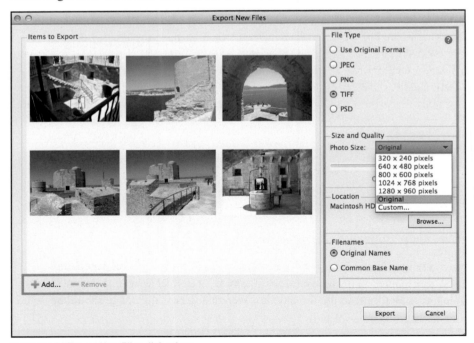

Figure 11.21 Export New Files dialog box.

chosen, the Export New Files dialog box opens with the following options, shown in Figure 11.21:

FILE TYPE: Allows us to assign the export file format for the selected images.

SIZE AND QUALITY: Provides a drop down menu for sizing options along with a Custom size option.

LOCATION: Provides a Browse button to choose a location for the new files.

FILENAMES: Allows the files to retain their original names or have a common reference name applied followed by -1, -2, etc.

ADD/REMOVE: Allows us to add or remove files prior to applying the export command.

11.8 Preparing Images for a Web Page

When preparing images for a web page, optimization becomes critical. The Save for Web dialog box in the Editor can ensure that our images will look as good as possible while still downloading and opening as quickly as possible. Preparing images for a web page is a two-step process: crop the image to the desired pixel dimensions first and then optimize the image in the Save for Web dialog box.

11.8.1 Cropping an Image for a Web Page

Working in the Expert mode of the Editor, let's open the photograph named Lily. jpg located in the Practice_Import 18 files folder within the Practice Files folder you copied to your hard drive. Before optimizing an image, the final pixel dimensions it will need based on its future web page application should be determined first. For this exercise, we will envision that we need this photograph to have final pixel dimensions of Width: 600 px, Height: 400 px, and Resolution: 72 ppi. When we choose Image>Resize>Image Size, we can see that this file currently is Width: 3000 px, Height: 2400 px, and Resolution: 300 ppi, resulting in a file size of 20.6M (megabytes). Let's cancel this dialog box and select the Crop tool. In the Tool Options bar, let's assign Show Preset Crop Options: Custom, W: 600 px, H: 400 px, Resolution: 72 ppi, then crop the image as shown in Figure 11.22. (We *must* add the "px" when typing in the dimensions so that the Editor will convert the default unit of measurement from inches to pixels for us.)

Once the crop has been applied, when the Image Size dialog is reopened, the pixel dimensions have changed from 20.6M to 703.1K (20.6 megabytes to 703.1 kilobytes). Before entering the Save for Web dialog box, the image should be saved.

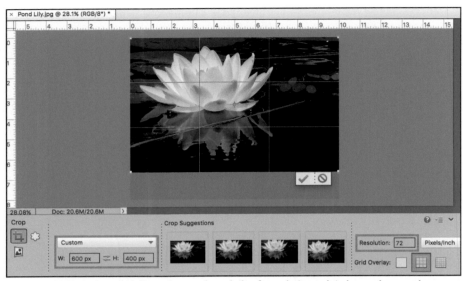

Figure 11.22 Assigning pixel dimensions and resolution for a photograph to be used on a web page.

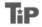

If an image is cropped and saved for the web with its crop dimensions added to its name (i.e., lily_600-400.jpg), in the future you will know its dimensions at a glance as well as being able to return to the original file to recrop it and save it with different dimensions if needed.

11.8.2 Optimizing an Image in the Save for Web Dialog Box

The file format selected in the Save for Web dialog box should be chosen based on the pixel content of the image:

GIF: Best used for clip art graphics with flat areas of color.

JPEG: Best used for continuous tone (photographs).

PNG-8: Best used for clip art graphics with flat areas of color.

PNG-24: Best used for continuous tone (photographs) with transparency.

Let's choose File>Save for Web. When the dialog box opens, "before" and "after" previews appear based on the selected file format and quality setting. When applying optimization settings in this dialog box, it is important to use its Zoom tool to magnify in to various areas of the optimized preview to examine the effects of the chosen format and settings. The quality should be reduced *as low as possible while still maintaining the integrity of the image*. Let's choose Preset: JPEG Medium, Optimized file format: JPEG, Compression Quality: 30. Once we do that, we can see in the previews shown in Figure 11.23 that the size has been reduced from 703K to

23.53K. Listed below the optimized size, 5 sec @ 56.6 Kbps indicates its estimated download speed based on the assigned settings, with a down arrow menu to choose another size/download time estimation.

NOTE▶ The Image Size section of this dialog box provides New Size>Width, Height, and Percent fields. The image should not be enlarged here, nor should the chain link icon be clicked to appear "broken" to adjust its dimensions disproportionately. When a smaller proportional pixel width and height or percentage is desired, the new dimensions can be conveniently typed in here.

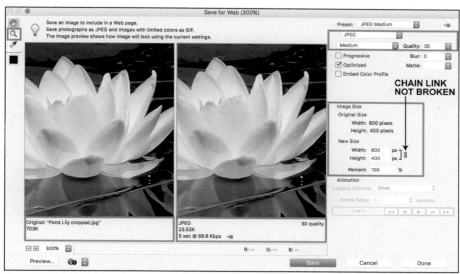

Figure 11.23 Optimizing an image in the Save for Web dialog box.

When the Save button is clicked, the Save Optimized As dialog box opens. For our purposes, we will click the Cancel button, then close the file and choose not to save the changes when prompted.

PRACTICE MAKES *PERFECT*✓

Before beginning Chapter Twelve, feel free to reinforce some of the new information covered in this chapter by completing one or both of the following practice projects.

PRACTICE PROJECT 1

1. Working in the Editor Expert mode, choose File>Open, then Shift-click to select the three images provided in the folder named C-11 Project 1 located in the Practice_Import 18 files folder within the Practice Files folder you copied to your hard drive.

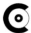

2. Choose Create>Photo Collage, select 11.00 × 8.50 inches, uncheck Autofill with Selected Images, then click OK to open the layout template.

3. Click the Layout button in the Taskbar, then double click the 4 Photos template to apply it.

4. Click the Advanced Mode button, then the Layers panel button in the Taskbar. In the Layers panel select the large image frame group, then Right/Control click to delete the group and its contents as shown in Figure 11.24.

Figure 11.24 Deleting the large frame group and its contents from the collage.

Figure 11.25 Completed Hampton Beach collage.

5. Collapse each of the remaining frame groups, then rotate the frames and arrange them to resemble the positioning shown in Figure 11.25.

6. Drag and drop the images from the Photo Bin into the frames in any order.

7. Click the Graphics panel button in the Taskbar, then select the Background category and double click the Beach with Seashells background graphic to apply it.

8. Select the Graphics category of the Graphics panel, then drag and drop the Beach Chairs graphic onto the collage, placing it in the blank area at the top right.

9. With the Beach Chairs layer selected in the Layers panel, choose Image>Transform>Free Transform. In the Tool Options bar assign Constrain Proportions, W: 150%, H: 150%, then choose Image>Rotate>Flip Layer Horizontal.

10. Select the Horizontal Type tool and type "Hampton Beach," using any font, size, and color.

11. Apply a drop shadow to the beach chairs graphic and to the text with style settings of your choice.

12. Select each layer group in the Layers panel one at a time, then Right/Control click and choose Edit Layer Style from the context-sensitive menu that appears. Change the drop shadow settings for the three frames to Size: 80, Distance: 10, Opacity: 75%, with your collage resembling Figure 11.25.

13. Add any additional enhancements you would like, then save and close the collage.

PRACTICE PROJECT 2

1. With the Organizer open, locate the folder named C-11 Project 2 inside the Practice_Import 18 files folder within the Practice Files folder you copied to your hard drive, then drag and drop it onto the All Media pane to add the images into the Organizer.

2. When the imported media appear as thumbnails in the Last Import view, choose View>File Names, as shown in Figure 11.26.

3. Select all of the thumbnails *except* the slide named slide7.jpg, then choose Create>Slideshow.

4. Select the Themes button, then choose the Black and White theme.

5. Select the Audio button, then in the Audio dialog box, click the minus sign next to the Corn Sequins track in the Selected Tracks column to delete it, then select the Light Jazz track in the Audio column and click its plus sign to add it to the Selected Tracks column.

Figure 11.26 Choosing to view file names for thumbnails.

6. Click the Media button to edit the slides.

7. Right/Control click the opening text slide and choose Remove from the context-sensitive menu that appears.

8. Click the Add photos and videos button above the slide show, then choose Add Photos and Videos from Organizer. In the Add Media dialog box that opens, click the Media from the Grid radio button, select the Chateau d'If image, click the Add Selected Media button, then the Done button, as shown in Figure 11.27.

9. Arrange the slides as shown in Figure 11.28.

10. Choose Save As from the Save down arrow menu, then name the slideshow "Chateau."

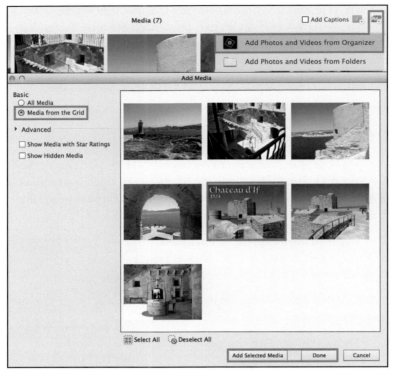

Figure 11.27 Adding an image to a slideshow from the Organizer.

11. Choose Export>Export video to local disk.

Figure 11.28 Arranging the slideshow sequence.

12. In the dialog box that opens, assign Filename: Chateau, Location: (choose a location on your hard drive), Quality: 1080p HD, then click OK as shown in Figure 11.29.

13. In the Elements Organizer dialog box that opens, choose No to not import the exported video, then locate the .mp4 file on your hard drive and play it.

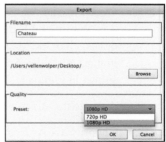

Figure 11.29 Assigning export settings for the Chateau slideshow.

12

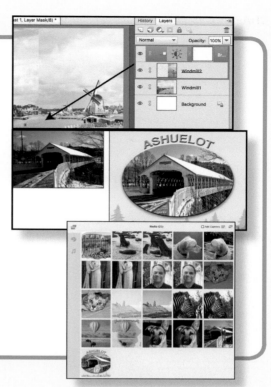

Applying Your Expertise

- Combine photographs to create a composite image, adjust color and content, and more

- Remove unwanted content, adjust tones using commands and tools, and more

- Apply filters, add custom shapes, image text, and more

- Create a professional porfolio of your work

In your future work, while some of your photographs will be "picture perfect" as taken, others will need the tools, commands, and techniques of Photoshop Elements 2018 to get them there. Each of the projects provided in this final chapter include multiple types of corrections designed to challenge and perfect your skills as an expert.

NOTE It is time to apply your expertise. Each project will begin with a bulleted list of the specific tools, commands, and techniques required to complete the project, along with a before and after sample, followed by step-by-step instructions to complete it. Feel free to follow the steps provided, or after reviewing the project sample and the list of its required skills, feel free to finish the project on your own. As we have learned, sometimes a correction can be accomplished more than one way. Feel free to tap your experience to complete each of these projects using other methods you have learned rather than the specific ones detailed in the exercise.

12.1 ELEMENTS EXPERT PROJECT

Figure 12.1 Original images and completed composite project.

12.1.1 Required Tools, Commands, and Techniques

- Brightness/Contrast adjustment layer

- Clone Stamp tool

- Content-Aware fill command

- Convert a color profile

- Crop assigning width, height, and resolution, using the Rule of Thirds

- Eraser tool

- Feather command

- Healing Brush tool

- Lasso and Polygonal Lasso tools

- Layer stacking order and opacity

- Layer Via Copy command

- Magic Wand tool
- Move tool
- New Blank File dialog box
- Photo Filter command
- Resampling an image
- Transformations

A copy of each figure shown in this chapter can be viewed in the companion files included with this book.

This project uses three photographs provided in a folder named Expert Project_1 located inside the Practice_Import 19 files folder within the Practice Files folder you copied to your hard drive. This project will be completed in its entirety working in the Expert mode of the Editor.

1. Open each of the three photographs one at a time then choose Image>Resize>Image Size, *uncheck* Resample Image, then assign Resolution: 300 ppi, as shown in Figure 12.2. From the Image menu, choose Convert Color Profile>Convert to Adobe RGB Profile, as also shown in Figure 12.2.

2. With the three windmill images still open, choose File>New>Blank File. In the dialog box that opens, assign Width: 16 inches, Height: 8 inches, Resolution: 300 ppi, Color Mode: RGB Color, Background Contents: White as shown in Figure 12.3. Once the document has been created, choose File>Save As and name the file Final_1.psd.

3. Use the Layout down arrow menu in the Taskbar to select All Grid, then using the Move tool drag and drop to add *only* the Windmills_1.jpg and

Figure 12.2 Resampling an image and converting a color profile.

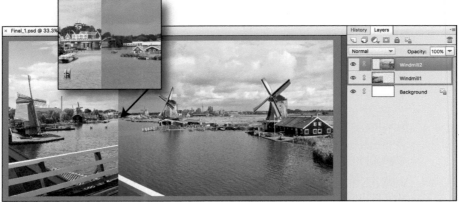

Figure 12.3 Creating a new blank document.

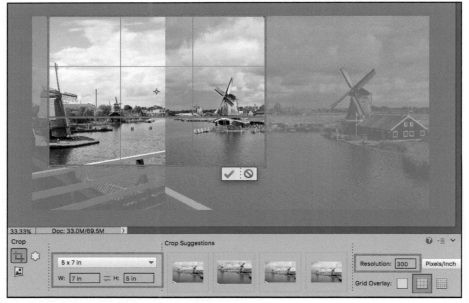

Figure 12.4 Positioning the imported images and using the Layers panel to assign layer names and stacking order.

Figure 12.5 Cropping an image using the Rule of Thirds.

the Windmills_2.jpg files into the blank document; choose to close the Windmills_3.jpg file for now and save the changes to it when prompted. Once the Windmills_1.jpg and the Windmills_2.jpg have been added to the composite image, the original files can be saved and closed.

4. Position the imported images as shown in Figure 12.4: Windmills_1.jpg on the left and Windmills_2.jpg on the right. Name the layers and adjust their stacking order as shown in Figure 12.4.

5. Crop the composite image, assigning Show Crop Preset Options: W: 7 in, H: 5 in, Resolution: 300 ppi in the Tool Options bar, using the Rule of Thirds to place the horizon line along the grid, as shown in Figure 12.5.

6. With the Windmill2 layer selected in the Layers panel, add a Brightness/Contrast adjustment layer clipped to affect

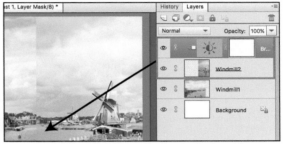

Figure 12.6 Adding a Brightness/Contrast adjustment layer clipped to affect only the Windmill2 layer.

only the Windmill2 layer, with a setting of Brightness: 38 and Contrast: 0 to match the color of its water with that of the Windmill1 layer, as shown in Figure 12.6.

7. Choose Flatten Image from the Layers panel menu.

8. Use the Polygonal Lasso tool to draw a selection around the area of the sky where the two images join, then choose Edit>Fill Layer>Use: Content-Aware.

9. Repeat step 8 to cover the rails in the water and to match the water where the two images join.

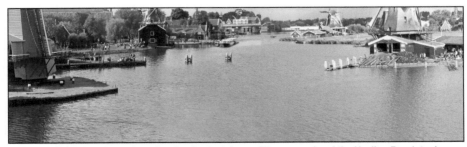

Figure 12.7 Blending the water using the Content-Aware fill command and the Healing Brush tool.

10. Select the Healing Brush tool, then in the Tool Options bar assign Size: 100 px, Aligned unchecked, Source: Sampled, Mode: Normal. Sample and apply content on either side of the water as needed to further blend the water of the two images naturally, as shown in Figure 12.7.

TiP Duplicating the Background layer first before applying the Healing Brush tool to it will allow you to lower the opacity of the copied layer if needed after applying the brush. If you choose to duplicate the layer, merge its layer down once the Healing Brush tool has been applied.

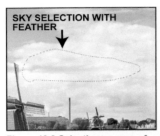
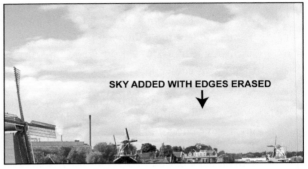

Figure 12.8 Selecting an area of the sky, applying the Layer Via Copy command, and applying the Eraser tool.

11. Use the Lasso tool to select the area of the sky shown in Figure 12.8, apply a feather with Radius: 5 px, then apply the Layer Via Copy command. Move the copy to the location also shown in Figure 12.8.

12. Select the Eraser tool, then in the Tool Options bar assign Size: 90 px, Opacity: 50%. Apply the tool to the outer edges of the layer content so that it blends naturally with the adjacent content, as also shown in Figure 12.8, then merge the layer down.

Figure 12.9 Using the Clone Stamp tool to meld the image content.

13. Magnify in to the area where the buildings are joined. Apply the Clone Stamp tool, with Tool Options bar settings of Size: 12 px, Opacity: 100%, Mode: Normal, Aligned unchecked, Clone Overlay options checked, and then clone to cover any content as needed for a realistic appearance, as shown in Figure 12.9.

14. Open the Windmills_3.jpg file, then select All Column from the Layout down arrow menu in the Taskbar.

15. Using the Lasso tool, select around the smaller distant windmill in the Windmills_3.jpg image (accuracy is not important—add some extra surrounding content for a fudge factor in your selection). Apply a feather with Radius: 5 px, then use the Move tool to drag it into your Final_1.psd file. Once you have done that, close the Windmills_3.jpg file, choosing not to save the changes if prompted.

16. Select the newly added windmill layer in the Layers panel, then choose Image>Transform>Free Transform. In the Tool Options bar with Constrain Proportions checked, assign W: 20%, H: 20%.

17. Use the Move tool to position the windmill as shown in Figure 12.10 (temporarily lowering the opacity of the layer can help with its positioning). Erase the building content below the windmill with the Eraser tool, using a small soft brush with Opacity: 100%, so that the windmill appears to be located behind the trees.

18. Choose the Magic Wand tool, then in the Tool Options bar assign Tolerance: 10. Select the sky area around the outside of the windmill, apply a feather with Radius 1 px, then delete it (optionally choose to use the Eraser tool to remove the sky around the windmill instead if desired), as also shown in Figure 12.10.

19. To create the appearance of aerial perspective, lower the opacity of the distant windmill layer in the Layers panel to 90%, then merge the layer down.

20. Choose to apply a final color correction to this composite image by assigning Filter>Adjustments>Photo Filter. In the dialog box that opens, assign Use: Filter>Cooling Filter (80), Density: 20%, Preserve Luminosity checked. Your completed project should now match the sample shown in Figure 12.1.

Figure 12.10 Selection of Windmill_3 added to Final_1.psd, with W: 20%, H: 20%, content erased, layer Opacity: 90%.

12.2 ELEMENTS EXPERT PROJECT

Figure 12.11 Original image and completed project.

12.2.1 Required Tools, Commands, and Techniques

- Blending Mode
- Color Picker
- Cookie Cutter tool
- Crop and straighten
- Dodge tool
- Graphics panel
- Guides
- Horizontal Type tool
- Hue/Saturation adjustment layer
- Layers: Create and Convert to Background
- Levels adjustment layer
- Rectangular Marquee tool
- Resize Canvas Size command
- Shadows/Highlights command
- Sponge tool
- Spot Healing Brush tool
- Styles
- Unsharp Mask command
- Warped text

1. Open the photograph named Ashuelot Bridge.jpg located inside the Practice_Import 19 files folder within the Practice Files folder you copied to your hard drive, then save the file as Final_2.psd. This project will be completed in its entirety working in the Expert mode of the Editor.

2. Select the Crop tool, then in the Tool Options bar assign Show Crop Preset Options: W: 7 in, H: 5 in, Resolution: 300 ppi. After creating the crop preview, place the pointer just outside one of the corners of the preview to rotate the image to straighten it, as shown in Figure 12.12. Adjust the position of the preview to include the back of the bridge and the telephone pole on the left then choose to apply the crop.

Figure 12.12 Crop and straighten with Tool Options bar settings of Show Crop Preset Options: W: 7 in, H: 5 in, Resolution: 300 ppi.

3. Add a Hue/Saturation adjustment layer with settings of Hue: +15, Saturation: –35, Lightness: 0 as shown in Figure 12.13.

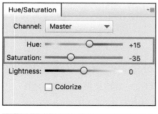

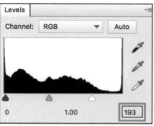

Figure 12.13 Adding a Hue/Saturation and a Levels adjustment layer to the bridge photograph.

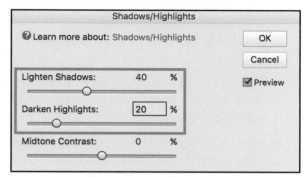

Figure 12.14 Applying the Shadows/Highlights command.

4. Add a Levels adjustment layer with settings of Shadows: 0, Midtones: 1.00, Highlights: 193, as also shown in Figure 12.13. Once both of these adjustment layers have been applied, choose to flatten the file.

5. Apply the Shadows/Highlights command (Enhance>Adjust Lighting>Shadows/Highlights), with settings of Lighten Shadows: 40%, Darken Highlights: 20%, and Midtone Contrast: 0%, as shown in Figure 12.14.

6. Magnify in to remove the power lines using the Spot Healing Brush tool, with Tool Options bar settings of Type (mode): Proximity Match, Brush: Hard, Size: just slightly larger than the width of the line you are covering (depending on your magnification, a size of 5 px should work well).

7. Using the Rectangular Marquee tool, select the trees to the right of the telephone pole, then apply a feather with Radius: 2 px. With the selection active, apply the Layer Via Copy command, then use the Move tool to drag the selection to the left to cover the pole, as shown in Figure 12.15.

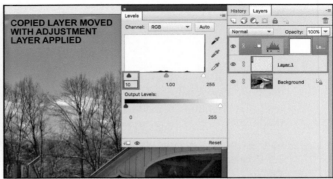

Figure 12.15 Selecting an area of trees for the Layer Via Copy command, with a Levels adjustment layer clipped to affect only the copied content to match its tonal quality with the adjacent content.

8. Add a Levels adjustment layer clipped to affect *only* the copied content layer, then adjust the Shadows slider only to 10 (you may need to assign a slightly higher or lower number based on your selection to match your adjacent sky tone), as also shown in Figure 12.15.

9. Flatten the file, then select the small pieces of clouds that remain in the top left area of the sky and apply the Content-Aware fill command to remove them.

10. Select content to the right of the rest of the visible area of the pole, apply the Layer Via Copy command, move it to cover the base of the pole, then flatten the file.

11. Although the photograph has been lightened significantly, there are some areas that will benefit from applying lightness selectively using the Dodge tool. With the tool chosen and Tool Options bar settings of Range: Midtones, Brush: Soft, Size: 95 px, Exposure: 25%, apply the brush to the shadow area of the road, the snow bank, the fence above it, and the front of the bridge, as outlined in red in Figure 12.16.

12. The road appears slightly bluer than natural. The Sponge tool with Tool Options bar settings of Mode: Desaturate, Brush: Soft, Size: 100 px, Flow: 25% can be brushed across it to reduce the blue color cast, as also outlined in red in Figure 12.16.

DODGE TOOL APPLIED TO SNOW AND FRONT OF BRIDGE **SPONGE TOOL APPLIED TO ROAD**

Figure 12.16 Dodge and Sponge tools applied selectively to the bridge photograph.

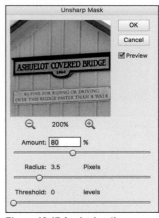

13. Select each of the signs above the entrance to the bridge one at a time using the Polygonal Lasso tool, apply a feather with Radius: 2 px, then choose Enhance>Unsharp Mask. In the dialog box that opens, choose Amount: 80%, Radius: 3.5 Pixels, Threshold: 0 levels, as shown in Figure 12.17.

Figure 12.17 Assigning the Unsharp Mask command.

Remember that holding down the Alt/Option key will temporarily convert the Polygonal Lasso tool to the Lasso tool to easily trace around the curved section of the bridge sign.

14. Choose View>Rulers, then add vertical guides at .25" and 6.75", and horizontal guides at .25" and 4.75".

15. Select the Cookie Cutter tool, then in the Tool Options bar assign Oval from the Shapes category of the Custom Shape picker down arrow menu, Set Geometry Options: Unconstrained, From Center checked, Feather: 1 px, Crop unchecked. Draw an oval that aligns with the guides added. Prior to applying the check mark to commit the crop, adjust the bounding box handles if needed to align with the guides. Once the Cookie Cutter tool has been applied, choose to clear the guides (View>Clear Guides).

16. Click the Create a new layer icon in the Layers panel, then drag the new layer (Layer 1) below the bridge layer (Layer 0).

17. With Layer 1 selected in the Layers panel, choose Edit>Fill Layer>Use: Color, Mode: Normal, Opacity: 100%, Preserve Transparency unchecked. When the Color Picker opens, use the eyedropper to sample the sky just above the roof of the bridge, as shown in Figure 12.18, or assign R: 158, G: 179, B: 226.

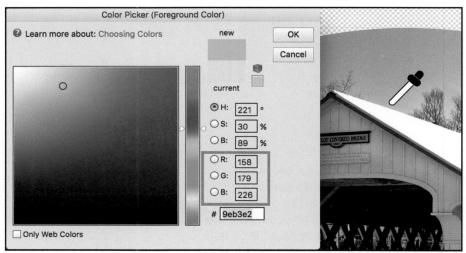

Figure 12.18 Selecting a layer fill color using the Color Picker.

18. With Layer 1 still selected, choose to convert this layer to the default Background layer (Layer>New>Background from Layer).

19. With the Background layer selected, choose Image>Resize>Canvas Size. In the dialog box that opens assign Width: 8 Inches, Height: 6 Inches, Relative unchecked, Anchor: center, Canvas extension color: Other. When the Color Picker opens, assign the same color chosen to fill the layer (R: 158, G: 179, B: 226), using the dialog box shown in Figure 12.19.

20. Duplicate the Background layer and then, with the Background layer selected (not the Background copy layer), open the Graphics panel (Window>Graphics). Select the Pine Trees background from the Backgrounds category, then double click it to apply it or drag and drop it onto the image.

21. Select the Background copy layer, then select Overlay from the Set the blending mode for the layer drop down menu in the Layers panel.

22. Select the bridge layer (Layer 0), then choose the Horizontal Type tool, single click on the page and type "ASHUELOT" (all caps). With the text selected, in the Tool Options bar assign Font: Arial (or the font of your choice), Style: Bold, Color: (use the Color Picker to select one of the medium blue colored trees of the background or R: 135, G: 152, B: 229), Size: 48 pt (size may vary based on your font; choose one comparable to the size shown in the sample), Leading: Auto, Alignment: Left.

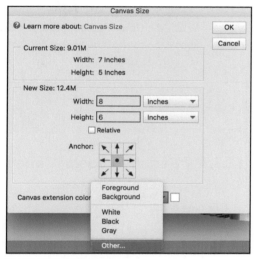

Figure 12.19 Adding canvas.

23. With the text selected, click the Create warped text icon. In the dialog box that opens, assign Style: Arc, Horizontal, Bend: +29%, Horizontal Distortion: 0%, Vertical Distortion: 0%, as shown in Figure 12.20. Once the text has been warped, use the Move tool to position it above the oval, as shown in Figure 12.11.

24. Select the bridge layer (Layer 0) in the Layers panel, then open the Styles panel (Window>Styles). Select Bevels from the Select a type drop down menu, then Simple Emboss. Once it has been applied, double click the style icon in the Layers panel (fx) to open the Style Settings dialog box. Click the check mark to add a drop shadow with Size: 60 px, Distance: 28 px, Opacity: 60%.

25. Select the ASHUELOT text layer, apply Styles>Bevels>Simple Emboss, then save the file. Your completed project should now match the sample shown in Figure 12.11.

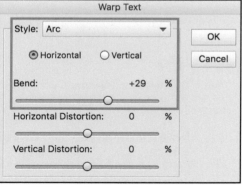

Figure 12.20 Assigning a warp to text.

12.3 ELEMENTS EXPERT PROJECT

Figure 12.21 Original image and completed portfolio slideshow opening text slide.

12.3.1 Required Tools, Commands, and Techniques

- Adjust Color Curves command
- Clipping Mask
- Custom Shape tool
- Filter Gallery
- Gradient tool
- Inverse command
- Layer Mask
- Lens Blur filter
- Quick Selection tool
- Slideshow
- Transform Selection command
- Type Mask tool

NOTE▶ This project will first build a document in the Expert mode of the Editor, followed by creating a slideshow in the Organizer to showcase work you have completed throughout this book. The document created in the Editor first will become the opening text slide for the slideshow.

1. Create a folder on your hard drive and name it "Portfolio."

2. Working in the Expert mode of the Editor, open the file named 100_1839. jpg located inside the Practice_Import 5 files folder within the Practice Files folder you copied to your hard drive. Choose File>Save As, and save the file as Portfolio_cover_layers.psd into the folder named "Portfolio" you created on your hard drive.

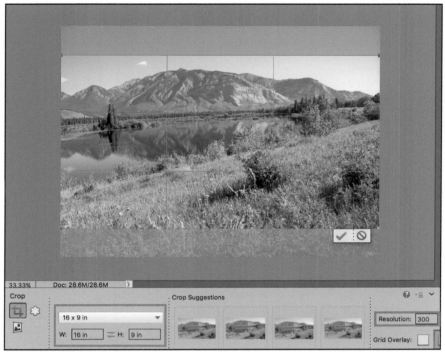

Figure 12.22 Cropping using the 16 × 9 in crop preset with Resolution: 300 ppi.

3. Choose the Crop tool, then in the Tool Options bar assign Show Crop Preset Options: 16 × 9 in, Resolution: 300 ppi. Crop the image as shown in Figure 12.22.

4. Choose to duplicate the Background layer.

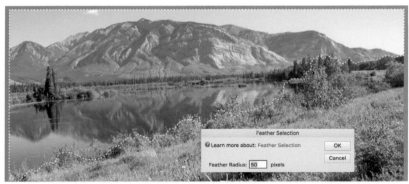

Figure 12.23 Using the Quick Selection tool to create a general selection of the water and mountain areas of the photograph.

5. With the copied layer active, create a *general* selection which includes only the water and mountain areas of the photograph using the Quick Selection tool, then apply a feather with Radius: 50 px, as shown in Figure 12.23.

6. Choose Select>Inverse to instead select the field in the foreground, then choose Edit>Cut, then deselect the selection.

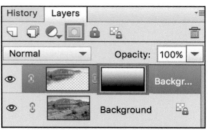

7. With the copied layer active in the Layers panel, single click the Add Layer Mask icon to add a layer mask.

Figure 12.24 Adding a gradient to the layer mask.

8. With the mask selected (*not* the image thumbnail) in the Layers panel, select the Gradient tool, then assign the default colors of black as the foreground color and white as the background color; add the default Linear gradient style. With the Shift key held down, press and drag from the bottom edge to the top edge of the image to create a gradient mask, as shown in Figure 12.24.

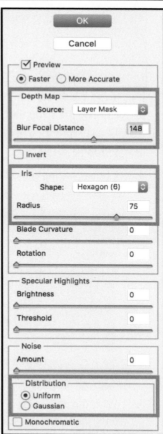

9. Double click the *image thumbnail* (not the layer mask), then select Filter>Blur>Lens Blur. In the dialog box that opens, assign Depth Map Source: Layer Mask, Blur Focal Distance: 148, Shape: Hexagon, Radius: 75, Distribution: Uniform, as shown in Figure 12.25, then flatten the file.

10. Choose Filter>Filter Gallery. In the Filter Gallery dialog box, select Artistic>Dry Brush, then assign settings of Brush Size: 4, Brush Detail: 10, Texture: 2.

11. Choose View>Rulers, then add vertical guides at 1" and 15", and horizontal guides at 1" and 8".

12. Select the Type tool, then in the Tool Options bar select the Horizontal Type Mask tool, Font: Arial, Style: Bold, Size: 175 pt, Alignment: Left. Type "PORTFOLIO" (all caps), then click the check mark to create the type selection.

Figure 12.25 Adding a lens blur to a photograph.

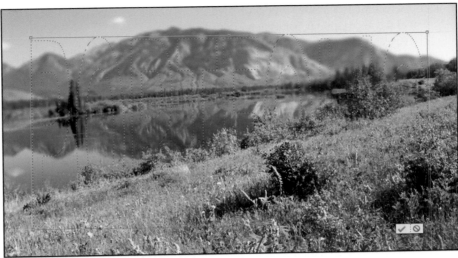

Figure 12.26 Transforming a type selection.

13. Choose Select>Transform Selection, then drag the bounding box handles to align with the guides, as shown in Figure 12.26, then click the check mark to commit the transformation.

14. With the selection active, apply the Layer Via Copy command.

15. With the image text layer now active in the Layers panel, choose Enhance>Adjust Color>Adjust Color Curves. In the dialog box that opens, select the Increase Contrast option, then drag the sliders to create the "S" curve shown in Figure 12.27.

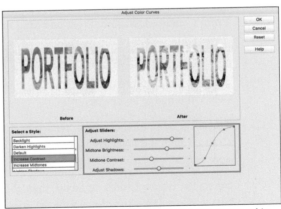

Figure 12.27 Applying the Adjust Color Curves command to image text.

16. With the image text layer still selected in the Layers panel, open the Styles panel (Window>Styles), then choose Bevels>Scalloped Edge. Once it has been applied, double click the Styles icon (*fx*) in the Layers panel to open the Style Settings dialog box, then assign Size: 50 px. While still in this dialog box, click the Drop Shadow checkbox and assign Lighting Angle: 30 degrees, Size: 60 px, Distance: 40 px, Opacity: 60%.

17. Select the Horizontal Type tool, then in the Tool Options bar assign Font: Brush Script Italic (or a font of your choice), Size: 150 pt, Alignment: Left. Single click the foreground color in the Tools panel, then use the eyedropper in the Color Picker to sample the color, as shown in Figure 12.28, or apply R: 163, G: 223, B: 246. Type: "Of Expertise."

Figure 12.28 Using the Color Picker to select a text color.

18. With the text layer still active in the Layers panel, open the Styles panel (Window>Styles), then choose Strokes>Black Stroke: 20 px. Double click the Styles icon in the Layers panel (*fx*), then assign Size: 26 px, Position: Outside, Opacity: 100%, then click the color box to open the Color Picker. Sample the dark blue area to the right of the letter "R." While still in the Style Settings dialog box, add a drop shadow with settings Lighting Angle: 30, Size: 65 px, Distance: 80 px, Opacity: 90%.

19. Select the Custom Shape tool in the Tools panel, then in the Tool Options bar assign Shapes: Crop Shape 18, Set Geometry Options: Unconstrained, From Center unchecked. Press and drag from the top left corner to the lower right corner of the image to add the crop shape (the shape can be filled with any color, as it will become a mask).

20. Convert the Background layer to a regular layer, then drag the shape layer below the image layer (Layer 0).

21. Select Layer 0, then choose Layer>Create Clipping Mask (or Right/ Control click the layer and select it from the context-sensitive menu that appears).

22. Select the Shape 1 masking layer, then choose Image>Transform Shape>Free Transform Shape. In the Tool Options bar, uncheck Constrain Proportions, then adjust the bounding box handles as needed to have all edges of the crop shape visible in the document.

23. Select Layer 0 (clipping content layer), then choose to create a new layer. Once it has been created, drag it below the Shape 1 masking shape layer.

24. With the new blank layer at the bottom of the stacking order in the Layers panel, choose Edit>Fill Layer>Use: White, Blending Mode: Normal, Opacity: 100 %, Preserve Transparency unchecked.

25. Choose to clear the guides (View>Clear Guides), then choose File>Save.

26. Now flatten this file, then choose File>Save As and rename this file Portfolio_cover.psd, also saving it into the folder named "Portfolio" you created on your hard drive. (By also saving the layered file, you can return to it if needed to make corrections/adjustments to it at any time.)

27. Choose any ten projects you have completed throughout this book. For each one, locate the original file and the completed file, adding a copy of each into your Portfolio folder. If a project you choose to add has the Adobe RGB profile attached to it, choose to convert its files to sRGB (Image>Convert Color Profile>Convert to sRGB Profile). Once you have done that, the folder should contain 22 items: a before and after copy of each portfolio piece, the Portfolio_cover.psd file, and the Portfolio_cover_layers.psd file.

28. Launch the Organizer, then drag your Portfolio folder onto the Media view pane of the Organizer. (If the Import Attached Keyword Tags dialog box opens, click OK.)

29. When the thumbnails display in the Last Import window, select all of the images *except* the Portfolio_cover_layers.psd file (use the pointer to drag-select across all of the thumbnails, then Control/Command click to deselect the Portfolio_cover_layers.psd file).

30. Choose Create>Slideshow.

31. Click the Media button, then Right/Control click the Memories slide and choose Remove from the context-sensitive menu that appears. Once you have done that, arrange the slides with the portfolio cover slide at the beginning of the show, then each of your projects with the before file followed by the after file, as shown in Figure 12.29.

32. Click the Themes button, then select the Pan & Zoom theme.

33. Click the Audio button, then delete the Captainzero track. Add the Light Jazz track to the Selected Tracks column followed by the Shumann_Scenes_From_Childhood track, then single click the slideshow window to test the changes.

34. Optionally click the Media button again to adjust the playing order of your portfolio pieces or add more than ten works to your portfolio, and also assign more or different audio tracks.

35. When you are satisfied with your slideshow, choose Save As, then name the slideshow "Portfolio Slideshow." Choose Export>Export video to local disk. In the dialog box that opens, assign the name, location, and quality you would like for the slideshow. When the slideshow has been exported and the dialog box opens asking to import it into the Organizer, choose Yes or No.

Figure 12.29 Assigning the play order of the slideshow.

12.4 Where to From Here

Congratulations. You can be proud to call yourself a Photoshop Elements 2018 expert! From here, there are options if you hit a bump in the road or if you decide to forge forward to Adobe Photoshop CC.

12.4.1 When You Need a Little Help

You may have noticed that many of the dialog boxes we have used had a small question mark icon or the script Learn more about: followed by the name of the

command chosen. When single clicked, either one of these cues will launch the Adobe help site and bring you directly to a page detailing the use of the command in question.

The eLive tab provided in both the Organizer and the Editor will also launch a page detailing various features of the Organizer and the Editor, providing another great resource.

12.4.2 Working in Adobe Photoshop CC

If you decide that you want to move up to Adobe Photoshop CC, you can do that. With the confidence and knowledge you have gained, you will recognize many of its tools, dialog boxes, and commands. Although in some cases the locations of the commands may differ or the dialog boxes appear slightly different, your experience will help you find your way.

12.4.3 Practice

And most of all, practice, practice, practice. The more varied the projects you complete, whichever Editor mode best fits your working style, the more experience you will gain, and you will discover some "tips" and some "tricks" all your own. Good luck, and remember to always have fun.